Masterpieces of Primitive Art

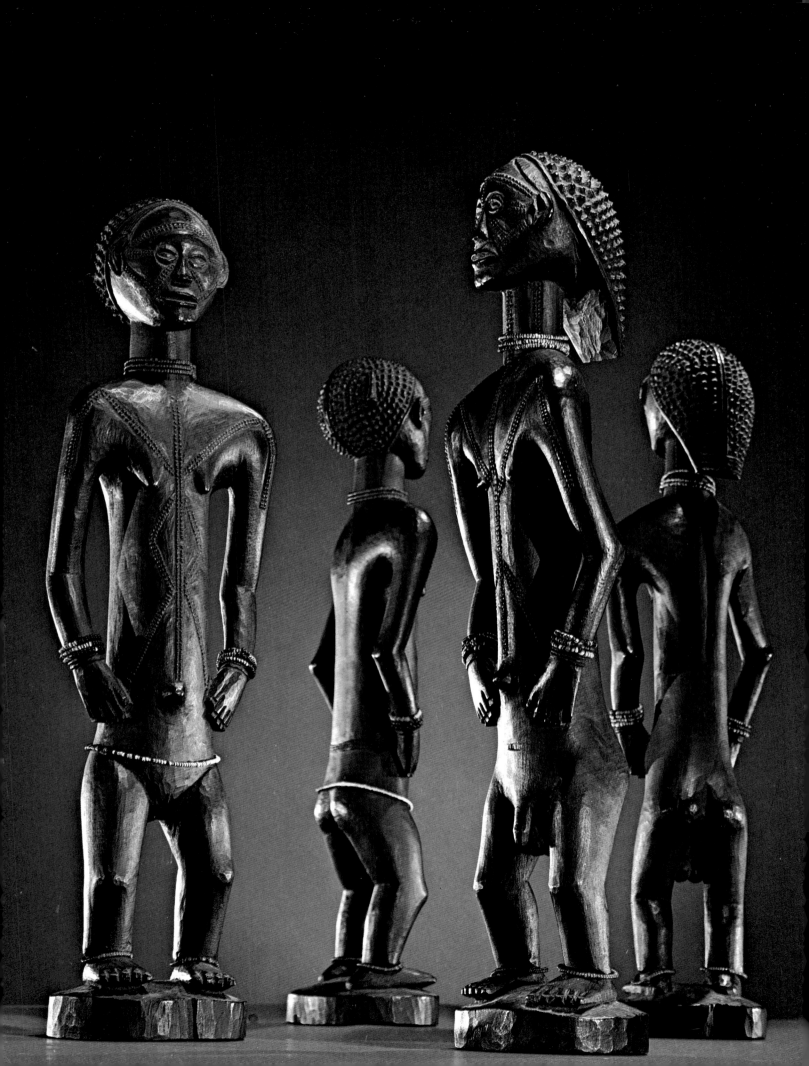

THE NELSON A. ROCKEFELLER COLLECTION

Masterpieces of Primitive Art

Photographs by Lee Boltin

Text by Douglas Newton

Foreword by André Malraux

Introduction by Nelson A. Rockefeller

ALFRED A. KNOPF NEW YORK 1978

Facing title page: A pair of figures representing
male and female ancestors, from the Tabwa tribe of Zaïre

Pages 6–7: A gold nose ornament worn by the Mochica
of Peru, about A.D. 100. The delicate filigree design
incorporates figures of spiders.

This is a Borzoi Book
Published by Alfred A. Knopf, Inc.

Copyright © 1978 by Nelson A. Rockefeller Publications, Inc.
All rights reserved under International
and Pan-American Copyright Conventions.
Published in the United States by
Alfred A. Knopf, Inc., New York,
and simultaneously in Canada by
Random House of Canada Limited, Toronto.
Distributed by Random House, Inc., New York.

Library of Congress Cataloging in Publication Data
Main entry under title:
Masterpieces of primitive art.
(The Nelson A. Rockefeller collection)
Bibliography: p.
1. Art, Primitive. 2. Rockefeller, Nelson Aldrich
[Date] —Art collections. I. Boltin, Lee.
II. Newton, Douglas [Date] III. Series.
N5310.M286 709'.01'10 7401471 78-54888
ISBN 0-394-50057-1

Manufactured in Italy

First Edition

Contents

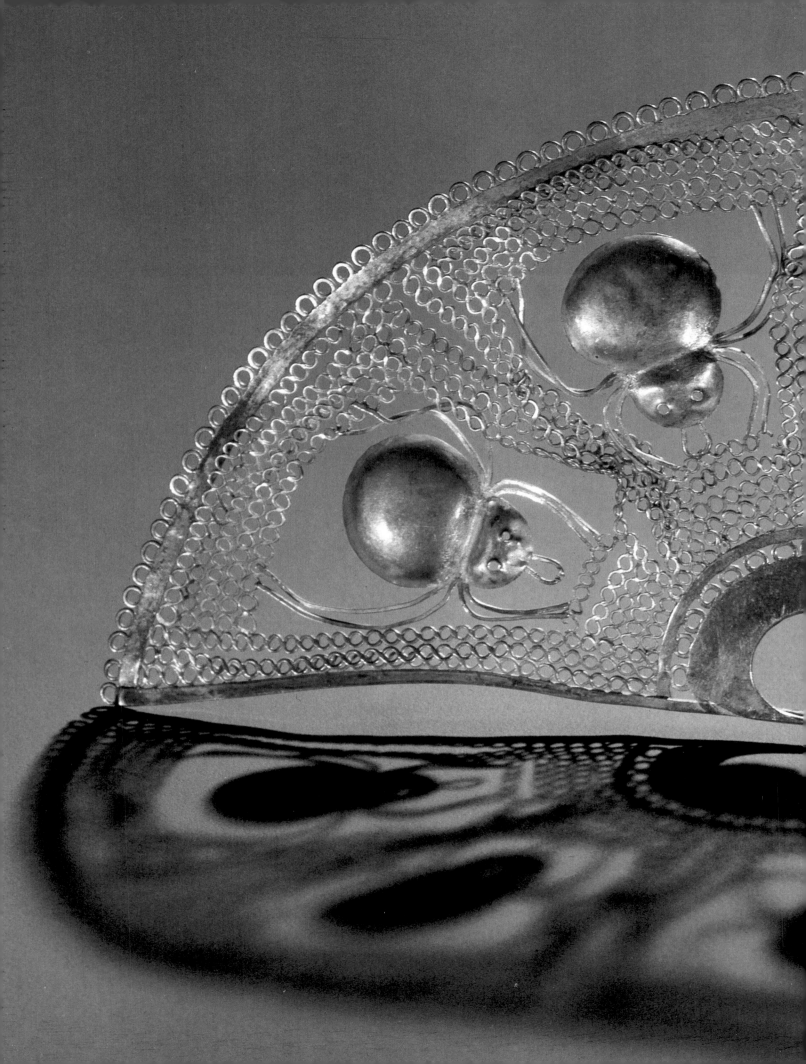

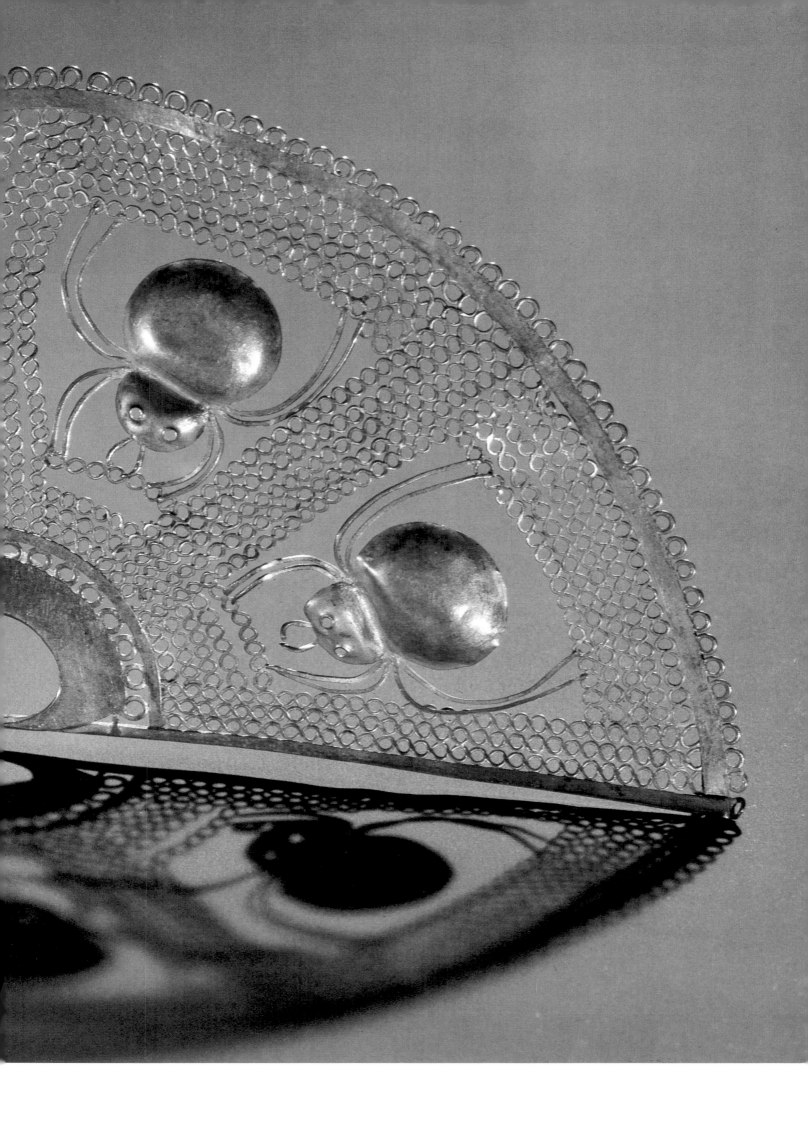

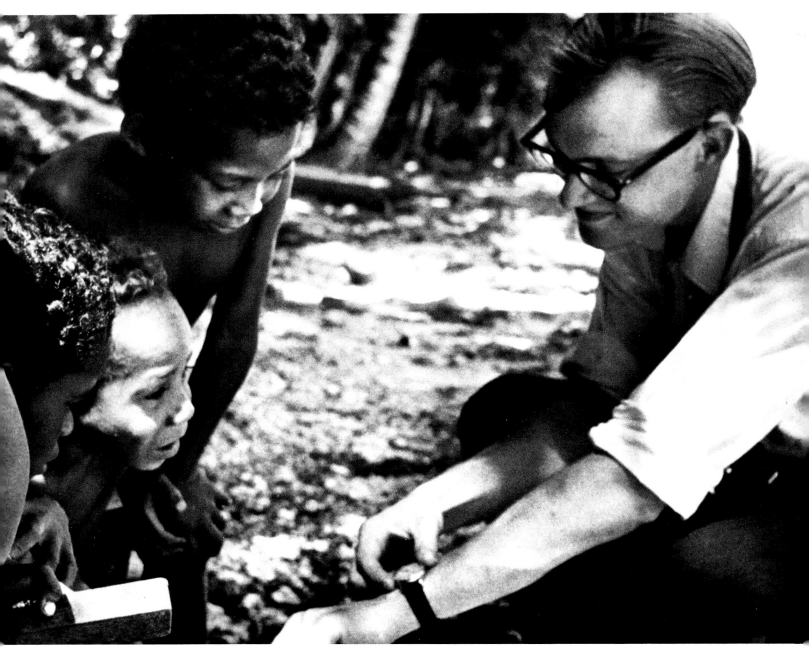

Michael Clark Rockefeller on his first trip to New Guinea, spring of 1961.

Michael C. Rockefeller

LESS THAN a year after his college graduation, Michael Rockefeller met the Asmat people of New Guinea—one of the last groups of people who were still living as a Stone Age culture.

He was the sound man and still photographer for a documentary film unit sponsored by Harvard University to make a film of the life and culture of the Asmat.

Mike was an independent, self-contained person—independent in his approach to life and self-contained in his approach to people and events. He was acutely aware of what was going on around him and he had an inner joy of life—a love of people and beauty and a fascination with the unknown or unexplored. This joy was something which he could share with others, while not depending on them for emotional support or approbation.

Michael had a great love of beautiful things. From the time he was little he painted and sculpted, and he became an excellent photographer. During his years at Harvard, he collected prints—Japanese, contemporary European and American. He spent a great deal of time at both The Museum of Modern Art and The Museum of Primitive Art, of which, in 1959, he became a trustee.

Mike's talent for friendship extended to a rare ability to relate to people of other lands and other cultures—seemingly without effort—and this is borne out by the way he became totally absorbed in the patterns of life, and fascinated by the rituals and the art of the Asmat. The Asmat were equally intrigued by him—and by his intense interest in them.

When Michael came home after the film was finished, we discussed his intention of returning to New Guinea to collect the art of the Asmat for The Museum of Primitive Art. He felt he could do well, because many of the greatest Asmat woodcarvers had already become his friends and he believed they would share their best works with him. It seemed like a marvelous opportunity.

Mike planned his trip carefully, taking a large supply of axes, knives, and other modern implements the Asmat people very much wanted, to trade for art. In addition, he took an outboard motor which he planned to attach to two dugout canoes, tied together, as his means of travel. He had a Dutch friend, René Wassing, who was anxious to go with him.

Mike was obviously thrilled to get back to New Guinea, and his letters were filled with excitement and praise for the creativity and strength of the Asmat art he was finding.

He moved from village to village, traveling by the canoes which were virtually their only means of transportation. But on November 18, 1961, at the mouth of the Eilanden River, he got caught in a riptide. Water killed the engine and the canoes were overturned.

Two Papuan assistants swam to shore for help. Mike stayed to salvage camera equipment and field notes which he managed to retrieve from the water. But the current was strong. Mike and René were swept out to sea.

René couldn't swim. After nearly a day without food and water, with no help in sight, Mike decided to try to make it to shore. Tying two gas tins together with his belt to act as a life preserver, he left the canoes and struck out for shore, now twelve miles away, fighting the river current in shark-infested waters.

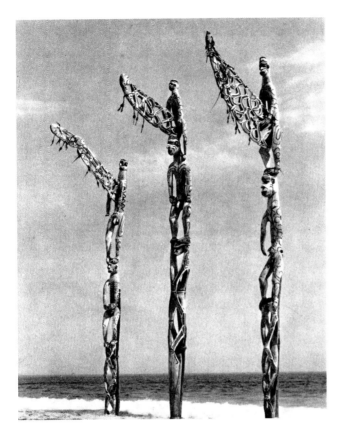

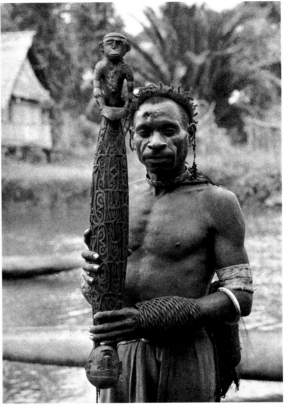

Bis poles from the ceremonial house at Omadesep Village on the Faretsj River. Figures represent specific ancestors. Photograph by Michael C. Rockefeller

The woodcarver Terépos from Omadesep Village with headrest scroll he brought for barter, June, 1961. Photograph by Michael C. Rockefeller

It was a decision typical of Mike. He knew something had to be done and he didn't hesitate to do it, even though the odds were heavily against him—too heavily.

When I heard of the situation from the Dutch ambassador in Washington, I immediately flew to New Guinea with Mike's twin sister, Mary. I shall always remember her love for Mike and her courage during this devastating period.

The Dutch Air Force searchers had spotted the overturned canoes—with one man. They dropped a raft and food and a naval vessel later picked up René. They continued to look for Michael. They only found the two empty gasoline cans floating on the sea.

The Papuans were wonderful. They kept a vigil on shore for days—but in vain. I shall always be deeply grateful for the generous response of the Dutch government and their military; and to the Australians who sent up two helicopters to assist in the search.

Mike invariably had the courage to do what he believed in—the courage to be different and not feel awkward about it, the courage to love people and art and the spiritual and moral values that give a framework and meaning to society.

And he died as he had lived—his own man, doing what he felt was right, what needed to be done.

He had almost finished his collecting, and the treasures were shipped back to the United States through the kindness of the missionary stations where he had deposited them.

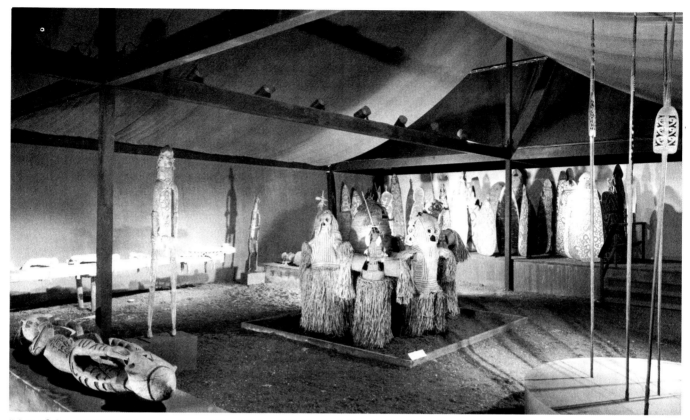

"Art of the Asmat": General view of the Michael C. Rockefeller Collection of primitive art objects from southwest New Guinea as exhibited September–November, 1962, at The Museum of Modern Art, New York. Photograph by Ezra Stoller Associates

René d'Harnoncourt installed a memorial exhibition the following year in the garden of The Museum of Modern Art.

There, the towering bis poles, the beautifully decorated canoes and paddles, the warriors' shields and spears provided a tangible and impressive record of the life and creativity of one of the last great Stone Age civilizations.

These items are now an integral part of the collection of The Museum of Primitive Art in the Michael C. Rockefeller Memorial Wing at the Metropolitan Museum of Art in New York.

And thus we honor the memory of Michael, who, had he lived, would have been a leader today of the new generation in the arts.

We miss his insight and perception.
We miss his inquisitive enthusiasm.
We miss the openness of his mind and spirit.
We miss his love.

Nelson A. Rockefeller
January 25, 1978

Foreword

DURING the eleven years following General de Gaulle's return to office in 1958, the unions agreed to work at night at the French National Museums on three occasions: for exhibitions of Romanesque sculpture, Mexican sculpture, and the work of Picasso. They agreed to do so a fourth time, to many people's surprise, for the exhibition of African art. This fact suggests that the emergence of primitive art, particularly of African sculpture, was not merely an aesthetic phenomenon, like the advent of a new school, but a phenomenon of civilization, like the Renaissance.

Since the second half of the nineteenth century, a growing resurrection of previously misunderstood forms of art has been unfolding in the same way that the renaissance of our own antiquity, which began with Greco-Roman art, grew to encompass archaic Greek art. Now we have resurrected our own "primitives" and Japanese prints in the realm of two-dimensional art; Gothic, early Oriental, Precolumbian, Romanesque, Khmer, Chinese, Scythian, and tribal works in the realm of sculpture. Gothic was "discovered" before Romanesque, Assyrian before Chaldean, T'ang Dynasty before Wei, African before Oceanic.

Why did African sculptures fail to pass into our museums, while masks and fetishes adorned our artists' studios? Primitive art was usually found in museums of natural history; it is still to be found there. Savagery—now a very fragile notion—no longer suffices to maintain this hesitant racism. Our taste commingles Aztec sculptures with African, and the Aztec empire was "civilized." It seems to me that the so-called savage arts are chiefly distinguished from historical ones by the absence of architecture, by the avoidance of monumental sculpture. More subtly, primitive art rejects the insinuating maternity of the cathedral, whose statues are attached to it like so many chicks to a brood hen; primitive art rejects sculpture's link with everything the monument implies—and first of all the city, whose gods are not those of the steppes, the savannas, and the forests.

Dealers in modern art began buying African sculpture around 1920, fifteen years after it had seduced the artists—not only the Cubists, who saw the fetishes Matisse owned before the mask in Vlaminck's studio. Then appeared works as important as Paul Guillaume's Dogon double-fetish. People had spoken of art nègre as of a highly picturesque, sometimes corrosive kind of folk art. After the First World War, one of the characteristics of living art became the creation of that-which-did-not-yet-exist, the artist's right to a convincing freedom. This right became linked to the taste for schematic or geometric, often archaic forms, and the interest in art nègre shifted from idols brought home by colonialists to the most arbitrary masks and figures. Apollinaire had his new fetishes converse with Le Douanier Rousseau—we make ours converse with Picasso. Before the First World War, people spoke of "art nègre"; after the Second, of "African sculpture"—not of the same works, not of the same style. For if the discovery of Khmer art, of Wei sculpture, had been that of a style, the discovery of primitive art (and, already, of art nègre) was the discovery of a plurality of styles, from naïveté to the boldest creation; from folklore fetishes to the Cézannesque mas-

terpieces of the Dogon, to Oceanic masks slashed and bristling like carnivorous flowers. The Crouching Scribe can represent Egyptian art; Gudea, neo-Sumerian art; a Bayon head, Khmer art; but what mask could symbolize the whole of African art? We can speak only of primitive styles, and we speak above all of their freedom.

Primitive sculpture once struck the public with the same impact as Cubist sculpture. Today, despite the Cubist sculptors, despite Picasso's sculptures, it still affects us so powerfully that many artists prefer it to any other and through it discover all sculpture, "tracing back," the way they discover all painting through the masters of our own time. It is absurd to speak of this sculpture as a minor art in an age when the artist's creation of forms that could not exist without him has become a fundamental aesthetic phenomenon.

Like other arts, the art of Africa was appreciated by us at first because of its kinship to what we already knew, the relation connecting tribal geometry with Cézanne, above all with Cubism. But it has touched painters—Matisse, Vlaminck, Derain—whose forms were quite remote from its own. Although the public has discovered African forms through Picasso, what Picasso had discovered in them was not in fact a system of forms. (In any case, it would have been difficult to organize the forms of African sculpture into a system, and it became impossible when Dogon or Bantu forms were joined by those of Oceania or the Eskimo.) What Picasso discovered was what he called the right to the arbitrary and the right to freedom.

The encounter of primitive, chiefly African, art with modern art represents one of the major metamorphoses of our epoch. The maker of that mask in which our painters discover their freedom would doubtless have altered not a feature without the shaman's authorization. Certain Oceanic figures are the creation of tribes in which professional sculptors do not exist. But the Dogon Hermaphrodite in the Rockefeller collection was not invented inadvertently. Artistic creation can come into being. We may not be able to trace the development of most of these styles, but we can do so enough to know that their destiny is not limited to an inexhaustible repetition. Certain of these figures seem to have no posterity; others play the role of prototypes, doubtless because they have been considered especially convincing. Their aesthetic power was called magical. Almost all primitive arts are functional arts of the soul. The metamorphosis a mask undergoes when it enters our museum erases the magic but not its imprint. The most geometric fetish never becomes a Cubist sculpture. The Cloisters could not revive Romanesque Christianity if we had lost it; but in a civilization from which even the name of Christ had disappeared, rediscovered Romanesque statues would not be mistaken for those of Ellora. We might say that magic (or better: "magics") turns into art; never, that we confuse magic with a purely aesthetic motive.

I like to cite a story Picasso told to me—and to others, no doubt—about his first visit to the Musée de l'Homme in Paris. "People are always talking about the influence the Negroes had on me. What about it? We all loved the fetishes. Van Gogh said his generation had Japanese art—we have the Negroes. Their forms have no more influence on me than on Matisse, or on Derain. But for Matisse and Derain, the masks were sculpture—no more than that. When Matisse showed me his first Negro head, he talked about Egyptian art. But when I went to the Musée de l'Homme, the masks were not just sculpture, not in the least. They were magical objects. (And why weren't the Egyptians, or the Chaldeans? We hadn't realized it. Primitive, but not magical.) Now, the Negroes' sculptures were intercessors—I've

known the French word ever since then: intercessors against everything — against unknown, threatening spirits. I understood what their sculpture did for the Negroes. Why they carved them that way, and not some other way. After all, they weren't Cubists—the Cubists didn't exist yet! Of course certain men had invented the models, and others had imitated them — isn't that tradition? But all the fetishes did the same thing. They were weapons—to keep people from being ruled by spirits, to help them free themselves. Tools. Les Demoiselles d'Avignon must have come that day, not because of the forms, but because it was my first canvas of exorcism! That's why, later on, I painted more pictures like the earlier ones, the Portrait of Olga, the other portraits—no one is a sorcerer every hour of the day! How could you live?"

The story, including its humor, invites reflection. If primitive art is more than the latest of our resurrections, it is not only because of its freedom, or the variety of its forms. It is because it belongs to a psychological area of human experience. What it tells us—like what the cave paintings tell us—is no longer what it told its creators—but it is irreplaceable. What we know in this realm is at best so many lottery tickets. If we want to win, we had better take the tickets. Yet the ethnology which "explains" Dogon myths has no effect on our relation with the Hermaphrodite in the Rockefeller collection or the Antelope Mask in the Musée de l'Homme. Our rapport with these figures will always owe less to our knowledge of what they represent, i.e., the Dogon myths, than to our own concept of the Museum Without Walls. Whatever the primitive arts may henceforth suggest about ahistorical, proto-historical, mythic man, they represent to us, first of all, an attitude, little known in the West for centuries but known today by every artist: the will to create. This will to create permitted the sculptors of a society without architecture to avoid what many of our sculptors consider a paralysis: a heritage which keeps them from a fundamental independence. This will, which we are only too happy to call magical in order to give it a name (and which, for us, does not come from magic), conferred on their sculptures the enigmatic unity that connects their work, even when it borders on random expression. This will establishes with us a dialogue intelligible only in the language we call art.

Primitive sculptures were once banned from the museum; now they enter it. Not only because they are the sculptures of half the earth, and of much more than half of time, but also because beyond the frontier figures of Sumer and Mexico, this crucial and ageless art, so strangely relevant to our own, is the art of our next investigation: the night side of man.

André Malraux
1974

Translated from the French by Richard Howard

Masterpieces of Primitive Art

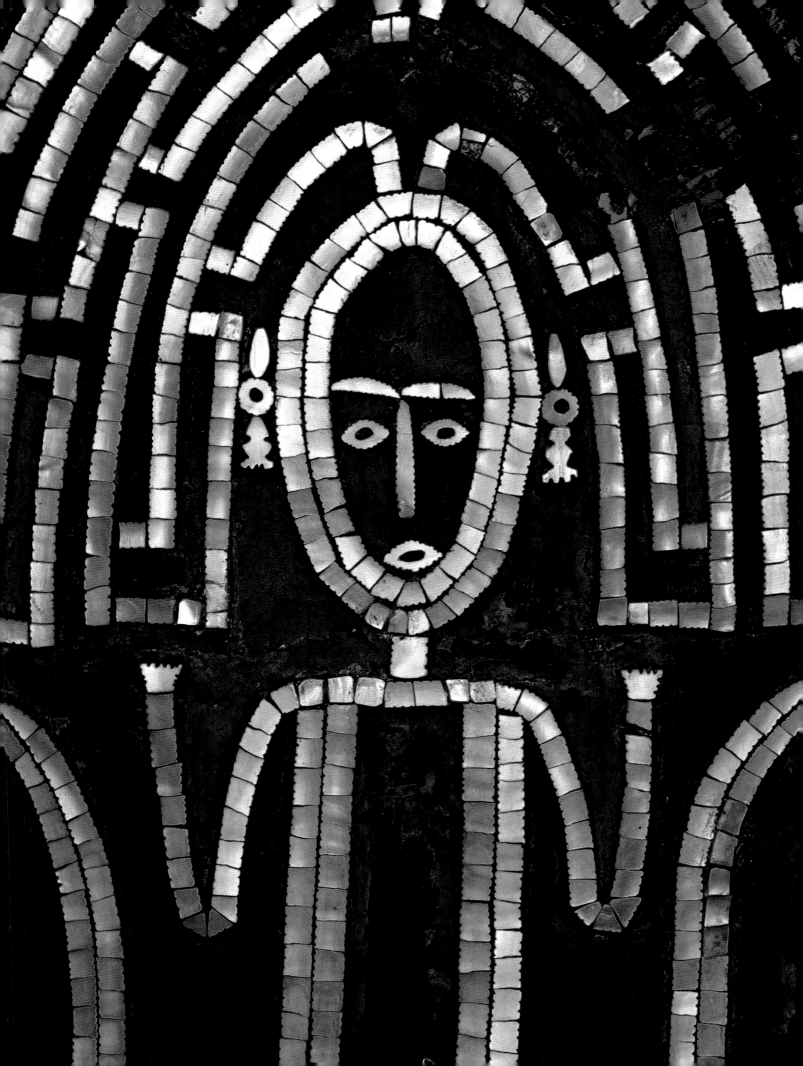

Introduction

THERE ARE inner forces in one's life that sometimes seem to be unrelated to conscious thought. This can be true of appreciation as well as creation of art.

Much of so-called primitive art was created as a direct response to strong feelings. My appreciation has been a direct response to the power and beauty of that creation—from different periods and different parts of the world — in different forms and by different peoples—but always an expression of those inner forces interpreted with compelling directness and simple beauty.

Gertrude Stein understood this very well. In her book on Picasso, the artist she (and I) most admired, she explained the basis of his struggle as he broke from tradition in the early 1900s: "...with the exception of some African sculpture, no one had ever tried to express things seen not as one knows them but as they are when one sees them without remembering having looked at them."

That to me captures not only the essence of Picasso's work, but the quality of primitive art which had such an impact on Picasso—as well as on many of the other young painters and sculptors who were destined to become the leaders of the modern art movement. At that time, they were in revolt against the realism of the French Academy and seeking new forms of expression. African art inspired them and gave them new insights.

By the 1920s, a few American artists and avant-garde collectors had discovered the strength and beauty of primitive art and had come to realize the importance of its place in the long history of human creativity. My mother was one of this small group of collectors. She was an extraordinarily aware and sensitive person who followed her own instincts, and not convention. Fortunately for me, she had a small art gallery of her own in our house on 54th Street in New York City. I still treasure the various pieces of African sculpture she had there along with the modern art—and they are part of my private collection today.

I was fortunate to be able to acquire—through osmosis, I guess—an appreciation and enjoyment of art in various forms. It was not a conscious intellectual effort on my part, or a matter of discipline. Thus primitive art never seemed strange to me. Even though I didn't understand it intellectually, I felt its power, its directness of expression, and its beauty.

The first piece of primitive art that I collected personally was a beautiful and simple wooden bowl which I found in Hawaii on a trip around the world in 1930. I couldn't resist it —and I still get great satisfaction from the shape of the bowl, the grain of the wood, and the warm, soft patina that came from centuries of loving care.

Later that year, in Bali, amid the splendors of nature and a joyful people, I found a small, old wooden figure of a woman—carved simply, and expressing great feeling.

I was beginning to learn the excitement and thrill of discovering beautiful things on my own.

A detail from a ceremonial shield from the Solomon Islands. The design is carried out in pieces of shell set in a paste spread over a wickerwork base. (The complete shield is reproduced on page 136.)

In Sumatra, we drove through tropical jungle dotted with clearings of little villages with thatched houses, their ridge poles upturned. In one, I discovered and purchased some interesting pieces: a dagger and a lute. That evening, I proudly showed these pieces to the Dutch manager of the dak bungalow or government rest house where we spent the night.

Much to my chagrin, he thought nothing of my purchases. His comment was that all the good primitive art had been burned by the missionaries years ago, and that what was available now was manufactured in Germany and shipped out for the tourist trade. Inasmuch as fewer than 100 tourists had stayed at his dak bungalow so far that year, this struck me as a rather cynical point of view. In any event, I still have and still enjoy the dagger and the lute as the joyful expressions of a people with a love of beauty.

That trip provided unique opportunities to visit the great and beautiful cultural monuments of early civilizations, such as Angkor Wat, Angkor Thom, the Ajanta caves in India, the greatest of all Indonesian Buddhist monuments at Borobudur, and the remains of pre-Neolithic Mesopotamia and Judea. We had the privilege of examining with Dr. C. Leonard Woolley his digs at Ur—a city destroyed and rebuilt on the same site many times in history. As we went down the excavation trench, he pointed out the continuous vertical layers of the various civilizations that swept the ancient Near East. I was especially fascinated to find the layer which he identified as the biblical Ur of the Chaldees.

In 1933, we spent three memorable months on another continent, South America. In Mexico we visited the monumental remains of the early Mayan civilization. We had a chance to pore over the great collections of Olmec, Toltec, and Aztec Precolumbian art with our friends, Miguel and Rosa Covarrubias and Diego Rivera. As artists, they were deeply influenced by the art of these early American civilizations. I found myself captivated by the power and exquisite refinement of these works. It was a most exciting and exhilarating experience, opening up new worlds—worlds little known and little appreciated at that time outside of Latin America and anthropological circles. Thus my interest in primitive art expanded to Precolumbian, and I couldn't resist collecting—even though at the time I knew relatively little about these various cultures.

By now I was rapidly gaining a more catholic understanding of the word "art." I saw "art" as widely varying expressions of individuals—individuals from all parts of the world and from all ages, with strong feelings and great creative capacities to express those feelings. No longer was my appreciation confined to classical forms of art as taught in our schools and shown in our great museums.

Unfortunately, at that time only museums of natural history collected primitive art, and primarily for its ethnological interest rather than its aesthetic qualities.

I had been on the board of trustees of the Metropolitan Museum of Art for some years and was concerned that the Metropolitan showed no primitive art. Having been intrigued for a long time by the reports in the Illustrated London News of the joint digs carried out by the British with Egypt and other Middle Eastern countries, I got the idea of a combined expedition of the Metropolitan and the American Museum of Natural History jointly with various countries of Latin America for Precolumbian archeological digs.

I thought this proposal was important for the Metropolitan and that it would create closer cultural ties with the other American republics. I enlisted the support of another

young trustee of the Met, Bill Harkness, and we offered to finance the program. The American Museum of Natural History was enthusiastic—but the Metropolitan wasn't.

For some years, I continued the struggle to put the idea across. I remember on a trip to Peru in 1937, I met Dr. Julio C. Tello, the leading Peruvian archeologist. Dr. Tello had made the mistake of getting into politics and being elected a senator in addition to his work in archeology. When I arrived, there had been a change in government and he was not only out as a senator, but also as the head of the government's archeological program—though there was no other archeologist in Peru at that time really qualified to take his place.

I found Dr. Tello in a state of desperation. He had close to 100 mummies from Paracas— one of the great pre-Inca desert burial grounds—which he had brought down to Lima, at sea level, where it was very damp. He had not had a chance to unwrap these mummies, which were enveloped in beautiful textiles representing all known weaves. The problem was that the materials had absorbed salt from the desert sands over the years and were now beginning to show signs of rotting, due to the moisture of the coastal area. Yet he could not unwrap and preserve the mummies and their wrappings because he had no funds.

I gave him money to start work on the unwrapping of these priceless treasures. Then I went to see the new President of Peru. President Prado understood the situation and renewed the government's support of Dr. Tello.

In the course of our discussions, I told Dr. Tello about my plan for a combined expedition. He was enthusiastic about the idea, and sent back two mummies with me, to illustrate to the Natural History and Metropolitan museums what could be accomplished by inter-American collaboration.

Scientists at the American Museum of Natural History were very excited and handled the unwrapping of the mummies—but the Met remained uninterested. After this rebuff, I gave up the idea and decided to collect primitive art more actively myself.

At that time, I was also a trustee of The Museum of Modern Art in New York. It was the first art museum in this country to recognize primitive art and its influence on modern painting and sculpture. The Museum already had started a series of exhibitions to demonstrate the cultural importance of these works and this relationship. The first show, held in 1933, was entitled "American Sources of Modern Art." It covered all aspects of Precolumbian art. This was followed in 1935 by an exhibition of "African Negro Art."

In 1939, when I became President of The Museum of Modern Art, I organized an exhibition of "Twenty Centuries of Mexican Art," held in 1940. In 1946, the Museum showed the "Art of the South Seas," and in 1954, the "Ancient Art of the Andes."

For me, collecting modern art and primitive art at the same time seemed completely natural. I did both with great enthusiasm and excitement. I shared that enthusiasm with René d'Harnoncourt. He and I collected primitive art together for more than thirty years in one of the happiest and most rewarding endeavors of my life.

René was an extraordinary human being, a former Austrian count who, destitute at the end of World War I, emigrated to Mexico. He survived at the beginning by decorating windows for shopkeepers. Out of this grew a friendship with an American, Fred Davis, who owned Sanborn's, a store located in one of the most beautiful buildings in Mexico City. Soon René started collecting Precolumbian and Mexican colonial and popular art for Mr. Davis.

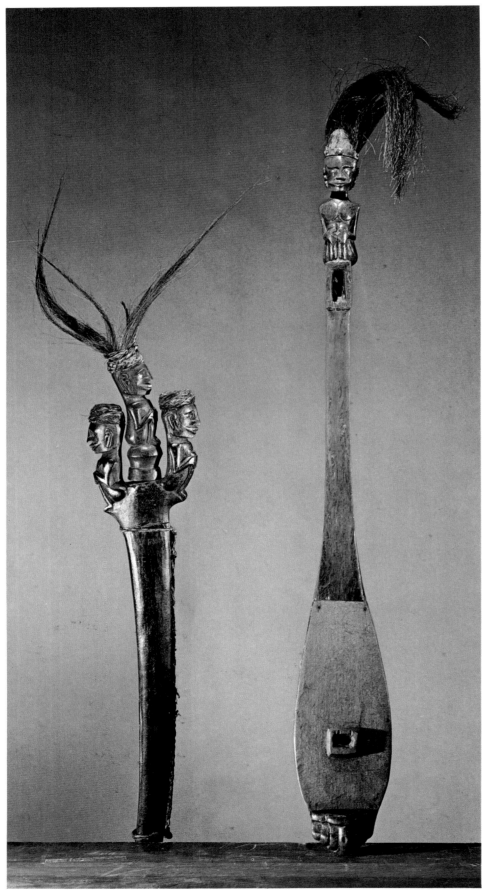

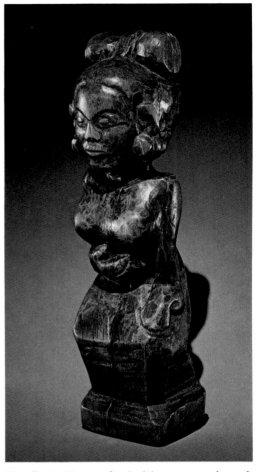

The first objects of primitive art purchased by Nelson Rockefeller in 1930. Left, a wooden lute and dagger from the Batak tribe, Sumatra. Above, a seated female wooden figure from Bali. Below, a Hawaiian poi bowl.

René became an authority in the field. This led to a close friendship with U.S. Ambassador to Mexico Dwight Morrow, who ultimately sent him to the United States to accompany an important touring collection of Mexican art.

This tour and René's love and knowledge of Mexican Indians and their art brought him into contact with the U.S. Department of the Interior, which persuaded him to undertake a study of the early arts of American Indians. He rediscovered the old designs and techniques and they were made available for modern production by the various tribes.

When I was appointed Coordinator of Inter-American Affairs by President Roosevelt in 1940, I persuaded René to head the inter-American arts program. After returning to New York in 1946, and again becoming President of The Museum of Modern Art, I asked René to rejoin me, first as secretary of the Coordinating Committee of the museum, and later as Director.

By the early 1950s, my collection of primitive art had grown to such proportions that we finally decided to create a museum of primitive art. We converted a building on 54th Street across from The Museum of Modern Art for this purpose.

The Museum of Primitive Art was opened in the spring of 1957—the first institution totally devoted to primitive art.

Because of limitations of space, we could only show about 10 percent of the collection. Therefore, it was decided that a series of carefully selected and beautifully installed small exhibitions would be held under René's direction. The exhibitions were wide-ranging: for example, "Sculpture from the Pacific" in 1962; "Art of Empire: The Inca of Peru" in 1963–64; "African Sculpture from the Museum's Collection" in 1966; and "North American Indian Paintings" in 1967.

They were accompanied by publications written primarily by two brilliant and sensitive authorities in the field, Dr. Robert Goldwater, Director of the Museum, and Douglas Newton, the Curator, who became Director in 1974.

Over the years from 1957 to 1975, other collectors made important contributions to The Museum of Primitive Art. Among them was my son Michael, who had a tremendous interest in art and who became active as a trustee of The Museum of Primitive Art in 1959. Michael's collection of Oceanic art, formed in the early 1960s, remains a significant feature of the Museum.

For the first time, primitive art had a home of its own, and by the late 1960s and early 1970s, it had come to be accepted by the critics and the public. Art News of January 1968 put it this way: "The Museum of Primitive Art was born lucky, but it has had the brains to push its luck, becoming in the dozen years since its founding one of the few museums to combine a passion for the past with a modern philosophy."

But René and I were increasingly concerned by the fact that primitive art was still not recognized by the classical art museums of the country as deserving a place in the history of the world's great art.

We were particularly interested in the Metropolitan Museum, for it was a major standard-setter in the art world. We felt as we had for a long time that it was absolutely vital that the Met include the whole range of primitive art in its collection and thus give the arts of the great African, American, and Oceanic civilizations their proper recognition in the world's panorama of art.

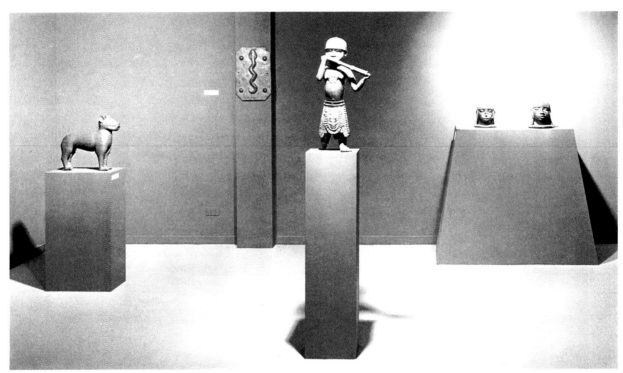

"Benin Bronzes" exhibition at The Museum of Primitive Art, 1959. Photograph by Charles Uht

In the late sixties, René came up with the idea that if we could persuade officials of the Metropolitan to put on a major exhibit of the entire collection of The Museum of Primitive Art, it would have tremendous impact and perhaps change their attitude. Finally, the Metropolitan Museum agreed to a show in 1969. Tragically, René never lived to see the realization of our dream for he was hit and killed by a car earlier that year while bird-watching off a country road on Long Island. His installation of the show at the Met would have been a fitting culmination to our thirty years of devotion to primitive art. But his distinguished protégé, Douglas Newton, had learned from René over the years and outdid himself in the installation at the Metropolitan—the first time this collection of primitive art was shown as a whole.

Two weeks before the show opened, Mrs. Brooke Astor, one of the most creative and imaginative people in New York City and a trustee of the Met, told me she had seen the exhibition and felt that the collection simply had to stay at the Met permanently. There was to be a big dinner before the opening, and she said that if I would be willing to give the collection to the Met, it could be announced that night—and it would be sensational. Her idea was that there should be a special wing built to house the collection; she offered to contribute toward its construction.

It was too good to be true! Here, thirty years after Bill Harkness and I had tried to get the museum into the field of Precolumbian art, one of its most prestigious trustees was actually suggesting that they accept, on a par with art of all the other great civilizations of the world, the long-neglected creative work of the so-called primitive artists of Africa, the Americas, and the islands of the Pacific.

I shall always be grateful to Brooke Astor for the spontaneity and courage of her proposal—and to Douglas Dillon, chairman of the board of the Met, who immediately embraced the idea.

A formal agreement was signed in the next ten days—a record for inter-museum cooperation. Thus René's and my goal became a reality even before the exhibition opened on May 10, 1969. The agreement provides that the collection is to be housed in a new wing of the Met, named in memory of my son Michael. The fact that Michael's life work would thus be memorialized was a poignant source of additional gratification from this endeavor.

Now the great works of primitive art will be available side by side with the best creative work of Egyptian, Near Eastern, Greek, Roman, Asian, European, American, and modern artists.

My purpose in publishing this book—and in reproducing some of the most exciting works from the collection—is to make these masterpieces more widely available so they can be enjoyed by people everywhere.

One may wonder how and why 250 objects were chosen out of the collection of approximately 3,500 for reproduction in this book. Our concept of the book seemed simple, but the actual selection of pieces was very difficult.

The concept was an outgrowth of the whole purpose of the collection—namely that the creative expressions of great civilizations in Africa, Oceania, and Precolumbian America ranked on a par in terms of aesthetic value with great art forms of other so-called classical civilizations.

Therefore, we simply selected those objects we considered most beautiful—from both my personal collection and the collection I helped to shape as Founder and President of The Museum of Primitive Art—the greatest masterpieces of these so-called primitive civilizations. At the same time, we attempted to give a fair representation of all the outstanding creative periods of each civilization.

Finally, we organized the material in a form that emphasizes the beauty and creative qualities of the objects rather than their ethnological background exclusively. We hope we have struck a satisfying balance.

I have spent my life collecting art of a great many civilizations. It has given me infinite pleasure, opened my eyes, and deepened my understanding of humanity. It has been an enriching experience and a balance to the pressures of business and politics—a constant source of spiritual refreshment and strength. It is a privilege to share the joy of this collection with those who read this book.

N.A.R.

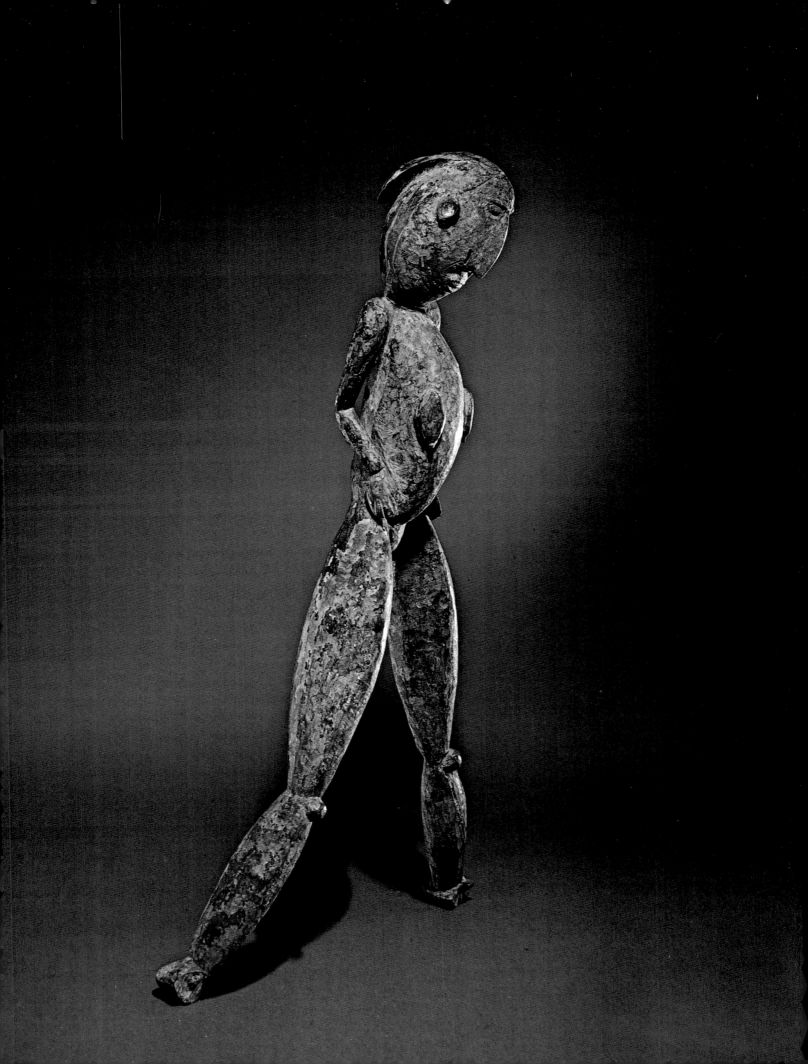

Primitive Art
A Perspective

Douglas Newton

I OVER the last century, and with increasing momentum over the last fifty years, Western culture has attempted to comprehend the cultures of the rest of the world. Our vast curiosity about other modes of thought, religion, and behavior can only be paralleled by our equally vast curiosity about the physical world. But while the West's most pervasive effect is the spread of its technology, our claims on world culture seem to be devoted to its assimilation— one can cite music, philosophy, and religion as instances.

Another very clear field is that of the visual arts— and perhaps the most surprising taste is that for the arts of primitive peoples. The arts are always the most intimate form of a people's self-expression, and the inner meaning of that expression can therefore be its most obscure. To reach out for such meaning is a true sign of a desire for self-expansion. Why this has happened, and how, and how successful the effort has been, is well worth investigation.

II WHAT IS "primitive" art? There is no simple answer. We do not mean art which is primitive in the sense that it is crude or rough. Much of what we call primitive art clearly is nothing of the sort. Nor can it be said that the people who produced it were primitives in their social structures or thought. In this context, the word may stand as a general label, as "Gothic"— originally meaning "barbaric"—was used as a label for pre-Renaissance European art until Horace Walpole and his friends discovered its beauties in the eighteenth century. The Fauves, who some of their contemporaries thought painted like "wild beasts," are now recognized as the earliest masters of modern art. The word "primitive" itself has also been used to describe the painters of Europe before the beginning of Renaissance development of humanism and illusionism.

Used as a term of reference, without implied judgment, to what then does "primitive art" refer? The term can cover a great deal of ground, if not very precisely. It encompasses the art of those peoples who have remained until recent times at an early technological level —who have been oriented toward the use of tools but not machines. Once the term is accepted, we can see immediately that it comprises an enormous proportion of the world's surface and its past populations. In the Old World, it covers the major part of Africa; it includes many of the tribal peoples of India and Southeast Asia as well as those of Siberia and the Ainu of Japan; the continent of Australia and all the islands of Melanesia, Polynesia, and Micronesia must also be included. The whole of the New World, from Alaska to Tierra del Fuego, is part of its province. One begins to see, faced with the image of this expanse, that primitive culture, considered in its true perspective, is perhaps the major part of human experience over the world's surface. The aesthetic significance of primitive art is correspondingly great.

A female figure used in initiation ceremonies by the Abelam people of Papua New Guinea.
Novices crawl between the legs of the figure and through a tunnel beyond in a ceremony symbolizing rebirth.

The time-spans involved are just as great, even though this is not immediately obvious. But if a stumbling block to the understanding of primitive art has been the idea that it has no history, that notion has now begun to be dispelled.

For example, recent archeological discoveries have exposed as hopelessly mistaken the long-held belief that the history of Oceania began a mere 10,000 years ago. Now we know that Australia was first inhabited at least 40,000 to 50,000 years ago—and the first works of art so far discovered there are about 20,000 years old. These were contemporary with the great cave paintings of Paleolithic Europe, but are of an entirely different order. Naturalistic depiction of animal life is nowhere to be seen in Koonalda Cave in western Australia; instead, there are groupings of engraved lines which though completely abstract seem to be placed in strategically significant areas of the cave. Other datable works from ancient Australia are the petroglyphs—images pecked onto rock surfaces—in a style named after Panaramittee in northern Australia. These depict bird and animal tracks, and are about 7,000 years old.

The age of other art traditions in the islands of Oceania must indeed have been coincident with the periods in which they became inhabited, ranging from 25,000 B.C. to A.D. 900. Though much apparently has disappeared, there still remains a certain amount of highly significant material. There is the Lapita ware (so called after the site in New Caledonia where it was discovered), with its elegant and sophisticated patterning, which was widespread throughout Melanesia (1200 B.C.–A.D. 650). Evidence of complex social structure and ritual beliefs is shown by the burial—at Retoka in the New Hebrides—of Roymata, a great chief living about A.D. 1200, who was accompanied to his grave by an entourage of forty richly ornamented human sacrifices. Legends which recalled the event down to the present day guided archeologists to the actual site in 1967. In New Zealand, elaborate whalebone and stone ornaments of the tenth-century hunters of the moa (an extinct giant ostrich-like bird), and wood carvings dating from perhaps four centuries later recovered from swamps, bear witness to a long and changing series of art styles. The most familiar, and the latest, of pre-European work in the Pacific is the large group of sixteenth-century stone colossi on Easter Island.

Africa's oldest surviving art is represented by the rock paintings of Tassili and other sites of the Sahara; but as with more recent rock art in Australia, the actual dates are obscure. These paintings include representations of masks, or details of costume, now found in West Africa far to the south, which suggests that the styles of the present may be ancient in origin. In sub-Saharan Africa, the Iron Age culture of Nok in Nigeria (beginning in 900 B.C.) left a quantity of ceramic sculpture; the tradition was established in Ghana in the seventeenth century, and has remained an important aspect of art in West Africa down to the present day. Nigeria is particularly rich in these memorials of the past of African art, partly because of the sophisticated use of enduring metals. Bronzes of convoluted forms were buried in the ninth century at Igbo-Ukwu in the Niger River Delta; the brass heads of the rulers of Ifé made in the subsequent centuries are famous, as are the cast brass heads, figures, and plaques of Benin, which were first seen by European visitors in the sixteenth century, and were finally looted from the city by the British in 1897.

More of this register of the past exists than a list of a few selected names may suggest; nevertheless, for one relic of the long procession through the millennia that has survived,

countless thousands of others have perished. We have here a record more of hiatus than history, but there is enough to show that there were continuous stretches of traditions between the fragments that have survived.

We must abandon the once-accepted idea that the primitive arts existed in some sort of limbo outside of change, development, or decline. To cling to this belief is only to suffer from a fallacy which is another obstacle to our understanding of them. They were not static, any more than the arts of the West and the Far East were static. No one today can think, as some art historians seriously stated in the last century, that ancient Egyptian art, or Chinese or Japanese art, remained unchanged throughout the millennia of their histories. The same must now be said of the primitive arts.

Ancient Mexico is a specific example. Its history, before the advent of Cortés, extends over nearly 3,000 years. Its land area is the equivalent of most of Europe. With monuments of stone, ceramic, and wood surviving from innumerable cultures—not to mention the massive architecture of religious centers—the student of Mexican art is faced with a task equivalent to the study of European art from Stonehenge to the present. A comparable wealth of art styles existed, as we now know from what we have already recovered, and from the new discoveries which are continually being made. One need not imagine the people of other parts of the world to have been less inspired and less inventive than the Mexicans, even though they worked in less enduring materials.

The cultural forms of the primitive past have been a major part of the human inheritance; so also are its arts, as we increasingly come to see.

III AS FAR AS the record shows, few cultures of the past have shown any very lively appreciation of, or even mild interest in, the art of foreign cultures.

The Roman Empire conquered the world it knew or could reach, and it brought home the world's wealth and something of its manpower; but it did not bring home the world's products. Rome was not embellished with the sculpture of Egypt, say, though it lay readily to hand. Only the art of Greece was an exception to this indifference, and then mainly, one suspects, because of the Greeks' reputation for intellectual superiority. Even fashionable imitation of foreign—"barbarian"—modes of dress, such as Celtic trousers and neck-rings, was viewed as a sign of decadence. The vogue for foreign cults, from Egypt and Syria, was equally considered a mark of decay. In this sphere, foreign concepts only were imported, while the rich art styles which accompanied them in their native lands were ignored.

On the verges of Mediterranean culture, the Celts of the northwest and the tribes across the Pontus—Sarmatians, Scyths, Thracians—took a different view. They showed an avid desire for the work of Greek master craftsmen. They craved the bronze and the gold, trading for it, collecting it, burying it in the graves of their chiefs on an equal status with the slaughtered wives, dogs, and horses. But what, if anything, did it mean to them as art? One thinks of the six-foot bronze vase imported from sixth-century Greece found in the tomb of a Celtic princess at Vix in southern France; did the reliefs signify more than an exalted form of the bronze in their own sword blades? And did the Eastern nomads care for the delicacy of the modelled animal and negro heads of the gold drinking cups, armor, and ornaments, or only that this was the richest possible manifestation of the gold which obsessed them? Sometimes it seems that the Greek manufacturing and trading centers on the Black Sea

which supplied them with these objects of astounding luxury were there because they conveniently obviated the nomads' need to move further west; that they were places where they could obtain, without undue effort, the purchased equivalent of loot.

Something of the same spirit informed those Portuguese who, in the early years of contact with the Africans around their trading posts in Sherbro and Nigeria, commissioned ivory objects from them. They bought spoons, forks, hunting horns, and those astonishing lidded and footed containers which may be saltcellars. They did not attempt to trade for the bronzes they saw in the palace of the Obas, the rulers of Benin; they admired the African's craftsmanship, but not his art. Consequently, the imagery of the ivories shows Portuguese grandees, horsemen, caravels, coats of arms—but only an occasional African face, a serpent, or a crocodile.

This was a two-way street, one should not forget. Important as they were to the local rulers, the foreigners do not figure largely in the African arts of the time. When they do, it is rather in terms of their equipment and their use than for themselves, a point which is made all the more explicit because of the strictly representational mode of Benin art. The interest of the Bini was in the arquebus and the mercenary, both useful additions to the Obas' technology, and went no further.

The Spanish adventures to the west were abrupt and violent. A handful of soldiers found themselves plunged into the heart of a civilization in Mexico they recognized as equal to their own in its complexity, its scale, and above all its wealth. Bernal Díaz, the old soldier who wrote his recollections of the conquest of Mexico during the hectic months of 1519–20, says: "Those of us who had been at Rome and Constantinople said [of Montezuma's capital cities] that for convenience, regularity, and population, they had never seen the like." The Spaniards were fascinated by the markets, the architecture, the dress and the cleanliness; but the evidence of gold dazzled them. The Aztecs and the Incas had produced magnificent works of sculpture, yet nothing in the conquistadores' training or background was designed to lead them to an admiration of such works. When they saw the field of gold and silver maize with the life-size golden llamas and herdsmen in the Temple of the Sun in Cuzco, Pizarro's men were not struck by the beauty: they saw only a vision of their own opulent futures.

In Mexico, the men of Cortés saw the great stone gods in the temples as slaughter-house gargoyles, amid the reeking blood from human sacrifices which bathed the walls and floor. Not long after, during the disastrous phase of the expedition, they were to witness their own friends, captured as prisoners of war, sacrificed in front of those very gods. The Spaniards could not bring to such sculptures our calm aesthetic interest; to them they were devils, images of immediate horror. Virtually the only voice of that period which approved of Mexican work was Dürer's, in the famous entry he made in his diary in August 1520, on seeing the objects Cortés sent back to the emperor Charles V:

Also I saw the things brought to the King out of the new golden land: a whole golden sun, a full yard wide, similarly a whole silver moon, equally big...all sorts of marvelous objects for human use much more beautiful to behold than things spoken of in fairy tales. These things were all so precious that one has appraised them worth 100,000 guilders. And in all the days of my life, I have seen nothing which rejoiced my heart as

these things—for I saw among them wondrous artful things and I wondered over the subtle genius of these men in strange countries.

Even here, one may ask what Dürer was really seeing. It looks as though it was the craftsmanship that spoke to him far more than the spirit, if indeed that meant anything to him at all. Then, too, these things were very strange, and Dürer was a man of great curiosity—it led him to copy a picture of a rhinoceros, and was the death of him when he went to inspect a beached whale in winter and contracted pneumonia.

By the end of the sixteenth century, the Spanish dream of empire was over. Tenochtitlán and Peru were ruined; but so was Spain, after the suicidal effort of the "Enterprise of England" and the Armada which failed to conquer that country. To the north, Elizabeth I, doubly horrible to the religious bigots and male chauvinists of the time in being both a Protestant and a woman, encouraged her ships into action which for the Spaniards had all the hopelessness of guerilla warfare. Spain turned its gaze toward the Pacific, where surely there must be new, rich lands, and sent expeditions in search of the hoped-for Terra Australis. The leaders were, almost every one, incompetents or cranks who could barely control their ships and crews, let alone understand geography. Their travels came to nothing. A century and a half would elapse before European presence in the Pacific became a reality.

The near-random voyages of the intervening period were superseded by the purposeful intelligence of the eighteenth century, which reached its highest point in the conduct of James Cook's three great voyages between 1768 and 1779. These confirmed earlier discoveries, made many more, and united them into an unprecedented whole. Moreover, for once knowledge was the intended goal, not a vague quest for wealth. It was true that Cook's secret orders from the Admiralty enjoined on him the duty of raising the British flag wherever it seemed appropriate, but the chief aim was scientific.

It was recognized that one of the objects of scientific study was now man himself; the scientists on board Cook's ships recorded the aspect and customs of the races they encountered, and the draughtsmen drew the people and their artifacts as commonly as they did landscapes or the kangaroo. Above all, they collected the artifacts themselves, cramming them into every corner of the small ships.

Quite apart from the voluminous official diaries kept by Cook as commander, many of the other members of the expeditions recorded their doings and reactions. In these documents we find, for the first time in the annals of European explorers, detailed comments on carving and craftsmanship. Naturally they varied with the personalities and experience of the writers.

W. B. Monkhouse, Surgeon on the Endeavour (1768–71), described the masks carved on the Maori canoe prows as "preposterous," though he conceded that their execution was "very neat." David Samwell, Surgeon on the third voyage, makes it clear that in Hawaii some "laughed at [various divine images] and treated with contempt even those we supposed the most sacred among them"—shades of things to come! Cook himself judged that the figures attached to Tahitian canoes were "very little inferior [to] work of the kind done by common ship carvers in England." However, that lively young man Joseph Banks, who was the leading scientific light of the first voyage, found Tahitian work generally in "so very mean a taste."

On the whole, Maori art (Monkhouse notwithstanding) roused the greatest interest. Cook writes of the canoes "adorned in as good a taste as any," with their carvings "in my opinion neither ill designed nor executed" (he used the same description for Easter Island work). The most enthusiastic, and the most perceptive, was, as usual, Banks. He was impressed by "the beauty of their carving in general," and, with remarkable perception, distinguished two styles which the Maori habitually used. Interestingly, unlike Cook and the others, he thought the execution of the canoe-carvings "rough," so that "the beauty of all their carvings depended entirely on the design."

The word which recurs in these statements, and which must engage our attention even more than the use of "beauty," is "taste." "Beauty" in the late eighteenth century could be applied to the wonders of nature; but "taste" implies that these men, some of them highly educated and among the best intellects of their time, were applying in the Oceanic remoteness of Polynesia pretty much the same standards as they would have at home in London. This lies beyond the wonder Cook himself never ceased to feel that so much fine craftsmanship could be carried out with the meager technology of Neolithic tools. Here was a genuine appreciation of aesthetic qualities, and it was something new. In fact it was before its time, and was to have little effect on conserving the objects of its admiration.

The reports of the explorers were grist for the mills of eighteenth-century free thought and inquiry. At one level, the "Indians" of the South Seas became the rage of London and Paris, the subjects for sentimental operettas. At another, they seemed to be the embodiments of the Natural Man proposed by Rousseau, and thus springboards for the liberal fantasies of Diderot—as well as for the nightmare sexuality of de Sade. This was radical enough, part of the rebellion against authority which culminated in the French Revolution in 1789.

Another aspect of that same rebellious spirit, however, was the rise of fundamentalist Christian movements with their powerful drive toward missionary work. Their energy drove them to the South Seas, and they found there not the bright world of the aristocratic, intellectual explorers, but a black morass of the most hopeless paganism. As they saw it, their duty was to enlighten such pagan culture in their own way, not to understand it. The past was to disappear—and the pagan gods, and the arts which served them, along with it. Wherever they could, the missionaries had the sculptured idols, whether tasteful, beautiful, or preposterous, consumed in public burnings.

IV THE EARLIEST European expeditions into Africa and Oceania were professedly in search of riches; at first they were, literally, marginal. They were restricted to coastal areas. The lure of wealth and the need to control its sources with increasing efficiency led to the establishment of colonial power, immediately in the Americas and considerably later in Africa. In Mexico and Peru, this could take place with such speed because the Spanish incursion destroyed the ruling hierarchies with catastrophic abruptness. Surely no one, not even Cortés or Pizarro, could have foreseen the degree of collapse that took place in days or weeks. But in Africa, there was no such debacle for centuries, as the English, Portuguese, and Dutch remained quietly in their coastal forts and let trade flow to them from the interior. Ironically enough, it was the British attempt to suppress slave trading that, beginning in 1807, led to the necessity for their establishment of secure and permanent settlements on

the West Coast. Exploration of the Interior had taken place before that date, but had been unofficial, sporadic, and hazardous. As it increased, the wealth of raw materials that was revealed as potential fuel for the rapidly accelerating industrial revolution caused a scramble for African colonial possessions. This was finally regulated to some extent by the Conference of Berlin in 1884—85, during which the major part of the continent, without consultation with its inhabitants, was carved up between the Powers.

Competition was not as fierce in the Pacific. The Polynesian Islands, at least, adapted quickly to European influence. Hawaii, Fiji, and Tonga submitted voluntarily to the missions and to German, English, and American governors. In Melanesia, the history of West Africa repeated itself when the Government of Queensland claimed Papua as part of an effort in 1883 to control "blackbirding," the violent trade in indentured native labor. The great trading companies, such as Godeffroy of Hamburg and Burns, Philp of Sydney, had been busy in the area much longer, almost as colonial forces in their own right. The Godeffroy Compagnie made it its business to exploit the ethnographic resources of the islands, along with the more conventionally profitable items of trade.

While certain of the objects presented by the rulers of Mexico and Peru to the conquistadores had been sent back to Europe, and found their way into the curiosity cabinets of the nobles of the Holy Roman Empire, no effort to accumulate more of them was made. After Cook's voyages, quantities of South Seas material found its way into private hands, among them those of Sir Ashton Lever, who devoted an ultimately disastrous amount of his fortune to the creation of a museum in London which was open from 1774 to 1786. Upon its failure, much of his collection passed to one William Bullock, who in turn opened a museum, and again eventually auctioned it off in 1819. Part of it was bought for Berlin's Königlich Preussiche Kunstkammer—a lineal descendant of the sixteenth-century curiosity cabinets—which later became the Museum für Völkerkunde. Other objects from the collection found homes in the museums of Vienna and Dresden.

With the rise of colonialism, which gave opportunities for the collection of material culture from the areas colonized, we find the concurrent growth of the ethnographic museum, especially in Germany. The years between 1850 and 1875 saw, the foundation of the great museums of Hamburg, Berlin, Leipzig, and Dresden. In 1885, Leipzig acquired the collection of the Godeffroy Compagnie. Collecting, no longer a hit-or-miss matter of picking up whatever some wanderer had to offer, became the occupation or even the duty of government officials and scientists. Ethnography became, indeed, a form of colonial intelligence work. The great Berlin expedition of 1912–13 not only collected and mapped in what is now known as the Sepik Province of Papua New Guinea, but also included in its reports assessments of the area's economic potential. Then there were such great showrooms for colonial propaganda as the Tropen Instituut of Amsterdam and the Musée Royale du Congo Belge de Tervuren, with their exhibits which combined ethnography with zoology and botany.

The thoroughness of the German museums was a cause of envy to others less blessed by their governments. The British Empire's rulers showed a singular indifference to the well-being and progress of the British Museum's Ethnographic Department, or even to British anthropology as a whole. Sir Charles Hercules Read, in presidential addresses to the Royal Anthropological Society, took more than one occasion to point out that anthropology

had much to offer to the government and to the commercial world, and surely might share in the rewards. At the very least, the insight of anthropology and its allied studies would be of the greatest help in reconciling native custom to British law. This argument seems to have got him nowhere. Sir Charles's pleas, however, reflected accurately the common attitudes of the time: that dominion over palm and pine would last forever, while native cultures would inevitably die out.

Nonetheless the very existence of such museums and their collections had, everywhere, a profound effect. Not perhaps on the general public, which was content to have its curiosity stimulated and its thoughts edified at a fairly low level. But scientists found laid before them a mass of raw material which confronted them with innumerable problems. Few of these men had the least desire to encounter in real life the makers of all those peculiar things; typical was the response of the great mythologian Sir James Fraser (author of The Golden Bough in a dozen volumes), on being asked if he would not actually like to meet a savage: "Good God, no!" The treasures arranged in the glass cases were another matter. The questions they posed about history, psychology, and religion were inescapable. Was Darwin's evolutionary theory applicable to the history of the species? Did primitive man represent the childhood of the race? Were the roots of religious belief to be traced somewhere among these extraordinary images? These and other problems were endlessly debated. Not least, they were a matter of deep concern to the art historians.

V THE STUDY of primitive art began just after the turn of the mid-nineteenth century, with the work of Gottfried Semper, whose attention was concentrated on the highly formalized patterning which adorns much of it. Semper, whose book was published in 1861, attempted to show that all "early" art derived from those techniques needed for shelter and usefulness. It seemed a simple and natural progression: the plaited sticks, the marks on the pots, were elaborated into design, which later became modified into crude representation, thus sowing the seed for literal and faithful representation which, as everyone knew at that time, was the true purpose of the visual arts. The English art historian Owen Jones, in his The Grammar of Ornament (1856), repeated and fortified this theory, though he showed far more admiration for the results than Semper did. A decade later, Frederic W. Putnam, then Curator of the Peabody Museum of Harvard, seemed to turn this argument on its head: study of Precolumbian Chiriquí ceramics from Panama revealed him as apparently the first to propose that conventional designs derive from a vision of natural forms.

Putnam's theories influenced those of A. C. Haddon, an English biologist by earlier training, whose belief in studying the living organism, when it turned to anthropology, led him into mounting the first large interdisciplinary expedition to a native people. His expedition to the Torres Strait, between Papua New Guinea and Australia, took place at the end of the century; the publication of the results took until 1935 to be concluded. One volume is dedicated to art, with which Haddon was much engaged. In 1895 he had already published Evolution in Art, in which, true to his training as a biologist, he discussed the transformation of designs from a Darwinian point of view. Taking (for instance) a large number of New Guinea arrows with foreshafts carved in human or animal forms, he sorted them into a series from most naturalistic to most stylized. The most remarkable aspect of this was that he considered this set of contemporary variations to represent a process, and moreover one

of "degeneration." Haddon, writing toward the end of the great period of Impressionist painting, and during the best years of Van Gogh and Gauguin, had evidently learned nothing that the great stylistic variety of contemporary art had to teach: he still considered a departure from the copying of nature as an aberration.

There was also an implicit historical bias in Haddon's work, which was in keeping with the tenets of evolutionism and contemporary developments in allied fields. Then, in 1899, W. M. F. Petrie, the English pioneer of modern techniques in archeology, made the great discovery that the changes in pottery styles to be observed from grave to grave in a prehistoric Egyptian cemetery could be formulated into sequences. Thus historic order, if not absolute chronology, could be drawn from a mass of unstratified, chronologically undifferentiated material. The theoretical base was again evolutionist as well as stylistic: the implications for archeological and historical practice were fundamental. Other archeologists attempted to fuse Haddon's and Petrie's principles into a synthesis, as George Mac-Curdy attempted in 1911 to establish a chronological sequence in Chiriquí design.

This met with a cool reception from the great American ethnologist and teacher, Franz Boas: such conclusions, he wrote, were "merely an enunciation of the principles of classification or seriation chosen by the student." In any case, such discussions had a hollow ring for Boas and some of his colleagues, as well they might. For fifty years, eminent scholars had been debating the origins of art, and they had got little further than proposing that one kind of design preceded another, or the reverse. "Art," it seemed, meant as far as they were concerned little more than pattern-making, applied decoration. And it is almost true that had all works of primitive art been destroyed by some catastrophe in 1895, little would now remain to us in their publications except the record of certain decorative arts, mainly ceramic. (A salutary thought, indeed, for those who doubt that now-vanished styles existed in the past.) Only a few writers so far had looked deeper; one was Karl von den Steinen, who in his work on the Xingú tribe of Brazil had gone so far as to find that they practiced art as an enjoyable activity.

For Boas, art was something produced by the living; by the Eskimos and the tribesmen on the Northwest Coast of British Columbia and Alaska, whose lives he himself had shared, and whose cultures were still largely viable—neither in deep decay, like that of the Torres Strait, nor totally dead, like those the archeologists studied. The Northwest Coast, besides, was extremely rich artistically, unlike the sparse products of a tribe like the Xingú. Boas tried to look behind the outer surface of the culture to the thought which animated it—and he discovered in Northwest Coast art a complex system of symbolism.

Symbolism, as Boas describes it, amounts to explaining the unit of stylized design or pattern in terms of the naturalistic meaning applied to it by the native artist, often with some reference to a related myth or legend, but not by any means always. He stopped there, without asking questions of a higher order about the significance of the myth itself. But he did maintain that the assembly of these units was a highly conscious and artful process: "The symbolic decoration is governed by rigorous formal principles. It appears that what we have called for the sake of convenience dissection and distinction of animal forms, is, in many cases, a fitting of animal motives into fixed ornamental patterns." The wealth of conventionalized art itself, he stated, reflected conscious preference and choice: "When the artist desires realistic truth he is quite able to attain it. This is not often the case; generally

the object of artistic work is decorative and the representation follows the principles developed in decorative art."

In spite of this, it is a striking fact that Boas said little about Northwest Coast three-dimensional sculpture; when he did, it was mainly in terms of the two-dimensional design applied to it. Here, willy-nilly, he followed the lead of his predecessors in the area he chose to explore. Even so, there is no doubt that he made a vital contribution: he established once for all that there is nothing simple about the material he discussed. His understanding of the role of "symbolism" may have been limited, but he opened the door to a more profound comprehension of primitive art's significance.

And, finally, he evoked the word "beauty," so rarely used before in this context, and insisted on it as characteristic of all peoples:

> We have seen that the desire for artistic expression is universal. We may even say that the mass of the population in primitive society feels the need of beautifying their lives more keenly than civilized man....Do they then possess the same keenness of aesthetic appreciation that is found at least in part of our population? I believe that in the narrow field of art that is characteristic of each people the enjoyment of beauty is quite the same as among ourselves....The complexity of our social structure and our more varied interests allow us to see beauties that are closed to the senses of people living in a narrower culture. It is the quality of their experience, not a difference in mental make-up, that determines the difference between modern and primitive art production and art appreciation.

And Boas broadened this declaration further still to his fundamental view of humanity: "Some theorists assume a mental equipment of primitive man distinct from that of civilized man. I have never seen a person in primitive life to whom this theory would apply." This statement is perhaps a greater contribution to the understanding of primitive art than any of his detailed analyses of Northwest Coast two-dimensional design or Eskimo needlecases. After Boas, it was no longer possible to hold that the artists of primitive cultures were anything but conscious, functioning adults in complex and rich societies.

VI WHILE the anthropologists and archeologists debated their problems, the artists were looking at primitive art with fascination and enjoyment.

The lonely figure of Gauguin may be taken as a starting point. As rebellious against modern society as Rousseau and Diderot, he balanced his hatred of the commercial career which was his profession with a contempt for the classical canons of art exemplified by Greek sculpture. What did he approve of? The art of "the Persians, the Cambodians, and a little of the Egyptian," he told a correspondent in 1897—about as radical a choice as could be made by anyone who frequented the resources of the Louvre at that time. He was also impressed by some Aztec sculpture, which he saw at the Paris Exposition of 1889. His admiration of Japanese art was, of course, something he shared with many of his fellow artists, who felt its influence much more strongly than he—one thinks of the very strange transformations it underwent in the hands of, say, Whistler and Beardsley. It is evident that, by contrast, Gauguin was at least attempting to push into less-explored territory. When he reached the South Seas, and realized the qualities of Marquesan design, he not only wrote

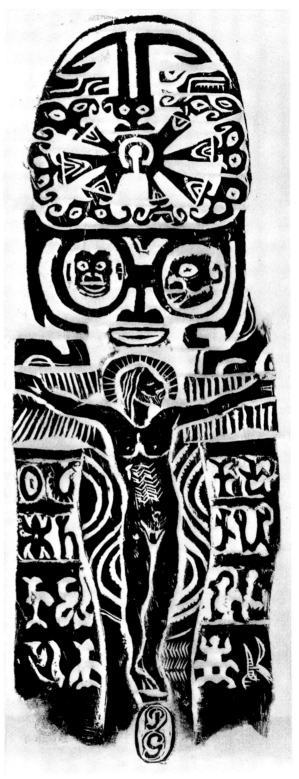

enthusiastically of its "unparalleled sense of decoration," but also transcribed some of its features directly into his own painting, sculpture, and woodcuts.

Apart from the ethnographic museums, primitive art was to be found in the few shops and dealers' establishments which specialized, as one of them put it, in "curiosities, weapons and coins." These catered largely to museums, but also to some amateurs. In England W. D. Webster of Oxford began publishing sales lists in 1895, W. O. Oldman of London in early 1903; and there were dealers in Paris and Germany about the same time. Primitive art could also be found in less expected places, such as a bar which the Fauvist painter Vlaminck entered one day in 1903 or 1904. There, among the bottles, stood a couple of African figures, which Vlaminck acquired for the price of drinks all round. He seems to have liked them for their "humanity," and perhaps their quaintness, rather than finding them a revelation as sculpture. His friend Derain must also have seen them, and indeed he later bought a now well-known Fang mask which Vlaminck owned. They thus became the first private collectors of primitive art as such in modern times.

Such is apparently the story (though it has been questioned) of a moment of cardinal importance in the history of the appreciation of primitive art. Other young artists followed the lead of Vlaminck and Derain; among them, both Matisse and Picasso (beginning in 1906) formed significant collections.

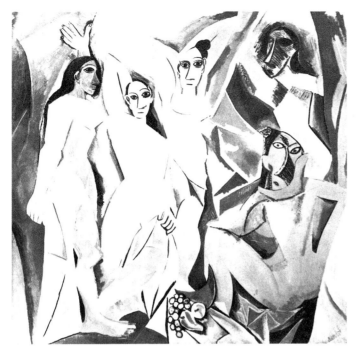

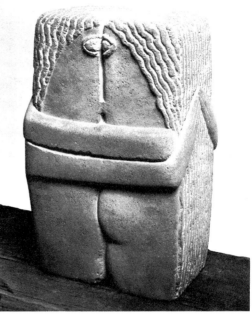

Pablo Picasso, <u>Les Demoiselles d'Avignon</u>, 1907.
Oil on canvas, 96 × 92 in. Museum of Modern Art, New York,
Lillie P. Bliss Beques:

Constantin Brancusi, <u>The Kiss</u>, ca. 1912.
Stone, 23 in. high. Philadelphia Museum of Art,
Louise and Walter Arensberg Collection

Naturally enough, it was the art of the French colonial possessions in Africa which was most available to them, and with which they became most familiar. The work of Fauvist painters was little affected by it; Picasso, on the other hand, became profoundly influenced by the sculpture of the Ivory Coast and the Gabon. In 1907 he embarked on the extraordinary paintings which stand between the rather sentimental beauties of the Rose Period and the rigors of early Cubism, and which include almost direct renderings of African sculpture. The most disturbing at the time, and to this day, was <u>Les Demoiselles d'Avignon</u>, with its forced marriage between European and African imagery. The violence of the faces on the right side of this work could be engendered only by Picasso's vision of Senufo or Bakota figures. By 1908, however, Picasso had assimilated much more. As he moved toward Cubism, his paintings left behind the grotesque and exotic qualities he saw in African sculpture, and developed a purer sense of its powerful volumes.

Sculpture itself was the natural medium for the employment of essentially sculptural ideas, and here also African sculpture had its effect. If this is not to be seen in Brancusi's work—and at least <u>The Kiss</u> of circa 1912 would suggest that it is—the sculpture of his follower Modigliani shows it clearly. The stone heads Modigliani carved after 1909 (when Picasso had already changed his style) have as their legitimate forbears the masks of the Guro and Baule tribes of the Ivory Coast, however interfused with other influences. Jacques Lipchitz, about the same time, was collecting primitive art and antiquities; critics discerned an African influence on his sculpture which he himself only grudgingly acknowledged. One may also mention Jacob Epstein, an American sculptor living in England, who began early to accumulate primitive art with an avidity that lasted all his life and ended in his owning one of the great private collections. (He was not alone in his enthusiasm in England; the painter Henry Lamb was known as an expert by 1914.)

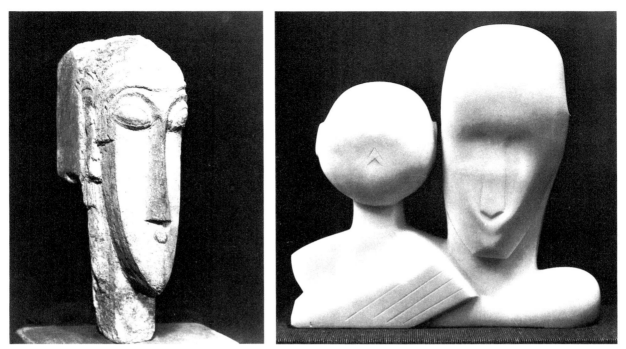

Amedeo Modigliani, Head, 1915 (?).
Limestone, 22¼ in. high. Museum of Modern Art,
New York, gift of Abby Aldrich Rockefeller in
memory of Mrs. Cornelius J. Sullivan

Jacob Epstein, Mother and Child, 1913.
Marble, 17¼ in. high. Museum of Modern Art, New York, gift of
A. Conger Goodyear

Epstein's strangely divided talent veered between passionately naturalistic, modelled portraiture and highly stylized carvings. Some of the latter, especially those of about 1912, are startlingly direct quotations of African sculpture.

In Germany, the discovery of primitive art had taken place simultaneously with that of the French, but in somewhat different circumstances, by the artists of the Blaue Reiter and Die Bruecke groups. When Ernst Ludwig Kirchner, for instance, first saw African and Oceanic art, it was not in a bar but in the ethnographic museum of Dresden, and it was as part of a widening interest among young German artists, which took in many other areas of art as well. Perhaps Oceanic art—so richly represented in German museums—had a stronger impact than African. Emil Nolde and Max Pechstein, the painters, actually made journeys to New Guinea and Micronesia, whereas no French artist dreamed of travelling to the Ivory Coast. Their works, accordingly, include not only renderings of masks and other objects but also genre studies of native and colonial life in the islands.

It is perhaps not so well known that American interest in the primitive arts was stirring at the same period. Marsden Hartley wrote from Europe to Alfred Stieglitz in 1912 about the concern of German artists with the art of children and primitives, and in 1914 Stieglitz mounted the first American exhibition of African sculpture at his gallery, "291." The works were largely drawn from the tribes of the French colonies, as were others he showed in company with those of Picasso and Braque in 1915. A year later, Marius de Zayas, who had assisted Stieglitz on the 1914 show, published a study of African Negro Art: Its Influence on Modern Art; he also introduced in 1918 an album of magnificent photographs by Charles Sheeler of African sculpture. In more recent times, a consciousness of their African heritage and its artistic wealth has been an influence on the work of such painters as Hale A. Woodruff, Romare Bearden, and Merton Simpson.

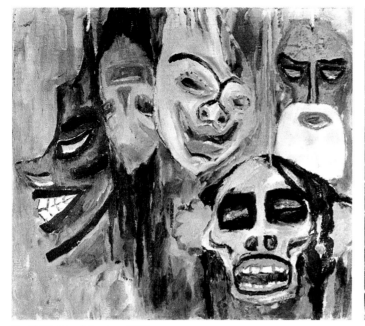

Emil Nolde, Masks, 1911.
Oil on canvas, 28¾ × 30½ in. Nelson Gallery—Atkins Museum,
Kansas City, gift of the Friends of Art

Romare Bearden, The Conjur Woman, 1964.
Collage and gouache on cardboard, 12⅛ × 9⅜ in.
Museum of Modern Art, New York, Blanchette
Rockefeller Fund

Collectors of contemporary art in America were deeply affected by African and Pre-columbian art, and began to acquire both. The Arensbergs, John Quinn, Agnes Meyer, and Paul Haviland placed them alongside their Picassos, Picabias, and Duchamps, reinforcing the connections between them.

The work of the artists themselves created a rather direct connection between primitive art and the public. As Robert Goldwater wrote in his classic Primitivism in Modern Painting (1939), it was untrue to say that Picasso and Modigliani (and of course all the others) had borrowed their styles from Africa; but "the relation is rather that of an admiration which, through the reproduction of certain details…creates a reminiscence of primitive art in the mind of a beholder imbued with a similar knowledge and admiration." Similarly, the admiration which Picasso and Modigliani arouse in a beholder unversed in primitive art can be transferred to primitive art; and many of us have in fact come to it by this route. In the arts, influence constantly works not merely in one direction, but is a reciprocal affair.

Although the greatest masters of modern art tended to be deeply concerned with primitive art for relatively short periods, its pervasive influence did not stop at that. Their early phases, and the example they set, have affected generations of their successors while continuing to reverberate in their own right. Through this tendency the public has, almost without understanding the process, become acclimatized to the aesthetic stances of the primitive arts. And there were more "public" manifestations, which also had their effect. The orientalizing of the early Ballets Russes presented by Diaghilev opened the path for such a ballet as Fernand Léger and Darius Milhaud's La Création du Monde (1923), with costumes based on African masks. It was not long before such imagery entered the fields of industrial graphics and design, bringing at least popularized distortions of it to the public in general.

Above all, of course, it was the aesthetic values of the primitive arts which taught the poets and artists, from 1904 to the present, lessons they passed on to the public: lessons in the use of volume, space, and the dynamics of imagery. The artists' aesthetic researches were self-oriented, however: their profound understanding of the physical attributes of primitive art did not extend (except in the most superficial way) to an understanding of its spiritual qualities, nor to its ideology. That problem for the time being remained unsolved.

Before 1914, primitive art had drawn a response from a few poets—the most famous being Guillaume Apollinaire, who, through his association with the Cubist artists, collected African sculpture. The young Chilean poet Vincente Huidobro also owned a few pieces—among them the famous Great Bieri, a funerary reliquary head from the Gabon later owned by Epstein and now in the Rockefeller collection (see p.64).

By 1917, the younger generation of poets was alive to the tug of the primitive arts. Tristan Tzara began writing articles about "negro" art and poetry. ("Negro" was then still used as a generic term for the art of both Africa and Oceania, which sometimes led to a fine confusion of geographical and tribal attributions.) The rebellion of the Dada artists, of whom Tzara was the leader, against those artists like Braque, Matisse, and Picasso whom they considered already old masters, led them to look at primitive art in a different light. Instead of in the formal qualities of primitive art, they found a reflection of their aims in what they thought of as its spontaneity.

The Surrealists, a few years later, shifted their interest quite decisively to the art of Oceania, particularly Melanesia, which they saw—quite wrongly—as equivalent to the liberated, unhindered reflections of the subconscious mind they themselves attempted to evoke in their work. The accumulative techniques of primitive artists had already been noted by Apollinaire when he wrote of fetishes covered with "charms, great plumes, pellets of resin, collars, pendants, iron tinklers, lianas, shells..." and so on through a long inventory. These conjunctions must have appealed to the object-makers among the Surrealists, as much as did the merging and crowded beings of New Ireland funerary carvings (malanggans) and Northwest Coast totem poles. They seemed parallel to the prime image of the Surrealists' intellectual ancestor, Lautréamont: "the meeting of an umbrella and a sewing-machine on an operating table." The Surrealist theoreticians and poets André Breton and Paul Éluard made notable collections early (their first, joint, collection was dispersed in 1931); Yves Tanguy, Max Ernst, Wolfgang Paalen, and others continued to do so.

A rarer influence was that of Precolumbian America, but this, too, made its mark on some sculptors, most notably the young Henry Moore. The reclining figures of Mayan gods were copied almost directly in Moore's earlier work, and have lingered on in the themes of his sculpture in later years.

The very active relationship of European artists to the primitive arts had a vital effect on the general appreciation of the latter, at first through the critics, those intermediaries between the modern artists and the public who had initially regarded them with such suspicion. By 1920, so great an authority as Roger Fry was able to write, "I have to admit that some of these things are great sculpture—greater, I think, than anything we produced in the middle ages. Certainly they have the special qualities of sculpture in a higher degree.... These African artists really conceive form in three dimensions." He could hardly have said more; but had his eye not been trained by Cézanne, Braque, and Picasso, would he

not have said much less? Omnivorous as Fry was, it is quite possible to conceive of him passing over African art as merely curious, had circumstances been different. Even by the time of his death in 1939, as the text of his Last Lectures shows, he had found little or nothing to interest him in Oceanic or Precolumbian art.

No one could state with any confidence that primitive art has, any longer, a profound effect on contemporary artists. Abstract Expressionism, Op Art, Pop Art, Minimalist, and Conceptual art offer us none of the avenues into primitive art that Cubism, Expressionism, and Surrealism once did. Nonetheless, the artists themselves have continued to collect works that exercise a hold on their imaginations, including Adolph Gottlieb, Chaim Gross, Matta, Arman, and many others.

VII THE PITT-RIVERS MUSEUM of Oxford, founded in 1884, unlike many ethnographic museums took a theoretical stance. It offered with its great collections a technological view of mankind tempered by evolutionary doctrine. Each class of objects was grouped together, regardless of geographical origin, and with the implication of improvement through time. Thus the projectile weapon and the plough were shown in such a way as to demonstrate the progress of their own forms and, in toto, that of all mankind's material culture.

This approach stands almost diametrically opposed to the museum work of Haddon, Boas, and their contemporaries, who developed the idea of the "culture area": a human and geographic entity like, perhaps, but also distinguishable from the entities surrounding it. The conception was to have an even more important influence upon the study of primitive art in the long run than did the essays in which Boas addressed himself directly to the subject. If culture areas could be defined, and a component of each culture was its art, then the differences between those arts were available to be traced: the notion of "style areas" in the primitive arts became inevitable. It was an important step toward the development of an art-historical approach to the primitive arts.

An important manifestation for the public eye was the series of illuminating museum exhibitions, based on style-area principles, which took place at The Museum of Modern Art. The earliest was in 1933, "American Sources of Modern Art," which displayed Precolumbian works. Their connection with modern art was perhaps tenuous, but the show was highly praised by no less a famous visitor than Henri Matisse. Precolumbian works also figured importantly in The Museum of Modern Art's "Twenty Centuries of Mexican Art," a gigantic display of 5,000 works lent in 1940 by the Mexican government, and largely organized by Nelson A. Rockefeller, the newly elected President of the Museum. Although at the time his principal interest was modern art, he had already started collecting primitive art (as his Introduction here describes).

"African Negro Art" was shown at The Museum of Modern Art in 1935; the impressive group of 600 objects was selected by James Johnson Sweeney, whose approach was uncompromisingly aesthetic. In the catalogue he wrote:

> Picturesque or exotic features as well as historical and ethnographic considerations have a tendency to blind us to [African art's] true worth. This was realized at once by its earliest amateurs. Today with the advances we have made in the last thirty years in our knowledge of Africa it has become an ever graver danger. Our approach must be held

quite conscientiously in another direction. It is the vitality of the forms of Negro art that should speak to us ... the art of Negro Africa is a sculptor's art. As a sculptural tradition in the last century it has had no rival. It is as sculpture we should approach it.

Other exhibitions which followed were grander still, especially the famous series at The Museum of Modern Art put on by its Director, René d'Harnoncourt. This heroic figure of the museum world never looked upon himself as an infallible scholar, but he did believe in his eye and his instincts, none more justly so. He relied on these, and he also relied on the expertise of professional scholars. His first important exhibition was at the Golden Gate International Exhibition, held in San Francisco in 1939. At that time general manager of the Indian Arts and Crafts Board, d'Harnoncourt organized the Indian art section in collaboration with Frederic H. Douglas, the Curator of Indian Art at the Denver Art Museum. Two years later, again working with Douglas, he organized the great exhibition "Indian Art of the United States" at The Museum of Modern Art in New York. This was followed by "Art of the South Seas" (with Paul S. Wingert of Columbia University and Ralph Linton of Yale) in 1946, and "Ancient Arts of the Andes" (with Wendell C. Bennett of The American Museum of Natural History) in 1954, both also held at The Museum of Modern Art.

Situated in a museum of great prestige, famous for its adventurous policies, these exhibitions brought to a large public largely unfamiliar works with the full panoply due to accepted styles of art. Apart from the qualities of the actual objects, the major contribution to the success of the exhibitions was René d'Harnoncourt's own, with the constant support and encouragement of Nelson A. Rockefeller, who by that time was again President of The Museum of Modern Art. D'Harnoncourt had an unrivaled genius for exhibition design, practicing a technique which he raised to nothing less than an art itself. Once again his eye was paramount: his set task was to transfer the intensity of his vision to another viewer. This he did with the subtlest means; he never overplayed or glamourized an object, for to do so would have been alien to his fastidious and aristocratic taste.

In the same years as "Ancient Arts of the Andes," Nelson A. Rockefeller founded and became President of The Museum of Primitive Art, with d'Harnoncourt as its Vice-President; the Museum's doors were opened to the public on February 20, 1957. In the 1940s and 1950s, Nelson A. Rockefeller and René d'Harnoncourt had devoted more and more time to assembling an extraordinary collection of Oceanic, African, and Precolumbian art. The works the Museum housed were from this collection, and the organization of the Museum was a long-planned culmination of their endeavors. Robert Goldwater, Professor of Fine Arts of the Institute of Fine Arts in New York, and an authority on both modern and primitive art, was appointed Director. The present writer joined the staff in a curatorial capacity shortly thereafter.

In spite of the great proliferation of museums which took place in the forties and fifties, and the enthusiastic endowment of art museums in particular during that period, The Museum of Primitive Art was unique. No other institution existed which shared the same aim; it thus had a truly pioneering task to fulfill in the elucidation of the subject and the formation of taste.

In his Introduction to the catalogue of the first exhibition mounted at the Museum, Nelson A. Rockefeller defined its purpose:

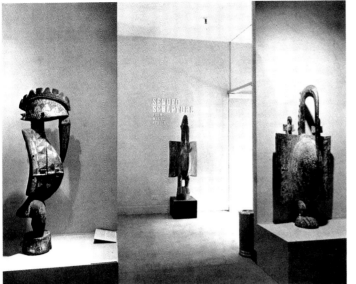

"Senufo Sculpture from West Africa" exhibition.
Photograph by Charles Uht

"The Art of Lake Sentani" exhibition.
Photograph by Charles Uht

A new museum calls for a word of explanation. When the trustees of The Museum of Primitive Art, originally named The Museum of Indigenous Art, applied for a charter they described their purpose in the following words: "To establish and maintain a museum in the City of New York devoted to the artistic achievements of the indigenous civilizations of the Americas, Africa, and Oceania, and of the early phases of the civilizations of Asia and Europe." We were thus suggesting in reality a museum of the arts of original populations of the six continents.

Museums of ethnology and "natural history" have, of course, long shown these arts. They have done so primarily to document their studies of indigenous cultures. It is our purpose to supplement their achievement from the esthetic point of view. However, we do not wish to establish primitive art as a separate kind or category, but rather to integrate it, with all its amazing variety, into what is already known of the arts of man. Our aim will always be to select objects of outstanding beauty whose rare quality is the equal of works shown in other museums of art throughout the world, and to exhibit them so that everyone may enjoy them in the fullest measure.

Throughout the Museum's existence, Nelson Rockefeller continued to provide alike for its financial support and for a sustained program of purchases. As a showcase for primitive art, the Museum maintained an active schedule of exhibitions, three to four a year for eighteen years, drawn from its own ever-growing collections, those of private collectors, and—perhaps the most illuminating—those based on specific themes. The last, it is fair to say, because of the opportunity to concentrate on areas, periods, and their styles, made the most valuable contributions to the field, and certainly engaged most public attention. Only a few can be mentioned. The exhibitions on the sculpture of the Bambara and Senufo tribes of Mali and the Ivory Coast (1960 and 1963), organized by Robert Goldwater, threw a new light on classic phases of African art. Neglected treasures were discovered or rediscovered

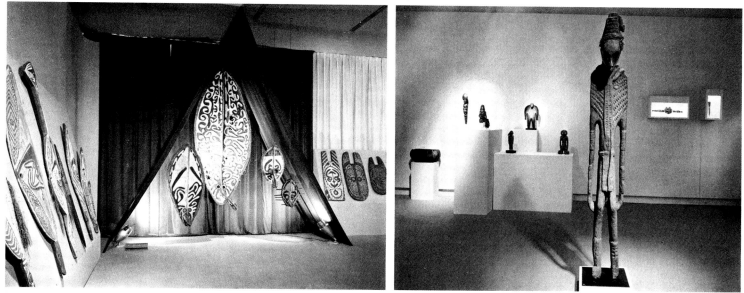

"Art Styles of the Papuan Gulf" exhibition.
Photograph by Charles Uht

"The Raymond Wielgus Collection" exhibition.
Photograph by Charles Uht

in exhibitions of the art of Lake Sentani (1959– 60) and the Gulf of Papua in New Guinea (1961), and unknown ones from the obscure area of the island's Upper Sepik River (1969). Exhibitions on the familiar art of the Inca of Peru (1963– 64) organized by Julie Jones (then Associate Curator), and on the pre-classic cultures of the Valley of Mexico by Michael C. Coe (1965), introduced new aspects of archeological art. Other exhibitions offered a conspectus of art areas in the Museum's holdings, such as "The Traditional Arts of Africa's New Nations" (1961), and were representative of their brilliant quality.

Most impressive of all was the exhibition of the art of the Asmat people held in 1962 in The Museum of Modern Art's garden, in a splendid setting designed by René d'Harnoncourt and Arthur Drexler. This was the comprehensive collection, including the towering funerary poles, huge canoes, and kaleidoscopically carved shields, so enthusiastically assembled for the Museum by Michael C. Rockefeller on his second visit to southwest New Guinea in 1961. His death in the dangerous seas off that coast brought to an untimely end a life absorbed with art and an expanding sympathy with its many manifestations.

The Museum's publishing program was also unusually active. About seventy publications were produced, many of them illustrated catalogues describing not only the Museum's holdings, but also such distinguished private collections as those of Jacques Lipchitz, Sir Robert and Lady Sainsbury, Jay C. Leff, Mr. and Mrs. John de Menil, and Raymond Wielgus. This was part of an intention to get into circulation a large body of illustrations of material, and in fact some 2,500 objects (mostly otherwise unpublished) were circulated in this way. The Museum also published about a dozen monographs which accompanied the major thematic exhibitions. These had substantial texts based on the best published fieldwork available at the time, as well as being richly illustrated, and most of them have proved to have lasting value.

An examination of these publications shows a radically different approach from that of, say, Roger Fry or James Johnson Sweeney. They are rigorously removed from the polemical

or propagandist. They describe types of objects, and they provide accounts of historical and cultural settings, but they do not dictate to the reader what he should look for or how he should look at it. There were few efforts at interpretation of the works of art; John H. Rowe's inquiry into the "form" and "meaning" of Chavin art (1962) was exceptional.

Most of the authors held in common (whether they knew it or not) two tacit assumptions. On the one hand, they believed that the works of art were indeed of supreme quality—otherwise there would hardly be any point in exhibiting or publishing them—and that any sensitive viewer could see this for himself. Here, indeed, purely aesthetic manifestos of influential earlier critics had paved the way for an open receptivity. On the other hand, this was not enough: it led to the risk that these works—from cultures which, after all, were actually very different—might be regarded as ancillary to the Western tradition. The very insistence that African sculpture, say, has a greatness in its fundamentals which it shares with Western sculpture, begs the question of what African sculpture really means to Africans. Other routes to understanding are not only desirable but necessary. The position taken by The Museum of Primitive Art's writers was that information, as full as possible, about the contexts in which and for which the objects had been made would carry the reader some distance. It was hoped that the intelligent viewer, without losing sight of the aesthetic qualities of the works, could absorb something of the preconceptions behind them, even though unable to partake fully of them.

Something of this osmotic approach was also implicit in the techniques used in the exhibitions. An important review of d'Harnoncourt's "Art of the South Seas" by the anthropologist Gregory Bateson pointed out that the installation, including the colors used and the lighting, conveyed subliminally the atmospheres and conditions of the cultures. There were no literal replications of any physical conditions. René d'Harnoncourt's followers (including the present writer) carried on these principles as much as possible, in an attempt to foster an intuitive understanding of the works of art rather than literal explanations. Explanatory devices, it was felt, could be more properly handled by the ethnographic museums.

THE INFLUENCE of The Museum of Primitive Art on the ethnographic and art museums of the United States was salutary, if not through the details of its practice, then by the very fact that it existed. At first, the Museum was greeted with some skepticism. A number of curators of ethnography rebelled against the thought that they had in their charge things which were not merely specimens of material culture but treasures of art. Before long, however, their museums were instituting separate departments of primitive art, or revising their installations to expose works of art in more prominent and privileged positions than they had ever held before. Indeed, there was almost a shift by which ethnographic museums began to transform themselves into art museums. A number of the art museums, notably the Art Institute of Chicago, themselves began to form departments of primitive art and to make collections. This is not to say that many did not have significant holdings already, but their attitude toward these now took on a higher degree of purpose and activity. Similarly, private collectors in considerable numbers started to compete for fine works. A few of them with great ambition made very large accumulations, amounting to small museums in themselves.

Twenty years after The Museum of Primitive Art was founded, and largely because of

its influence, "primitive art" is no longer a stepchild of Western culture, a marginal aspect of the history of art. It is becoming as familiar to the public as any other aspect of art—and directly, not filtered through Western artists. It has taken an equal footing in the great art museums with the arts of the great civilizations. It is, in fact, assuming the position in the general consciousness which has always been its rightful place.

VIII WE HAVE SEEN here how a long human history of ethnocentric indifference, or even hostility, to the art of alien cultures has undergone a radical change during the last century in the Western world. This has taken place to the extent that the sporadic fads of the eighteenth and nineteenth centuries for the exotic—the passion for Chinoiserie, Pompeian decoration, the Napoleonic view of Egypt, the orientalism of the Brighton Pavilion—have been superseded by something very different and apparently much more stable. Today we are not interested in graftings of some characteristics of other arts onto our own (leaving ours unaffected in cultural assumptions, even in basic form). Attention is paid to the work of art from another tradition for its own sake, its own identity, even when it comes from so remote a source—formerly geographically and still ideologically—as that of one of the world's primitive cultures.

The crucial influences here have been wielded by three main forces: the work of anthropologists, the establishment of museums, and the enthusiasm of modern artists. All three have contributed toward the assimilation of primitive art by a far wider public than could have been envisaged a mere half century ago.

The study of primitive art is today still largely the province of anthropologists and archeologists, who are physically closest to the material and its habitats. No longer confined to the bald reporting or simple armchair hypotheses of the past, such studies are now carried out within the framework of sophisticated theories, which range over most of the current schools of anthropological thought. There is an intense investigation of the questions of the societies', and the artists', intentions and goals, and much interpretation of them. Too, changing attitudes and methodologies, and the possibilities of personal access, have led to investigations—though still too few—of the individual artist and his aesthetic.

Museums continue their traditional work. The acceptance by one of the greatest and most traditional—The Metropolitan Museum of Art—of the Rockefeller collection of primitive art is a symbol of the enlargement of their scope by art museums in general. Significantly, many of the emerging nations have signalled the acceptance of their own pasts by founding museums: spectacular collections have been assembled by, among others, the museums of Nigeria, Zaïre, and Papua New Guinea.

Western culture, though ancestor worship has never been a part of it, has nevertheless suffered remarkably few bouts of doctrinaire iconoclasm: it has always been inclined to cherish its own past, and to lament the damage inflicted on its memorials. Recently it has begun to care for the past of other cultures in a way they themselves have often not been prepared to do. If Western ideology and technology have expanded throughout most of the world and have destroyed much cultural variety in doing so, it is one of the glories of another aspect of Western culture that it has simultaneously sought out so much that otherwise would have been lost, and has preserved it.

Faces

Faces

Even more than the human body, the face has been the great subject for the artist. It is, admittedly, a strange conjunction of the organs by which we sense the external world, and it is the small variations in the form that make each of us recognizable to, or distinguishable from, our fellows. In a way the face is reassuring, no matter what its expression—the idea of a faceless man is a source of nightmares — but it is also awe-inspiring. Artists, particularly those of primitive cultures, have always seen it as though through a mirage of feeling, which distorts it into myriad variations.

On the whole, the rulers of this world have always looked with favor upon representations that were more naturalistic rather than less. Rulers have always held the insignia that represent power, and have rarely wished themselves to be represented merely by insignia. To the extent they themselves are symbolic beings, it is in their own actual forms. The ruler may be a god — there are innumerable cases when rulers claimed divinity

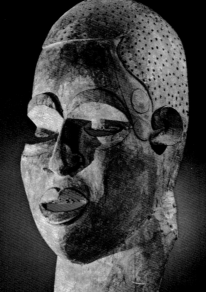

This wooden mask from the Ibibio of Nigeria is a single segment of a mask that originally consisted of three such faces.

—but it is a god in human shape. Some of the most naturalistic sculpture from the African continent are the heads of the Obas of Benin (pages 54–55). Few of them may be direct portraits of the men, but they are clearly portraits of men who rule.

In the realm of the supernatural, the need to follow the daily contours of the human face also exists, but usually with modifications that turn the viewer's sense of the face off-balance (page 71, right). The distortion of a particular single feature can do this very effectively; and the one most commonly used in this way is the eye. It is proverbially the most expressive of all the features. The mouth is capable of impressive grimaces, of humor or terror, and can appear as an entryway to unknown and dreadful regions — caves, the underworld, the grave. The protruding tongue, in Mexico or New Zealand (pages 86–87), suggests aggression. The nose can be elongated into a powerful weapon-like extension (page 79). But the eyes are almost infinite in the messages, sometimes ambiguous, they convey. The lowered lids of a Tlingit (page 70) or Guro mask (page 62) suggest tranquillity or rest, certainly, but also a brooding leashed energy. It is the full glare of the eye in, for instance, Sepik River carvings that leaves no doubt of a determination to intimidate the viewer, as on the shields from the area (page 85, right). Almost more alarming are the circular apertures of some Dan masks — especially since it was the real human eye that could once be seen, mobile and incongruous, lurking behind them (page 90, top).

The depiction of the face can be entirely metamorphosed into a new image by various forms of distortion, which, it should go without saying, are used as powerful tools by the primitive artists. Physical distortion, for instance, into geometric forms in which only the faintest traces of the original features can still be discerned through a veil of pattern (page 83) or even blank space (page 82, left). Distortion by way of the use of materials such as turtle shell (page 91), bark cloth, or fiber (page 92), which bear not the faintest relation to humanity. Distortion by the use of brilliant color overlaying the features (page 71, right). It is a testimony to the strength of the human face that in art it always remains recognizable and awesome.

From the Bini of Nigeria, the famous ivory mask at right was carved in the mid-sixteenth century, and was worn on the belt of a ruler as part of his regalia. The iron inlays on the forehead represent tribal scarifications, and around the hair is a frieze of stylized heads of contemporary Portuguese mercenaries.

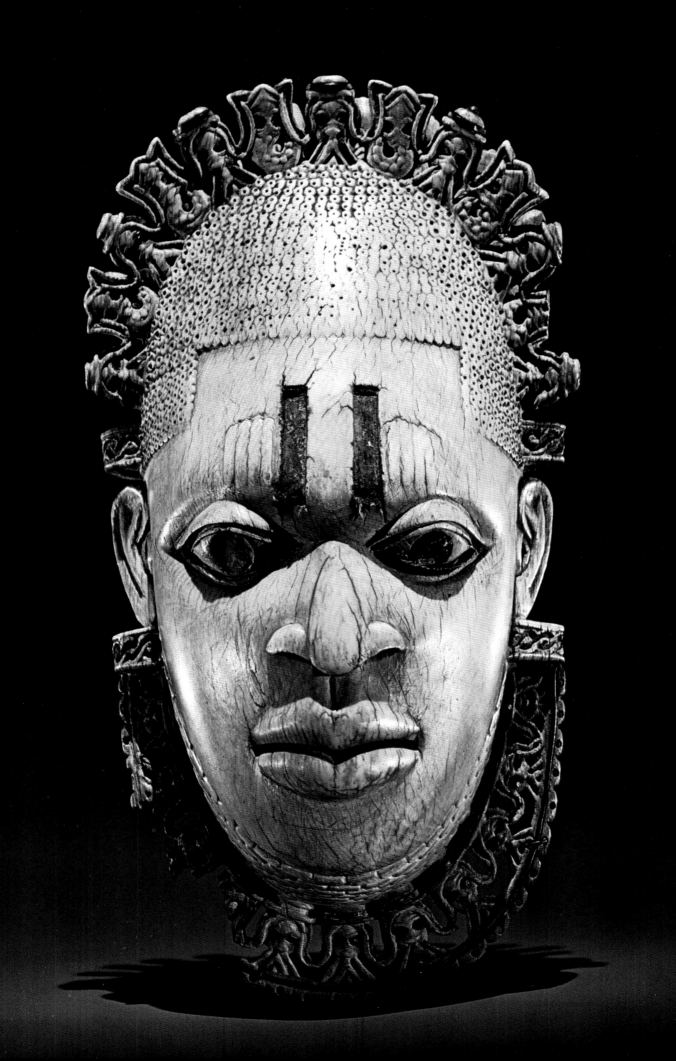

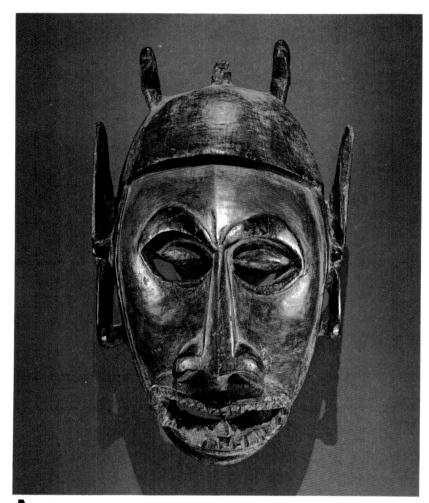

A mask, above, from the Astrolabe Bay area in Papua New Guinea was worn in terrifying dances during circumcisions. A similar face, with three-pointed headdress, adorns a bowl, below, from the same area. Stone heads from Guinea, right, may have been made by an earlier population as memorials, but are now used as fertility gods.

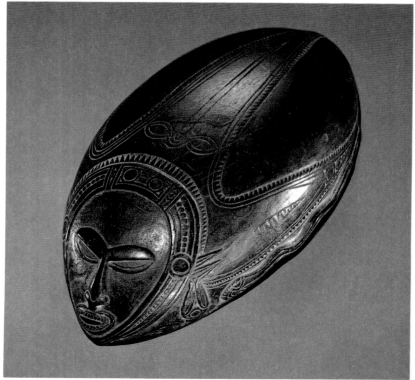

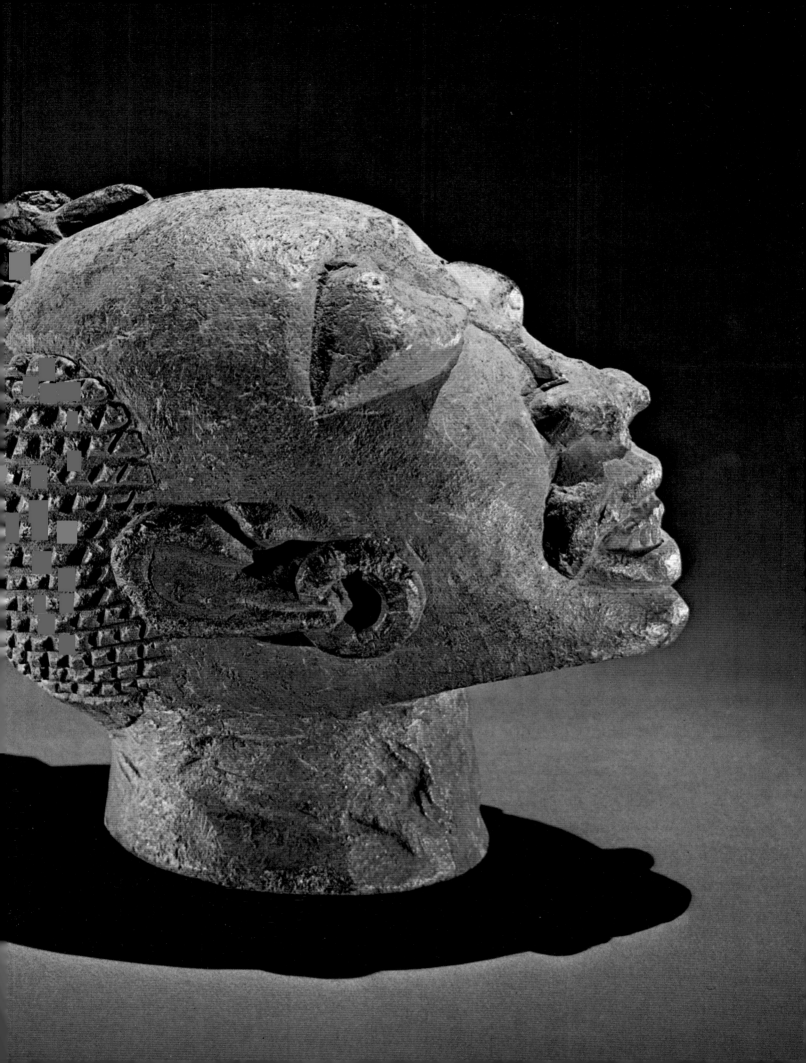

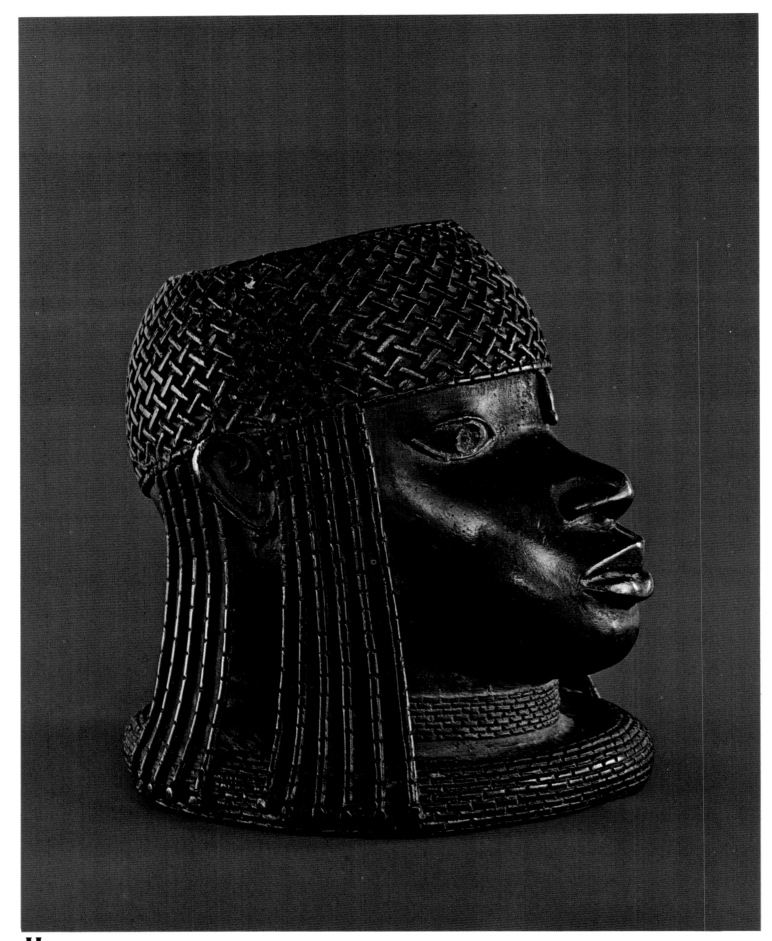

Heads in dark brass (usually called bronze) were kept on the royal altars of Benin as memorials to ancestors: in these two the subjects are shown wearing regalia—caps and chokers—of coral beads, as the king does to this day. The head on the left dates from the mid-sixteenth century; that on the right from about a century later.

54

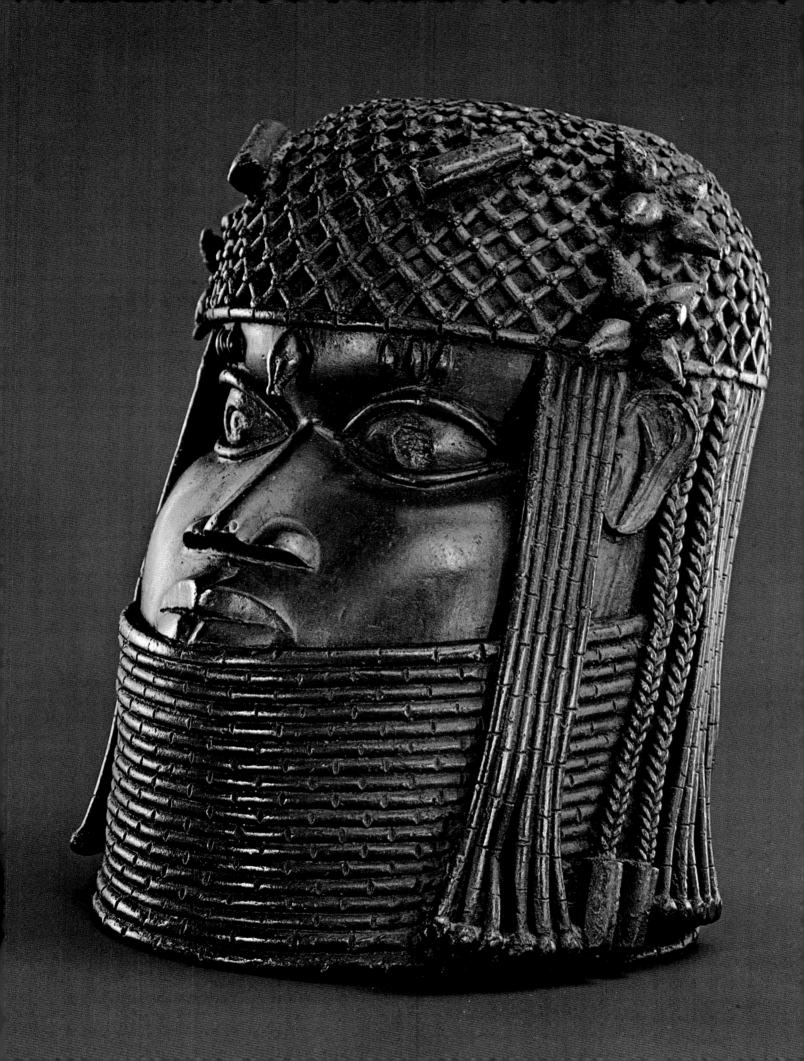

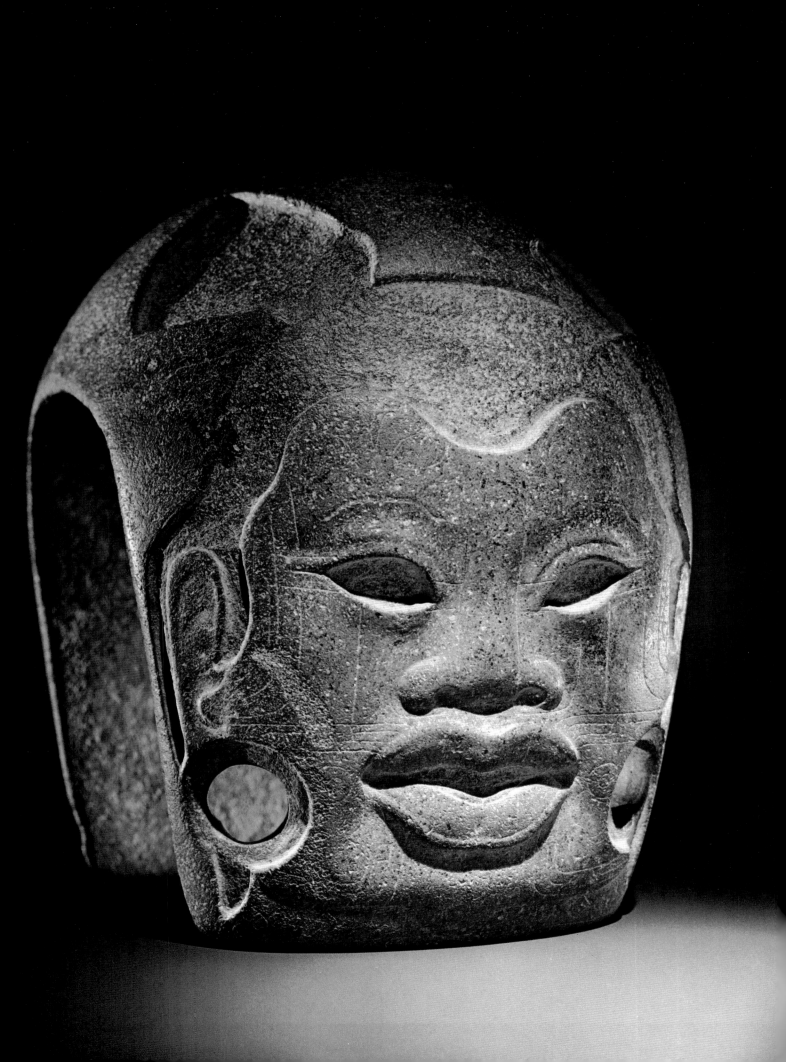

A type of arched stone object from ancient Mexico is known as a yoke after those worn at the waist in ritual ball games. The Olmec example, left, dates from 800—400 B.C. Precolumbian rain gods are shown in a stone head of Chac, right, from the Maya city of Chichén Itzá (A.D. 900—1000), and in a mask of Tlaloc in the Mixteca style (A.D. 1250—1500) of Mexico, below. The jar in the form of a one-eyed man's head, far right, is typical of the naturalistic ceramics of the Mochica of Peru (A.D. 500—700).

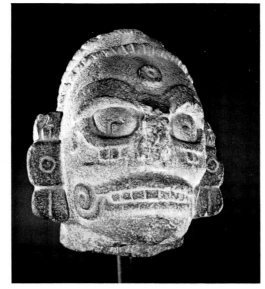

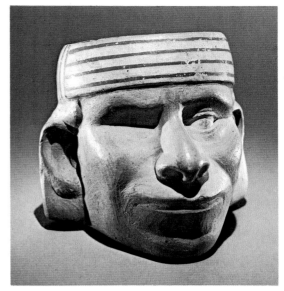

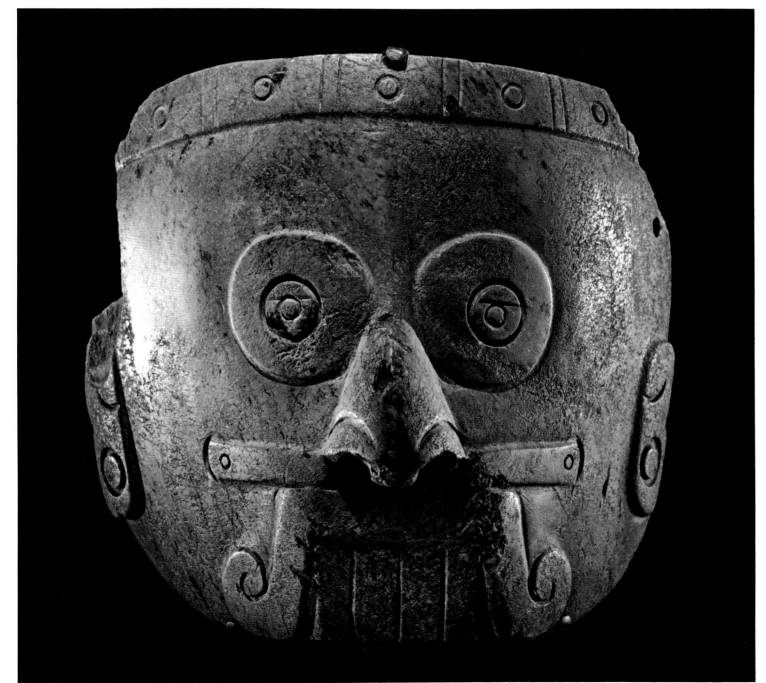

The small mask, below, from the Baule of the Ivory Coast exemplifies one of the African styles that first attracted the attention of European artists. The classically serene mask of a beautiful woman, right, was used by the controlling secret society called Mmwo of the Ibo in Nigeria.

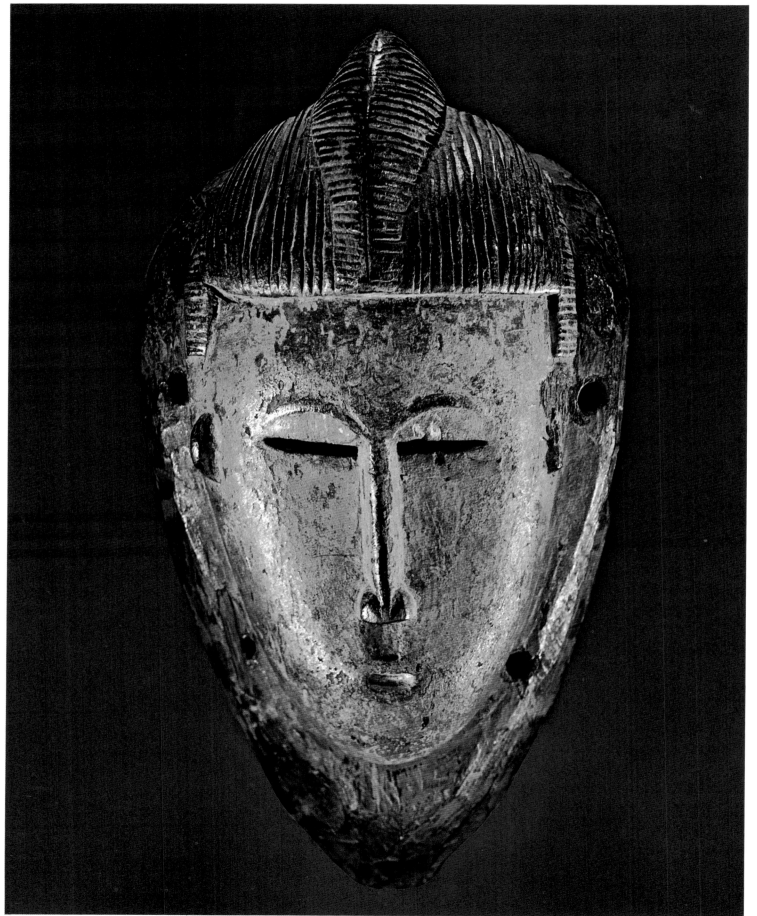

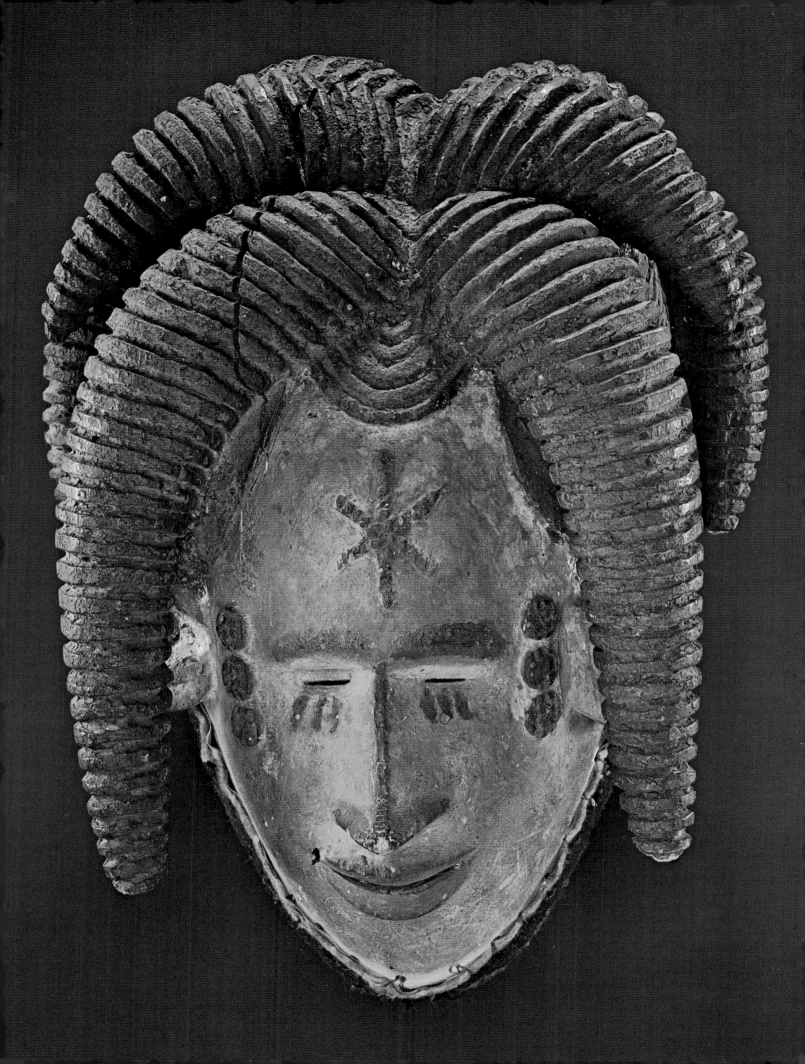

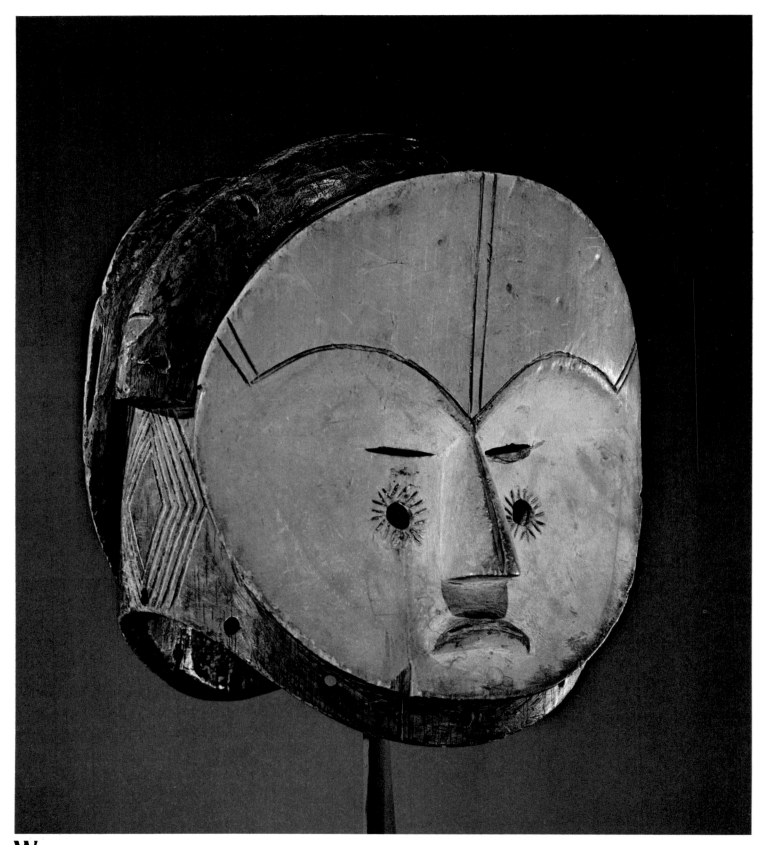

White-faced masks, above, are commonly made among the Fang
of the Ogowe River in Gabon. They represent ancestral female spirits,
denoted as such by the color, and were used by both men's and
women's societies. The Senufo mask, right, although typical in style,
including many features found on the tribe's wooden masks, is
unusual in being cast in bronze.

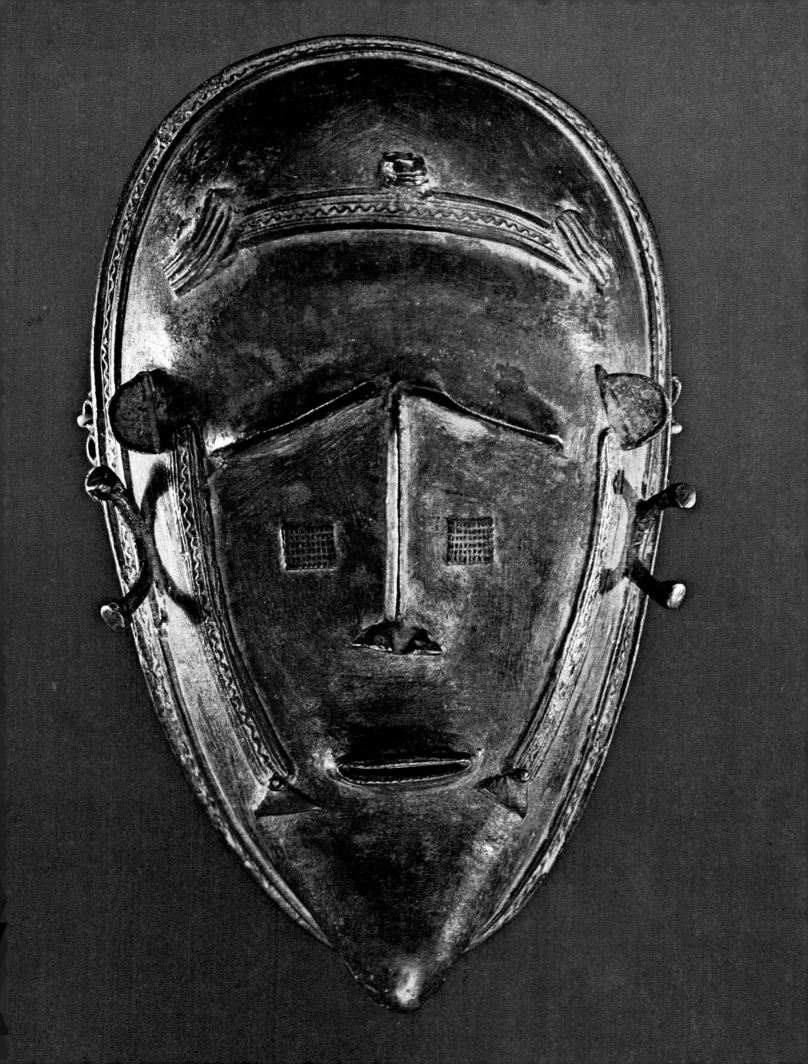

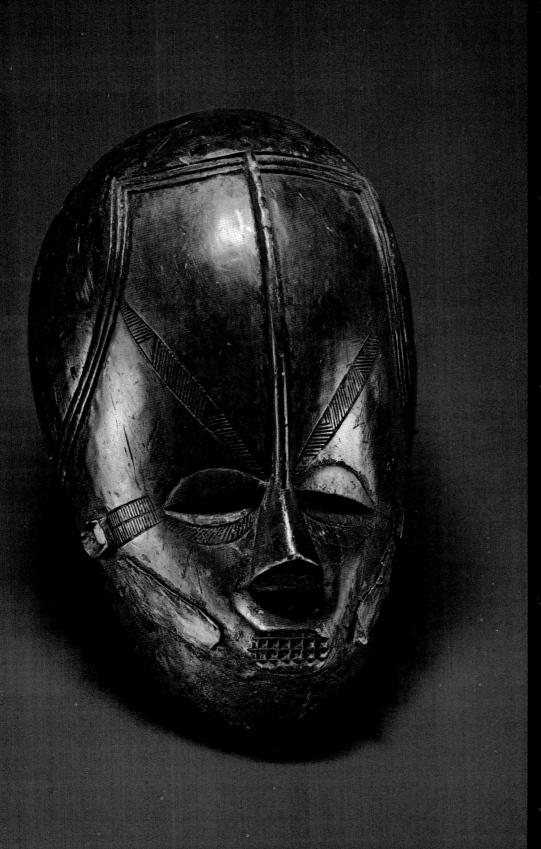

The mask at left has characteristics of the Guro of the Ivory Coast, but also of the Bete, who lie between the Guro and the Dan of Liberia; hence it seems to embody an overlapping of styles. Used as a grave marker, the head in blackened ceramic, right, is from the Ashanti of Ghana.

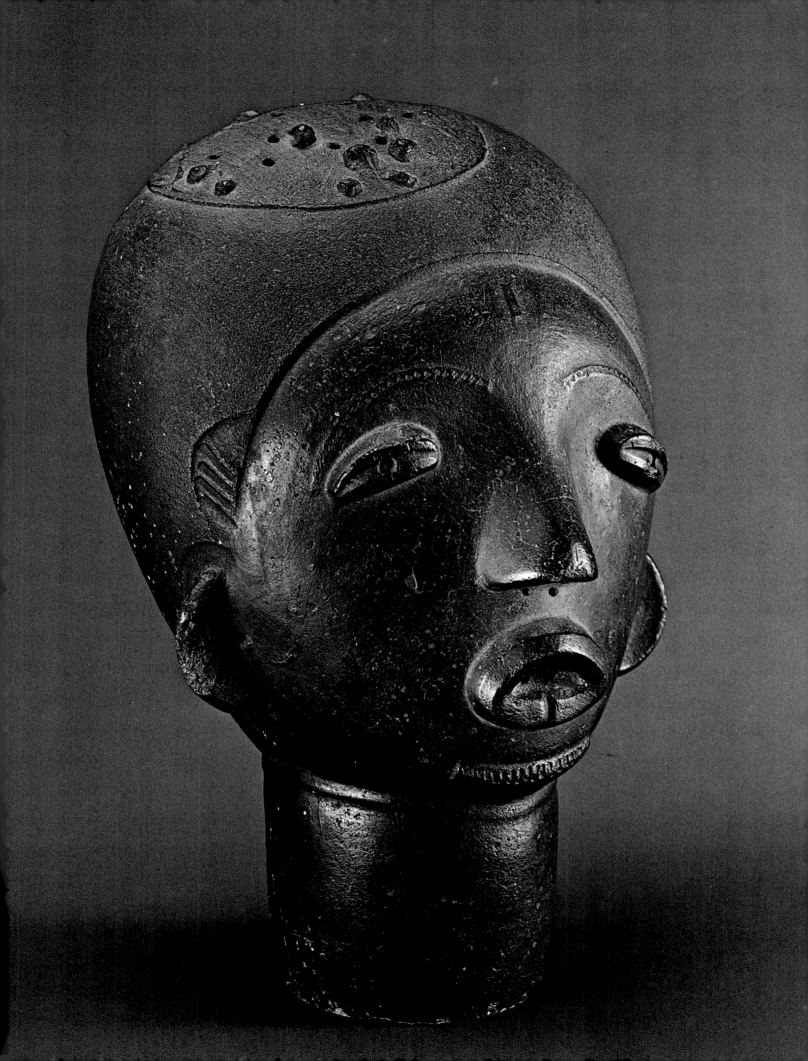

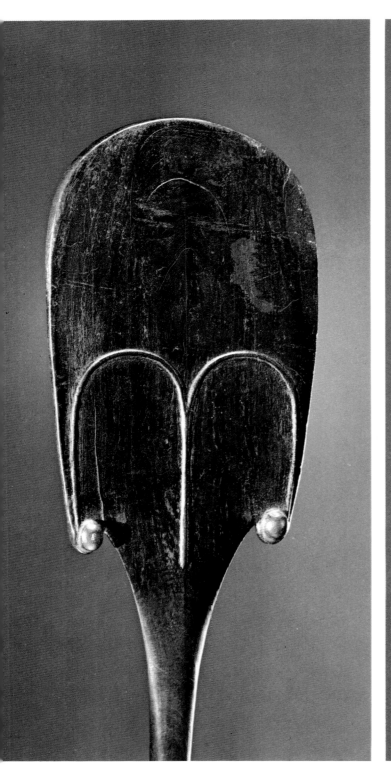

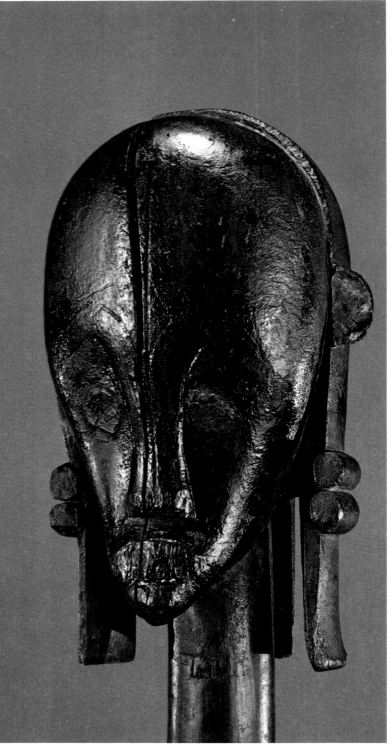

Carvings known as ceremonial paddles were carried in dances on Easter Island, left; the upper ends were carved with highly stylized faces, reduced to ears, brows, and nose only. although eyes seem to have been painted in on some examples. The Fang of Gabon made human figures and heads to be placed on cylindrical bark containers for ancestral bones. This head at center, of exceptional size, is also the most famous; it was once in the collection of the sculptor Sir Jacob Epstein. A similar function was performed among the Kota, who also live in Gabon, by metal-strip-covered heads, right, set on basketry containers.

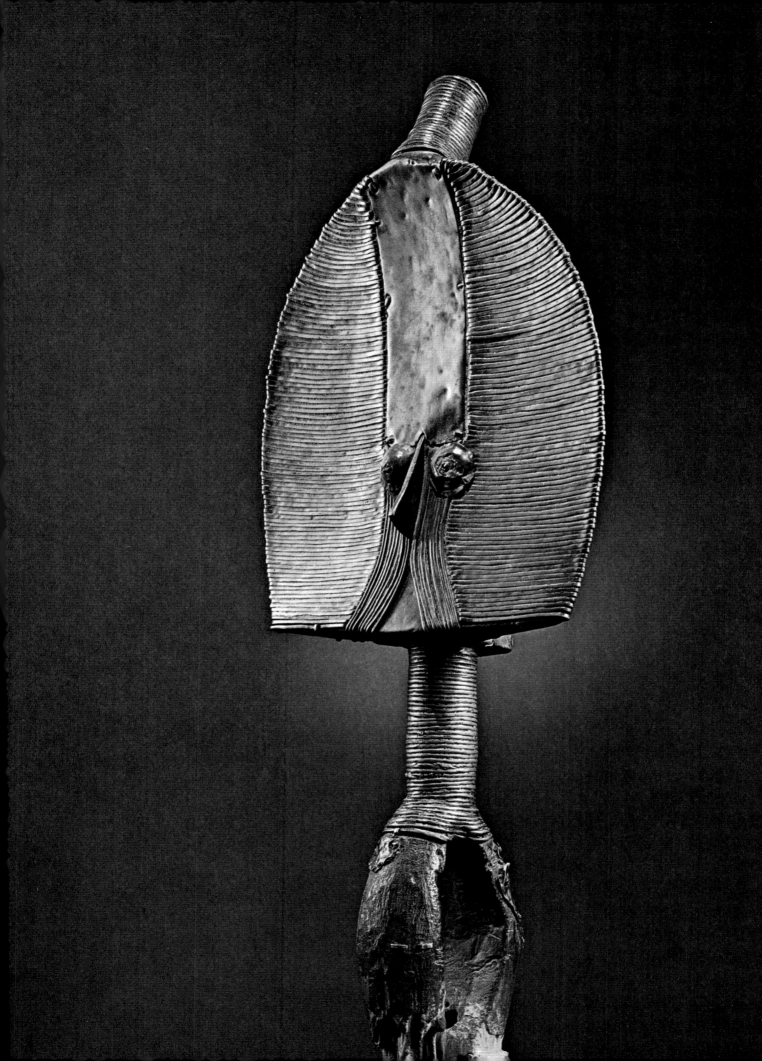

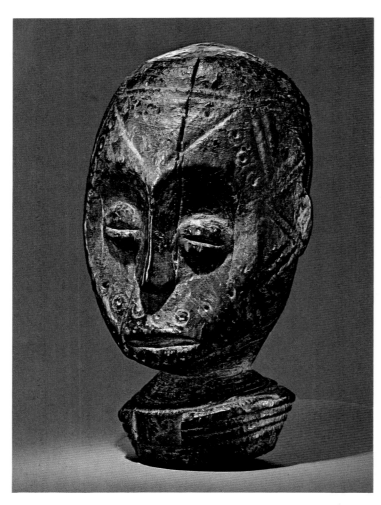

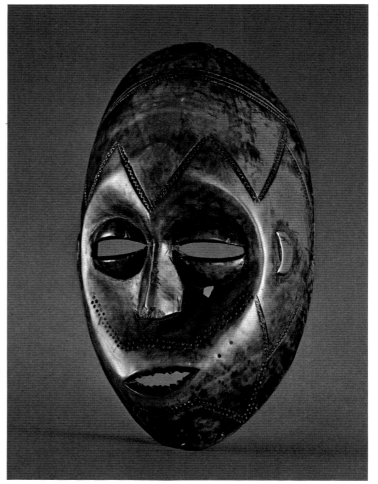

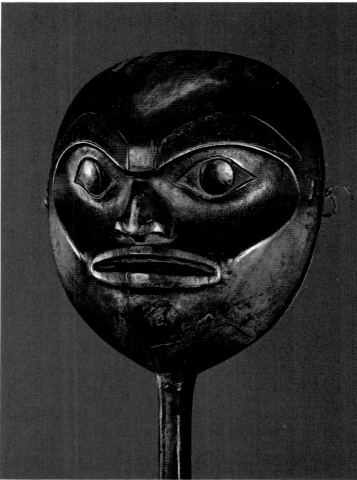

The rattle, left, is made of two pieces, containing pebbles, lashed together. It was used by a shaman of the Tsimshian of British Columbia to accompany his chants. The Lega of Zaïre were dominated by the Bwame Society, the ritual paraphernalia of which consisted of small carvings in wood and ivory—above left and right. Many of these exemplified moralistic sayings or proverbs intended to regulate behavior. These masks were not used for dances, unlike the usual practice of African cultures; they were set out in displays on fences or other structures around the ceremonial grounds. The Kwele mask at right from the Congo is among the more stylized types from Africa; it apparently represents a horned animal.

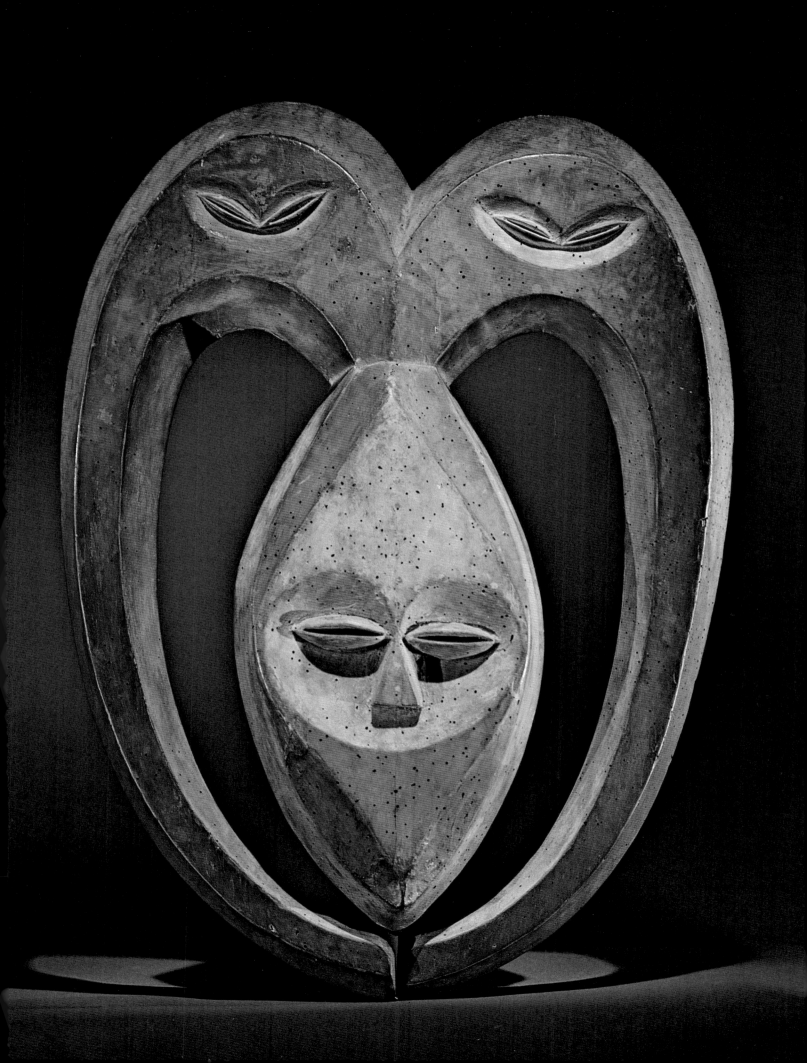

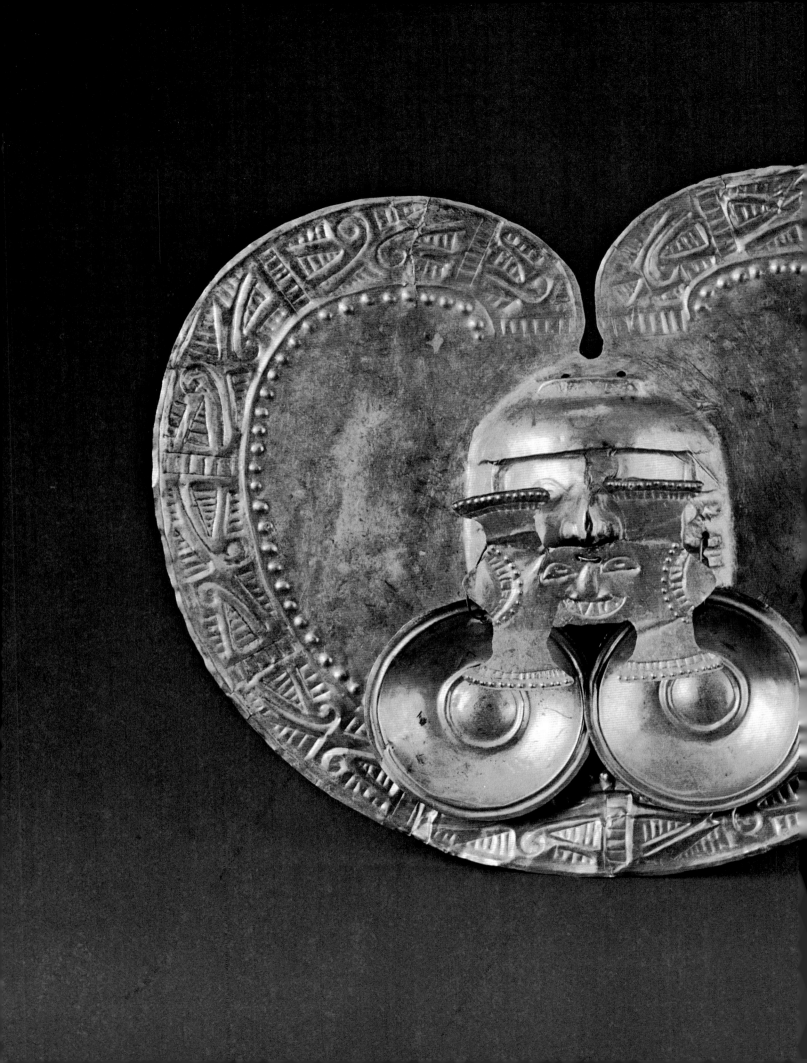

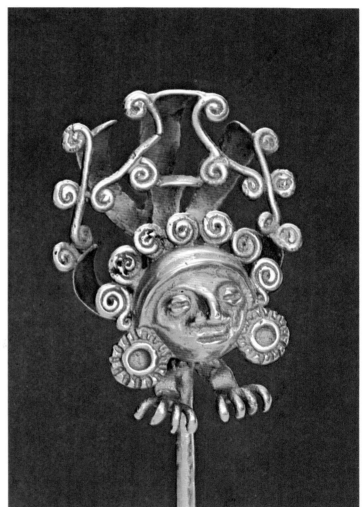

The central feature of the large gold breastplate, left, of the Calima people of Colombia (A.D. 400–700) is a face. This in turn is ornamented—and nearly obscured—by two disc-shaped ear pendants and a nose pendant that itself includes a small human visage. The large ornamental pin, above, from the Quimbaya (also of Colombia, about the same period) shows a face with disc ear spools and perhaps an elaborate headdress.

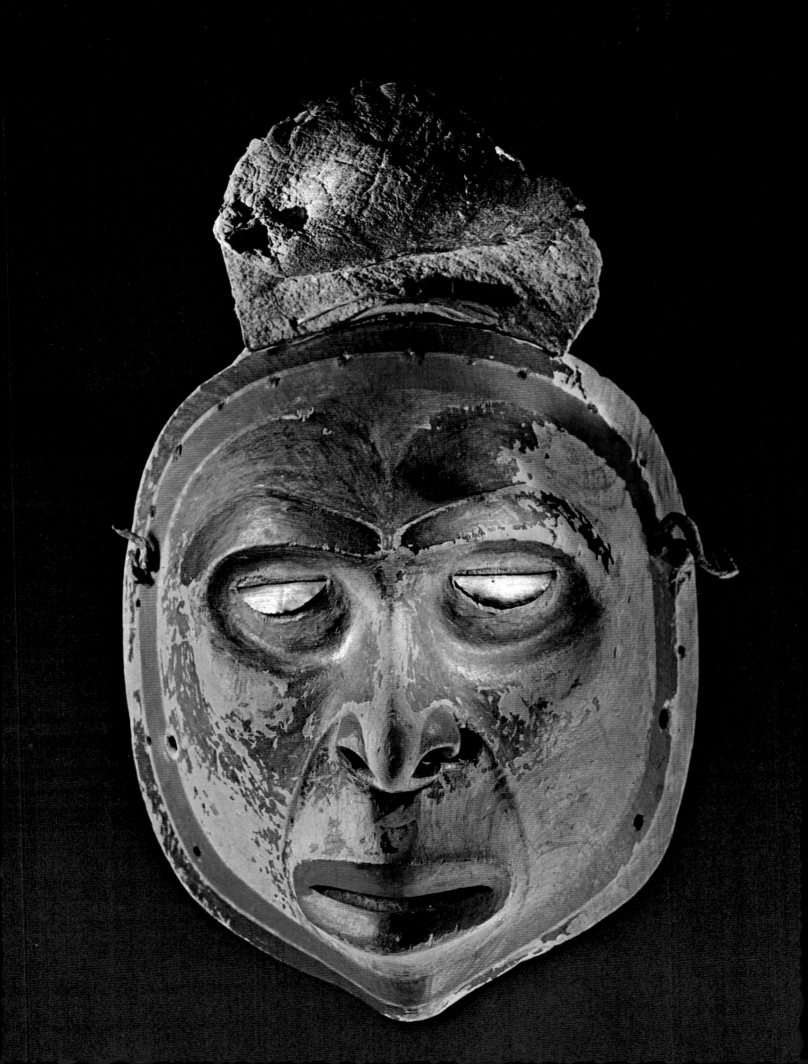

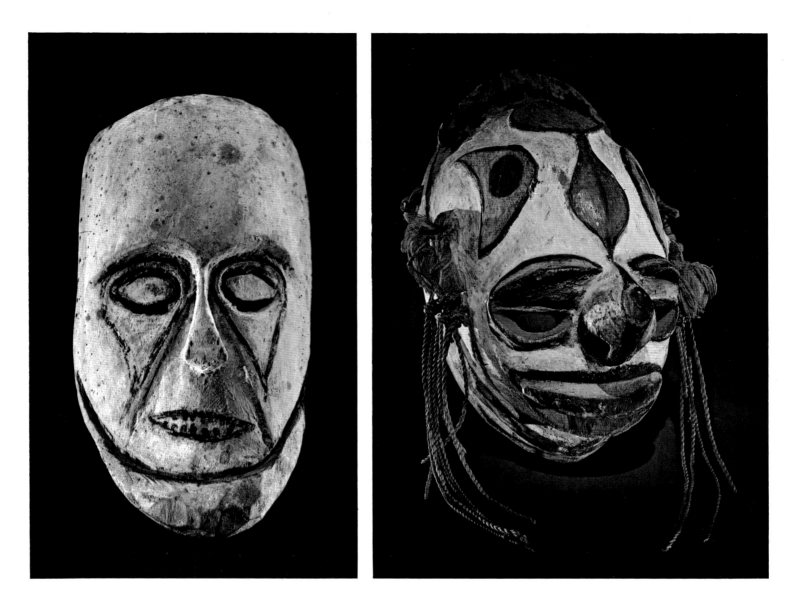

A mask of great naturalism, left, was used by a shaman of the Tlingit tribe of Alaska. It is said to have been found in his grave. The Tolai tribe of New Britain made masks, above left, of extreme simplicity that are probably related to a cult of the dead. Masks from the Biwat tribe of Papua New Guinea, above, are of unknown use but distinctive for their aggressive, bulbous forms.

The mask, below, from the Lwalwa of Zaïre represents a male spirit and was used in initiation ceremonies that ended in a head-hunt. Trophy heads were also taken in ancient Peru: witness, right, a double-spouted vessel representing one in Paracas Necropolis style (200–100 B.C.).

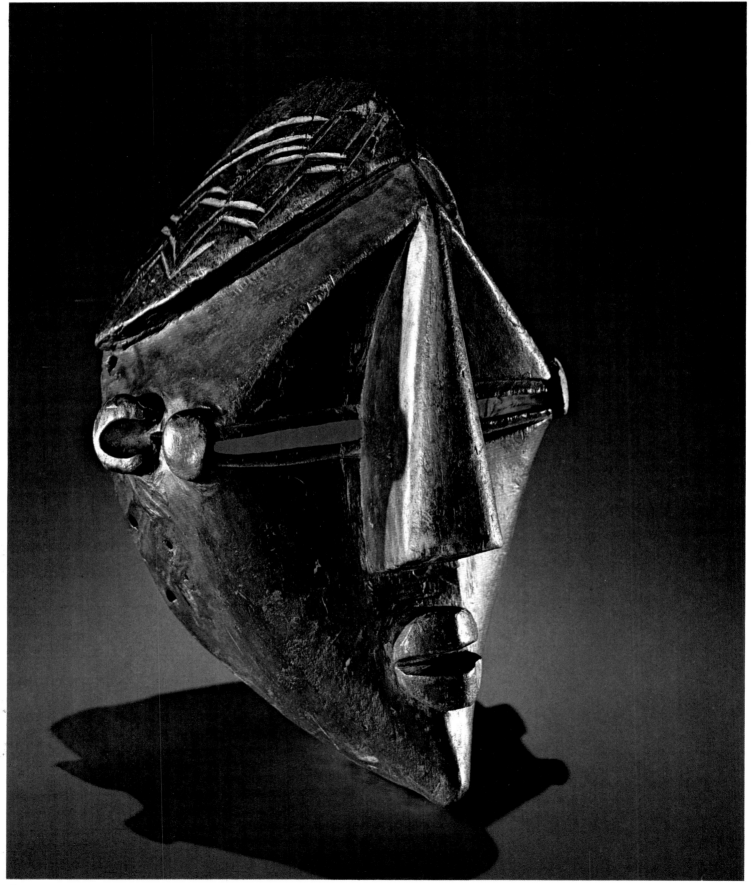

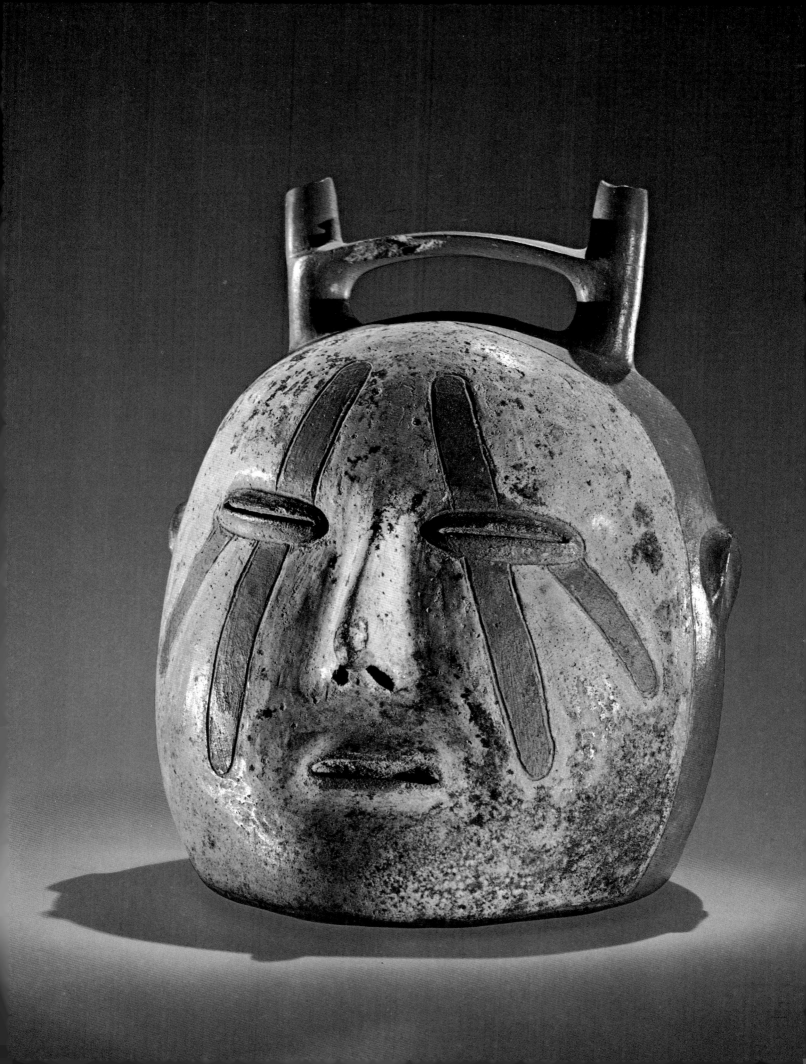

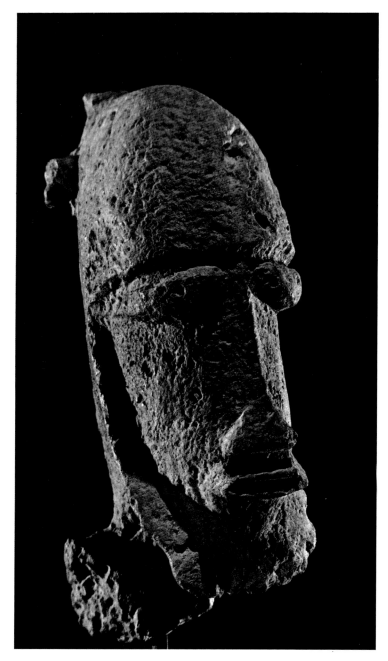

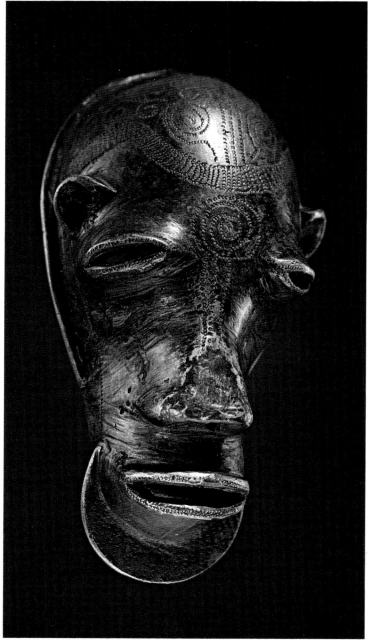

The Inyet secret society of northern New Britain used
stone carvings as sacred objects; these were of animal
and human figures, such as the human head above. The
mask cast in bronze by the Bron tribe of Ghana, center, is
reminiscent in form, and perhaps function, of similar
masks from Benin in Nigeria. A mask from the Kongo of
Zaïre, right, is naturalistic, like most of their sculpture;
but here a certain degree of stylization gives added
expressiveness.

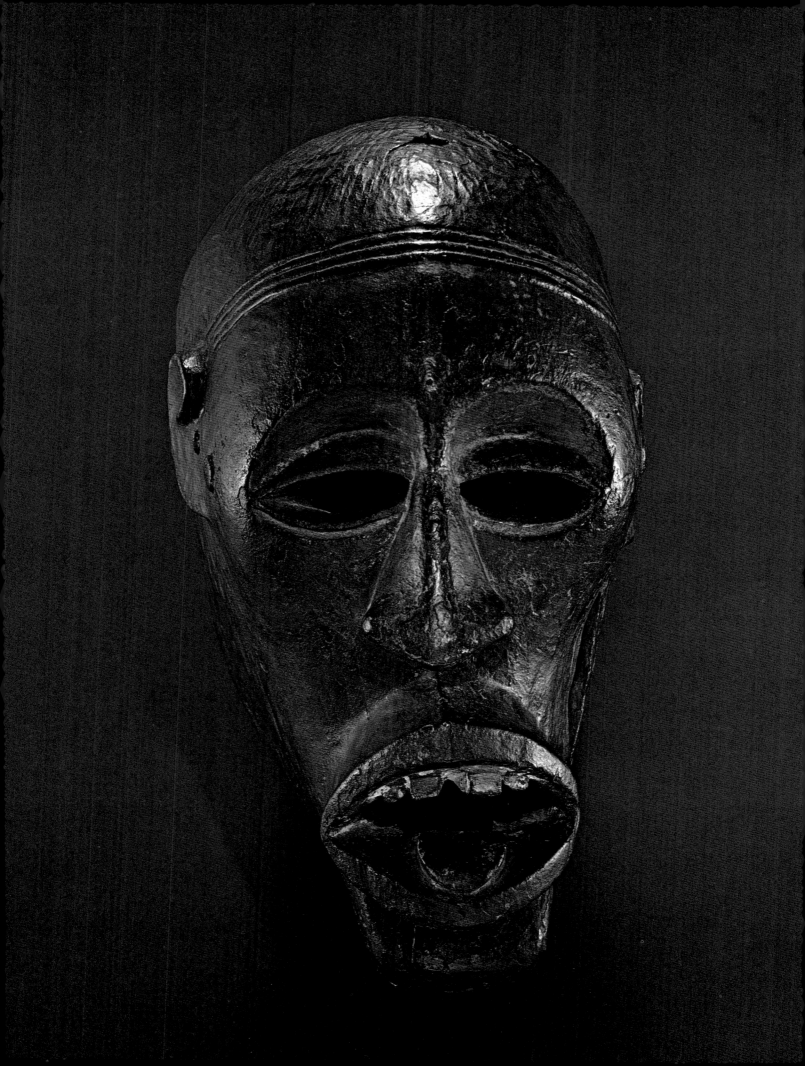

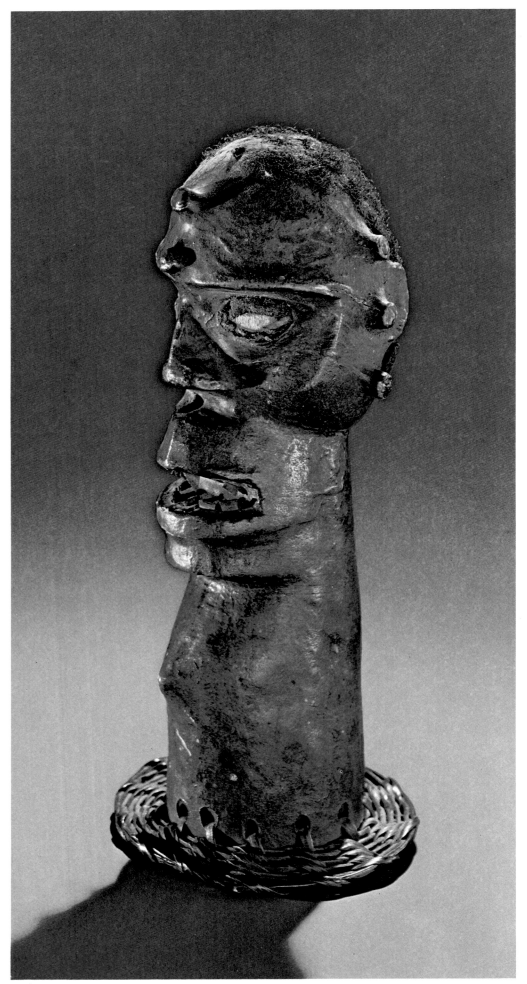

Several tribes of the Upper Cross River area in Cameroon are well known for costume crests, left, carved in wood but covered in skin; in recent times the skin is that of animals, but it is said that at one time human skin was used. The formal, elongated head, right, is a silver beaker from the central or south coast of Peru. Made as one of a suite of ten in about A.D. 1500, it demonstrates a taste for both luxury and <u>chicha</u>, a form of beer.

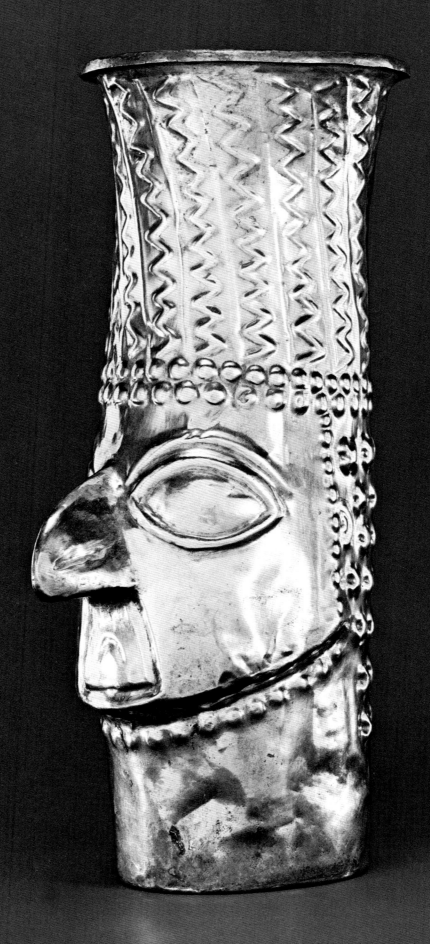

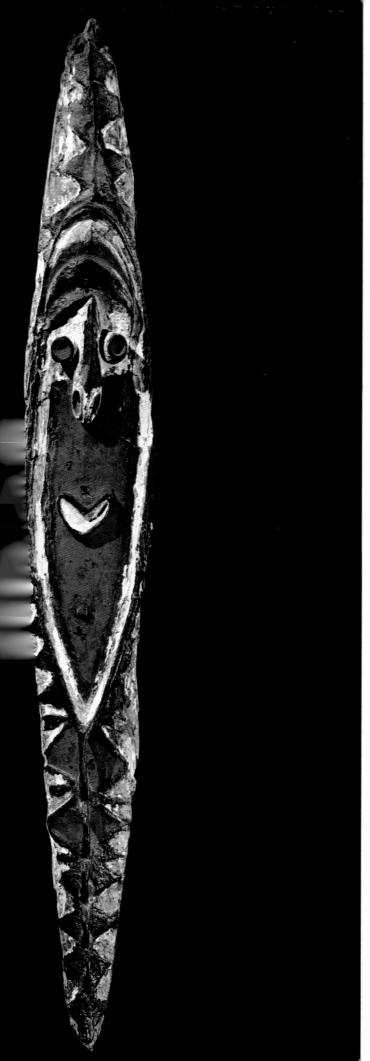

Both these carvings are from the Yau (or Warsei) people of Papua New Guinea, and are used in ceremonies for the harvesting of yams. The elongated form at left seems to embody spirits of water and the sky; the head, right, the original ancestors who rose from the earth.

Pages 80–81: Huge masks worn by dancers appear at funerary and agricultural ceremonies of the Do Society of the Bobo, Upper Volta. Some represent animals and birds —this one is perhaps a butterfly.

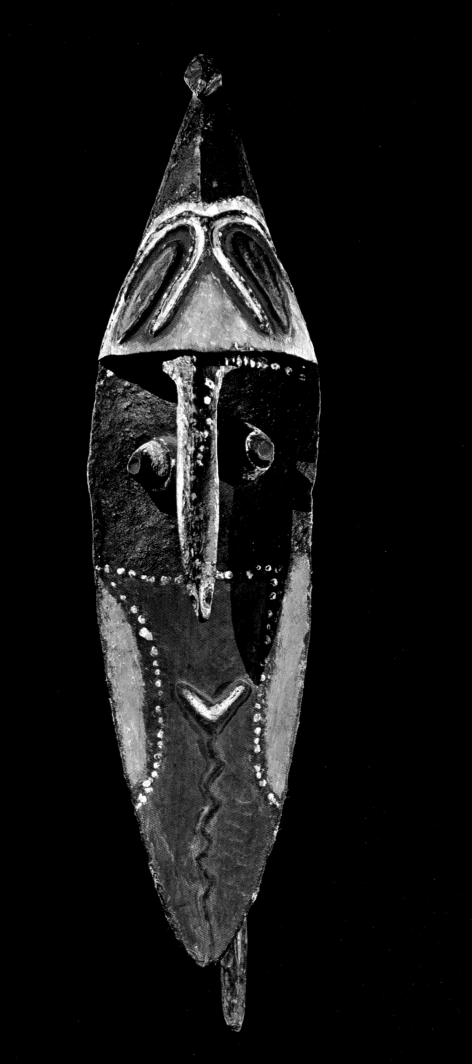

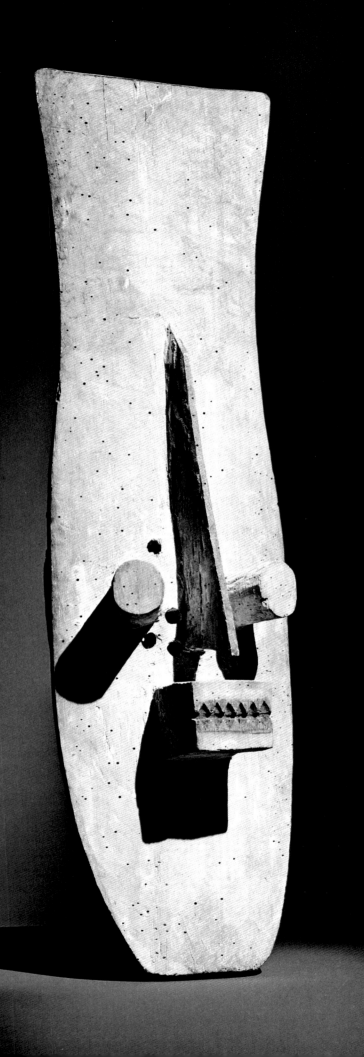

The mask, left, from the Grebo, or seafaring people of the Ivory Coast, is a remarkable instance of human features being reduced to their most elementary geometric equivalents. It is perhaps the most austere of all African masks. The two Songe masks, below and right, from Zaïre, on the other hand, though strongly stylized, are given rich, almost sparkling surfaces through the use of incised pattern. The type below is said to embody spirits when worn by witch doctors, and that on the right to be worn at ceremonies for the death and installation of kings.

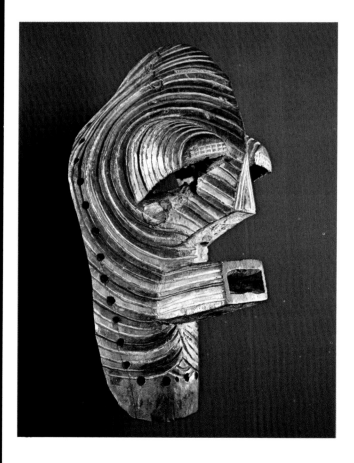

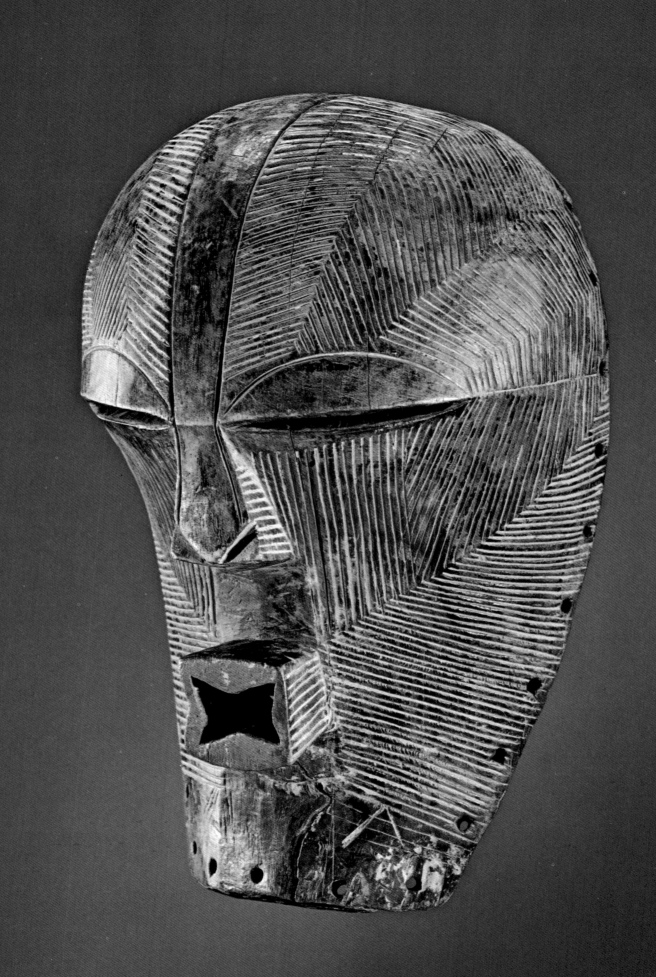

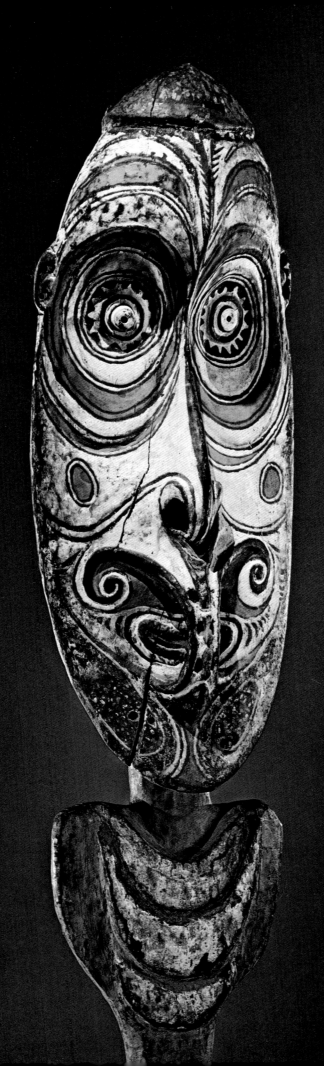

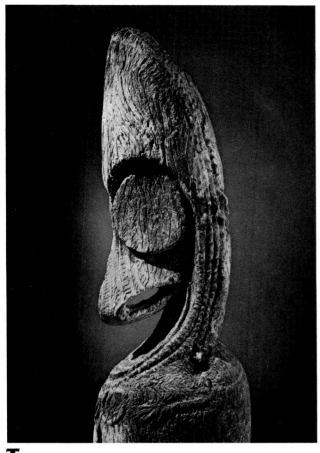

The head, left, used as part of a sacred enclosure's fence, and the shield, right, from the Iatmul people of Papua New Guinea, stress the threatening power of the eye and protruding tongue. The eye is also an important stylistic element in the head carved to top a huge, hollow log gong from the New Hebrides, above, and an ivory head, below, used in Nigeria by Yoruba diviners.

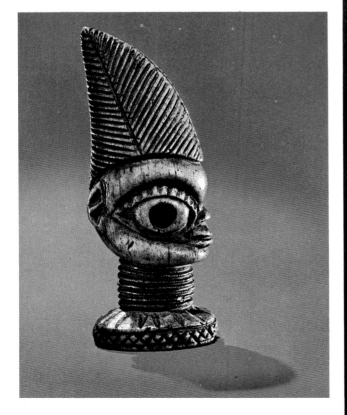

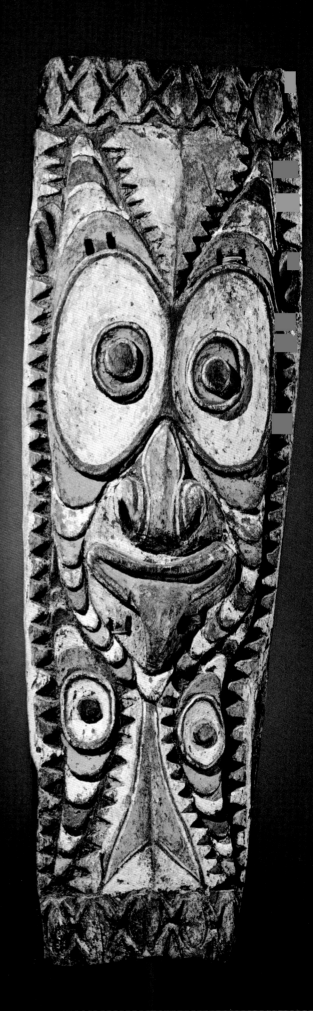

During the Middle Pre-Classic period of Mexico (800–400 B.C.), the dead of a large population at a place now called Tlatilco on the outskirts of Mexico City were buried in a great cemetery. The grave goods included quantities of ceramic objects, among them figurines. From these it is possible to tell that small ceramic masks—left—were worn ceremonially over the lower part of the face, the rest being either concealed by a headdress or left exposed. The use of the small wooden carving, right, from the Maori of New Zealand, though exemplary in style, remains a mystery. It has been suggested that the grooved sides held the cords of a bird snare.

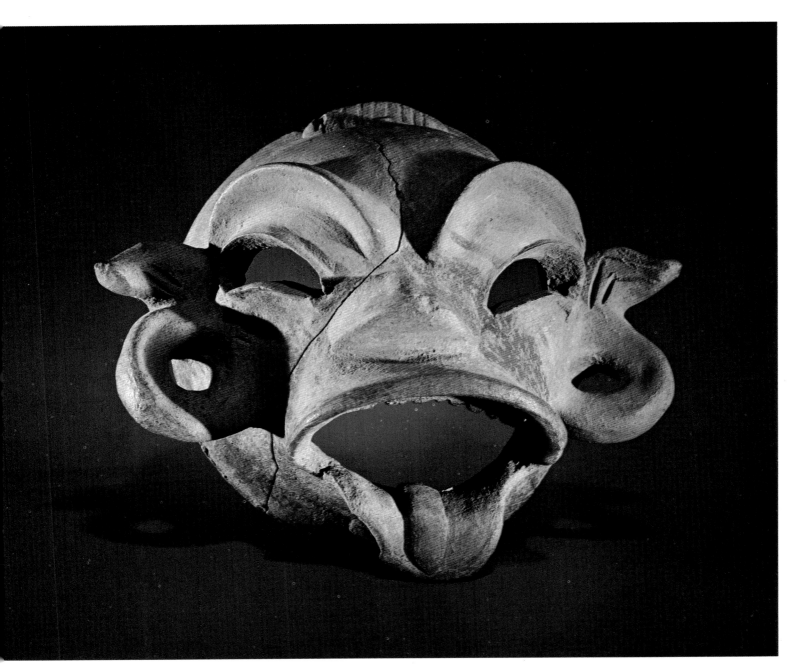

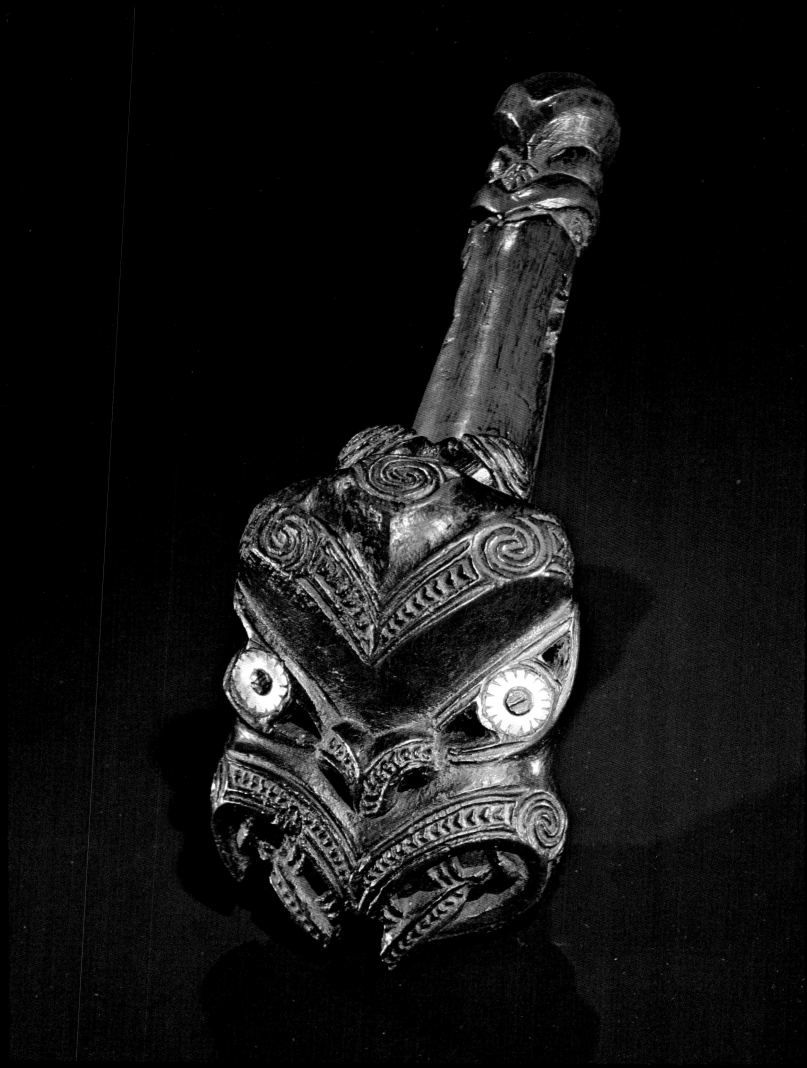

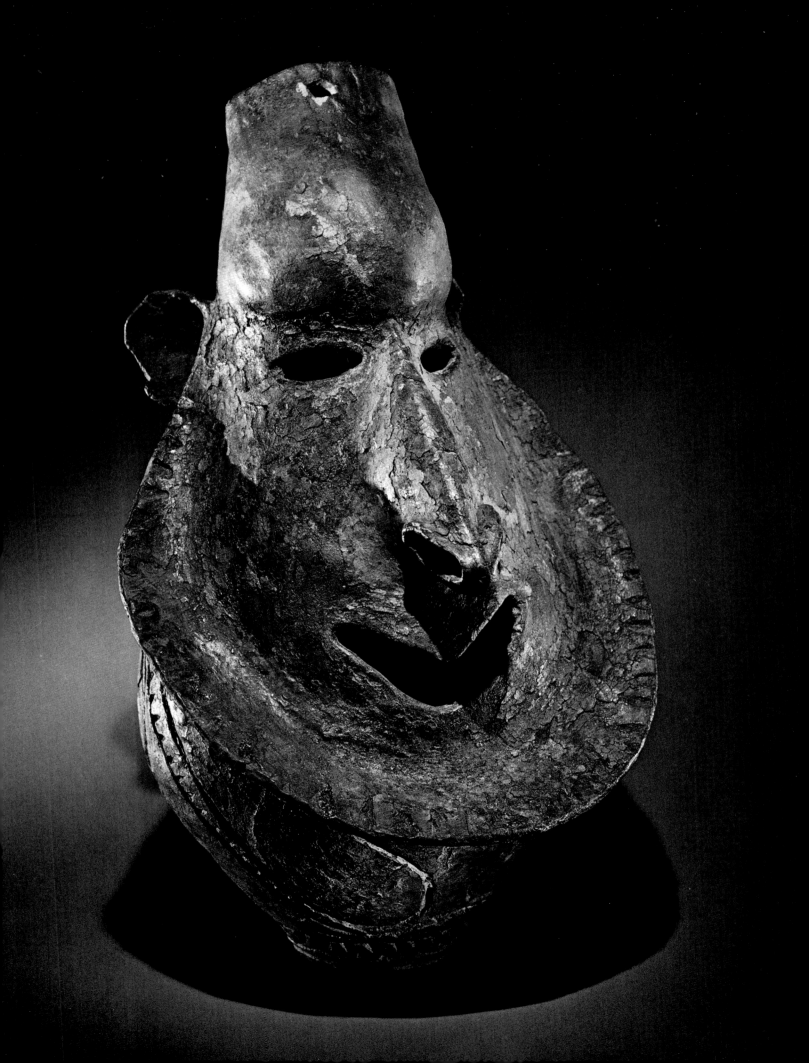

The most notable ceramic sculpture of Papua New Guinea was made by the Kwoma tribe. Among their finest achievements are large heads, such as the one at left, used in groups at yam harvest ceremonies. The large flange around the chin represents a beard; the tall brow was originally crowned with a wig of human hair. Dances for harvest and sowing festivals among the Mambila of Cameroon are carried out by men wearing large masks, below, often of animals and birds.

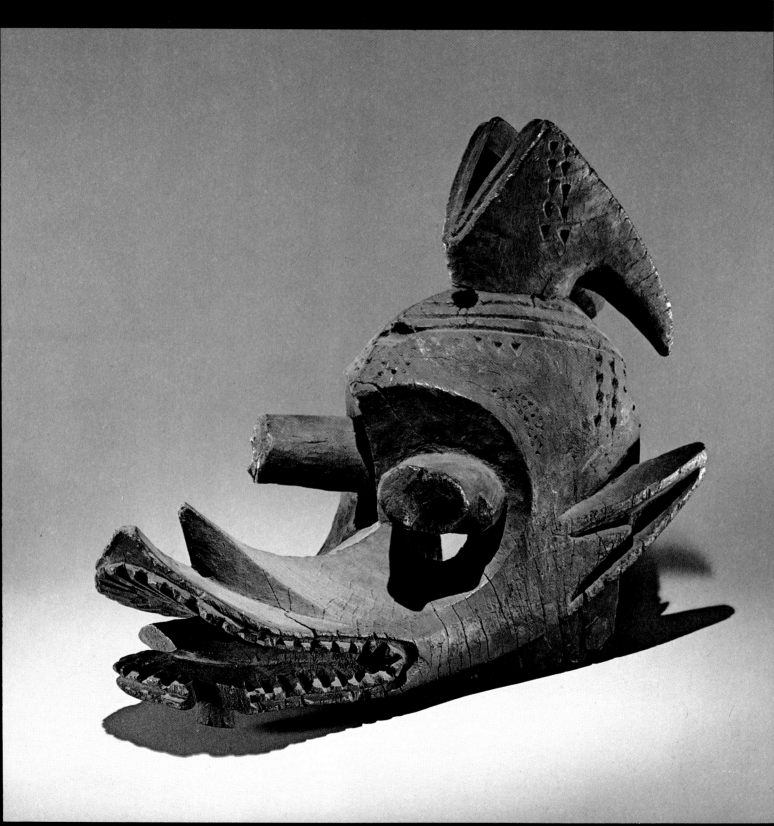

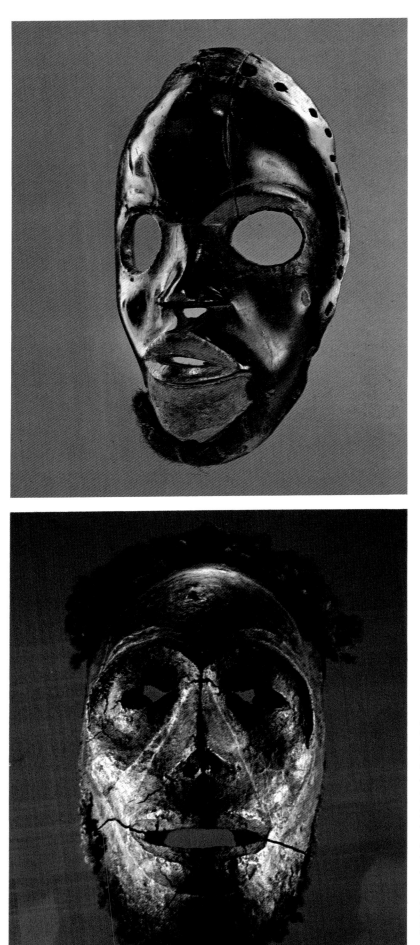

Masks among the Dan of Liberia—above left—
were used for a variety of functions, especially
regulating a wide range of local affairs. Some were
even worn by entertainers, such as virtuoso stilt-
walkers. This one is in polished wood with attached
beard. The extraordinary masks of the Tolai of
northern New Britain—below left—are built up
with a clay composition over the frontal bones of an
actual human skull. A wooden bit fastened across
the back was gripped by the wearer in his teeth. In
the Torres Strait Islands off southern Papua New
Guinea, a unique material was used for masks: thin
plates of turtle shell, right, pieced and tied together.
No specific use is known for naturalistic masks from
Erub Island, the source of this one; on other islands
they were worn at funerary ceremonies by men
who mimed the course of the sun as a symbol of the
passage of human life.

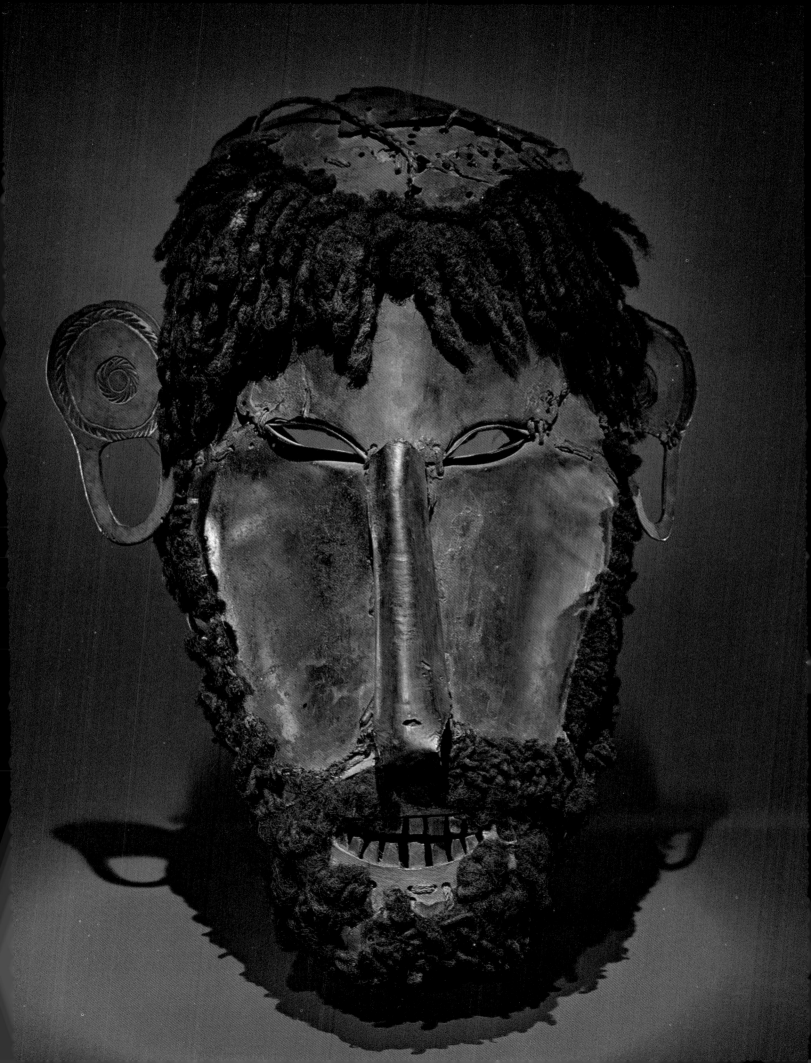

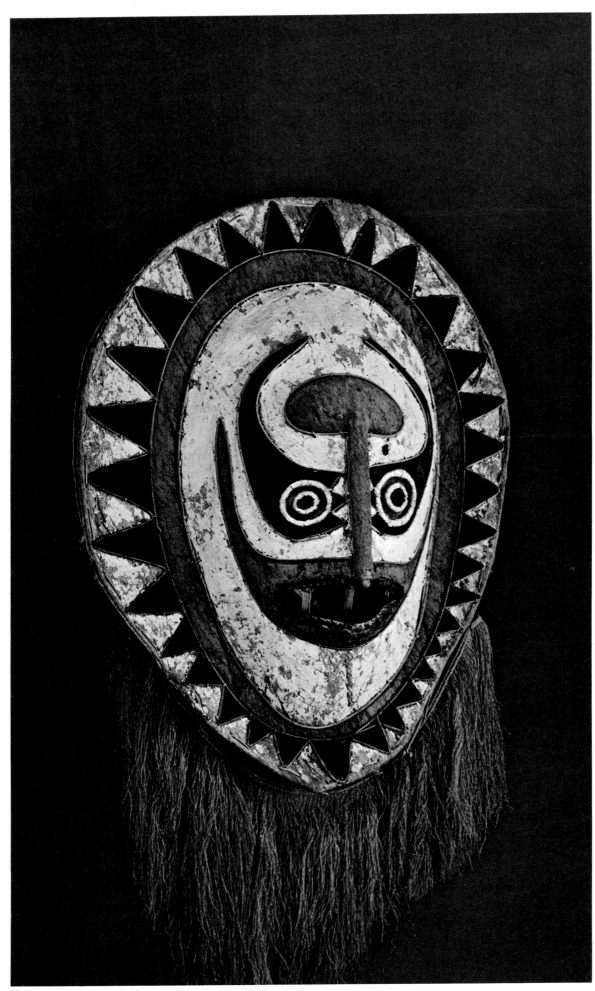

Rounded or conical masks played a subsidiary role among the Elema of the Gulf of Papua, New Guinea. Enormous flat, oval masks represented sea-spirits. The smaller ones, as at left, were probably bush-spirits, though in recent times they appeared to some extent as light relief in the great cycles of ceremonies, which lasted as long as twenty years. The masks were made of painted bark cloth stretched over cane frames. Masks in wood, right, from the Duke of York Islands, near New Britain, are extremely simple; they were probably associated with an ancestral cult.

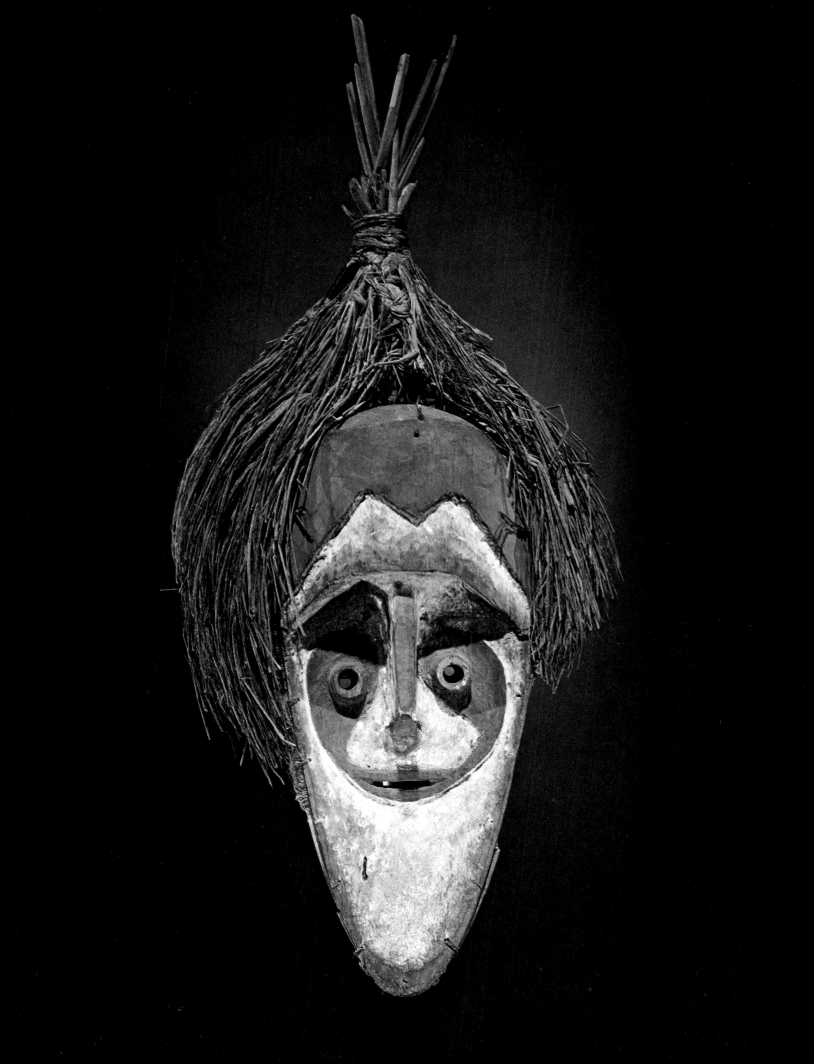

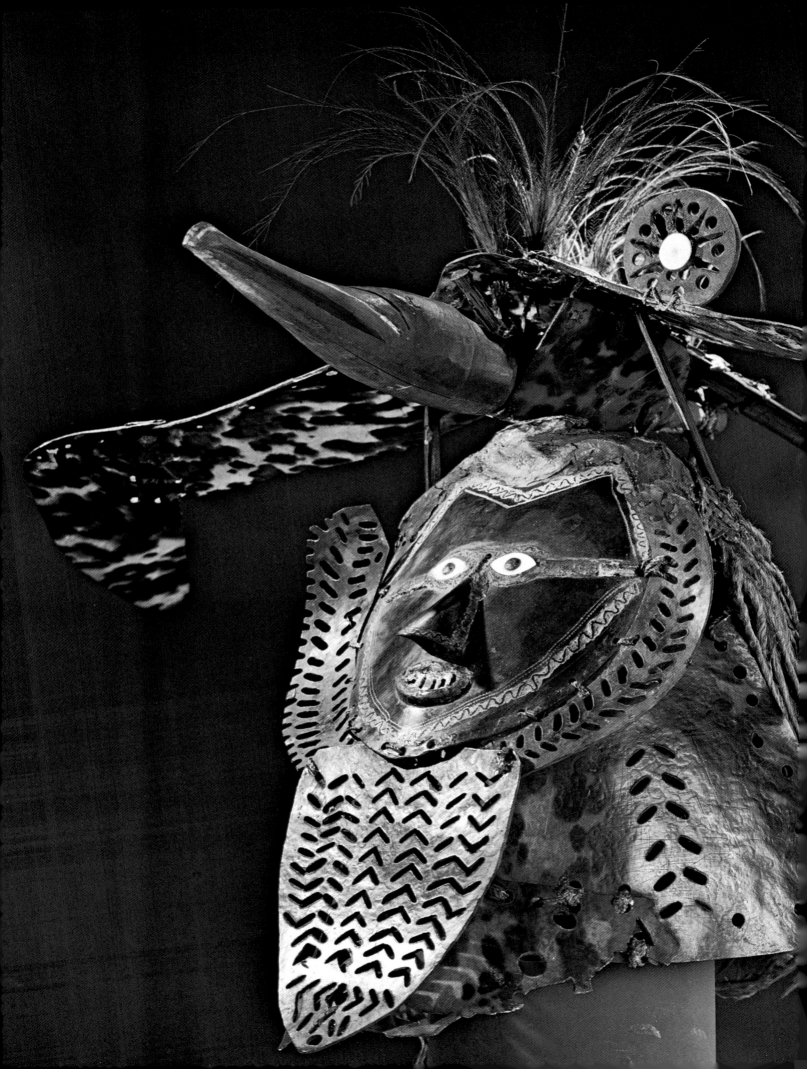

The mask in turtle shell, left, of a human head on which a frigate bird perches, is from Mabuiag, an island in the Torres Strait south of Papua New Guinea. Although a few others like it exist, their use and intention are unknown. Great masks, below, of wood sheathed with copper and shell and bead decoration, were made in the Cameroon Grasslands by the Bamum, among others. Worn as crests on top of the head, along with costumes concealing the wearer's body and limbs, they appeared at the funerary ceremonies of notables. In this case, the outlined design on the fan-shaped headdress may represent the frog, a symbol of fertility.

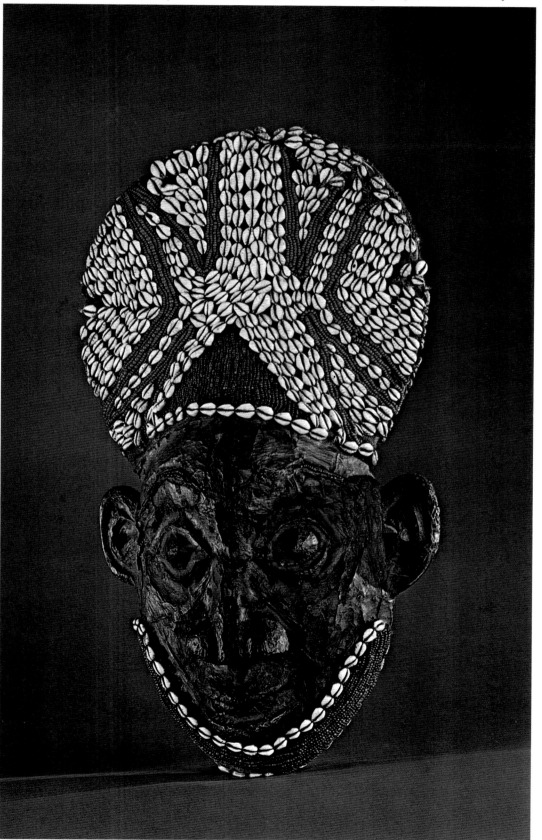

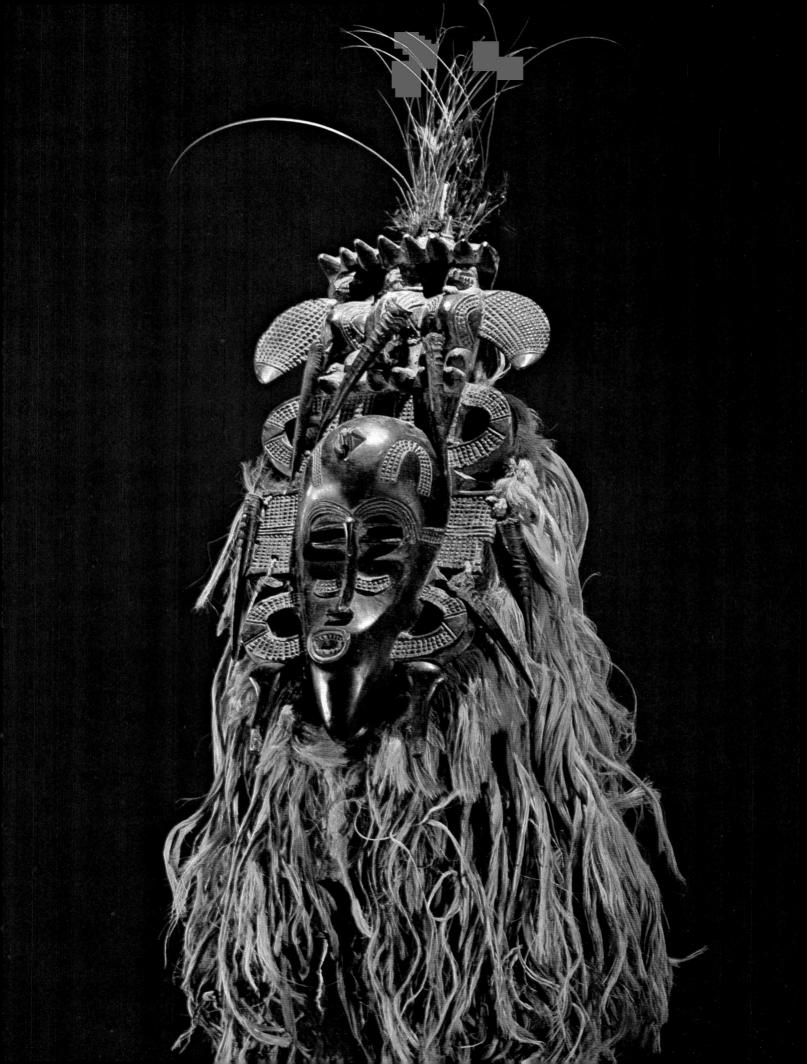

Members of the Lo Society, among the Senufo of the Ivory Coast, wore masks, as at left, with basically human features, but also incorporating symbolic forms and materials of cosmic significance. Initiates among the Yaka of Zaïre, following circumcision ceremonies, emerged from seclusion to dance in public for their families and nearby villages. They wore masks with wide shoulder ruffs of fiber. Their carved masks, right, show human features, usually with the upturned nose typical of Yaka conventions. Many have fiber-stuffed cloth models of animals as crests: this one has limbs, which may indicate it is an insect.

Overleaf: Luxury and elegance are shown by this ivory bracelet inlaid with copper from seventeenth- to eighteenth-century Benin, with its skillful incorporation of Portuguese faces into the design.

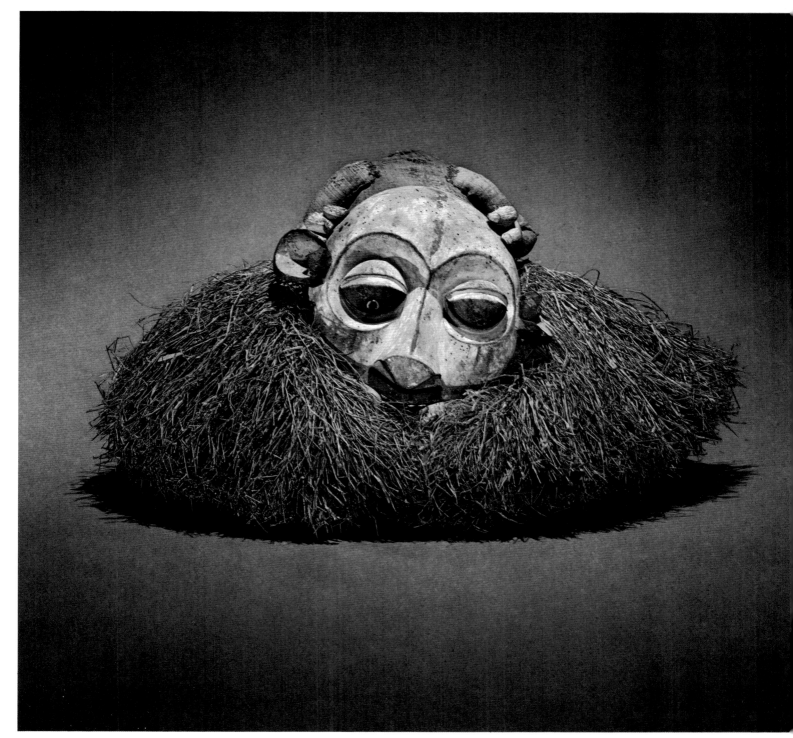

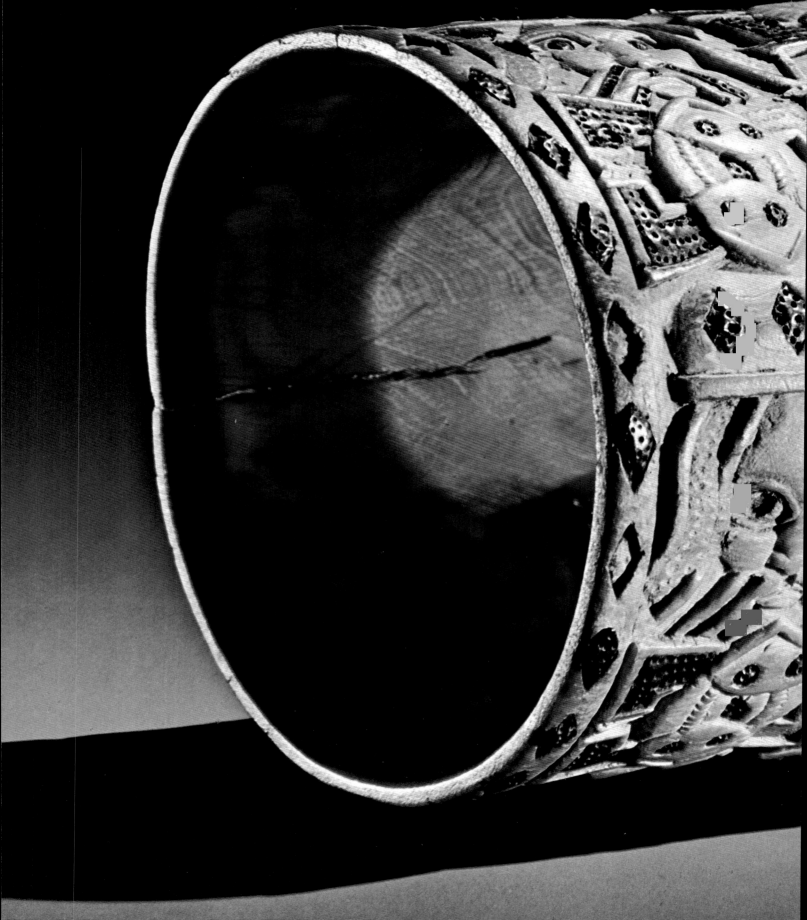

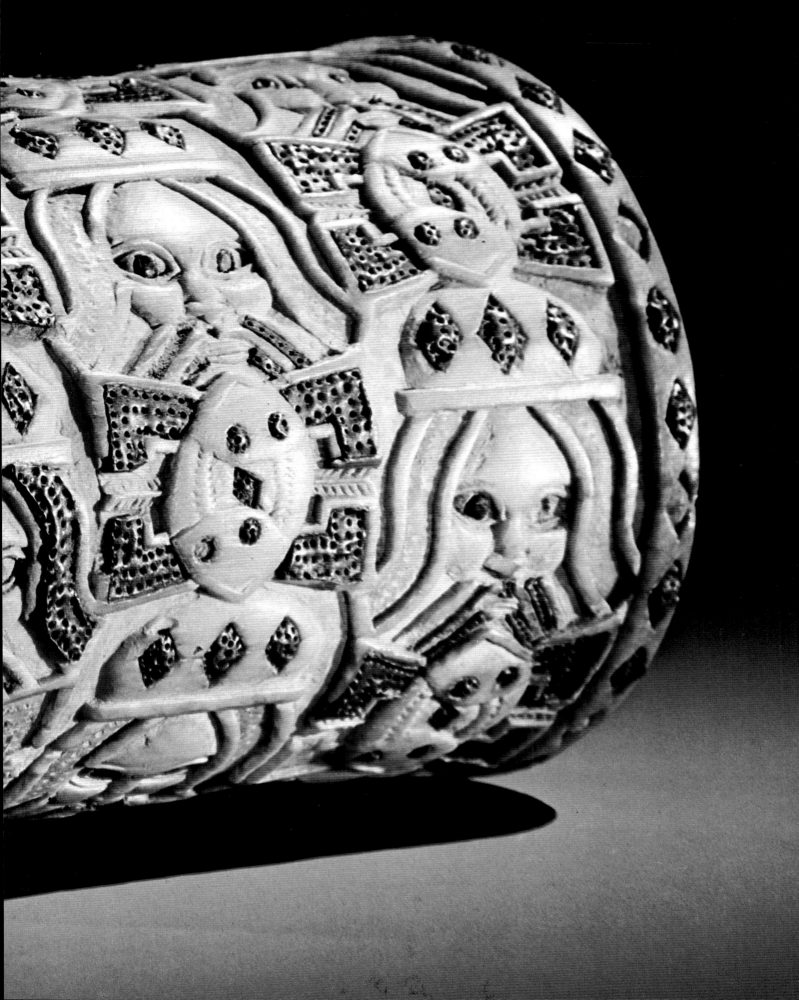

Double-face masks express the dualities of nature and society: for instance, in the rare type of Baule mask, below, from the Ivory Coast. Among the Ekoi of Nigeria, the masks or headpieces, right, of the Ekkpe Society are notable for their naturalism, which is enhanced by the use of animal-skin covering. The faces are again male—the darker of the two—and female.

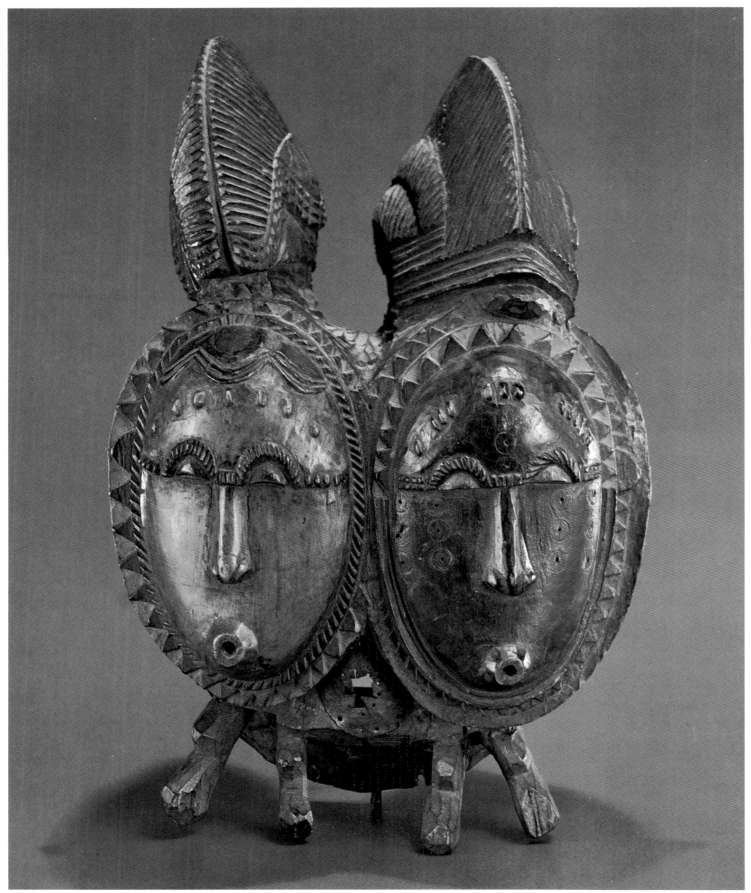

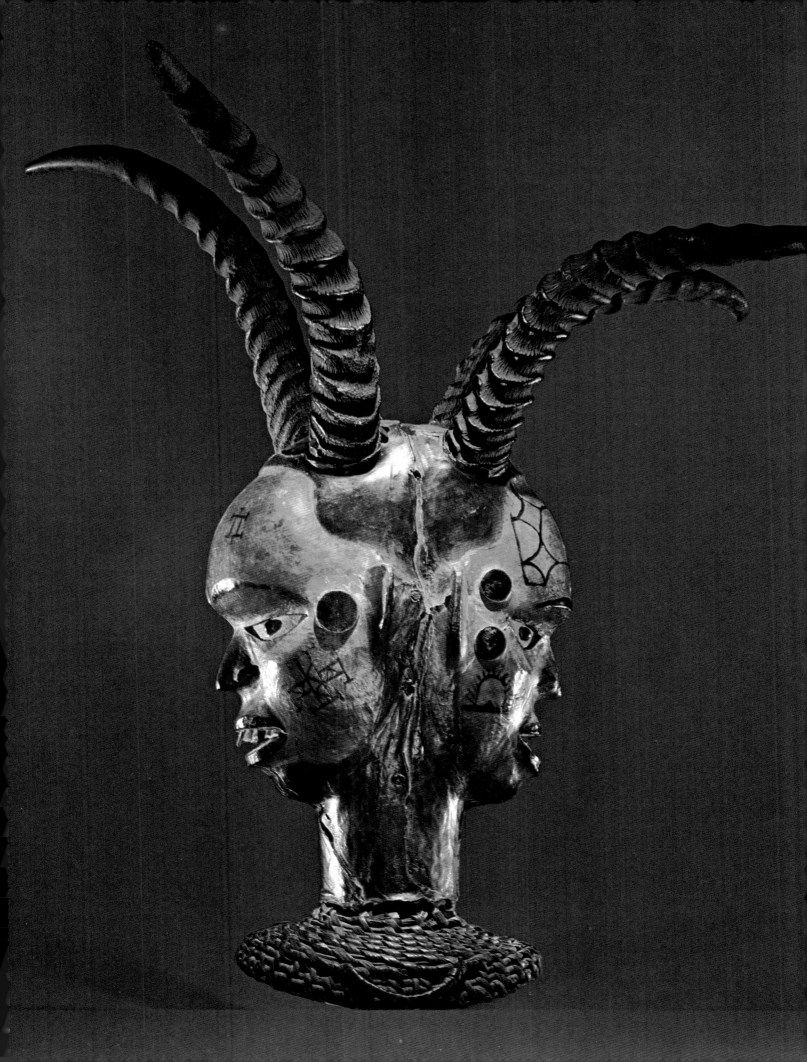

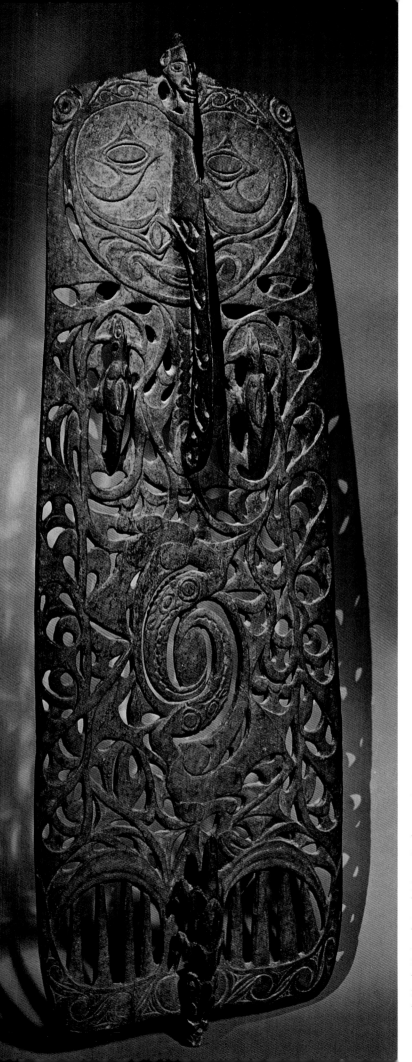

Large openwork boards, left, were carved by the Sawos people living in the Sepik River area of Papua New Guinea. Each has a broad face at the top, and a row of hooks at the bottom. Birds perch on either side of a hugely elongated nose, and a pig stands in the middle of the hooks. Anchored by a pair of hornbills eating a fruit, the largest part of the panel is formed by swirling designs that resemble stylized skulls. The meaning and use of these extraordinary images are both uncertain; according to one explanation, they were carved as memorials to boys who died under the rigors of initiation. The Ibibio mask, right, from Nigeria is used in masquerades of the Ekkpe Society·that concern the activities of ancestors revisiting this world.

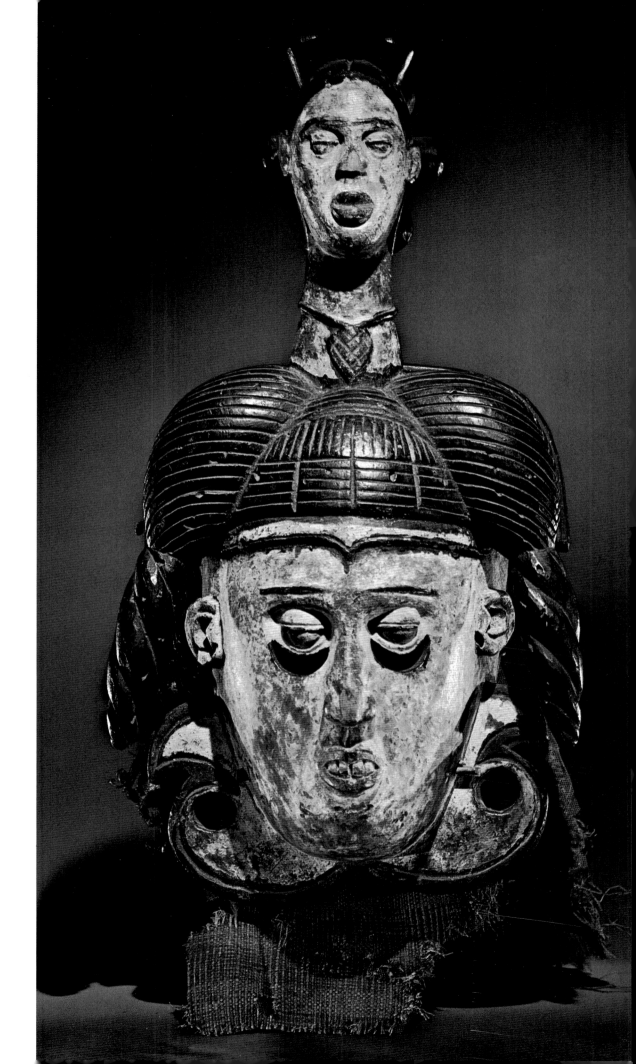

Figures

Figures

In primitive art, the human figure almost invariably represents an ideal of some kind, usually spiritual, and only rarely physical. Secular genre scenes are almost nonexistent; groups of figures, which are certainly common enough in the Precolumbian art of Mexico or Peru, are cult or ritual scenes (page 189). The dualism of the beings of the spiritual world, conceived as fraternal or sexual partners, is a theme that occurs frequently in primitive art. It expresses not only the oppositions and conjunctions of the actual world but also the conflicts and joinings of the remote ancestors which made this world possible (page 177). The multiplicity of spiritual attributes, which is a feature of African religious thought, can also be expressed in literal and visible form (page 176).

In many mythologies the first beast and the first man are only aspects of a single being who takes on the form of either, at will, like a garment. Hence some of those images in which an animal or bird apparently clutches a human figure (page 188, left) but is really meant to be melded into it.

Some works, though they are relatively few, depict the triumph of man over the animal world: mounted horsemen (page 187), a nobleman leading a tamed llama (page 188, right). These are statements of the triumphs of domestication. The animal's power is still important, but now only inasmuch as its subordination demonstrates the mastery assumed by the human being.

It is in the monuments of kingdoms, however, that we find secular groupings expressive of power and control which put us in mind of the great bas-relief scenes of conquering Egyptian pharaohs or the baroque frescos that glorify European monarchs. The same impulse lies behind the reliefs of Benin kings and their attendants (page 183) or

Small ivory figures were carved in the Ha'apai group of the Tonga Islands for export to Fiji, where one, above, was collected on Viti Levu in 1868.

Maya rulers receiving homage from their thrones (page 181).

In spite of these marvelous exceptions the single figure is the general rule in primitive art, in an expression of the concentrated power of the individual. It stands to reason that to undertake the difficult task of carving in wood or stone, or molding in ceramic, the artist needed a worthy subject and it follows that the worthiest that took human shape were the ancestors and the gods. Without the creative powers of the gods there could be no ancestors; and without the ancestors there would be no present day. The present day itself was best shown, if at all, in figures that embodied states of well-being, as among the Baule of the Ivory Coast (page 175).

There is a whole language of gesture in these human figures, and it is often ambiguous, or at least equivocal. Many figures kneel but this is not always a gesture of submission. The ecstatic Maya priest certainly has lowered himself to the ground to adore his god (page 152). On the other hand, contact with the ground is sometimes made by a seated god himself (page 159). To be raised above the ground on a stool is usually a mark of authority, and the stool itself is revered, as in parts of New Guinea and Africa (page 156).

The standing figure is perhaps the simplest manifestation of being. Of itself it makes no claims in its evident immobility and near passivity; the viewer must read into it what he sees and knows. When the hands begin to rise he knows he may be in the presence of supplication or threat, both modes of averting evil (page 169). When the hands reach upward at full strength (page 141) he knows with certainty that man is striving for completion, the junction of earth and heaven.

Over-life-size figures in wood, right, representing important ancestors, were carved by the Sawos of Papua New Guinea.

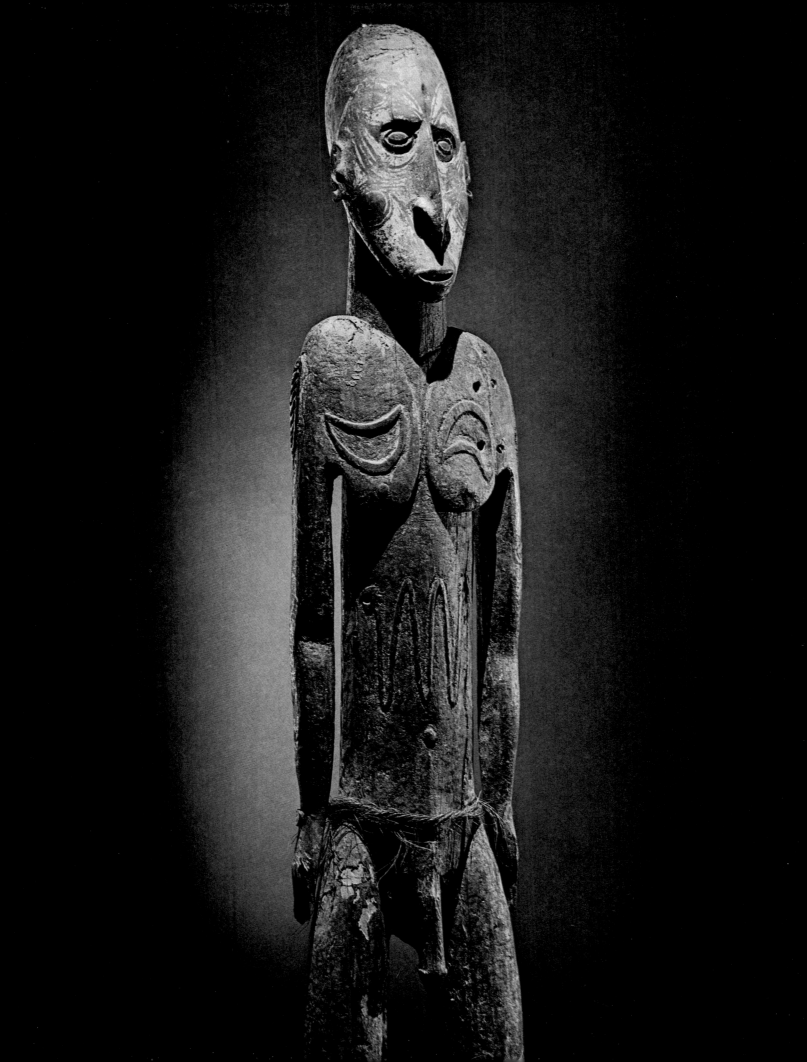

Three figures of women, in two materials and from two continents. The stark, almost featureless figure, center, carved by the Eskimo of Alaska at an unknown date, is a small handle, perhaps for a container of some sort. It is in walrus ivory, whereas elephant ivory is the medium for the figure, left, from the early nineteenth-century court of Benin in Nigeria. Wooden female figures by the Dan of Liberia, such as the one at right, may represent ancestors or simply attractive girls. The band of white paint across the eyes is worn by women on ceremonial occasions.

Pages 110–11: Ancient Peruvian nobles took considerable pride in enlarging their slit earlobes to accommodate huge earplugs. A pair, above left, in silver and gold comes from the area of Chan Chan, the capital of the Chimu Empire (A.D. 1000–1450). A single Mochica example, right, shows a being carrying spear and spearthrower (A.D. 300–600). The standing figure, below left, is a pendant from the Tairona of Colombia (A.D. 1200–1500).

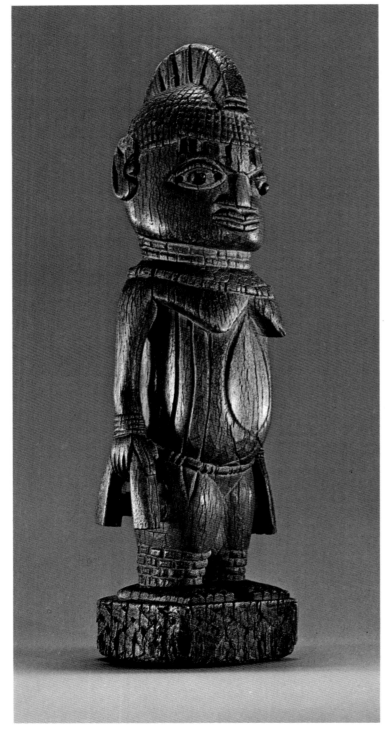

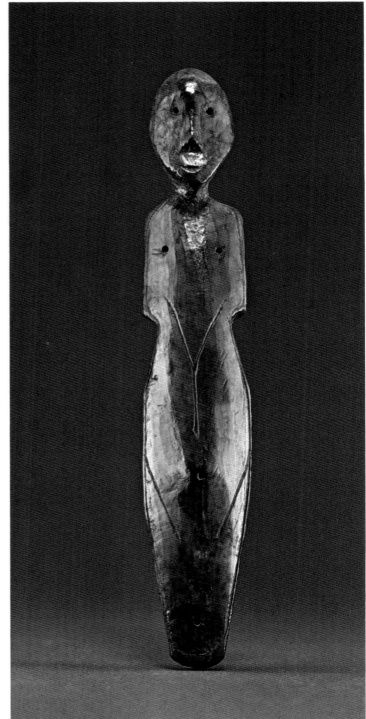

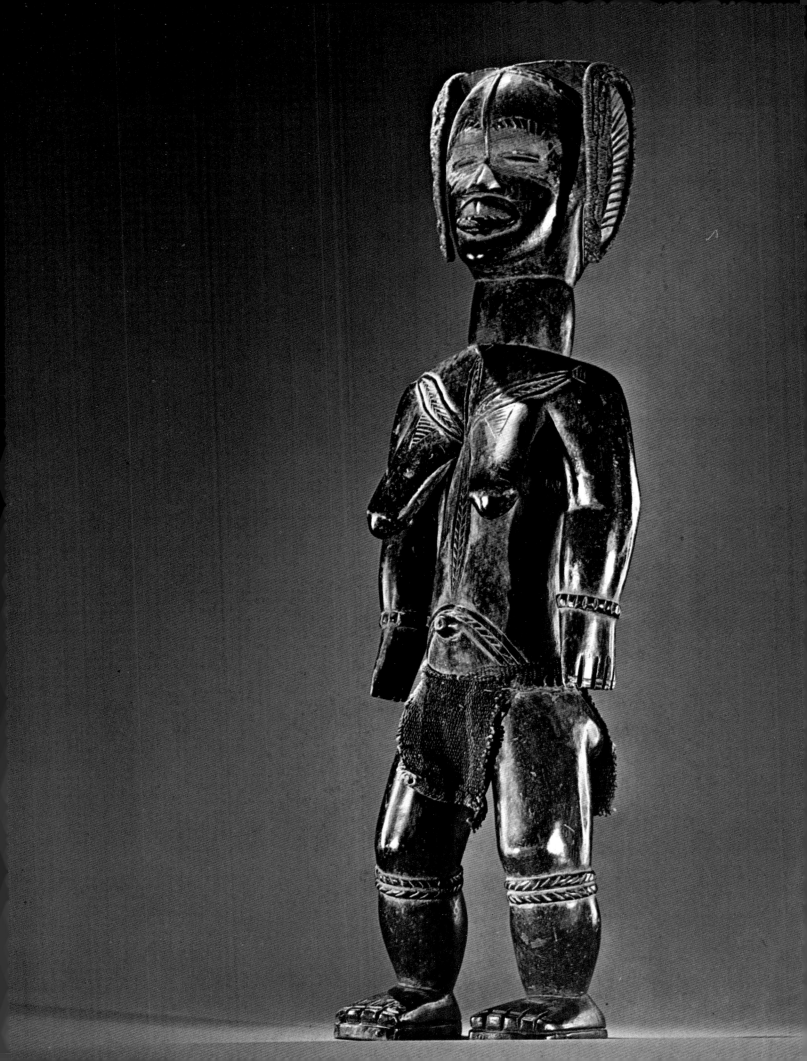

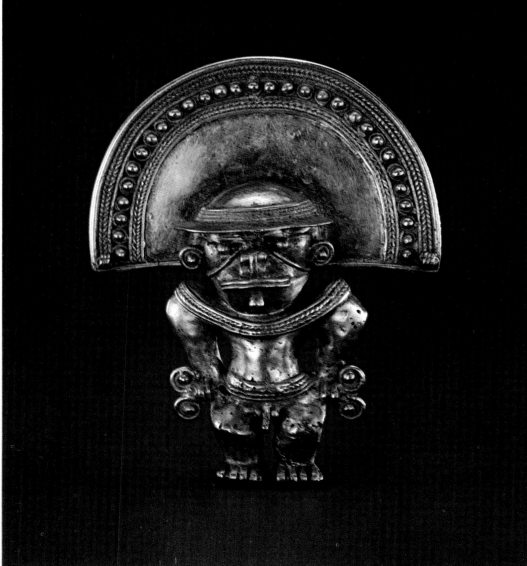

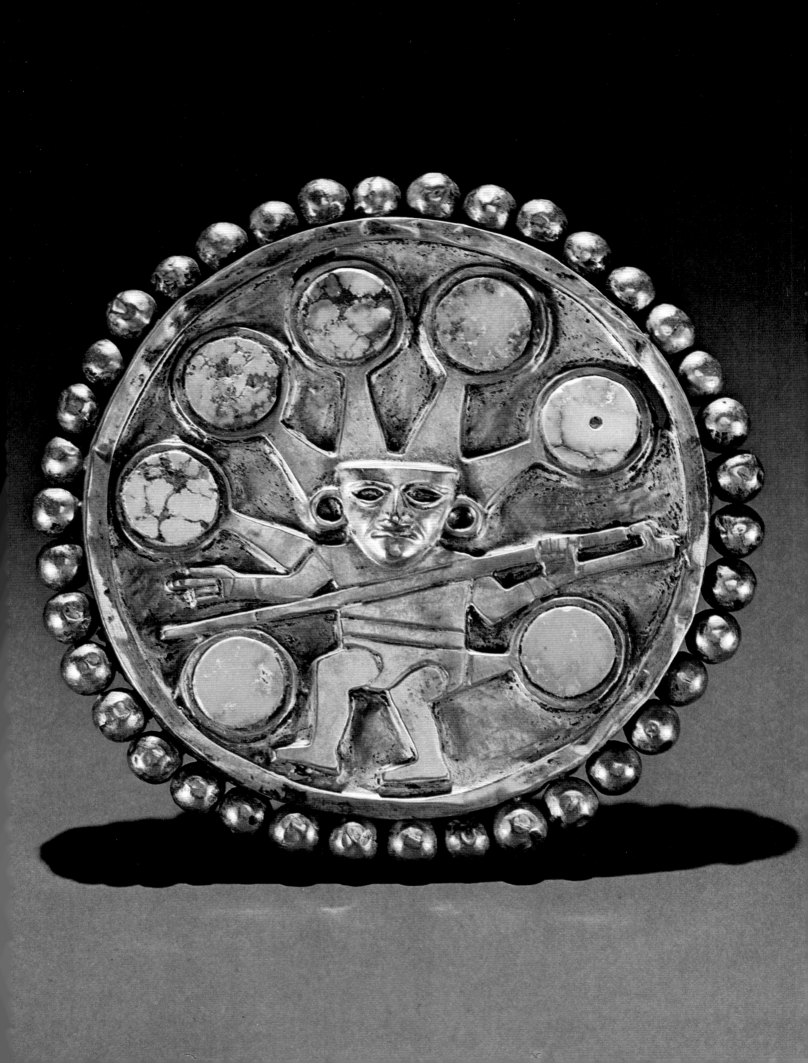

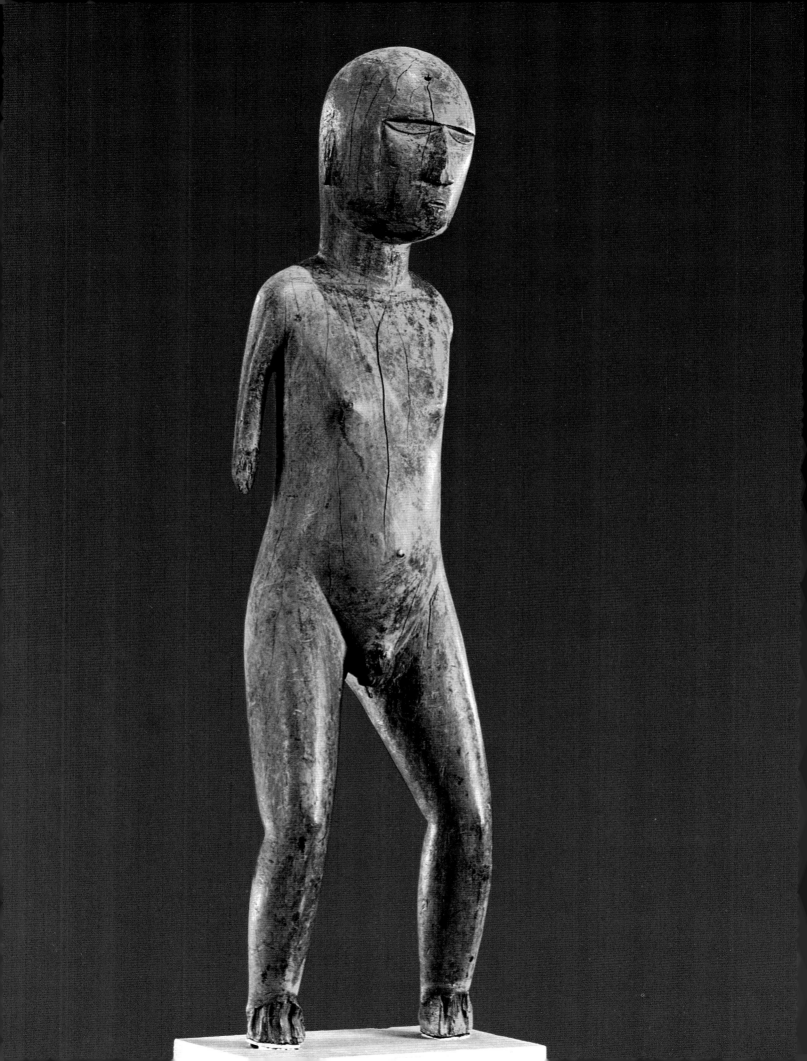

The figure, left, of a god, perhaps Rongo, is one of a handful known from Mangareva, in the Gambier Islands of Polynesia. The male figure, below left, of a hunting god is from the Karawari River area of Papua New Guinea. At right, two figures from Zaïre; above, a minatory figure of a man hanged for broaching initiatory secrets among the Mbole tribe; below, an ancestor figure of the Buye.

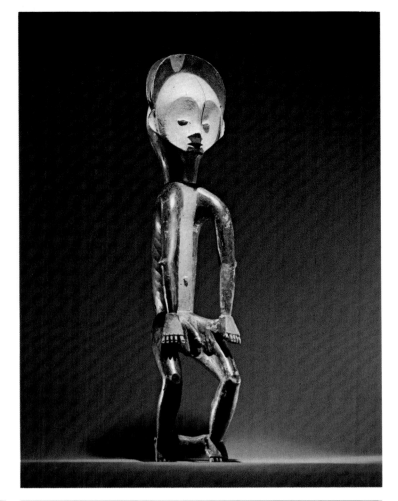

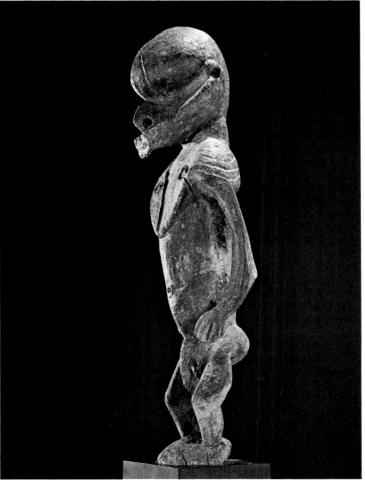

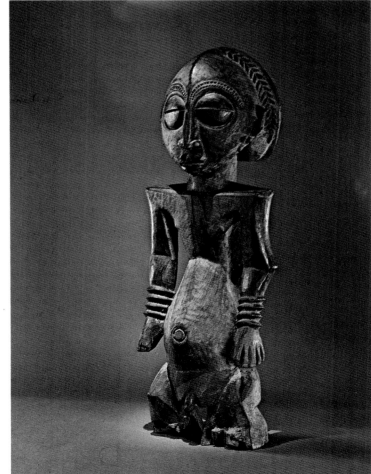

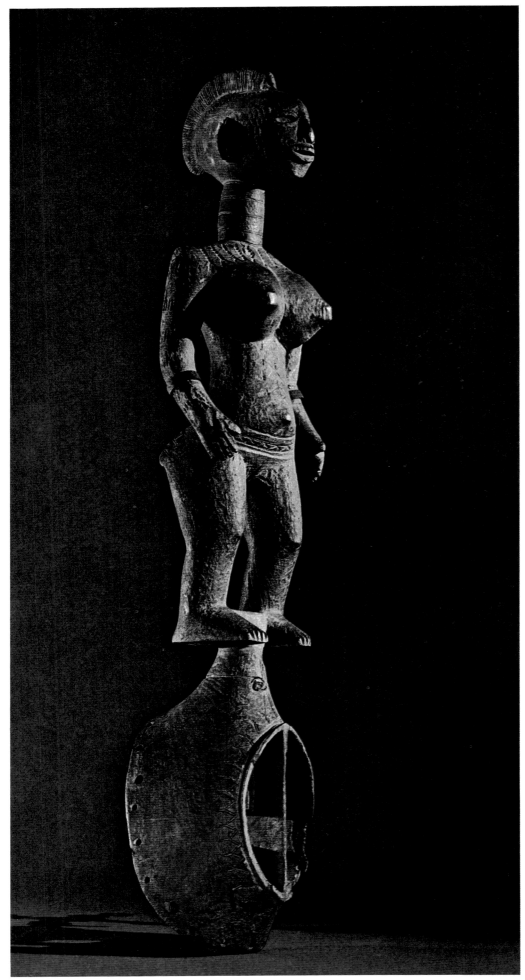

The mask surmounted by a female figure, left, is from the Mossi of Upper Volta. The deblé masks of the Senufo, right, always appear in pairs, male and—as in this case—female. Both are armless, but the male (not shown) carries a quiver for arrows on his back. Such masks are used particularly at funerary ceremonies.

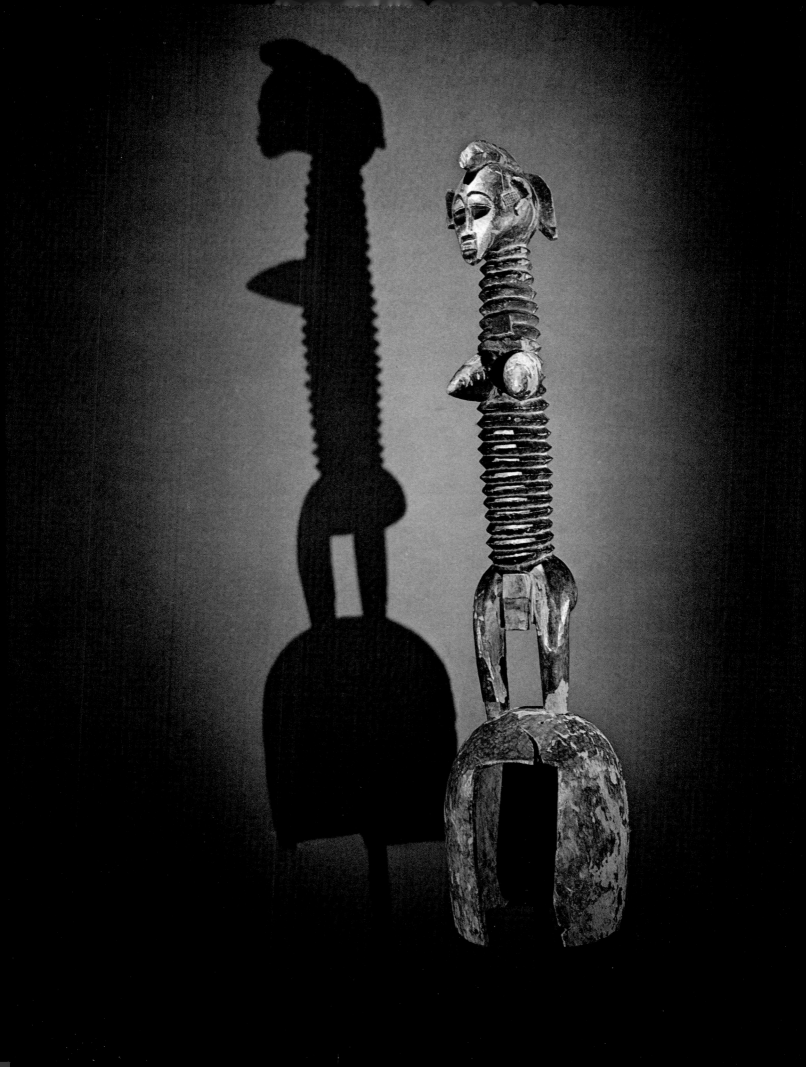

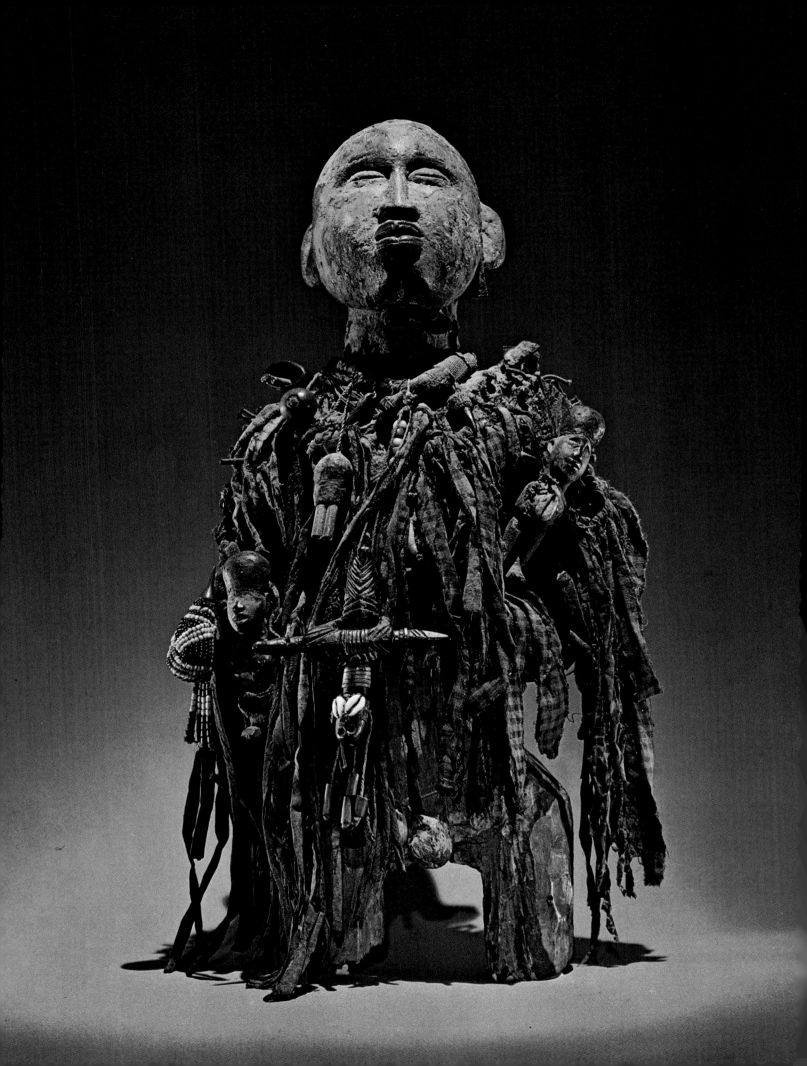

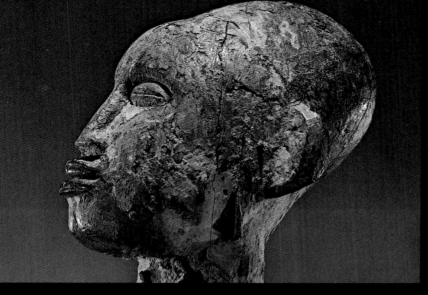

The serene face of a fetish figure from the Sundi of Zaïre, far left and left, belies its intention as a purveyor of malevolent magic embodied in the mass of minor fetishes that almost conceal the body. The head is smeared with red camwood paint, symbol of life and vitality. The same material built up into a solid mass over other fetish materials constitutes an essential part of a Teke figure from the Congo, below left, of which only head and legs are otherwise visible. Although reminiscent of this in form, the ceramic object, below right, of the Middle Paracas period (500–300 B.C.) of Peru is actually a drum, the swelling area being the sounding chamber.

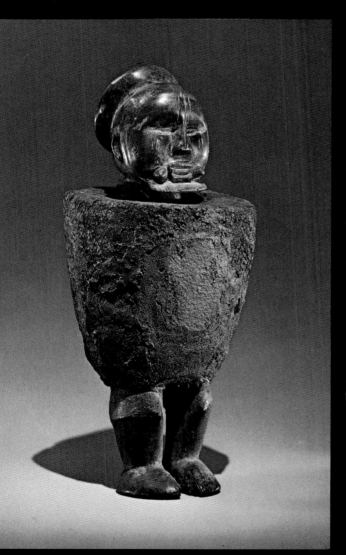

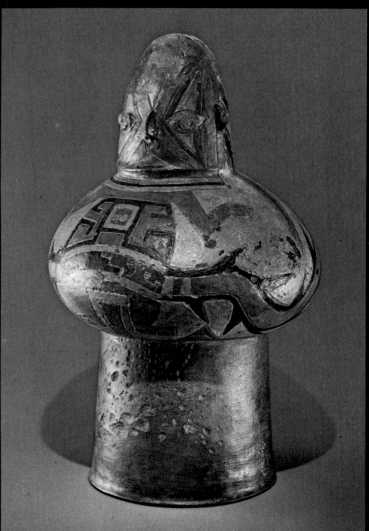

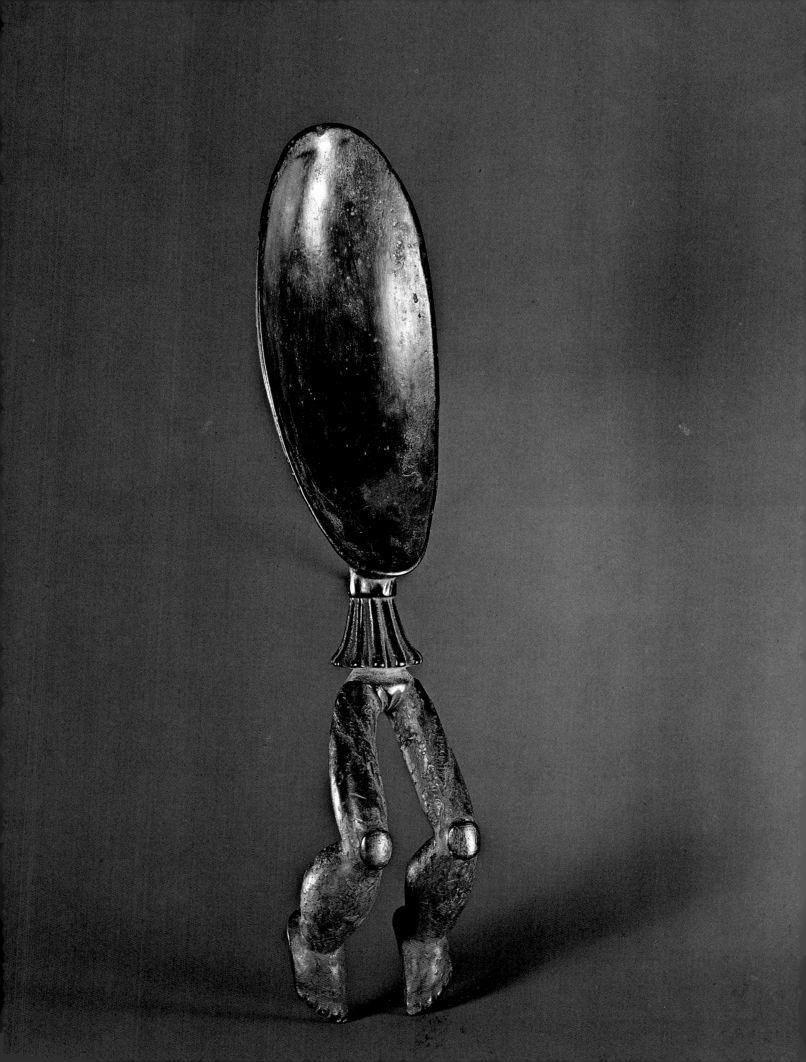

Spoons are universal tools for dealing with food, as knives and forks are not. The gestures of taking up and pouring out that can be made with them are expressions of abundance and generosity. This is especially true of the ceremonial spoons, left and far right, of the Dan tribe of Liberia: they are carried in danced expressions of pride by the wives of important men, and used to distribute quantities of rice at feasts. The small spoon at center reflects a European type; it is one of the ivory utensils made by Sherbro craftsmen of Sierra Leone about the sixteenth century on commission from Portuguese traders.

Pages 120–21: Left, a figure from Zaïre: a half-length female of the Luba tribe. Center, top to bottom: a stone figure used as a rain charm in the Torres Strait of Papua New Guinea. The large headdress-mask of a female spirit was carried on the heads of men of the Simo Society of the Baga tribe of Guinea. In the Teotihuacan style of ancient Mexico, the stone figure was carved about A.D. 200–600. Right, the ceramic half-length figure from Veracruz (A.D. 300–900) represents Ehecatl, the god of wind.

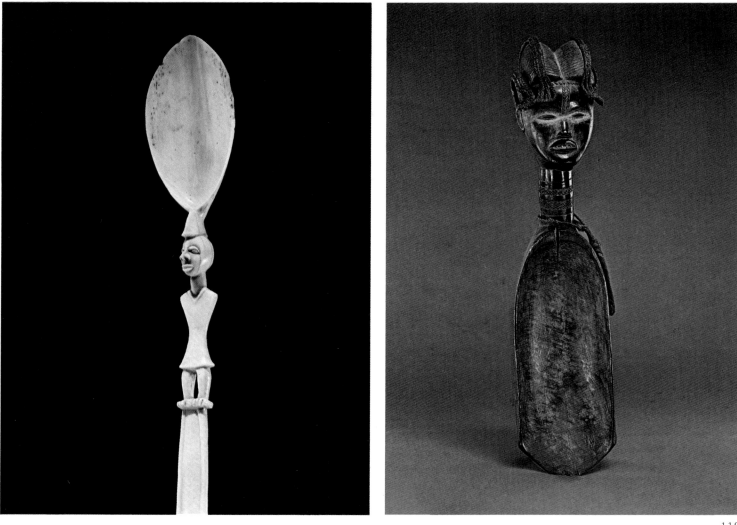

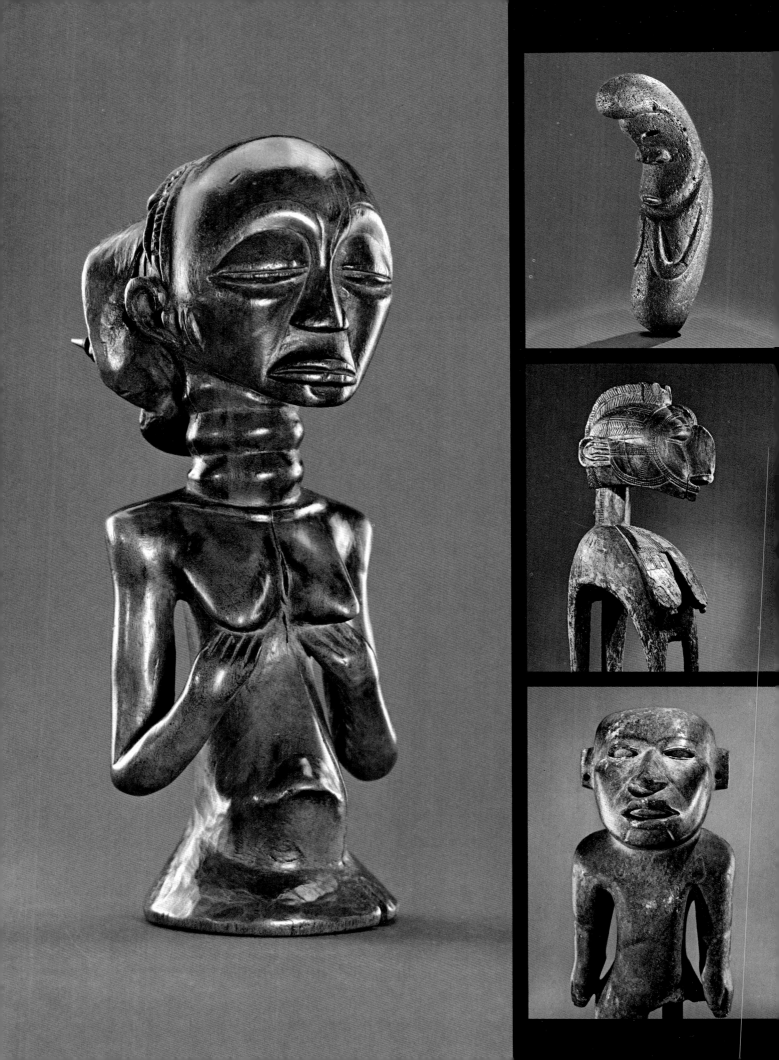

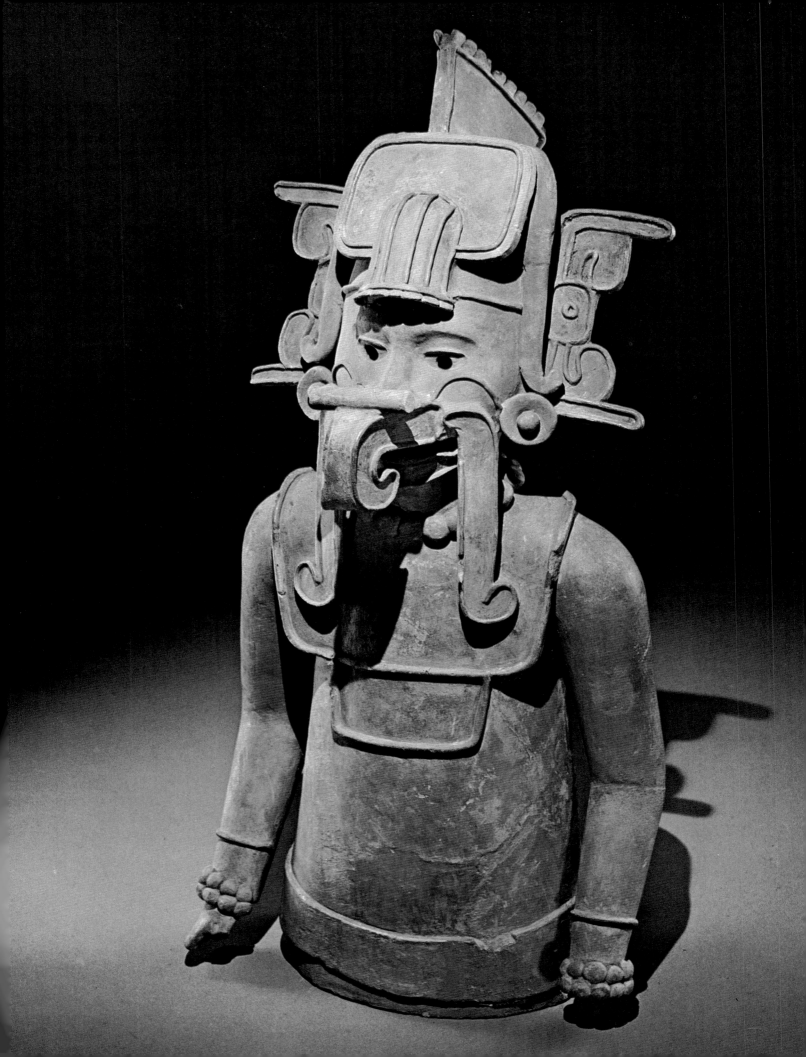

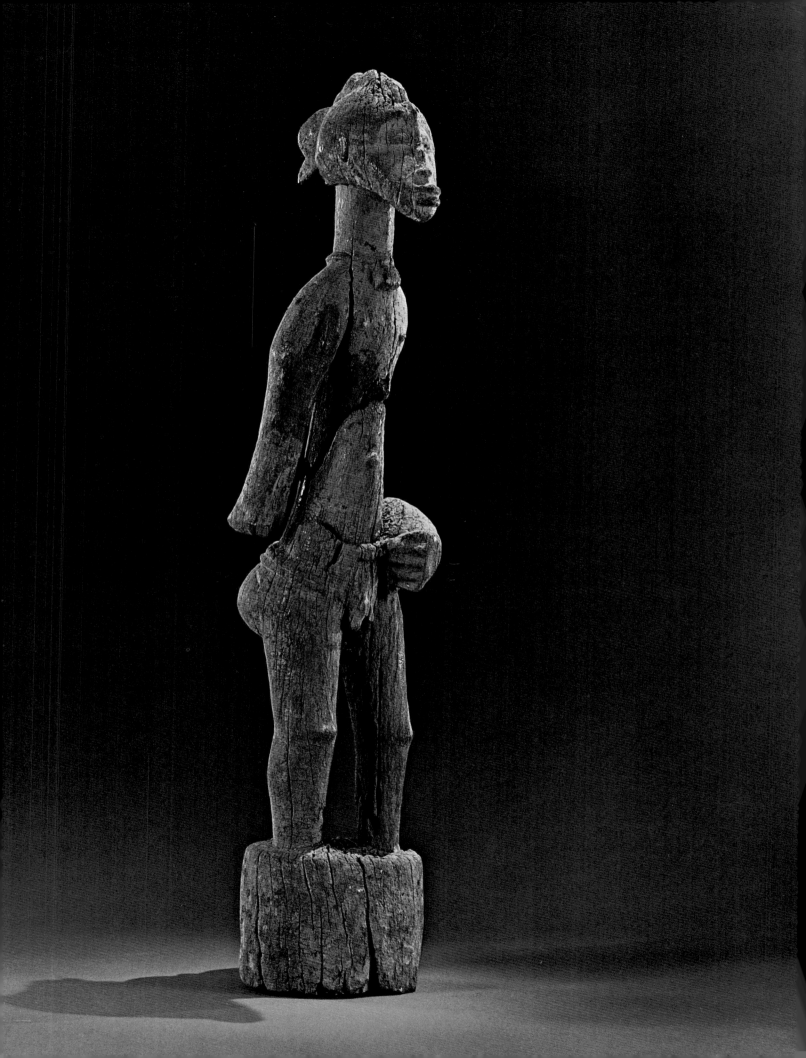

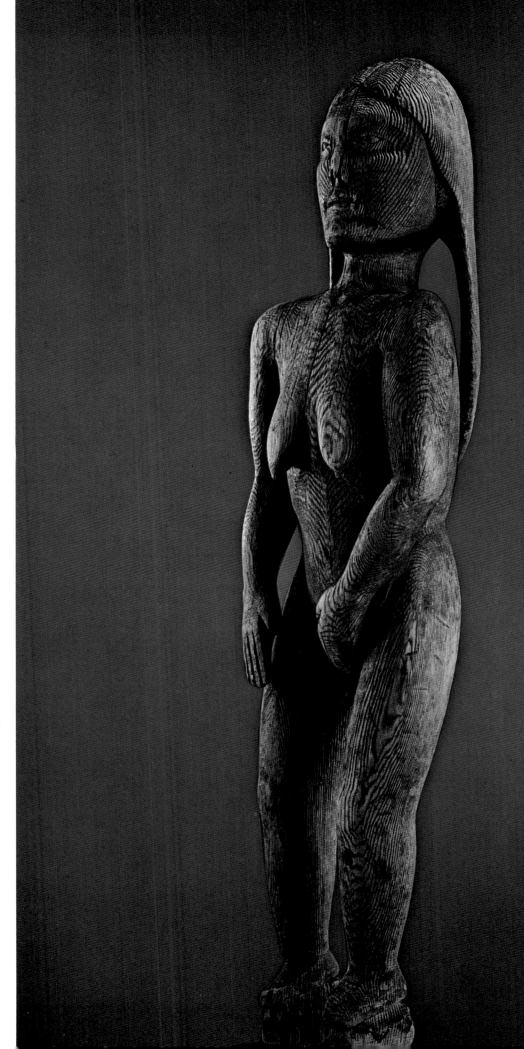

Male and female figures on heavy, cylindrical bases like the one at left were carved for the Senufo's Lo Society in the Ivory Coast, and used in memorial ceremonies for the dead. Newly initiated members of the society, standing in line, pounded them on the ground in rhythm, thus both purify-ing the earth and calling on the ancestors to par-ticipate in the rites. The woman, right, carved by the Kwakiutl tribe of Brit-ish Columbia, is probably a memorial.

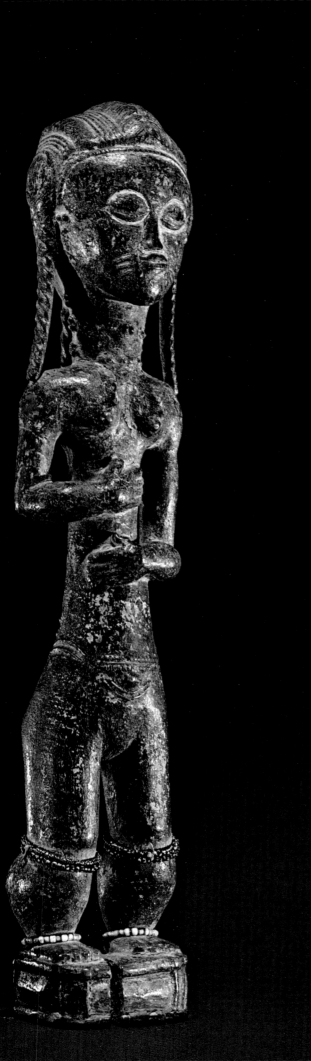

The figure of a standing young woman, left, might appear to portray a Baule beauty from the Ivory Coast. Appearances are deceiving, however; she is actually a hideous nature spirit, so depicted to ward off her anger. Beauty, to the Baule, is equated with spiritual power, never ugliness; hence the need for this flattering transformation. Standing male figures like that on the right, or simply heads, were placed on containers for ancestral bones by the Fang of Gabon. It is said that the infantile bodies combined with mature features symbolized the cycle of death and rebirth. The figure, below, from the Mezcala area of Guerrero, Mexico, is one of a great number in various styles from about 550–100 B.C. Unusual in being relatively naturalistic, this one shows a person wearing a large, animal-snouted headdress.

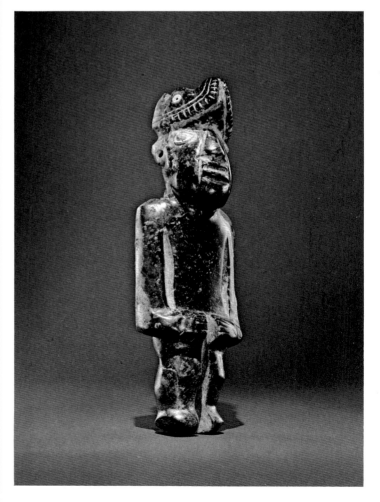

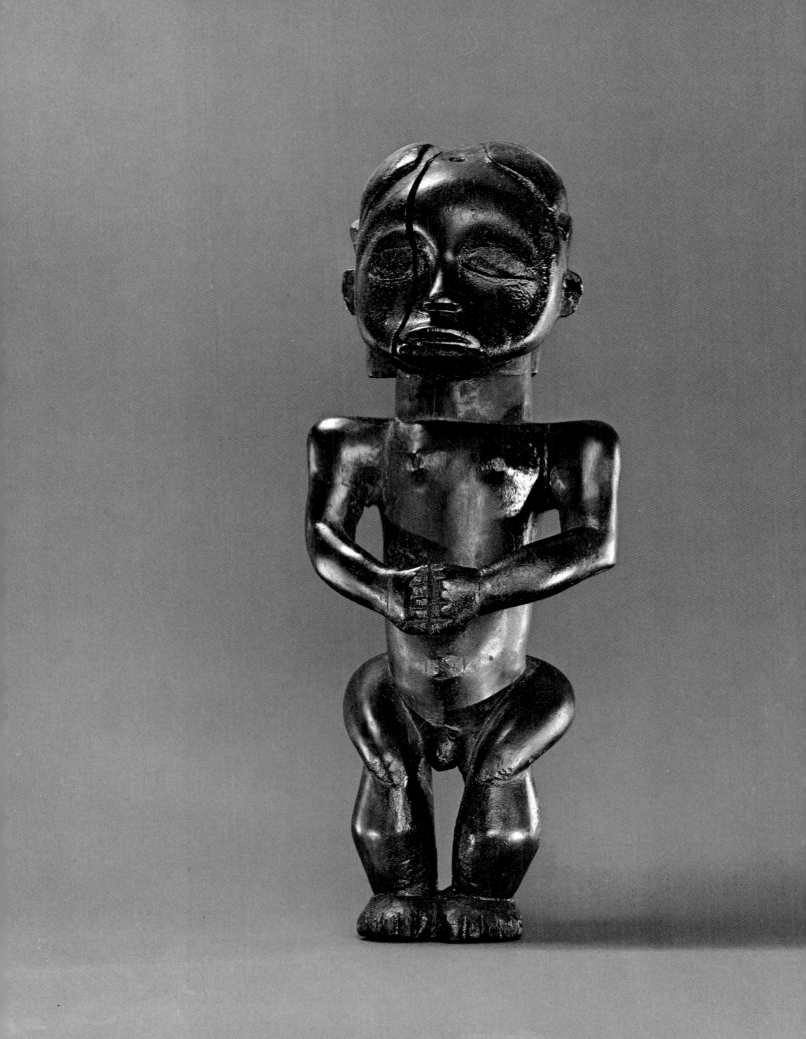

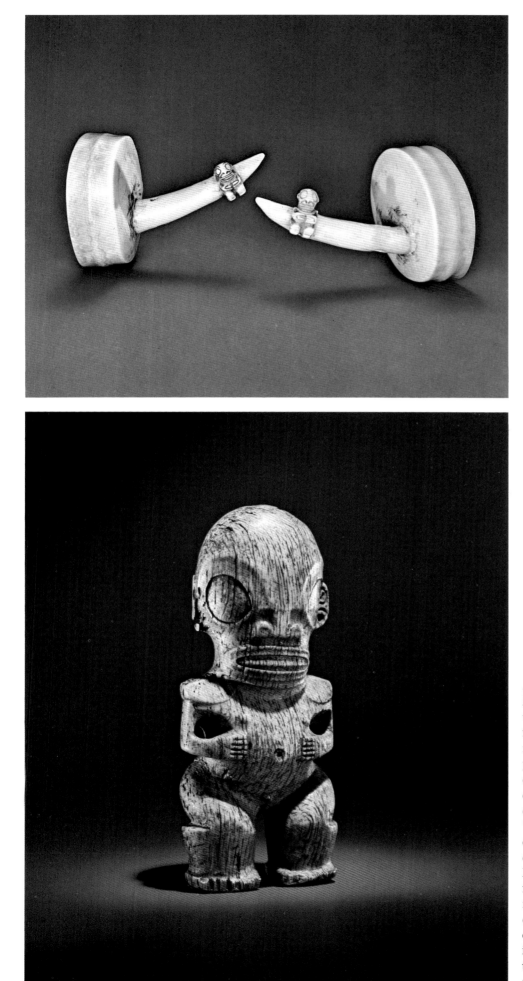

Ear ornaments in ivory, above left, were made in the Marquesas Islands for men. The disc was held in front by means of the shank thrust through the pierced earlobe; on each shank is carved a miniature <u>tiki</u> figure of a god or ancestor. A larger <u>tiki</u>, below left, carved in bone, was used as a pendant. The stone figure, right, from the area of Tiahuanaco in Bolivia was probably carved about A.D. 300–700. Each hand holds a symbolic plaque or tablet in front of the torso; the sash and leg garment are engraved with designs depicting the complex patterns found on Tiahuanaco textiles. In form and imagery, this figure is comparable to a twenty-foot-high monolith discovered at the site of Tiahuanaco itself.

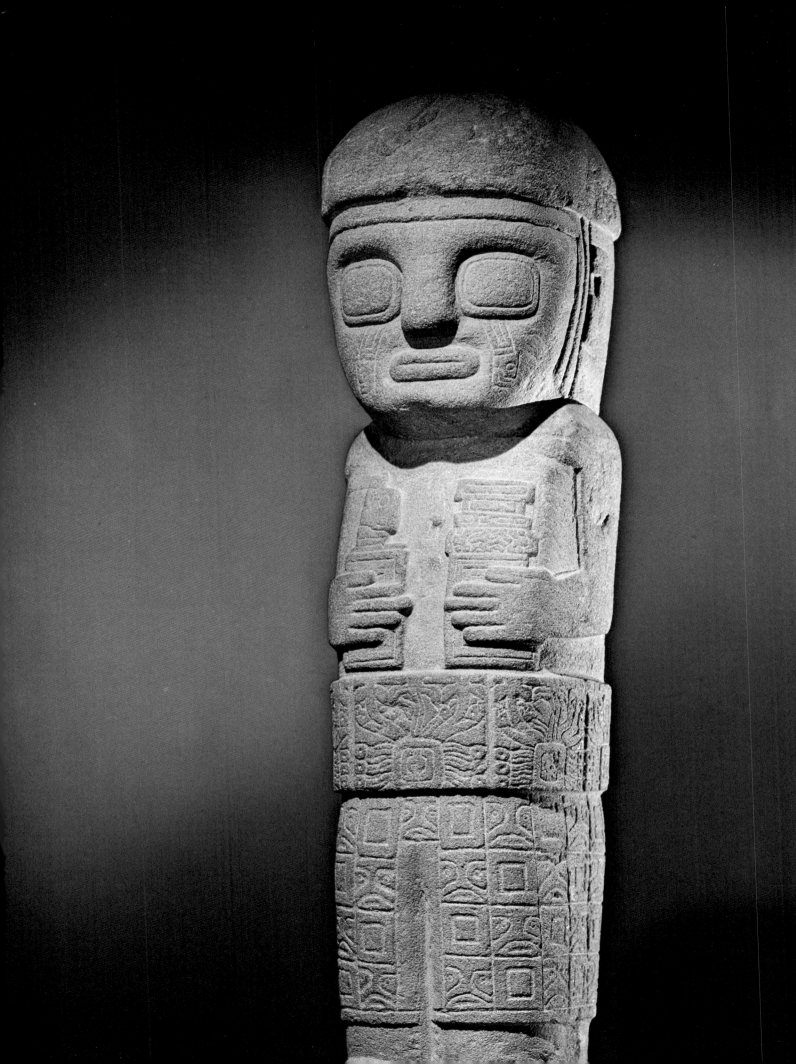

Maori sculpture from New Zealand is cha[...]
terized by simple basic forms overlaid by [...]
bands, curving or spiral, with interior bea[...]
which often obscure the representational [...]
aspect of the work. This decorative overlay[...]
relates to the complex tattooing with which[...]
the Maori covered their faces and bodies. [...]
smaller of these two figures, left, is a peg: [...]
Maori weaver used two of these, thrust int[...]
the ground, to secure the top edge of his w[...]
The decorated peg was placed on the right[...]
and was considered sacred (<u>tapu</u>), as the p[...]
on the left was not. The large figure, right, [...]
carved in relief on a shallow slab, the eyes [...]
inlaid with abalone shell. It represents a tr[...]
ancestor, and was once used as one of the [...]
planks lining the walls of a meeting house. [...]
The wooden parts of these buildings, espe-
cially pillars, lintels, and eaves, were fre-
quently carved with such representations.

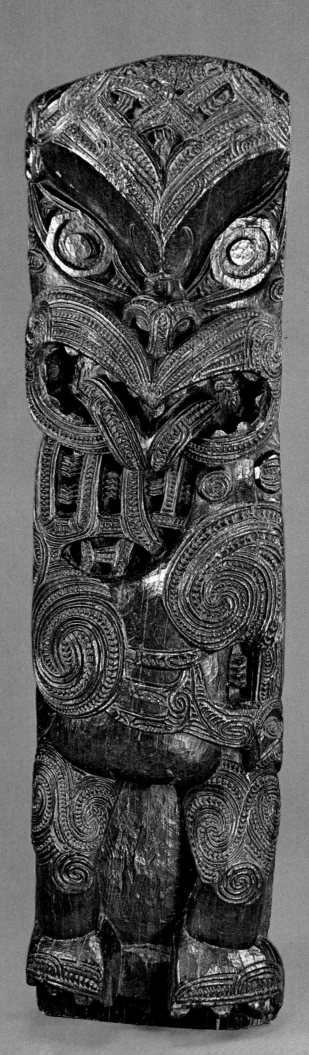

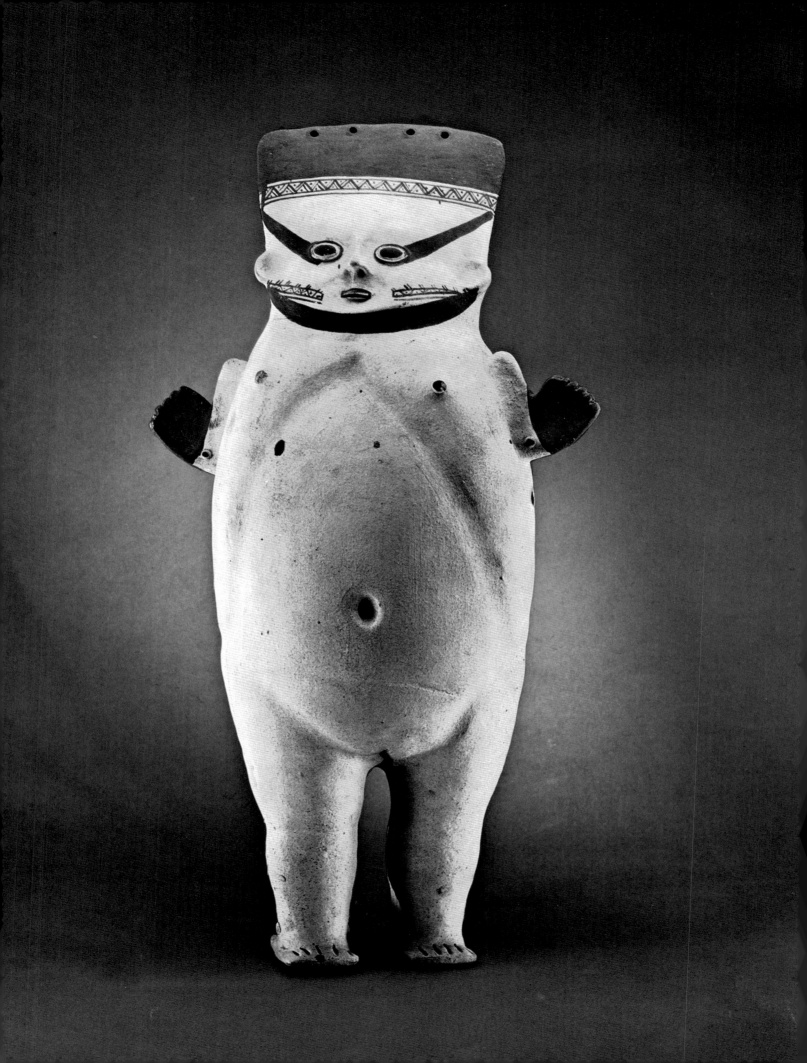

Ceramic sculpture by the Chancay of South Coast Peru (A.D. 1200–1450) is notable for large hollow figures of exaggeratedly fat women, left, with a few painted details. A grave-cloth, above, by the Huari of Central Coastal Peru (A.D. 600–1000) is painted in a summary , caricatural style that contrasts sharply with the color and discipline of their weavings.

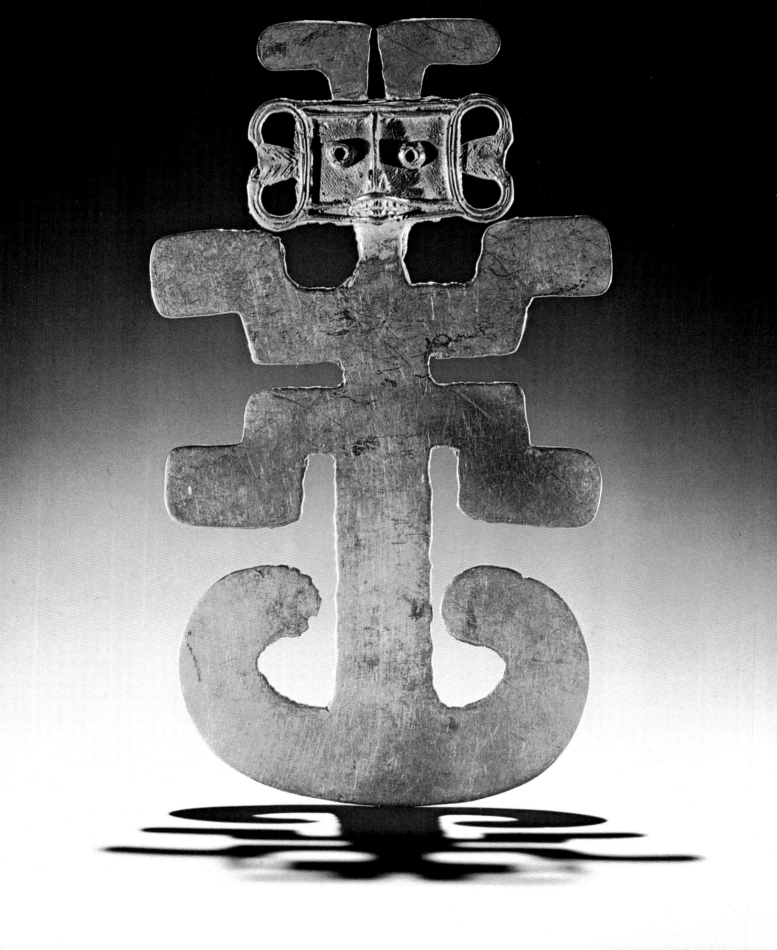

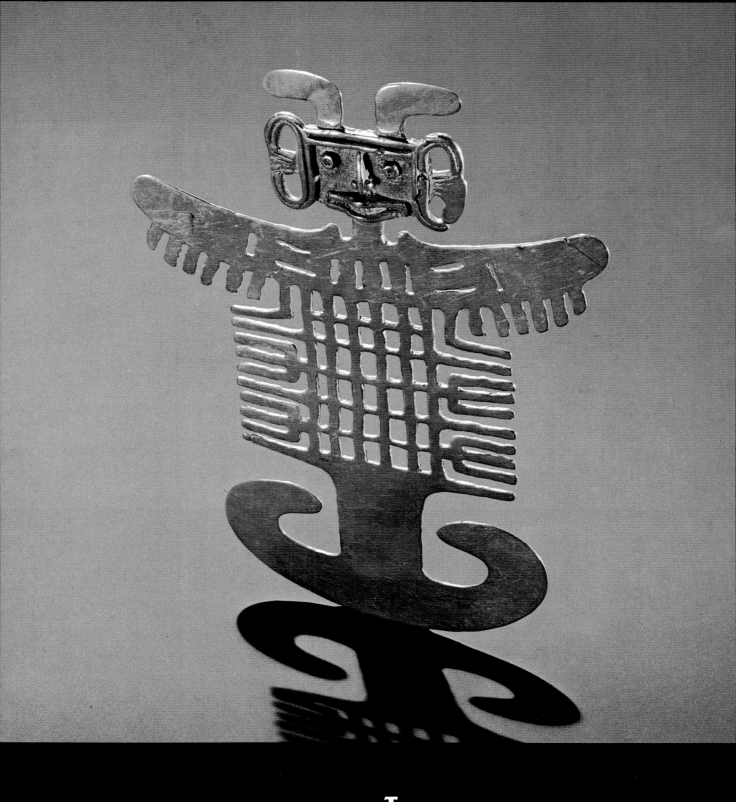

These two gold pendants represent a stylized human fig-

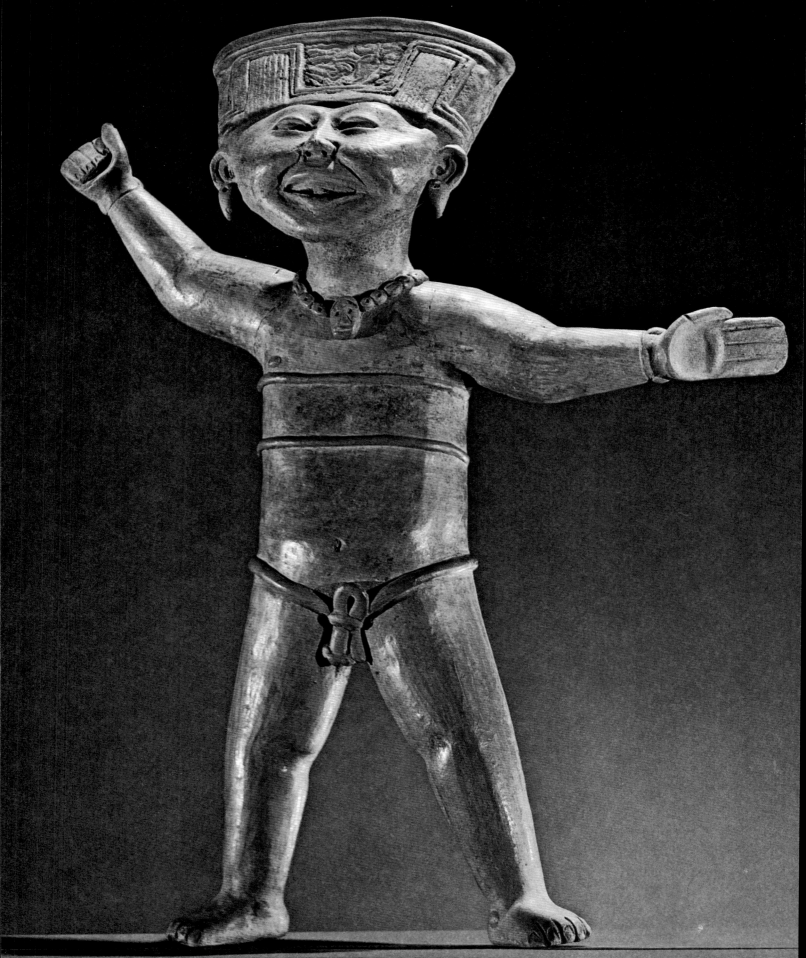

Large numbers of ceramic figures have been found in Veracruz. Among those of the Late Classic period (A.D. 600–900) are the so-called Smiling figures, famous for their broad faces, half-closed eyes, and apparently wide grins. It is by no means certain, however, what is meant by this expression. It has been suggested the men and women represented are impersonating divinities, especially the god of alcoholic drink.

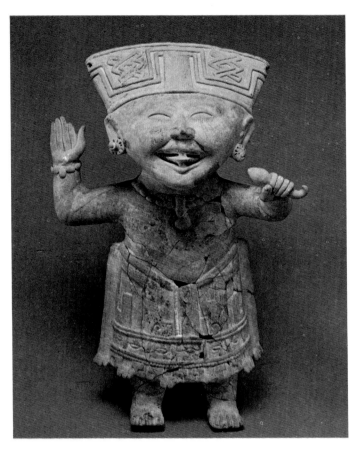

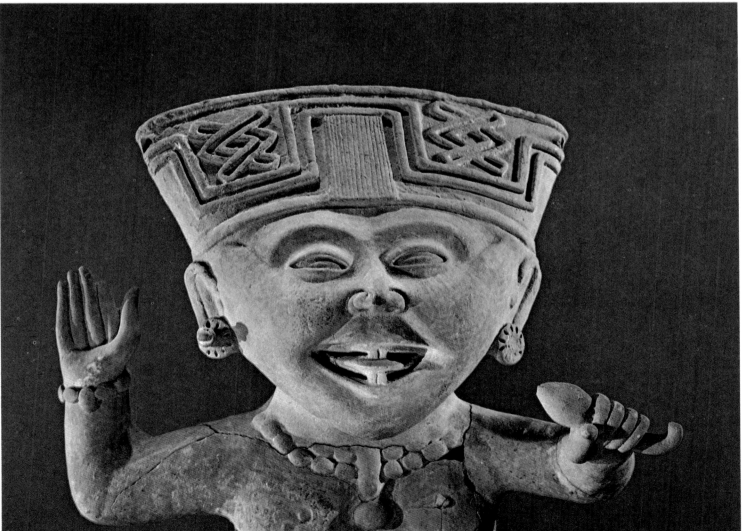

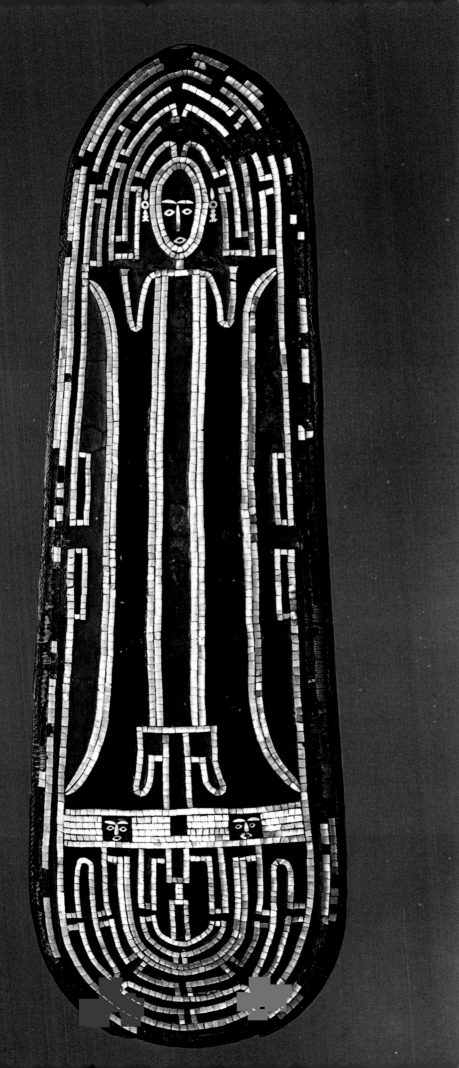

The shields generally used in the central Solomon Islands were elongated forms with rounded ends, made of basketry. A small number of them are enriched with designs, left, made up of hundreds of tiny pieces of nautilus shell attached by a resinous substance. They are too fragile to have been used in battle; it is more likely that they were valued parade objects for certain chiefs about the middle of the nineteenth century. In the Gulf of Papua (southern Papua New Guinea) the interiors of the men's ceremonial houses were divided by racks filled with trophy skulls of men and animals, and decorated with oval boards carved in shallow relief, right. The figures depicted appear to be protective and warmaking spirits.

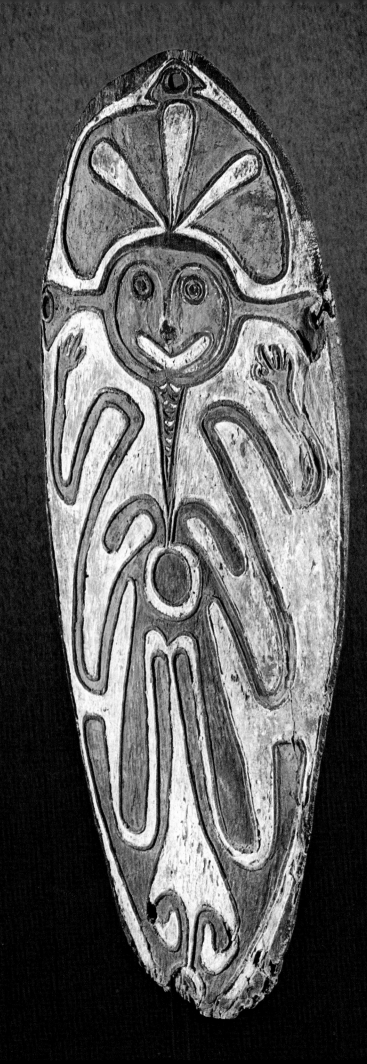

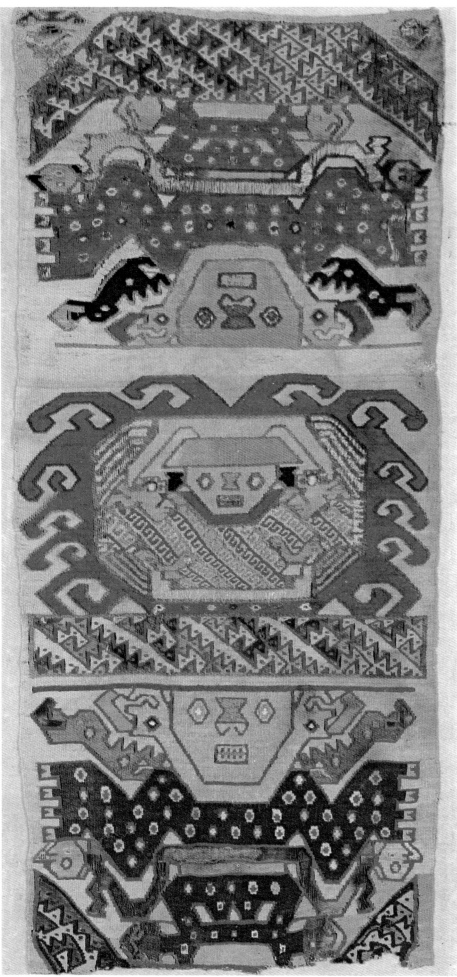

Three richly garbed beings are shown on a textile fragment from Peru, left, perhaps of the Inca period (A.D. 1438–1532). Xipe Totec, one of the chief gods of the Aztec of Mexico (A.D. 1300–1520), is the subject of a nearly life-size ceramic figure, right. He was the patron of metalworkers and vegetation. The extraordinary appearance of the garment in which the figure seems to be dressed is explained by the nature of the sacrifices offered to him. The bodies of human victims were flayed, and the skin was worn by Xipe Totec's priest as a symbol of growth and regeneration.

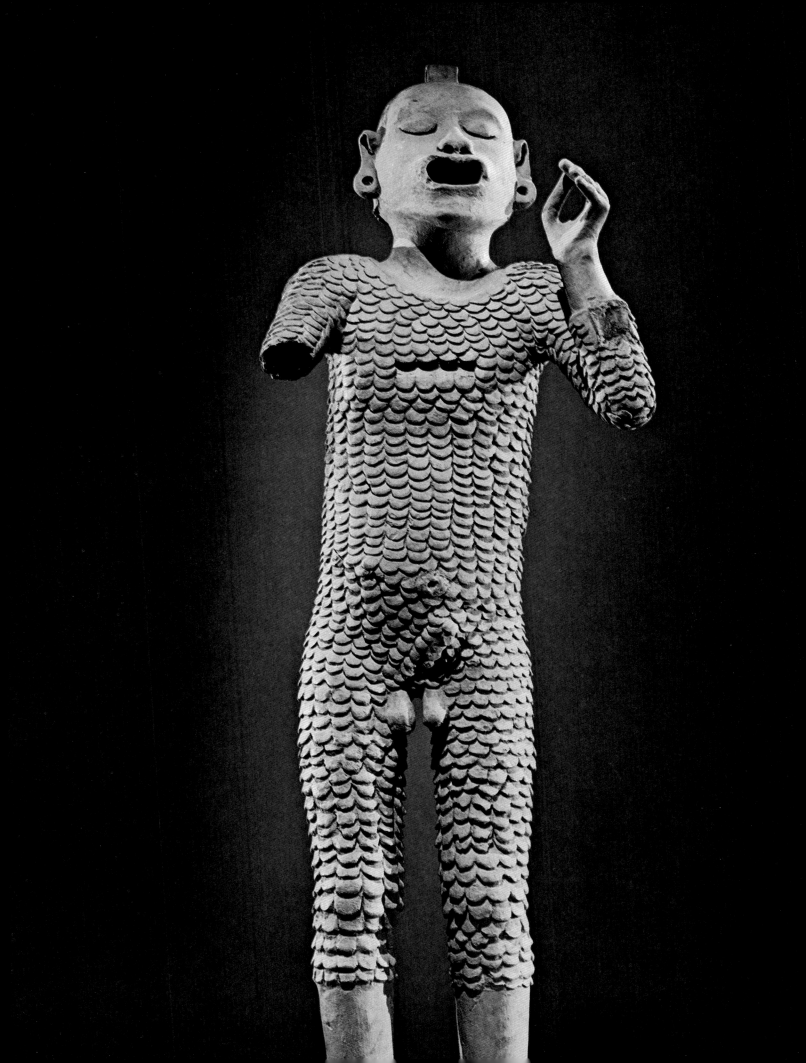

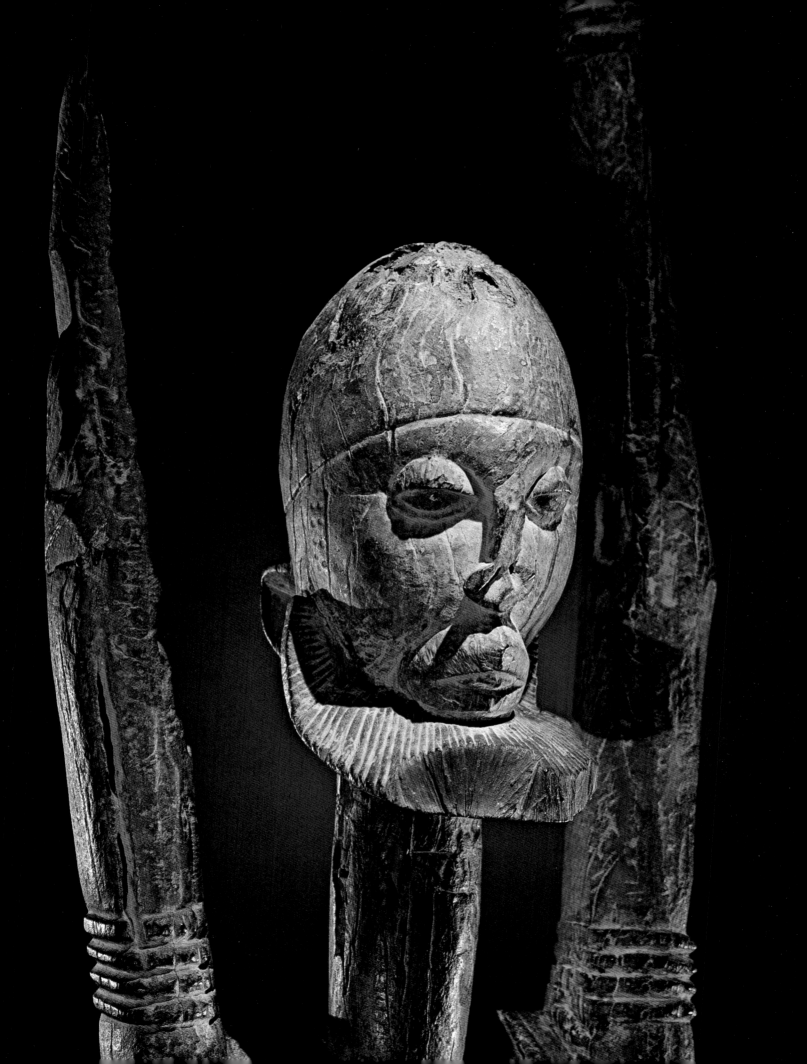

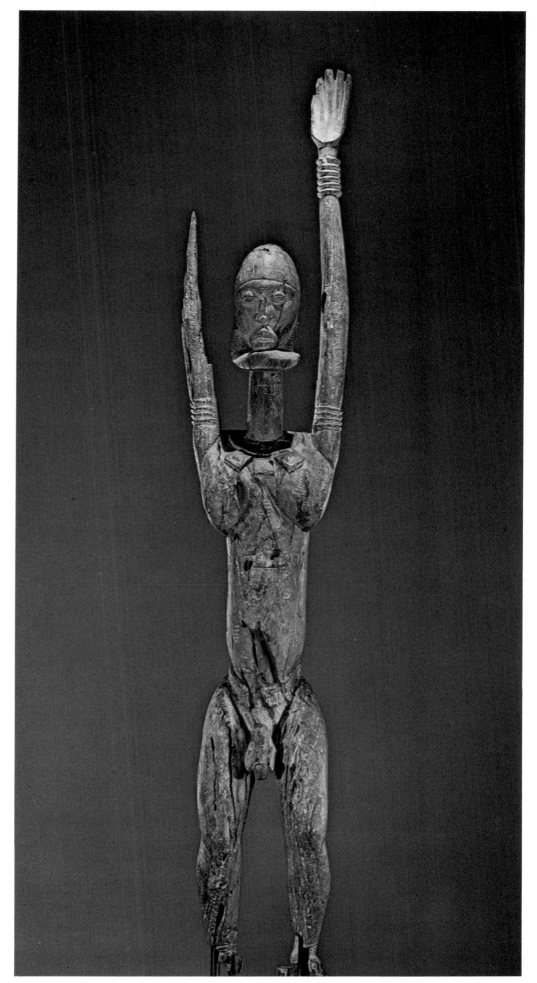

The elaborate mythology of the Dogon of Mali describes the origin of humanity from four of five pairs of twin beings who were children of the earth and a god. These beings were bisexual water-spirits, but each had predominant strains of maleness or femaleness. The four pairs—known as <u>nommo</u>—descended from the sky to become ancestors of the Dogon; one of them was sacrificed. This figure, perhaps the largest known from the . Dogon, shows one of these <u>nommo</u>: the gesture of the upraised arms seems richly symbolic, referring to an invocation for rain or to the sacrifice of the <u>nommo</u> ancestor.

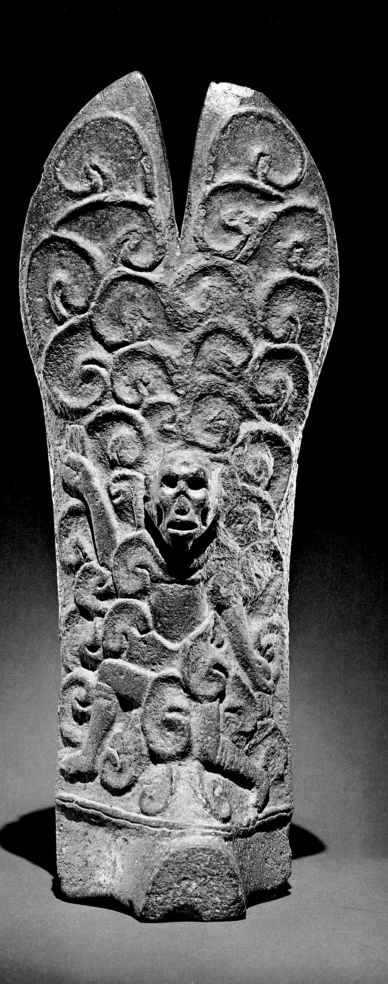

Participants in the ritual ball game of ancient Mexico wore a number of ornamental objects and protectors, including a vertical slab set in the front of the belt. Stone versions are common, though it is not clear whether they were actually worn during the game itself or used as ceremonial emblems. These palmas, or palmate stones, are found in many forms. On one, far left, a being with a skull-like head capers in front of a background of scrolls. On a jar, below right, painted by a Maya artist of the Late Classic period (A.D. 600–900), a ritual scene concerned with death and the underworld is in progress. In the detail shown, a young god is dancing, stone ax in hand, about to perform a human sacrifice. The use of scrolls typical of the Maori of New Zealand is evident on a box, below left. This was used for holding the tail feathers of the huia bird, which were a badge of rank, or greenstone ornaments. Since they were suspended from rafters and viewed from below, such boxes are usually best carved on the bottom.

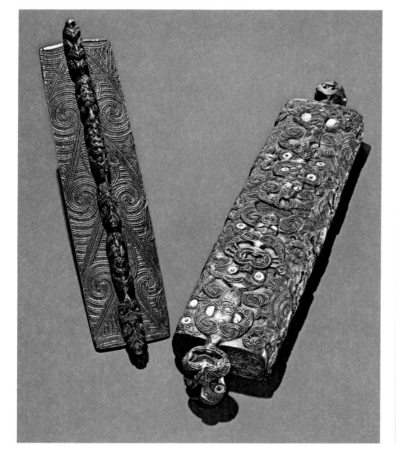

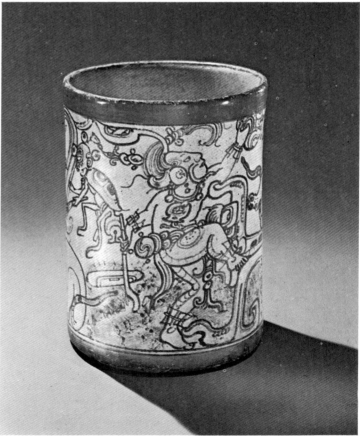

The goldwork of the Muisca people of Precolumbian Colombia includes a number of small pendant figures. Typically, these are formed of flat, triangular sheets of metal, on which details are indicated in wire. The figure at center is a mother with child. At the right is a nobleman wearing headgear, earrings, and necklace, and carrying a spear and spearthrower.

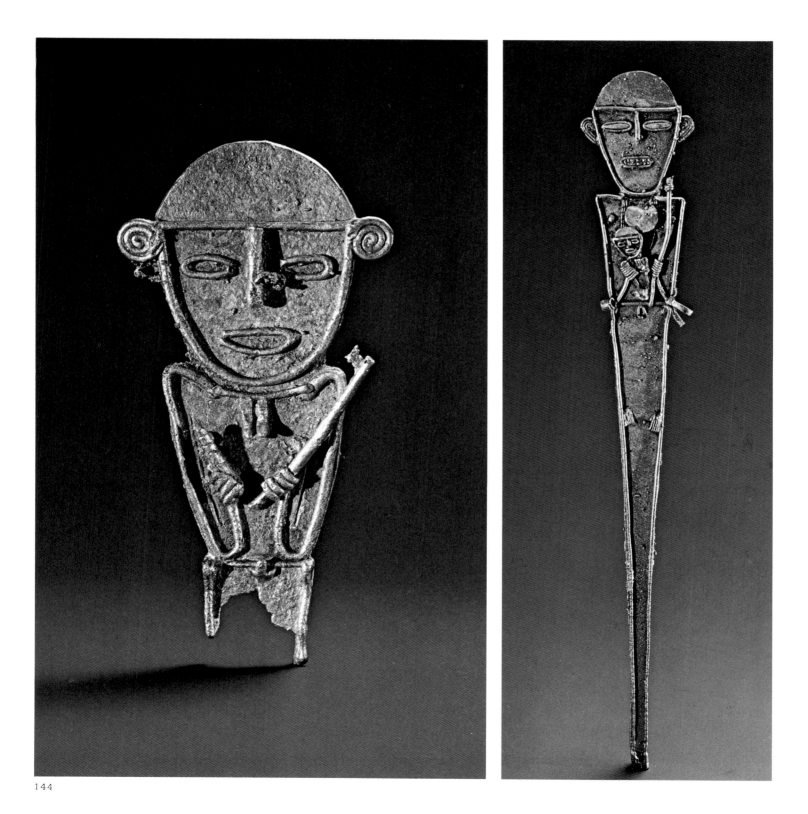

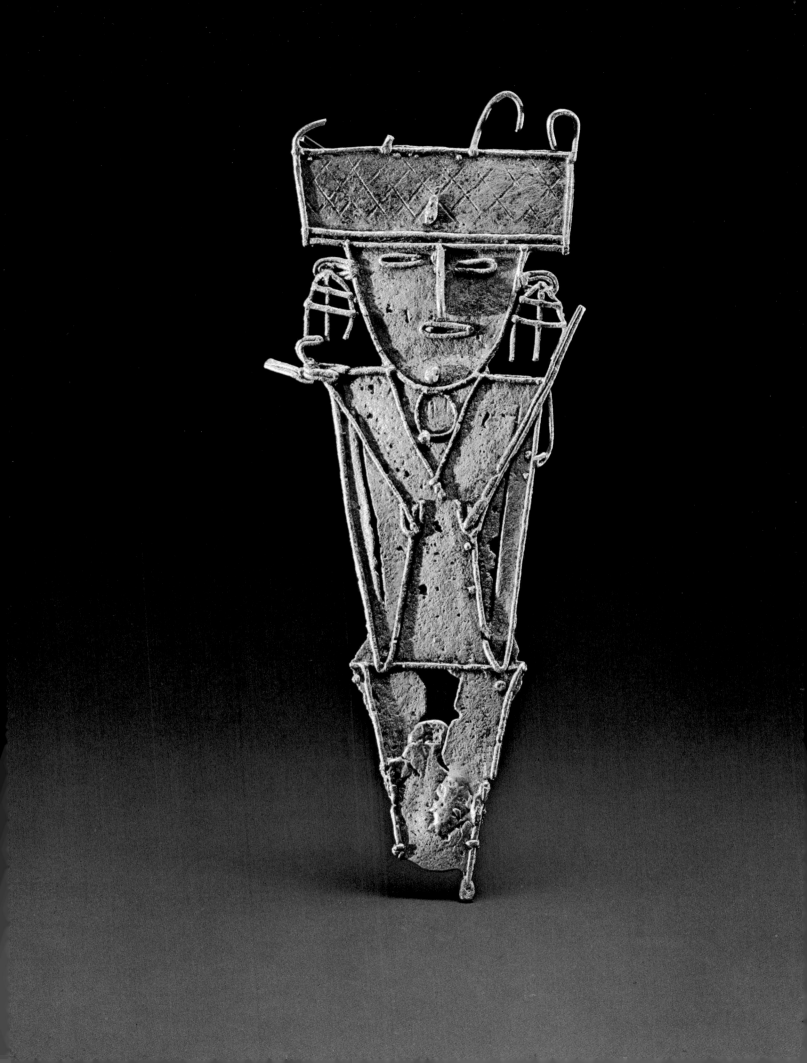

The figure, below, wearing a cruciform mask and perhaps a crescent nose ornament, is a gold pendant from the Calima, who lived in Colombia about A.D. 400–700. An elaborate staff is held in the right hand, and an object resembling a frond in the left. The Bangwa of Cameroon were one of the few African peoples to attack the problem of movement in sculpture. Among other instances of this they produced paired figures of kings and queens performing dance steps: witness the figure of a king, right; the whereabouts of the accompanying queen figure is unknown. The ruler is shown executing a rhythmical turning and crouching movement as he sings; he carries his pipe in the left hand and his drinking gourd in the right.

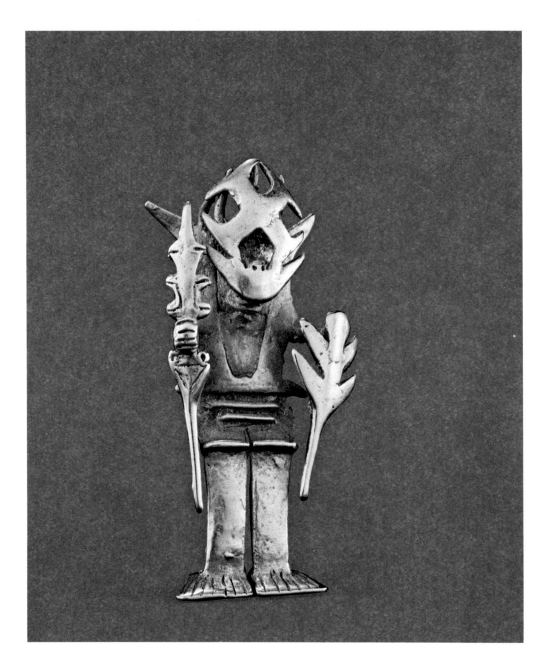

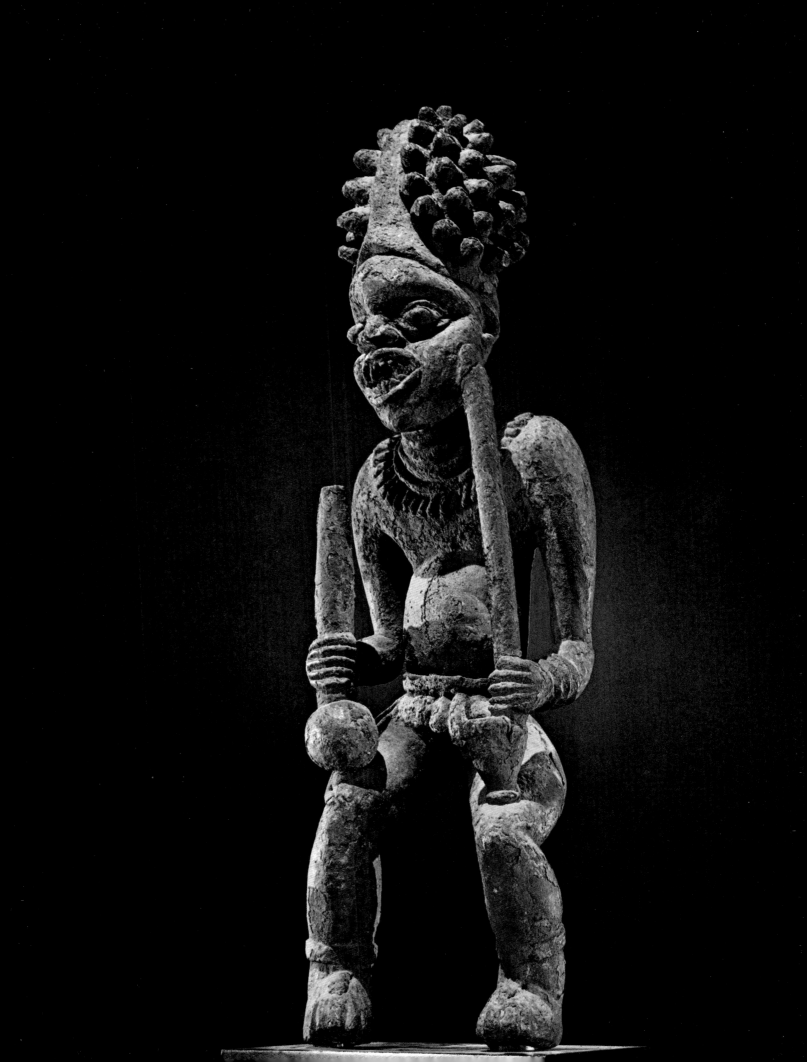

The protective figure, below left, from the Bena Lulua of Zaïre—a chief, as is shown by his leopard-skin apron—holds a container, perhaps intended for magical substances, in his right hand. His body and face are covered with decorative scars, a fashion that died out in actual use but was carried on in the carving tradition. The stone warrior at center from the central plateau of Costa Rica, carved about A.D. 1000, is shown holding a weapon in his left hand and the head of a slaughtered enemy or human sacrifice in his right. Such figures were set up around the perimeter of a sacred area. The old Huastec man, right, seems to be supporting his weight on a staff. The figure is from northern Veracruz, about A.D. 900–1200.

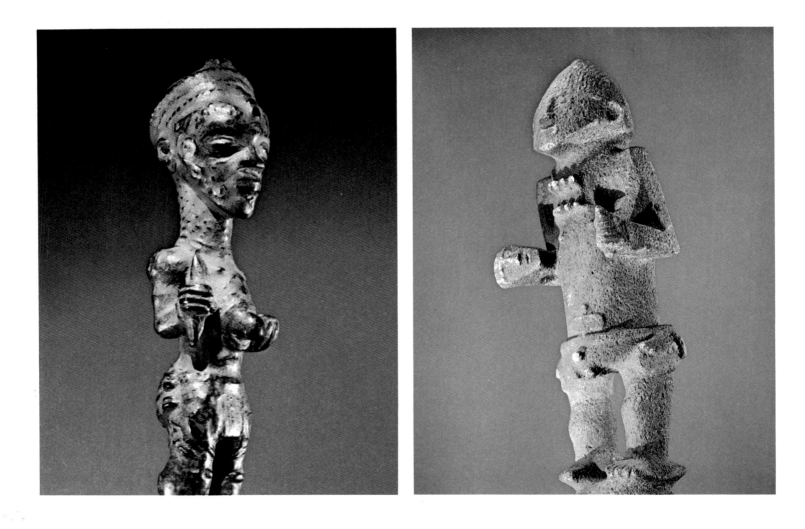

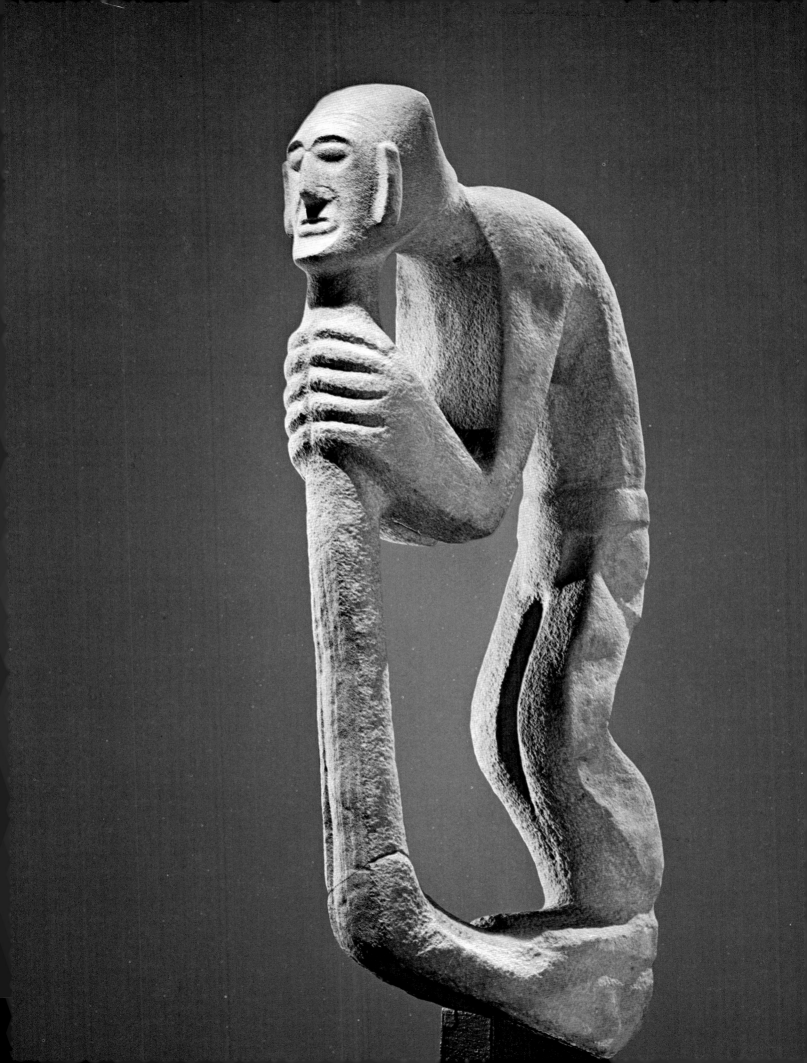

In these three works the actors are performing silent music. The horn player in brass, below, made in Benin in the sixteenth to seventeenth century, represents an attendant at the royal court. Pan-pipes are being played by the man in silver, center, from the Chimu of Chan Chan in Peru; the figure is also a vessel. The two musicians carved by the Dogon of Mali, right, are performing on a type of xylophone.

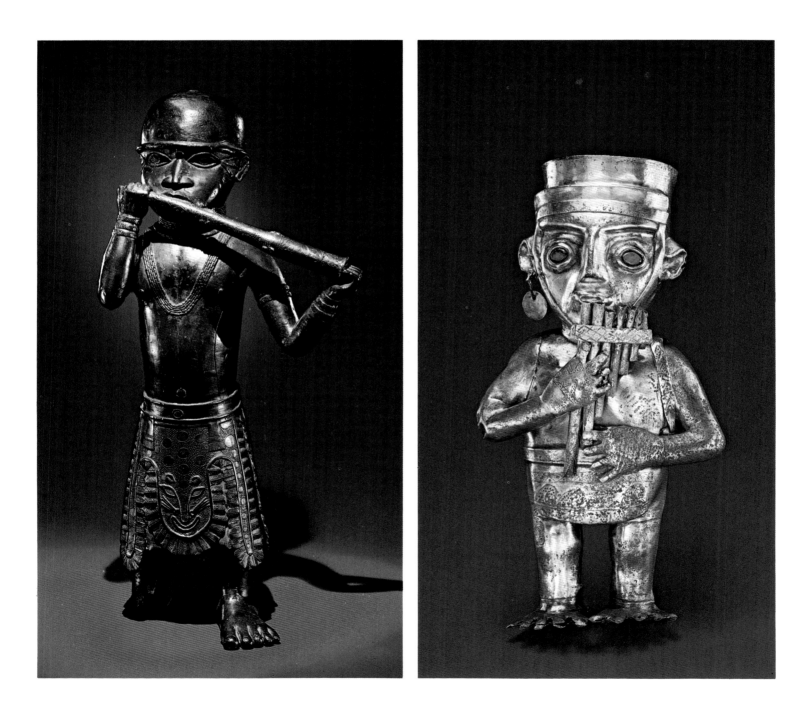

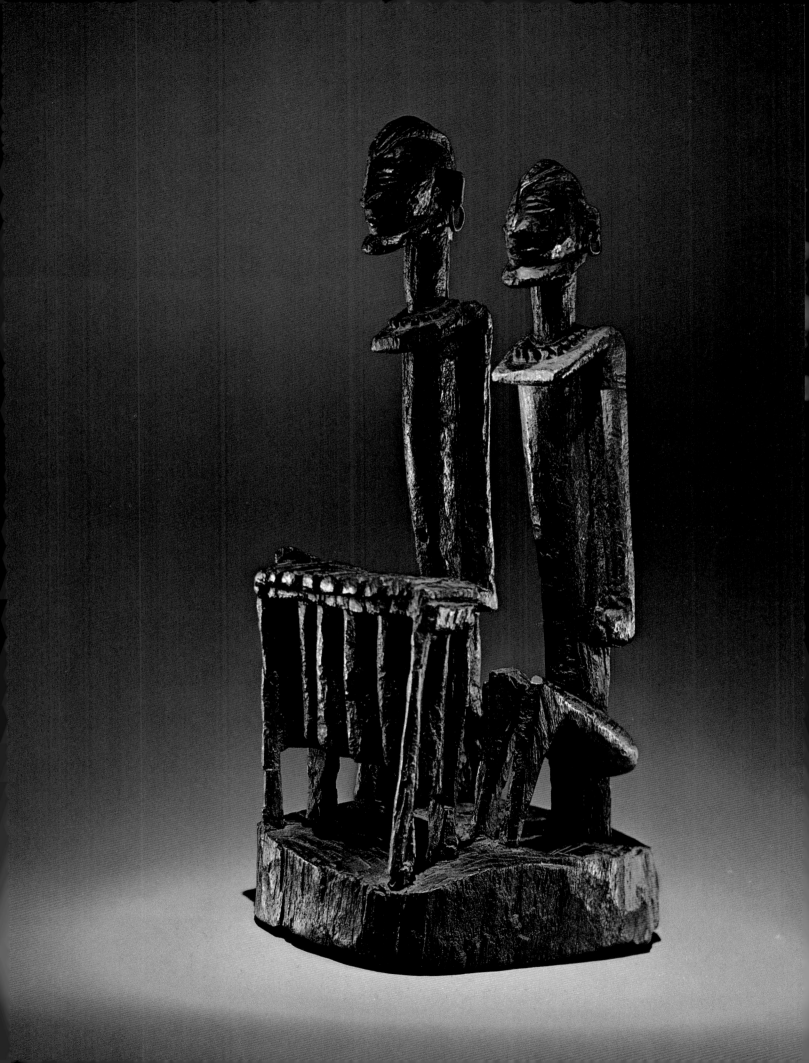

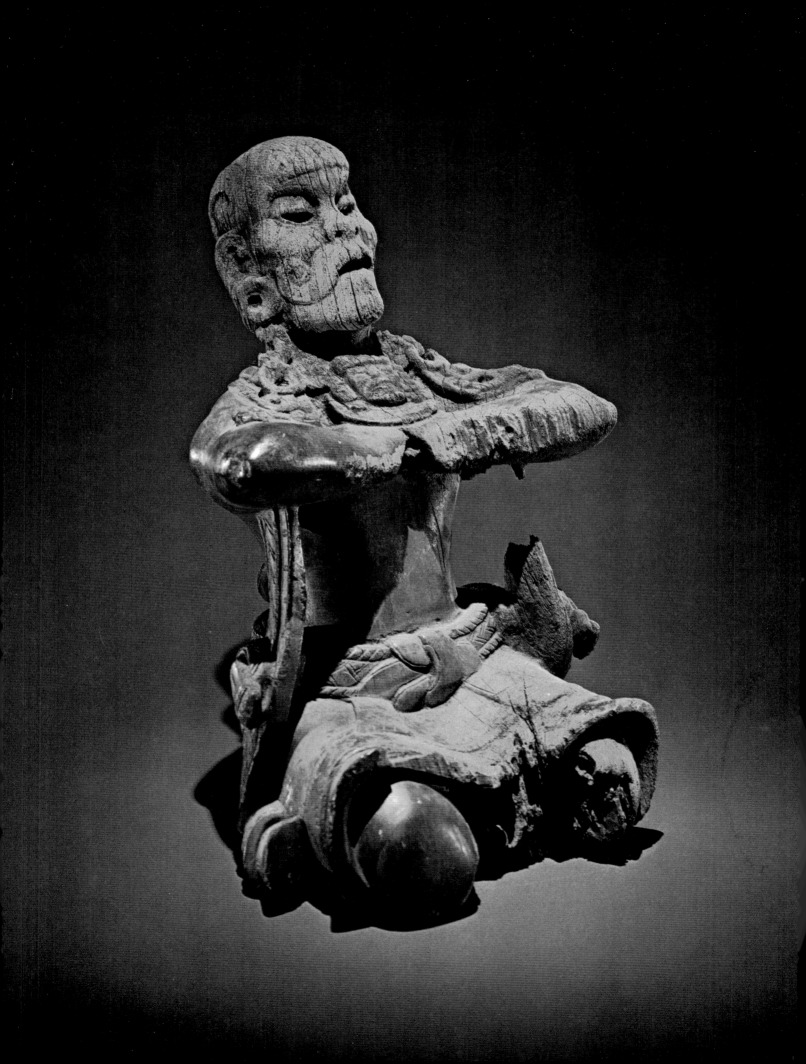

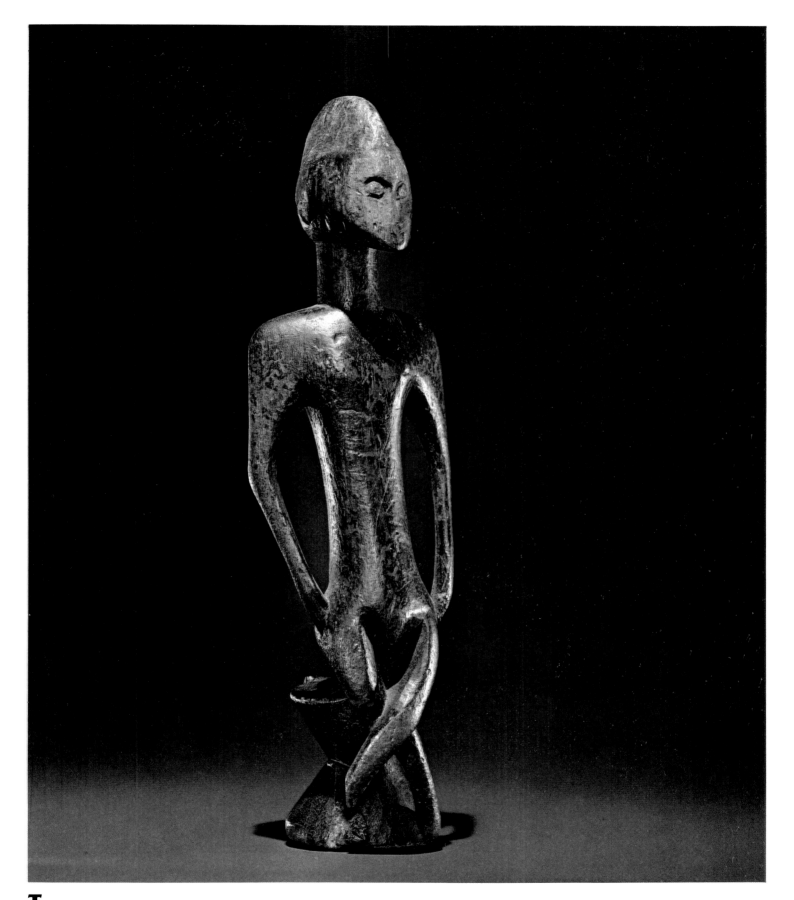

The small figure of a man seated on a stool, above, is from the Senufo of the Ivory Coast; when found, it was being used as a small girl's doll. The figure of a kneeling priest or dignitary, left, is an Early Classic Maya work of about A.D. 400–500. The personage is dressed lightly but richly in a stole, a skirt, a heavy belt; he also wears elaborate jade ornaments, and has a formal hair dress. The arms are held in an attitude of respect or adoration; at one time a plaque-like object was fitted between them and the thighs. Evidently the Maya were masters of wood carving as well as stone and ceramic work, but this unique figure is the only remaining witness.

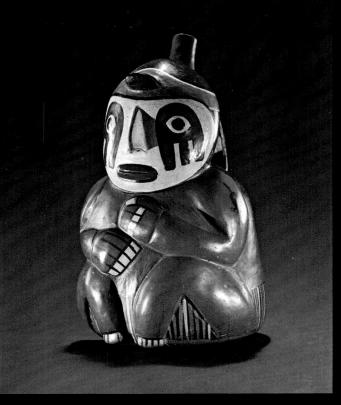

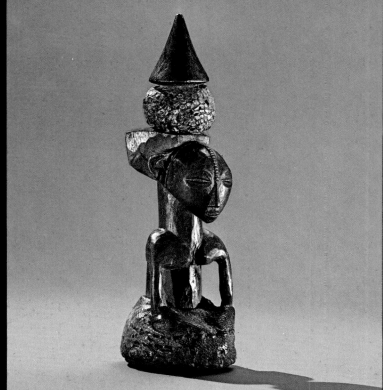

Two Precolumbian ceramic vessels in the form of figures are those of a seated man, above left, from the south coast of Peru (100 B.C. — A.D. 200), and of a prisoner in bonds, left, from the state of Colima in Mexico (about A.D. 300—600). A small fetish figure, above right, of a woman, half-length, with attached magical materials including snakeskin, is from the Luba of Zaïre.

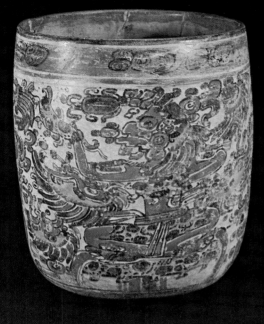

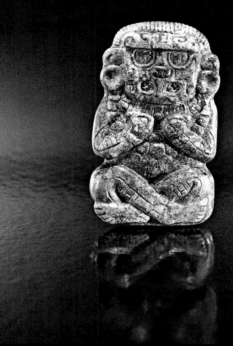

Gods of Precolumbian Middle America appear on a Maya painted vase, above left, from the Late Classic period in Guatemala (A.D. 600–900); as an Early Classic (A.D. 300–600) Maya stone carving from the area of the great city of Copan in Honduras, above right; and as a vessel in translucent onyx in Mixtec style from Mexico, about A.D. 1250–1500. The figure is Ehecatl, the god of wind, with his protruding mouth mask.

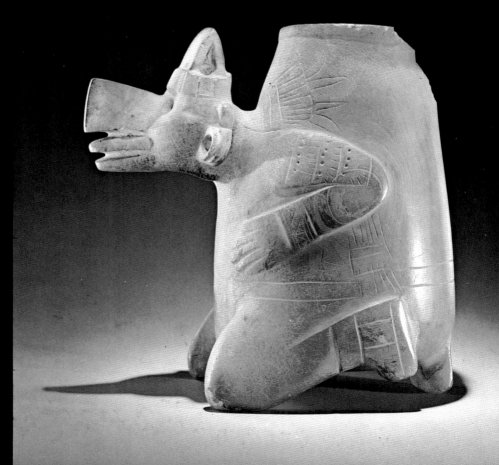

Stools, which elevate the body above the ground, confer dignity and express authority; sometimes they are authority itself. The sacred stools of the Iatmul of Papua New Guinea, below left, belong to no man, but to the ancestral being whose image stands or kneels in front of them. They are never sat on, or touched unnecessarily, but regarded as witnesses during important debates. In Africa carved wooden stools with caryatid female figures are a reminder that rulers frequently used the living bodies of slaves or attendants as seats. At the same time, it is likely that the image is an ambiguous one. The female figures probably also represent ancestors of the ruler, thus acting as his supporters with their authority as well as their bodies.

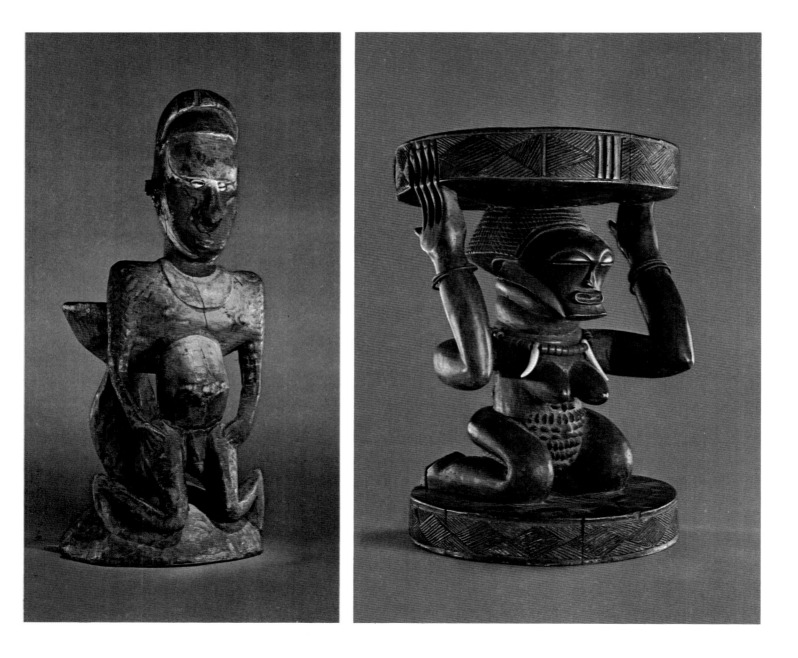

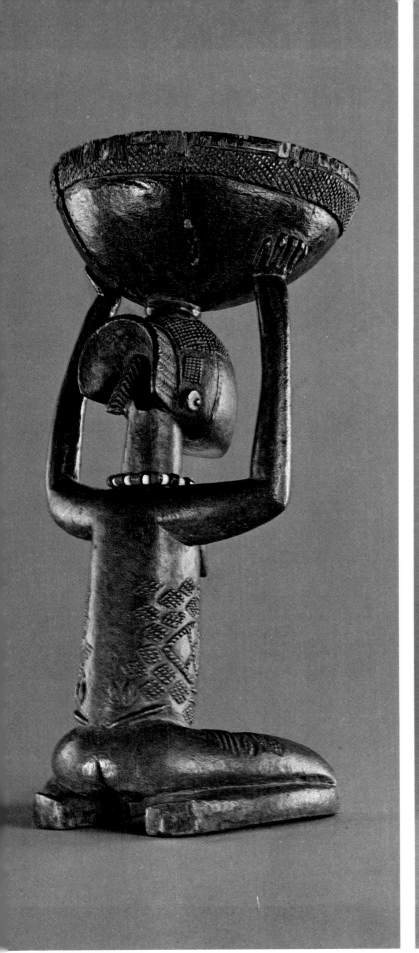
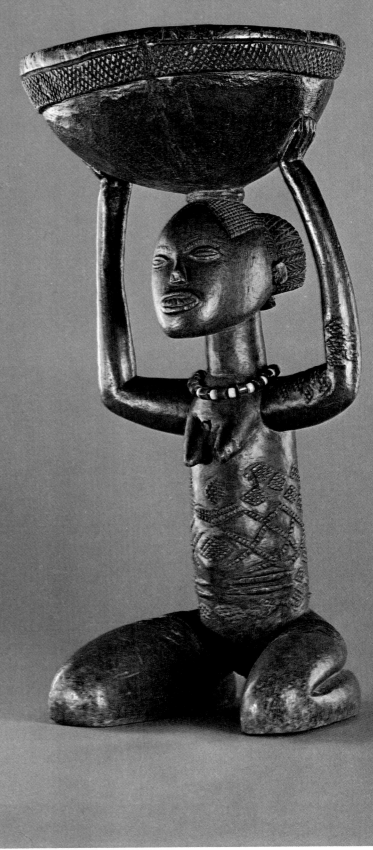

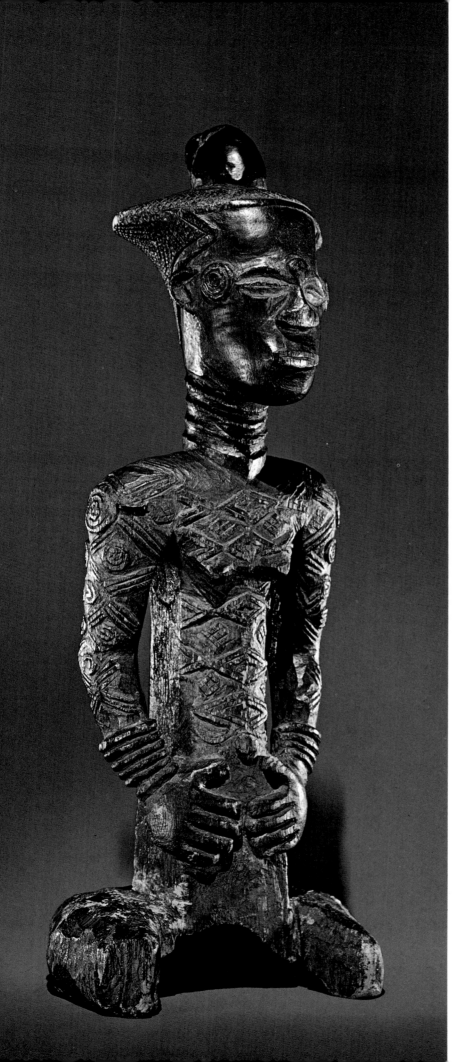

A memorial to a chief of the Dengese of Zaïre is represented in a kneeling figure at left, the elongated torso covered with decorative scar patterns. The vessel, below, made by the Inca of Peru (1438–1532), expresses a peculiar whimsicality: not only does it represent a hunchback, but the liquids with which it was filled could be poured out by way of a natural male aperture. There is nothing humorous, however, about the figure of a god at right, carved by the Taino people of Jamaica about 1500. The glaring eyes were once enhanced by shell plates, like the still-remaining teeth. Possibly the flat top of the support on the head was used as a table for the ritual taking of hallucinogenic drugs.

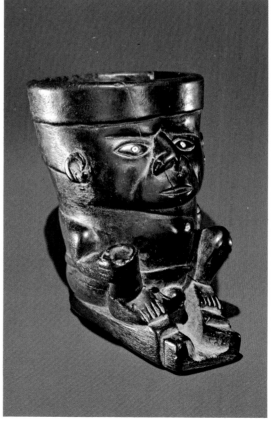

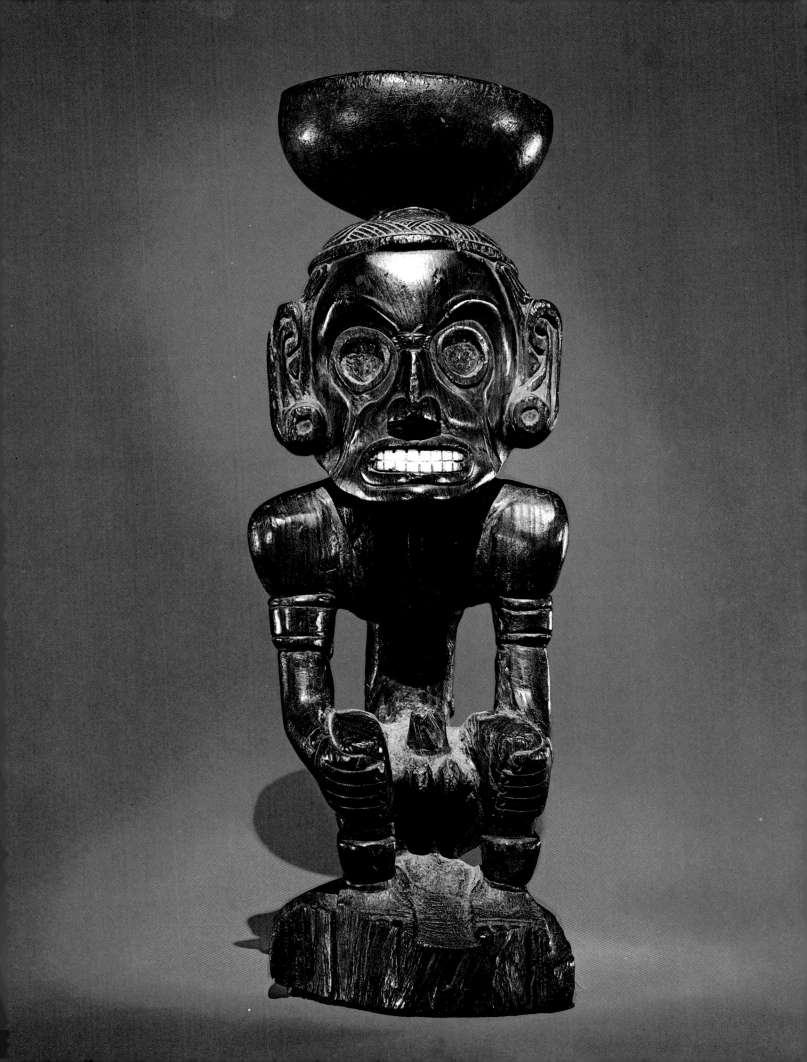

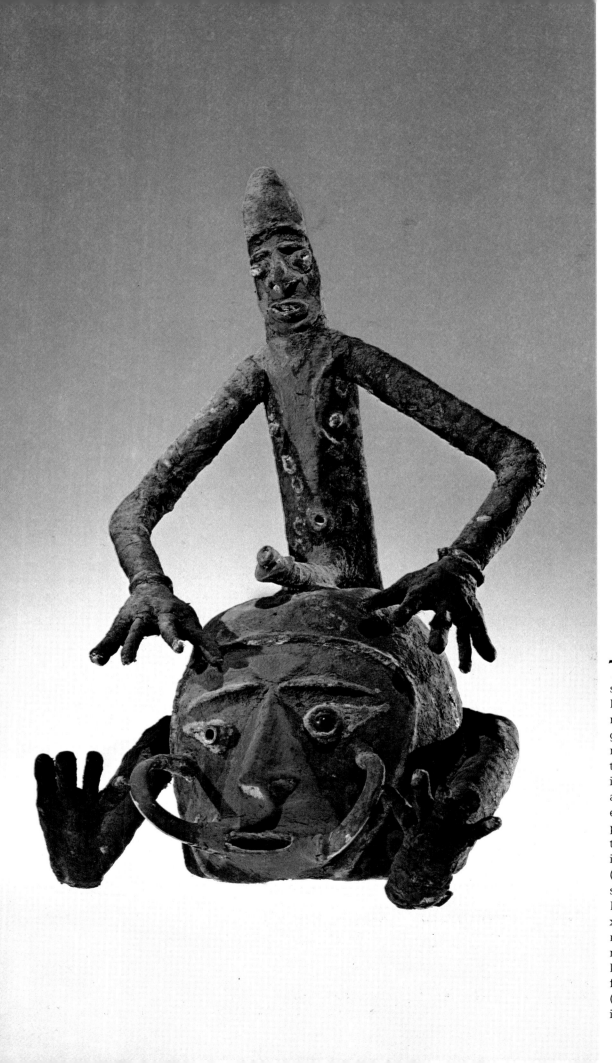

The most important social formation in the New Hebrides Islands is a men's society, with many grades through which men rise during their lifetimes. This society was invented by a cannibal ancestral woman. In an elaborate mask, left, partly modeled from vegetable matter and clay, she is shown carrying her son (or her husband) on her shoulders. At right, the Mexican god Macuilxochitl—Lord of flowers, music, and dance—is represented in a brilliantly painted ceramic figure by the Mixteca (A.D. 1250—1500), found in Oaxaca.

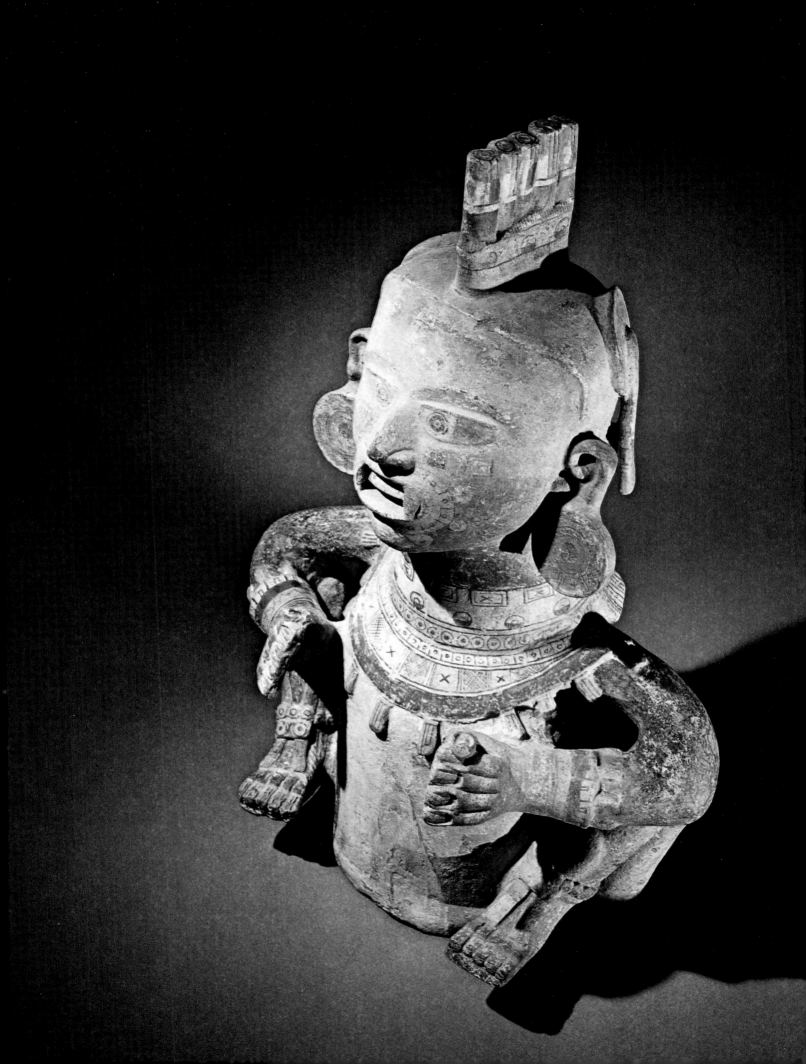

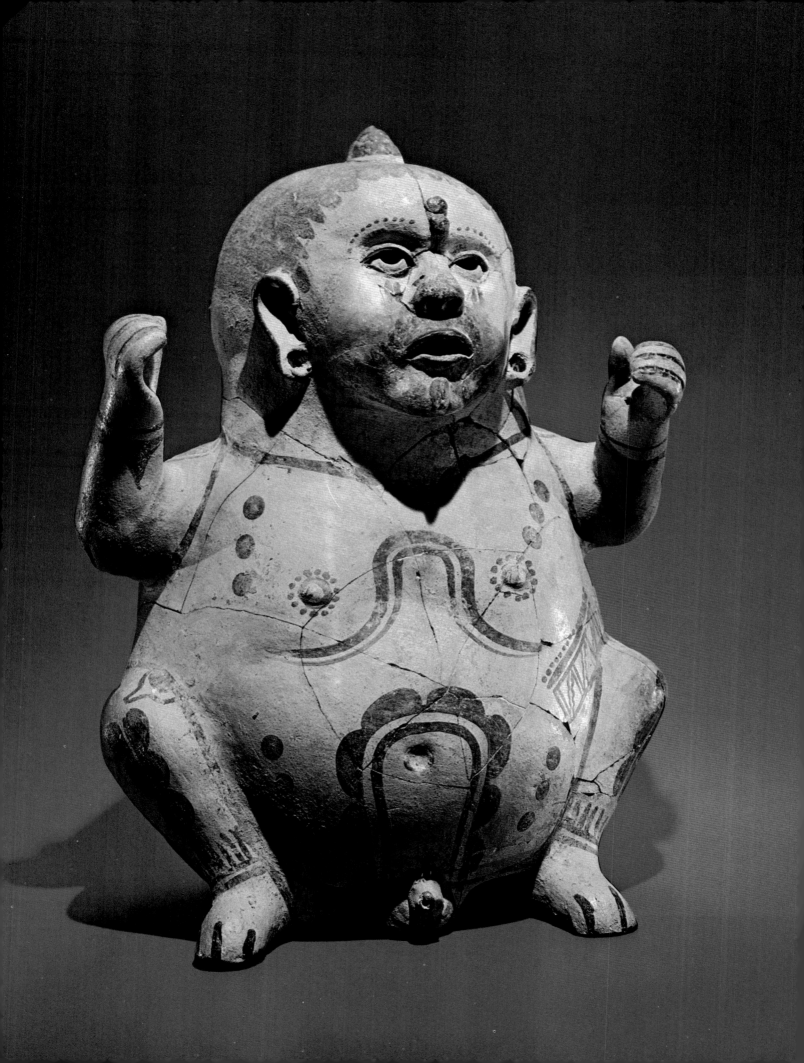

The obese figure, left, is a ceramic vessel
made by the Huastec people of northern
Veracruz about A.D. 1400—1500. The
strangely infantile form is ornamented with
beads between the brows and on the lower
lip, and is covered, apparently, with body-
painting designs. Like the fat babyish fig-
ures of the Olmecs, it hints at a strange
divinity. A vessel, right, from the state of
Colima, Mexico (A.D. 100—600), represents
a seated hunchback gesturing: he is thought
to be a shaman under the influence of hallu-
cinatory drugs.

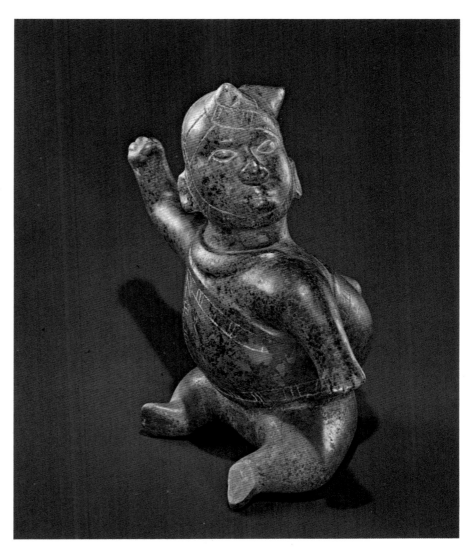

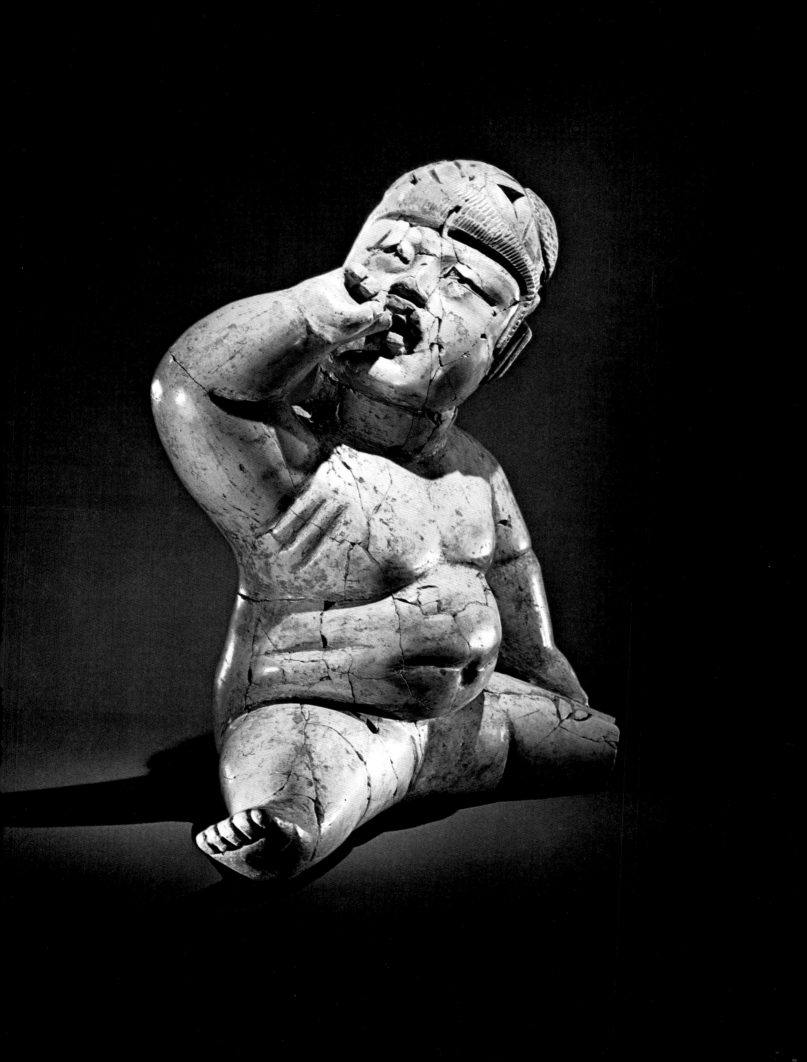

Another vessel from Colima (A.D. 100–600), right, may represent an extremely accomplished acrobat or, again, it may be a reflection in ceramic of a visionary state. A number of white-slipped ceramic figures in Olmec style are from central Mexico, and date from about 800 to 300 B.C.; the large one at left is a helmeted being, obese and sexless, with head thrown back as it sucks a forefinger. From the site of Las Bocas in the state of Puebla, it is thought to be a major deity of the Olmecs, one of the children of a human mother and a sacred jaguar father. Such deities governed the sky's manifestations—thunder and lightning.

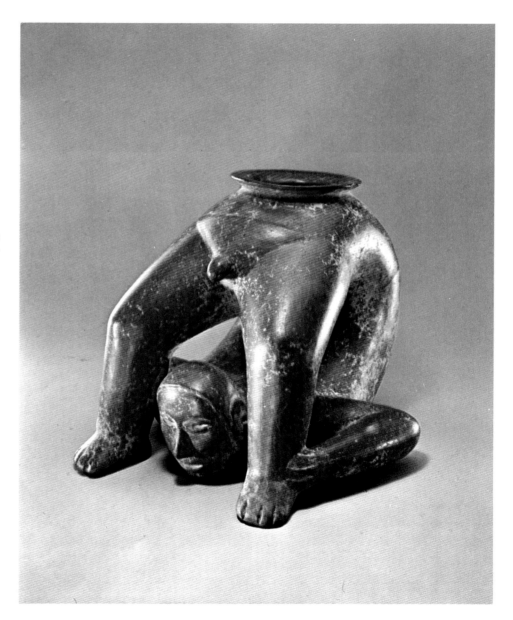

The figure from the Palau Islands in Micronesia, below, was originally set in the gable of a men's gathering house. Such figures represent a woman named Dilukai, who was strapped into this position, according to legend, for spreading disease among the people. Figure sculpture is otherwise rare in Micronesia; but similar figures are also found in the Sepik River area of Papua New Guinea—where they represent honored ancestral women. Another such woman, right, is shown on a Sepik suspension hook, used for hanging up valuables. Here she is in the act of giving birth to a catfish—an important totemic creature as well as a staple food in the area.

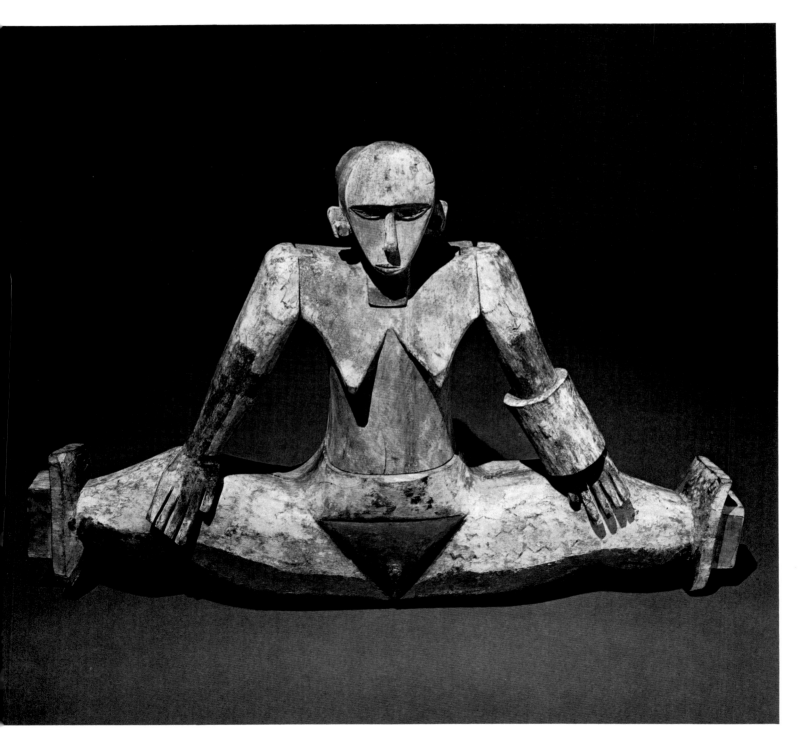

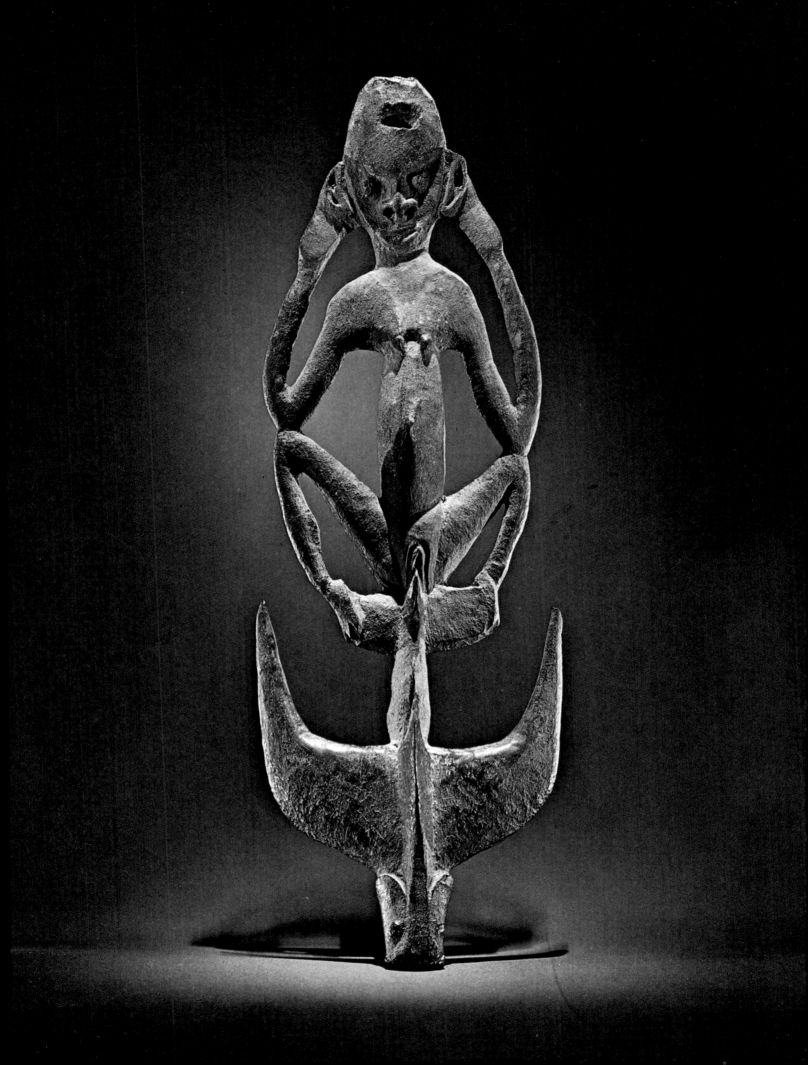

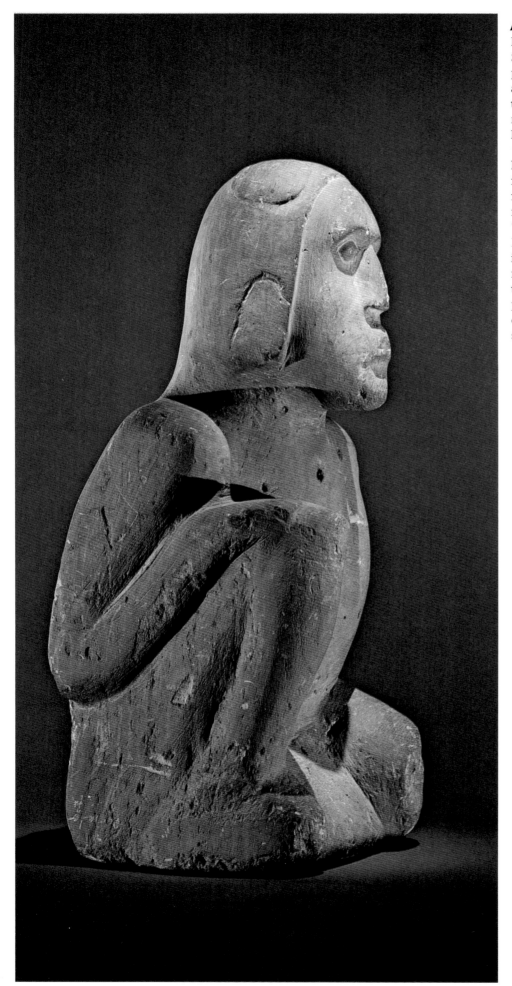

A number of stone figures, left, have been found in the southeastern United States, some in burials, and usually in pairs. It has been suggested that they are cult figures or possibly memorials to individuals. They date from approximately A.D. 1200–1600. A wooden beaker, below, carved about A.D. 600–1000 with low-reliefs of falcon-headed running messengers, comes from the south coast of Peru. Similar figures are shown on the famous monumental portal at the site of Tiahuanaco. The sculpture of the Kongo of Zaïre is often remarkably free in pose, as in the male fetish figure at right. These figures usually represent the spirit of a dead person, and can be protective or malevolent. This one is capped with a small wad of magical substances, including animal teeth.

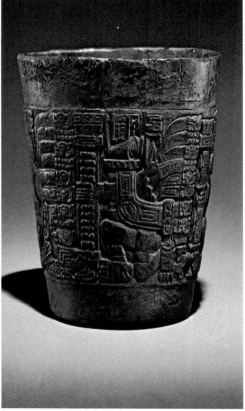

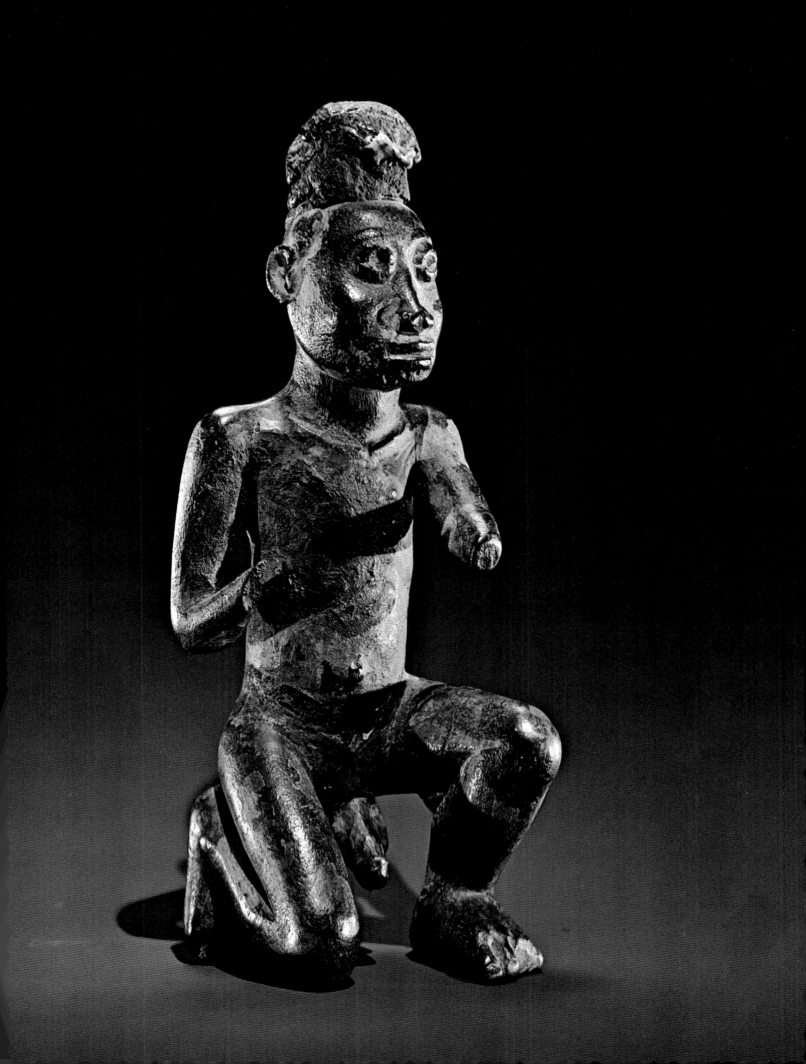

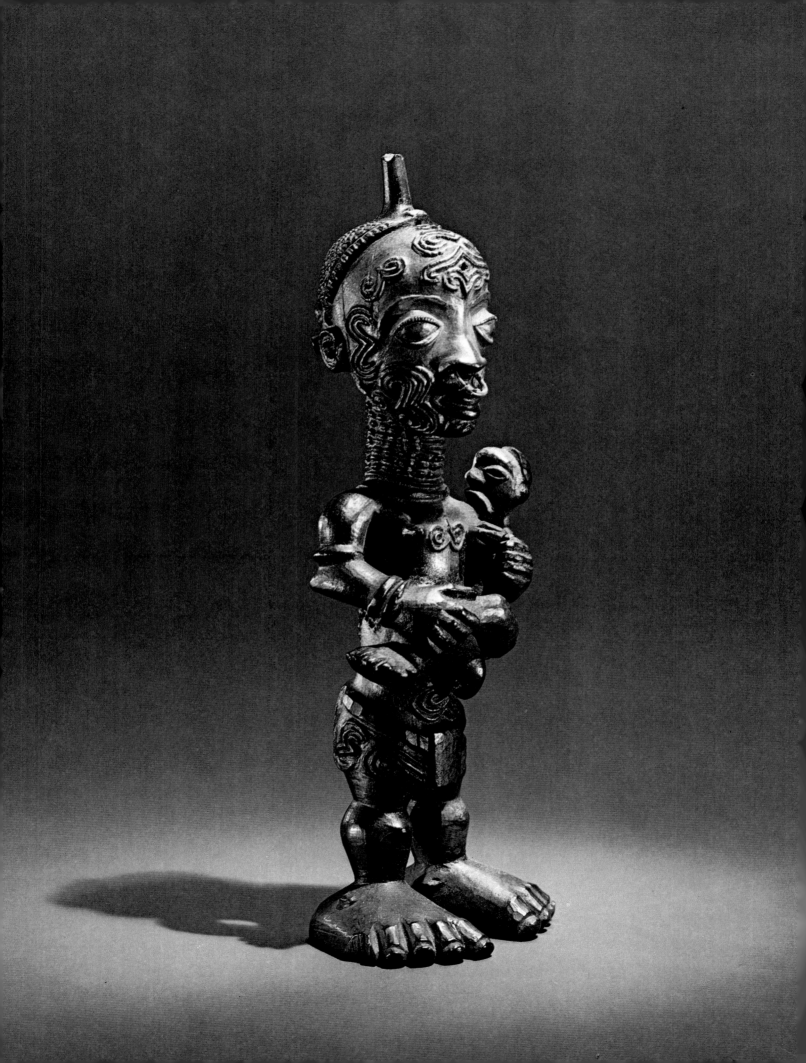

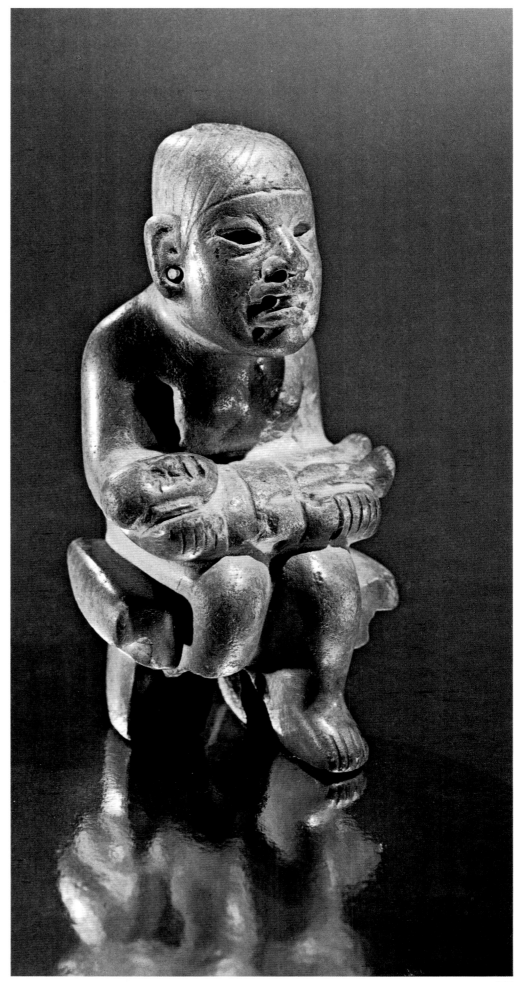

A child is the element that links these two groups, different as each is in intent and style. The mother, left, from the Bena Lulua tribe of Zaïre, covered with the raised ornamental scarification of her people, holds in her arms her human baby. On the other hand, the child supported by an enthroned youth at right is probably an infant god, or— judging by the stiffness of its limbs —the image of such a god. It is a stone carving by the Olmec of Mexico (1200–400 B.C.).

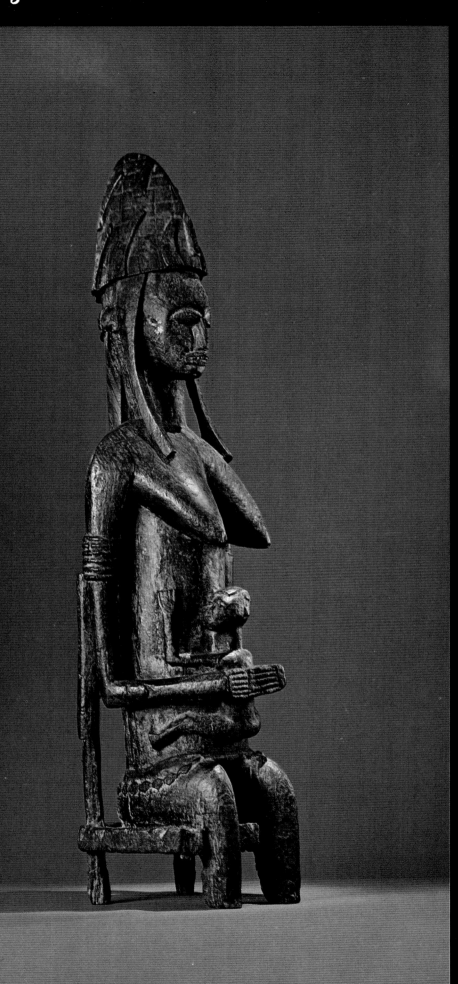

Groups of mothers and children are among the most powerful images in all art, in all countries: they usually seem to convey solemn overtones of religious significance, or at least of mythological power. Chieftains from the Bamana of Mali are both men and women, seated on high-backed stools wearing high headdresses. Some of the women, like the figure at left, carry children, perhaps in reference to fertility. A child is also held, right, by the priestess of Shango, the god of thunder among the Yoruba of Nigeria, whose emblem she wears on her head. The child probably symbolizes the fertility with which Shango rewarded his female devotees. The woman and child below were once part of a post in a chief's house at Lake Sentani, Irian Jaya (West New Guinea).

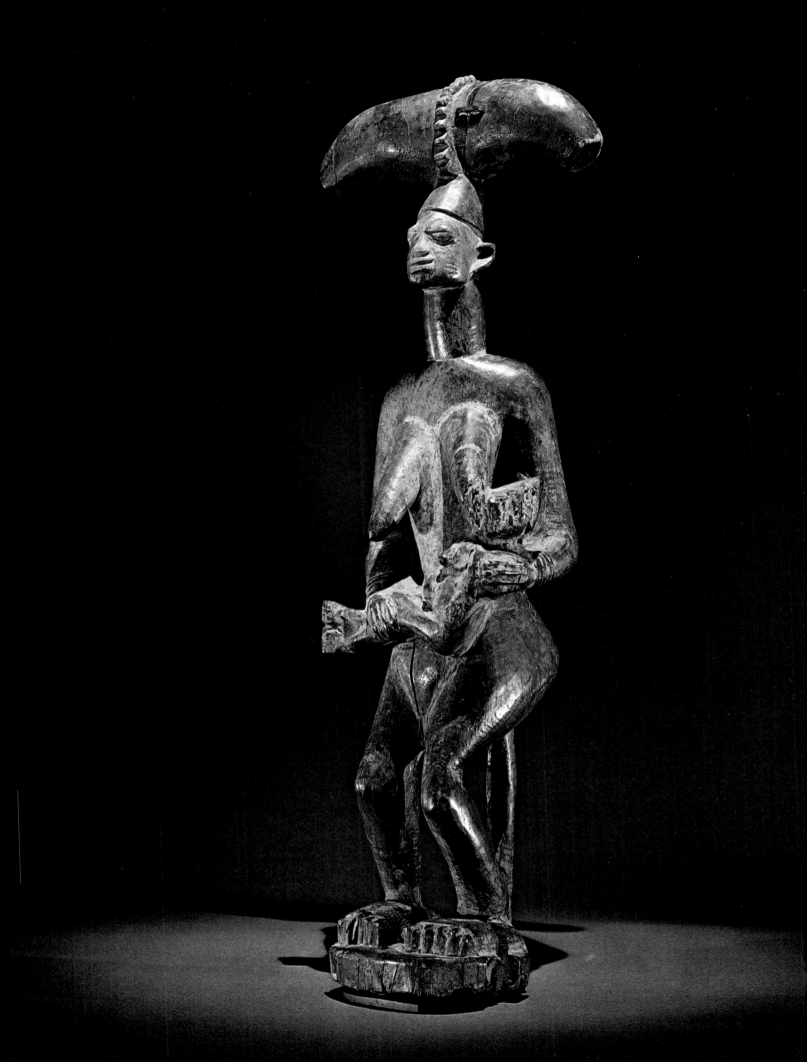

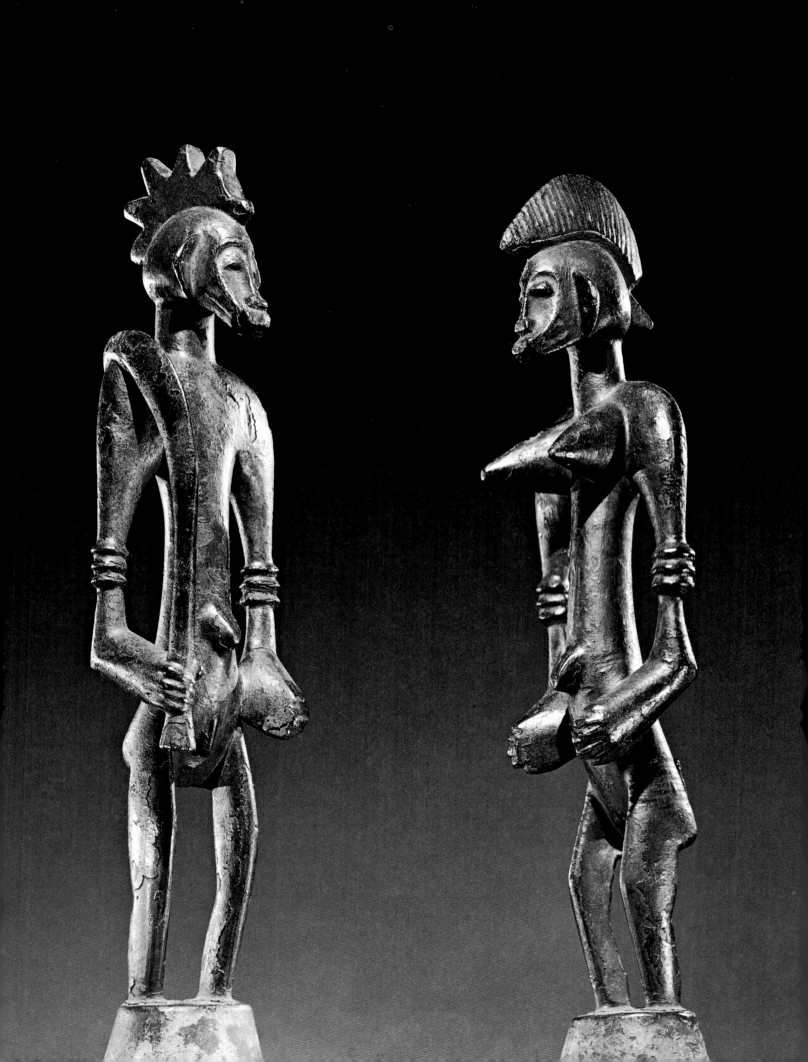

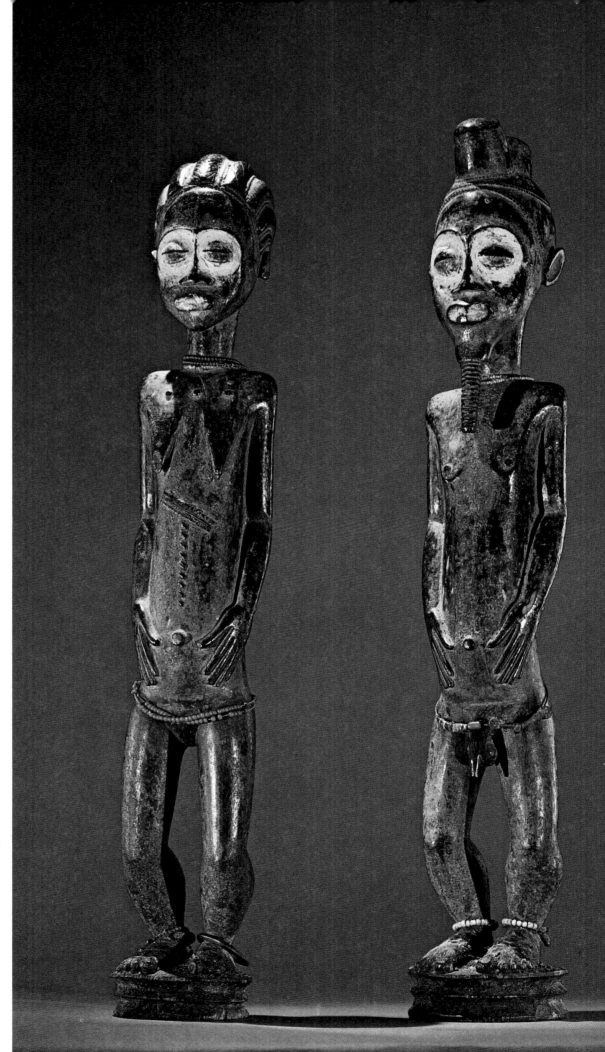

Ancestral figures, naturally enough, are often made in pairs and represent specific couples. They are sometimes even revered as the repositories of the ancestral spirits. These pairs are from the Senufo, left, and the Baule, right, both of the Ivory Coast. In each case, the pair shows such close internal affinities that it seems almost certain both pieces are the work of a single sculptor.

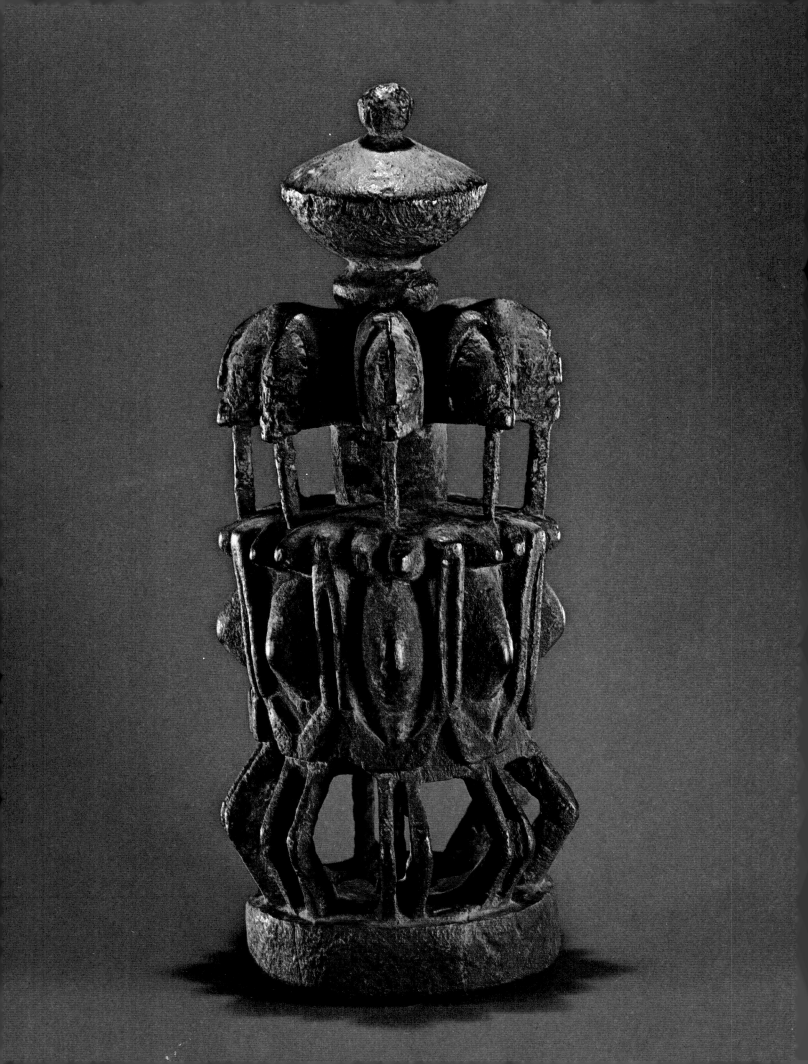

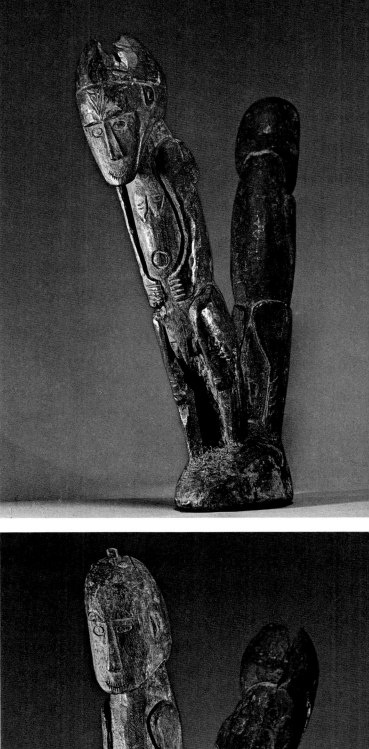

The stools of the Dogon of Mali consisted of two discs united by a column: this symbolized the sky and earth united by a tree. The ritual object at left, though certainly not a stool, retains something of the same imagery. Here four bearded pairs of hermaphroditic ancestral spirits stand on a disc, and support on their heads, by way of a single columnar neck, a covered bowl. An ancestral couple at right, leaning outward from a single base, was once the top of a decorative pole in a chief's house at Lake Sentani, Irian Jaya (West New Guinea).

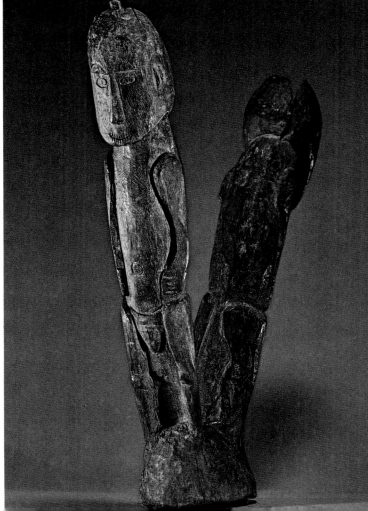

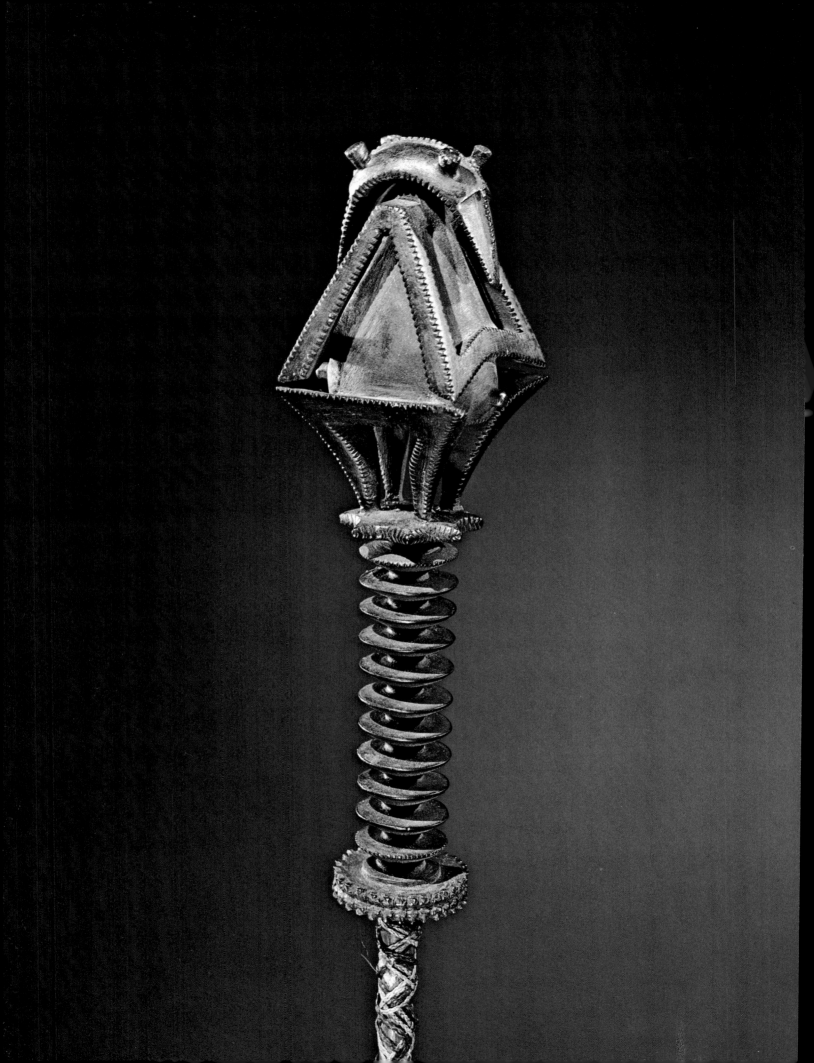

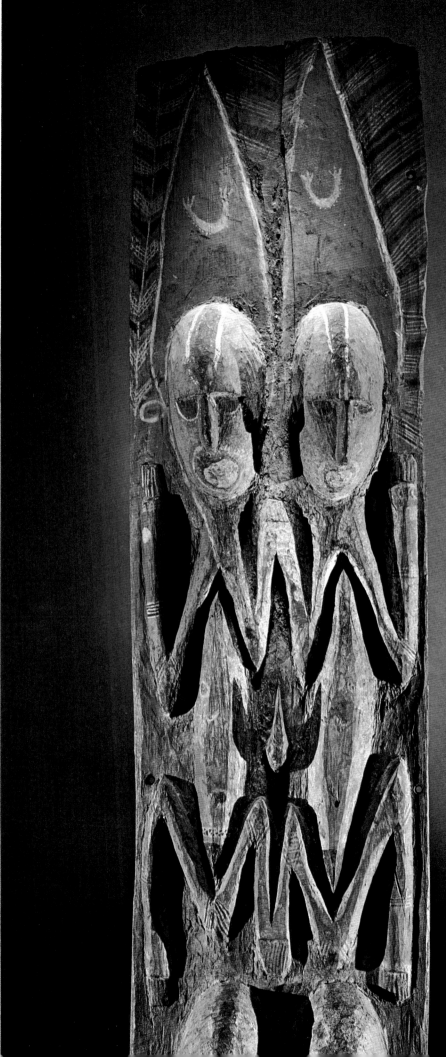

The theme of duality is frequently a subject of Pacific art. On the handle of a fly whisk, left, carved in the Austral Islands, a seated god is shown as a double being sharing a single body. Two ancestors of the Abelam tribe, right, appear on a board from a ceremonial house, wearing high triangular feather headdresses. The beak of an ancestral bird appears between them.

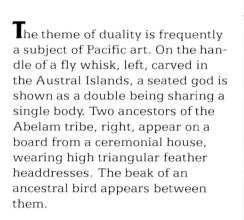

Overleaf: A bottle, above left, from the south coast of Peru, of the Paracas Necropolis period (200–100 B.C.), shows two personages, perhaps engaged in combat. On the sides of another bottle, below left, from Peru (A.D. 200–500), two figures from Mochica mythology, one with the head of a frog, converse. A lintel from a Late Classic (A.D. 600–900) Maya temple bears a relief of an enthroned lord of the city Yaxchilan; he is receiving incense, a feathered headdress, and other gifts from a pair of nobles.

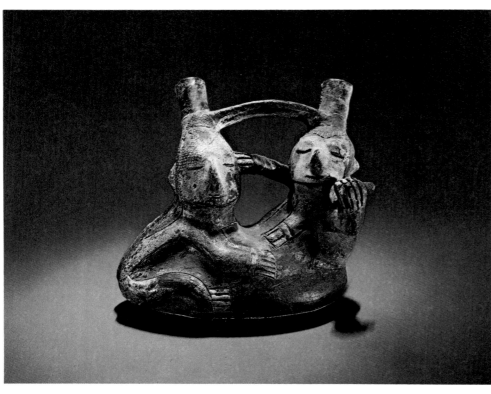

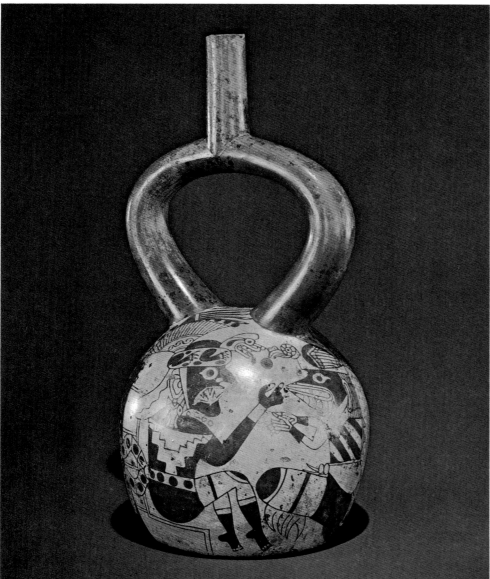

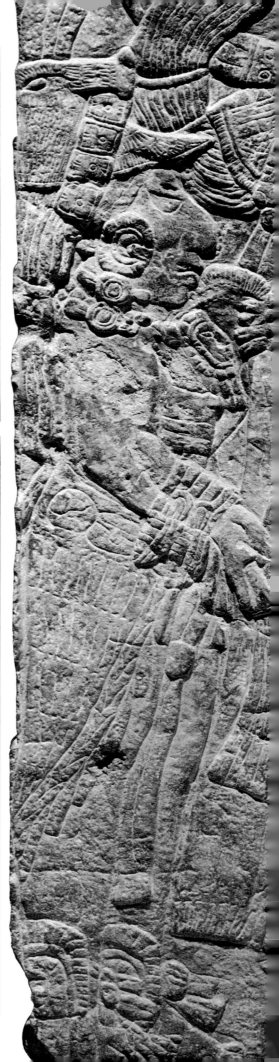

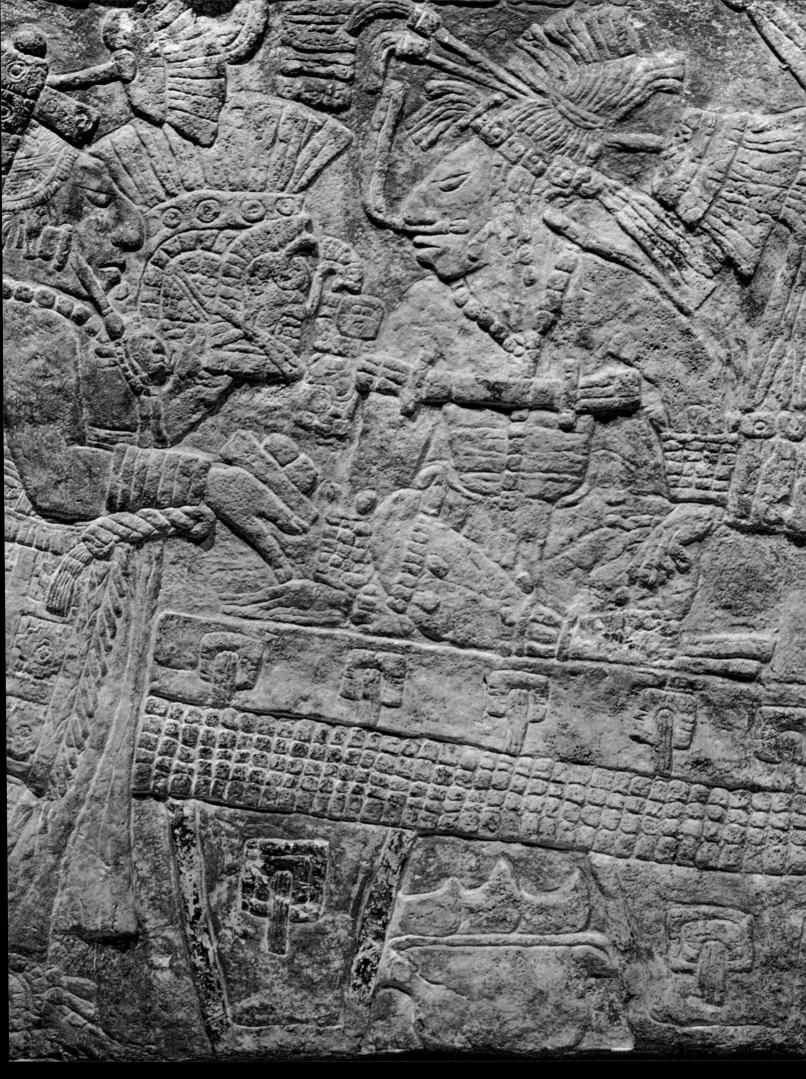

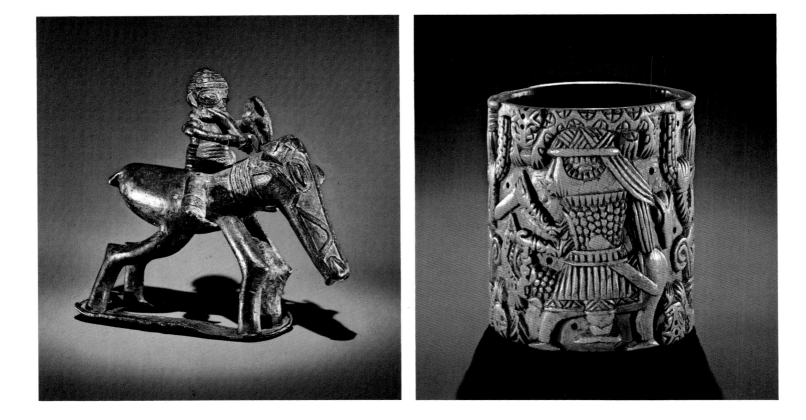

Brass (or bronze) works from the Lower Niger River
exist that may be to some extent contemporary with
those from the city of Benin (some indeed were found
there), but differ radically in style. Hence the contrast
between the Lower Niger-style horseman, above left,
and the plaque from Benin City, far right, which adorned
a pillar of the palace in the sixteenth to seventeenth cen-
tury. The ruler himself is seen, riding sidesaddle, sup-
ported by the hands of two retainers while being protec-
ted from the sun's glare by the shields of two others. The
ivory bracelet, center, also from Benin, dates from about
a century later.

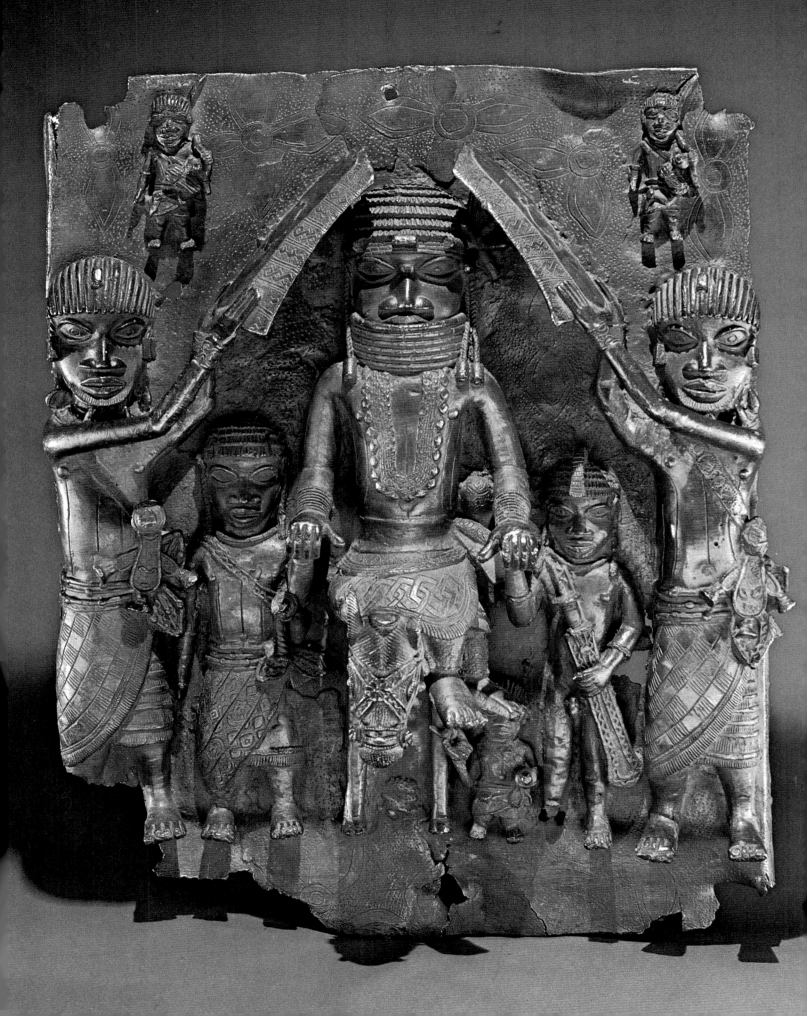

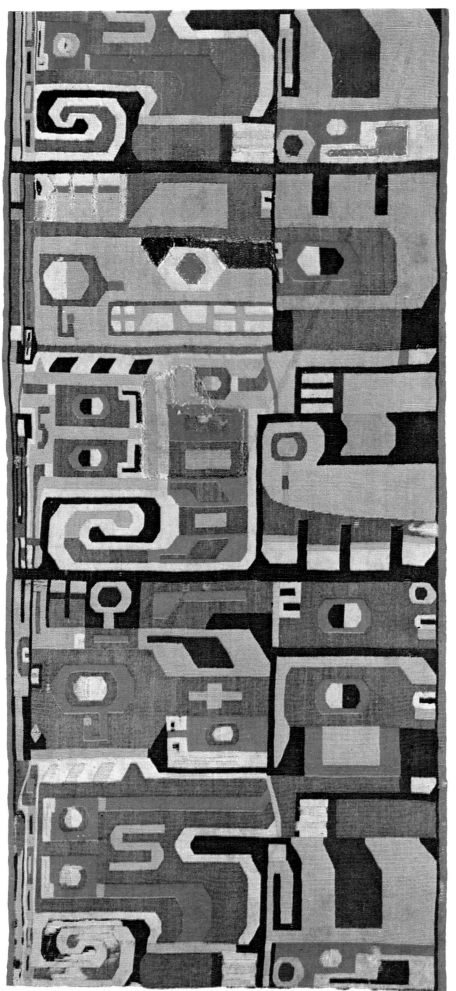

The Coastal Huari fragment of a poncho at left embodies a technique of design layout much practiced by these people in Peru about A.D. 700–1000. In spite of its apparent complication, it has a single motif, reversed in alternate registers. This is a feline-headed figure, holding in each hand a human-headed staff. The design is distorted by expansion on the right, and extreme compression on the left. A man (or spirit?) riding a dog is the subject of the Kongo fetish from Zaïre at right. The mirror set in the figure's belly seals in magic substances and, by reflection, deflects malign influences. The upraised hand probably held a weapon designed to inflict harm on enemies.

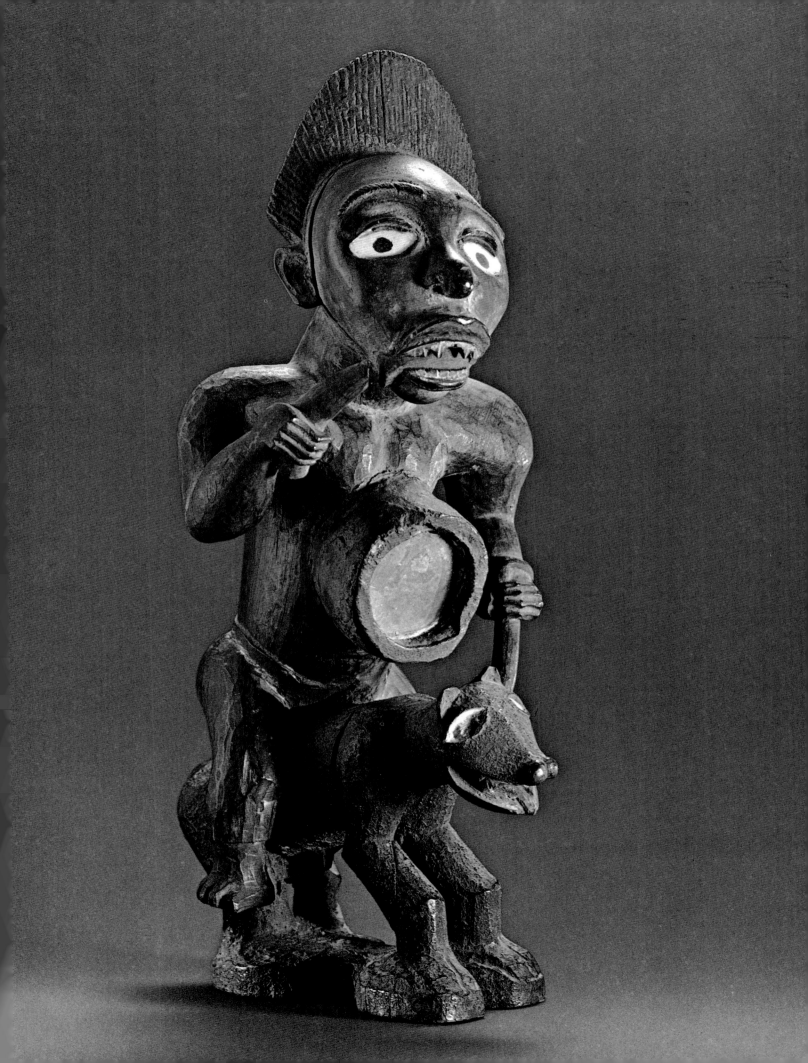

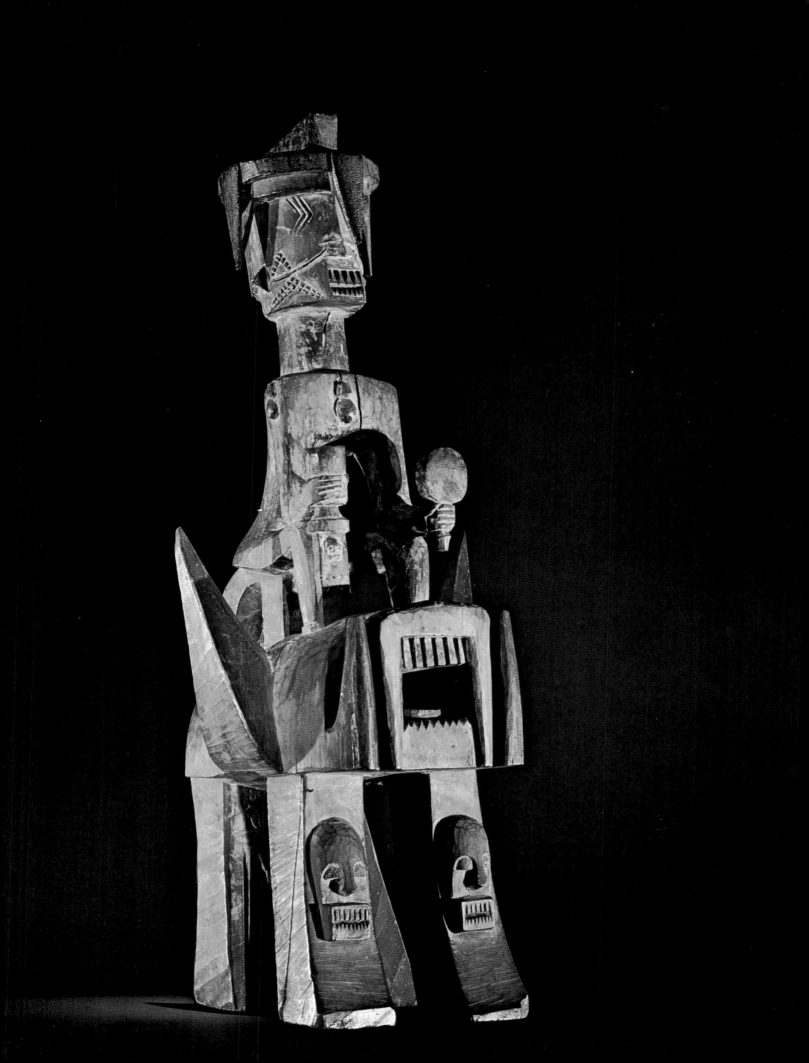

In southeast Nigeria, several tribes practice cults devoted to each man's own right hand, as the symbol of his aggressiveness and skill. A hand-cult figure from the Ijo of the Niger Delta, left, shows the owner, seated on a stool and carrying a fan and a libation cup, mounted on the back of a fanged and horned monster. Thus he rides a projection of his own aggression, which is more than sufficient to ward off aggression against him. Large covered bowls, right, carved for priests of the Dogon of Mali, were used to contain meals of mixed mutton and donkey meat eaten ritually at harvest time. The priest, mounted on his donkey, is carved on the top; the pattern on the barrel of the bowl may symbolize the ripe fields of millet.

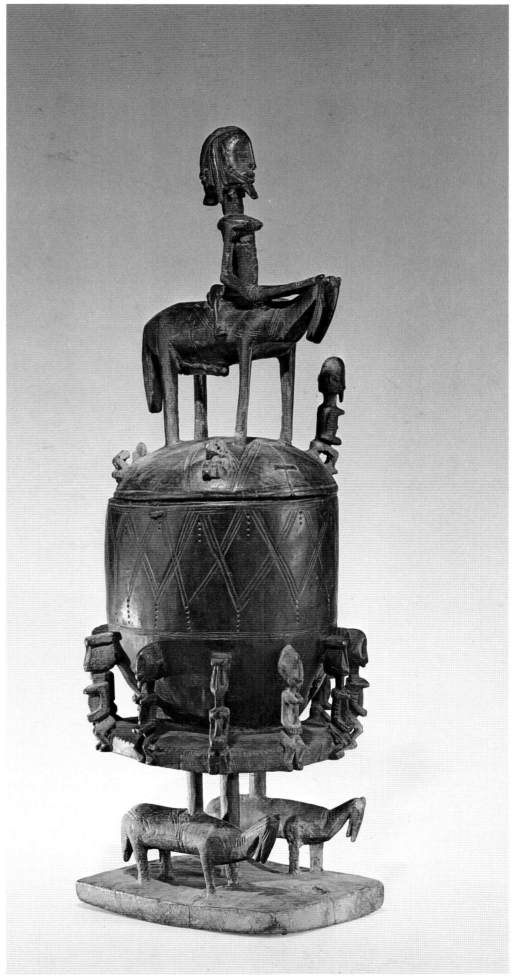

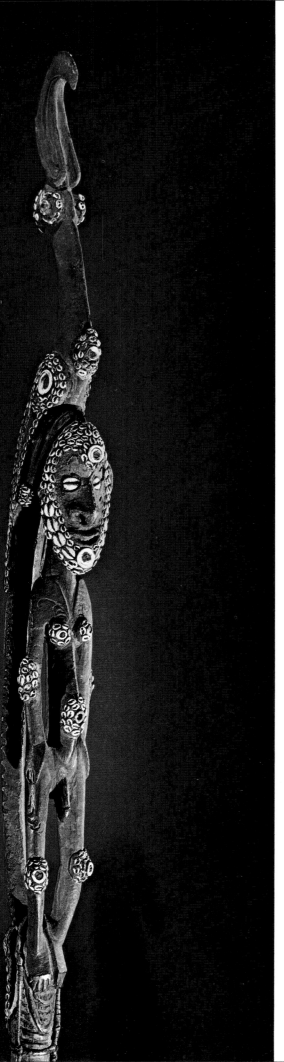

Animals and birds as companions or lords of mankind figure in these three objects. The eagle, left, holding and towering over a human figure—a carving attached to a sacred flute of the Sawos people of Papua New Guinea—illustrates the conception of man and bird as two aspects of a single supernatural being. In a ceramic group, below, by the Recuay culture (300 B.C.—A.D. 700) of Peru's Central Highlands, a richly dressed warrior escorts a young llama —perhaps to sacrifice. A double-chambered vessel, right, shows a mythological scene of the Early Classic Maya (A.D. 300–600) in which, at the top, a dignitary kneels before a monstrous birdlike creature, and an animal clambers up the side.

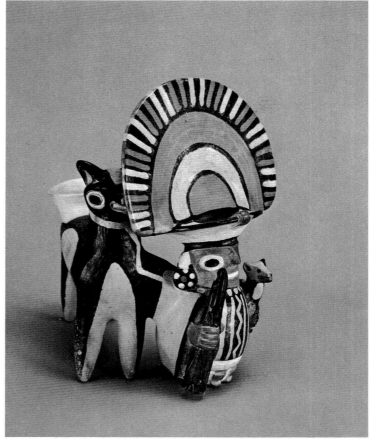

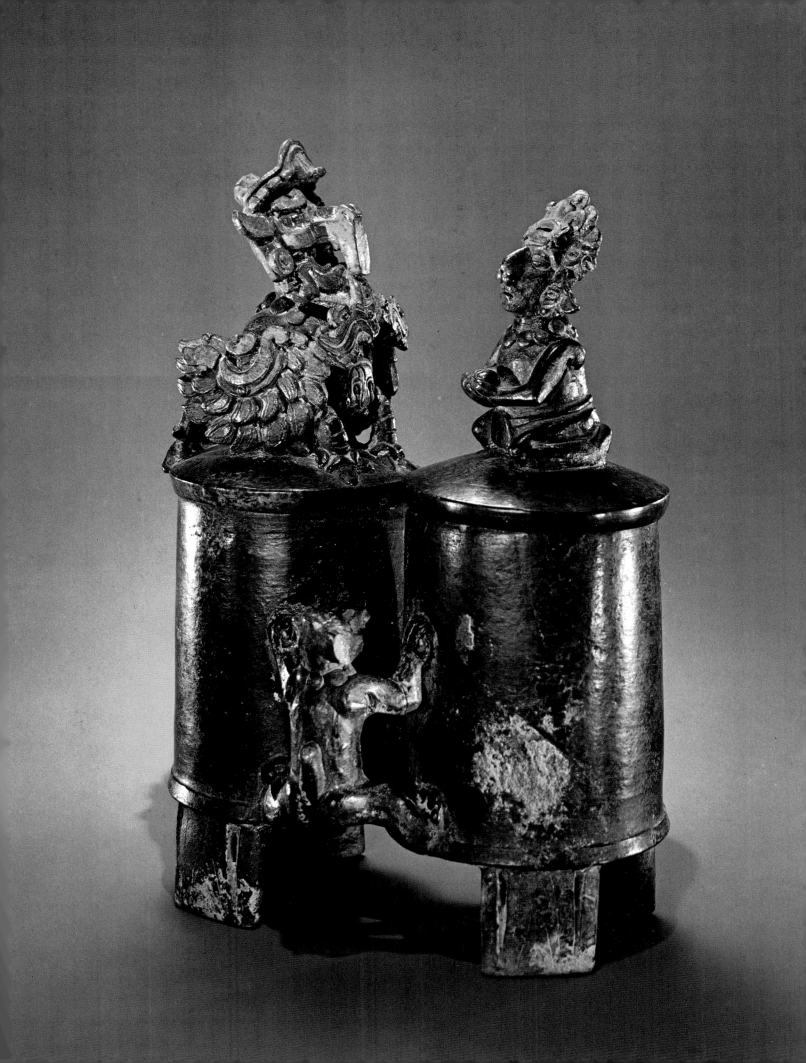

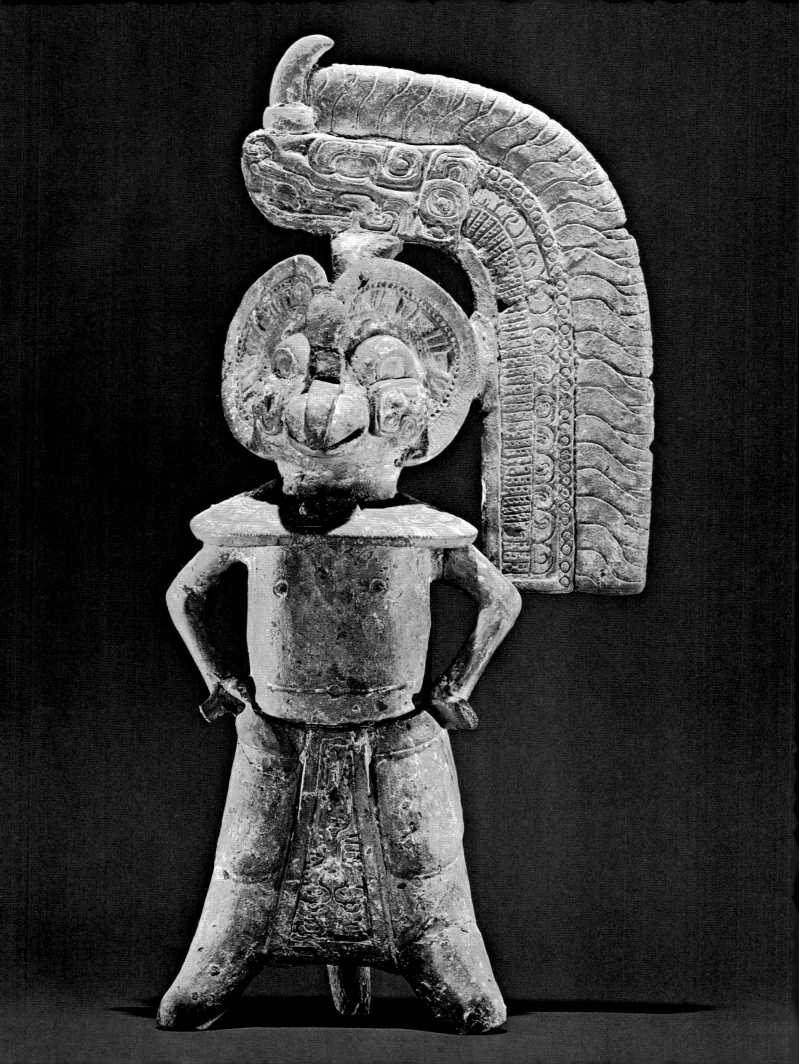

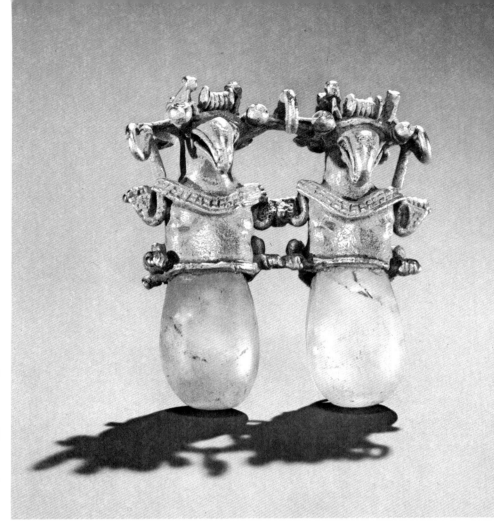

Many ceramic objects from Precolumbian America are whistles elaborated into human or animal form. The owl-headed human figure, left, wearing a huge feather panache, is one; it is from Classic period Veracruz (A.D. 300–900). Other bird-headed figures in gold, above right, form the mounts for quartz jewels on a pendant in Coclé style (A.D. 800–1200) from Panama. The Mochica vessel, below right, in the form of a bird-headed human holding another vessel, is from Peru (A.D. 200–500).

Overleaf: The fabrics woven in wool and cotton by the Coastal Huari of Peru (about A.D. 600–1000) are remarkable for a sternly geometric design based on representational elements. Some show recognizable creatures, such as the four crowned "felines," far right, carrying decorated staffs in their paws. In others, far left, the design is stylized to the point of incomprehensibility, though such features as eyes can be recognized. A mythological monster, below center, in semi-human form from Parita in Panama (A.D. 1100–1500) is cast in gold and served as a mounting for a tooth now restored. A jade celt or ax blade, above center, from the Olmec of Mexico (about 1200–400 B.C.) shows an incised head of a god.

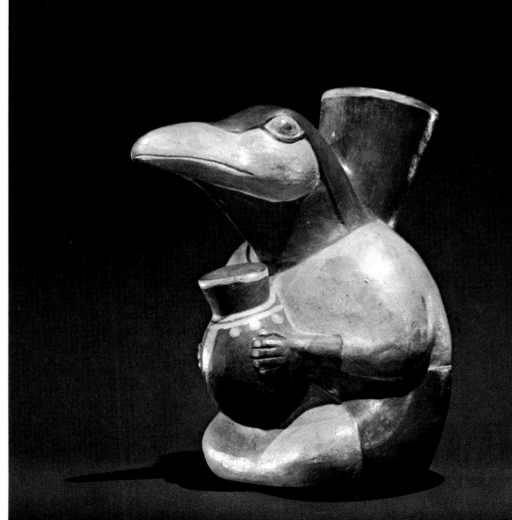

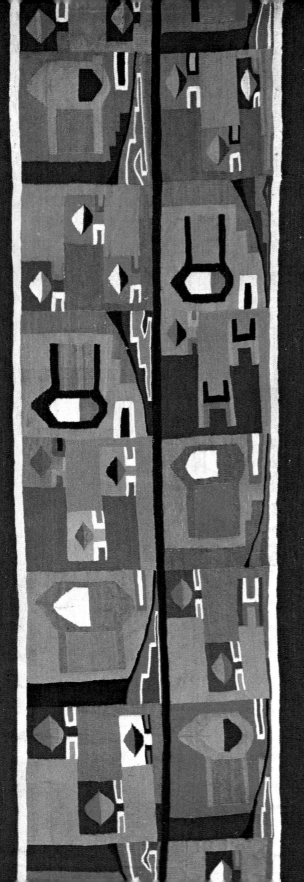
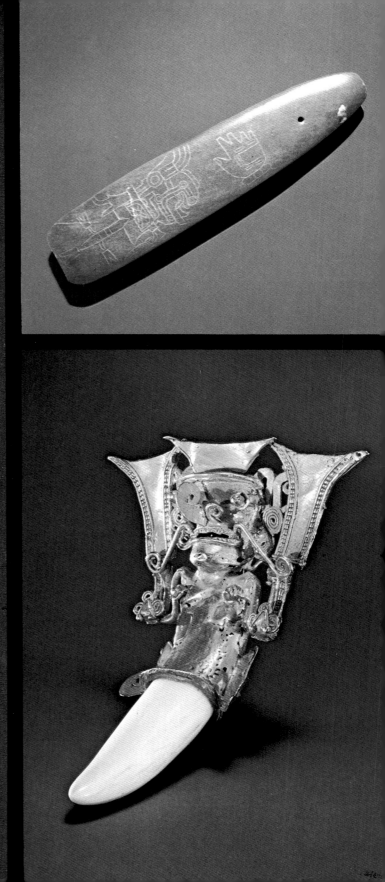

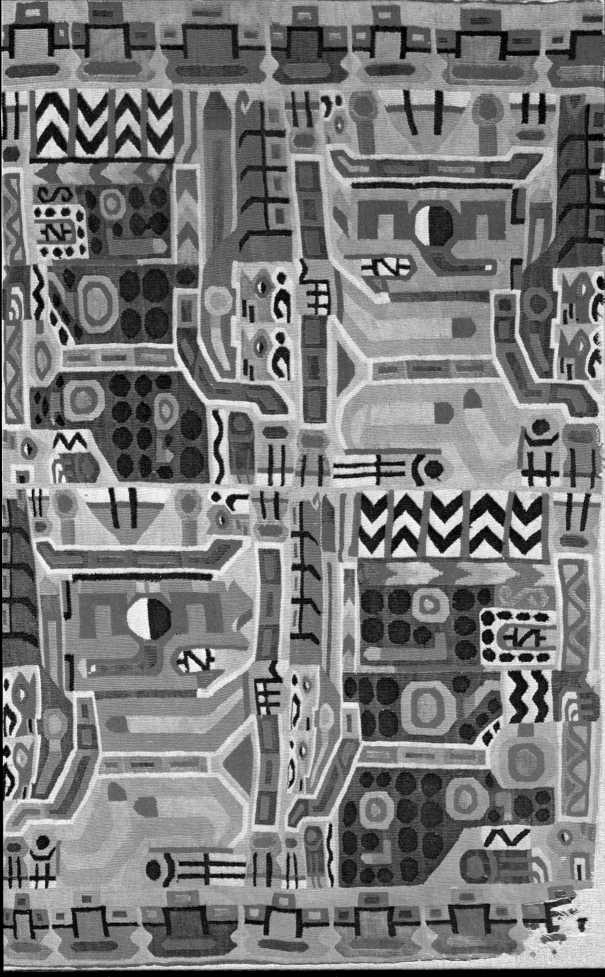

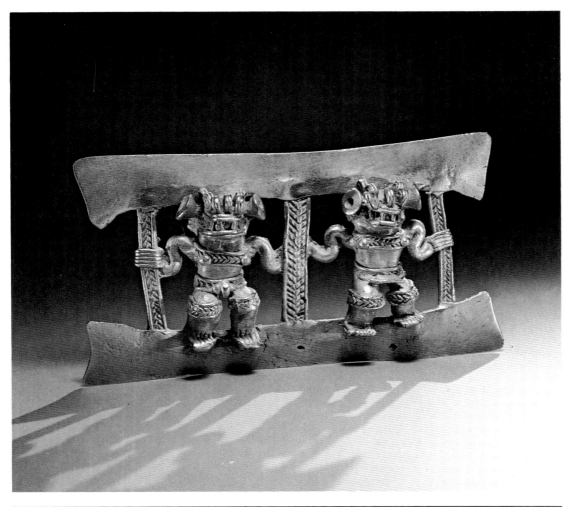

A god—or gods—with human body and crocodile head must have had an almost obsessive importance to the Precolumbian people of Central America. He figures on many of the gold pendants from the region, sometimes incorporated with attributes drawn from other creatures. A pair, above left, and a single deity, below left, of this kind appear on pendants from Veraguas, Panama. Another large single figure at right from Costa Rica is remarkable for its pyrite inlays and jointed neck. All date from about A.D. 1000–1500.

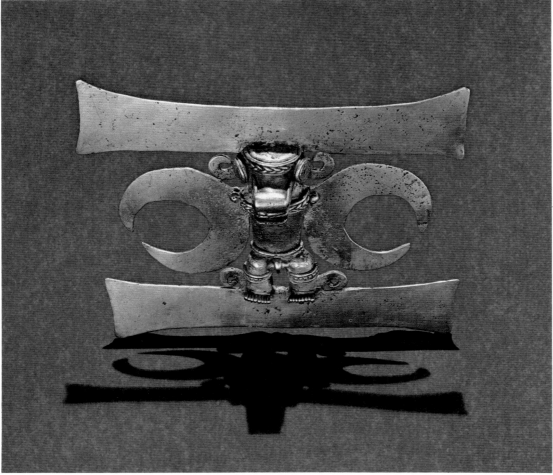

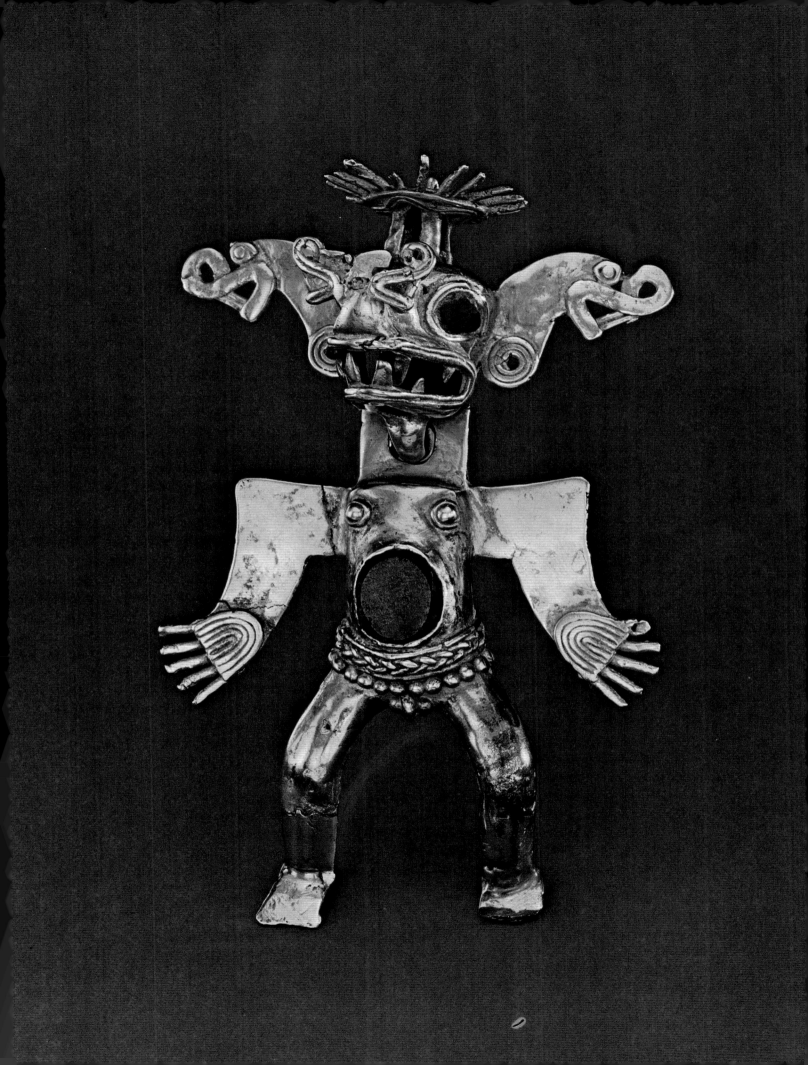

Animals

Animals

It is not without significance that the Bible describes the genesis of the birds, sea creatures, and animals as taking place before the creation of mankind. The story can certainly be read as describing the preparation of the world for Adam, who then establishes his dominion by giving the other creatures names—to name something, or to be able to call it by a name, often represents a claim to power over it. Names are generated not only by the breath of "life"; in many cultures they have been powerful magic spells.

Behind this common interpretation, however, lies an older conception of the world order. Before the time came when they turned into pets and unpaid laborers, or were funneled into controlled preserves and labeled "endangered species," the animals were the true rulers of the world. When the puny population of the human race could have been trampled out of existence under the advance of a single great herd of bison or reindeer, it was clear indeed who were the masters. Mankind knew well enough that the animals were stronger, fiercer, cleverer than themselves, and certainly more beautiful. They would have understood by instinct, even by conviction, the poet Paul Eluard's phrase, "The animals and their men."

It is with eyes attuned as far as possible to this view that we should look at the animals as they are shown by the artists of the primitive world. Many of them show the animals as ancestors of man. The species vary from one part of the world to another, but generally they are not the milder sort.

The jaguar, one of the great feline predators

This double-headed serpent in highly stylized form is a detail from a sampler of embroidery designs worked in wool on cotton from the south coast of Peru (Early Nazca period, 100 B.C.—A.D. 200).

prowls through all the ancient art of the Americas, a fanged and clawed image of terror (page 233). He occurs in a hundred guises as a being of water and the sky, and some of them he seems to share with the coyote (page 225). In Central America he merges with a water monster, the crocodile, which makes many appearances in its own right. The jaguar was seen in many parts of Middle and South America as the begetter of mankind itself.

Indeed it is a measure of their power that animals have often been seen as true ancestors, the real fathers and mothers of long ago. In this case the eating of the animal was often forbidden to his putative descendant. Others were obliged to ask the animal's permission for the hunt in advance and apologized to it for its loss of life afterwards.

Masks in animal form often express this kinship; the man becomes his ancestral beast and re-enacts its deeds. Sometimes he impersonates animals, or animal-like heroes, who taught humanity essential skills. The famous antelope headdresses of the Bambara of Mali (pages 20—21) represent Tyi Wara, a being who taught the secrets of agriculture. Very often in Africa the mask represents not so much the animal itself as qualities associated with it: the wildness of the gorilla, the power of the buffalo. Emblematic features are combined to make from a number of characteristics a synthesis that represents the totality of a god's attributes. It also represents the human being's haunting discontent with his own powers, his longing to make them ever greater.

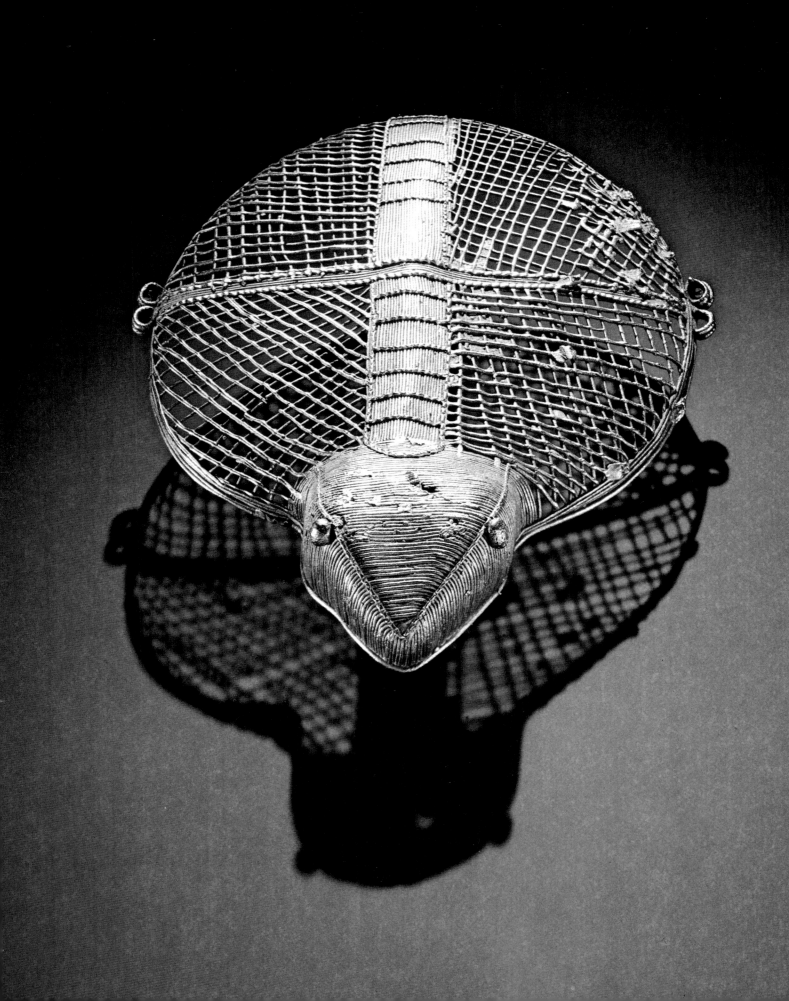

The turtle on the preceding page and the double lizard at right are badges worn by high-ranking members of the Ashanti tribe of Ghana, to whom gold was a semi-sacred material. These metal objects were cast by the lost wax process, which requires a separate model and mold for each. The gold and quartz pendant below shows two fierce images that are ambiguously feline or reptilian. It derives from the great Precolumbian burial site of Coclé in Panama (about A.D. 800–1200).

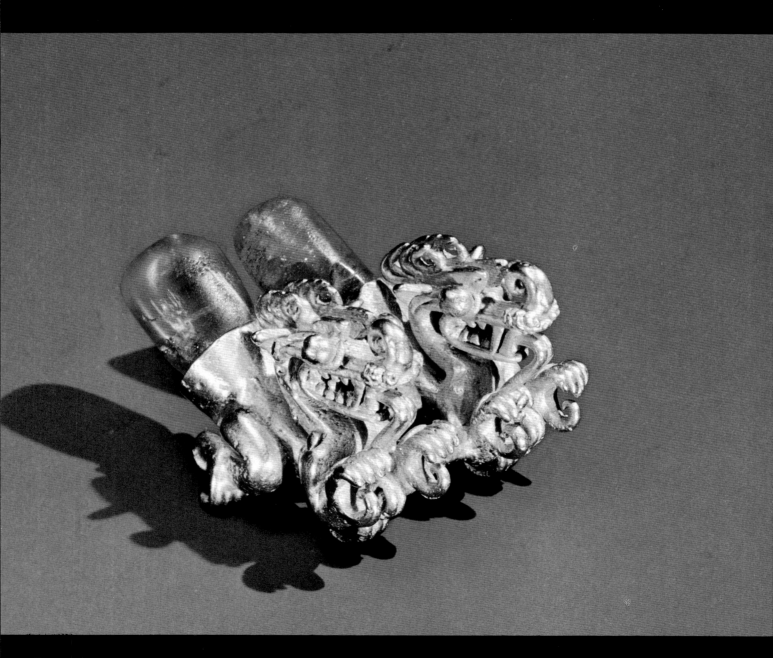

Pages 202–3: This nose ornament of phenomenal size

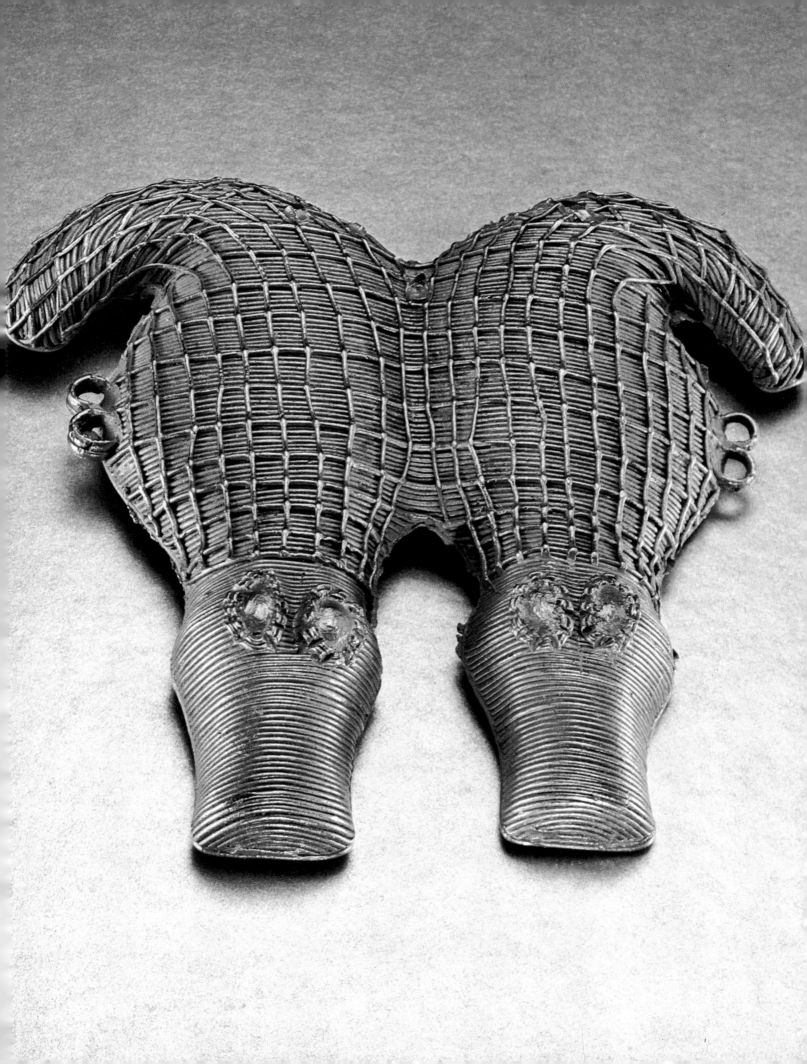

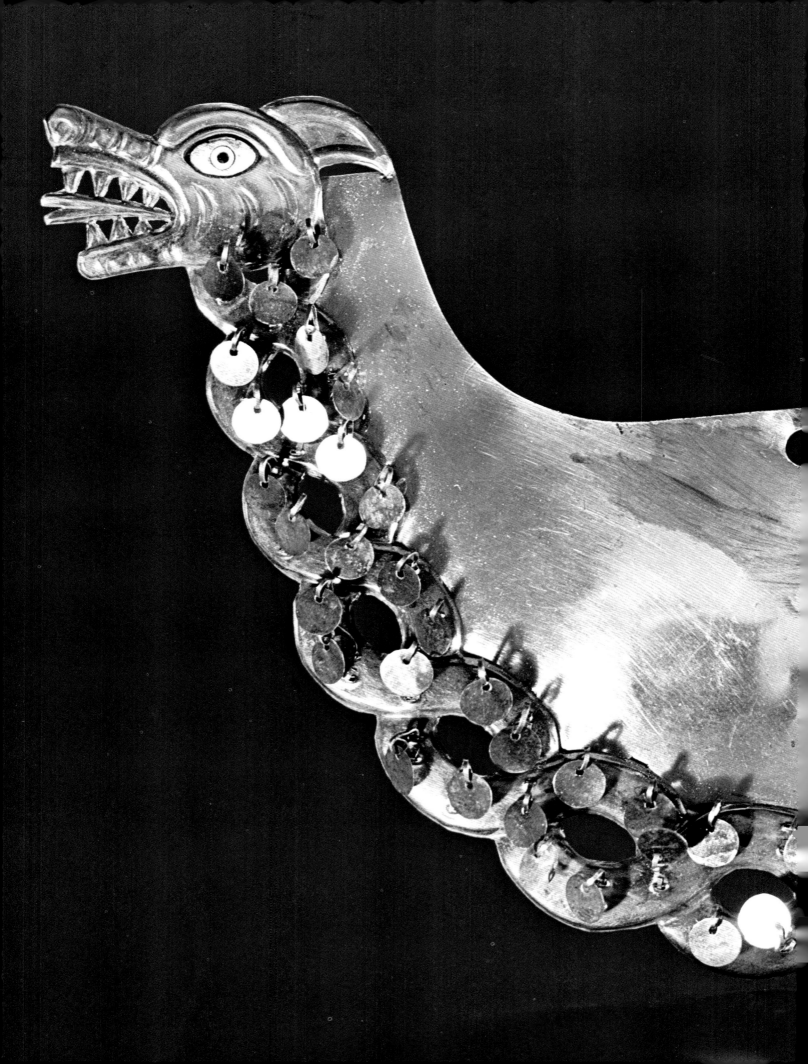

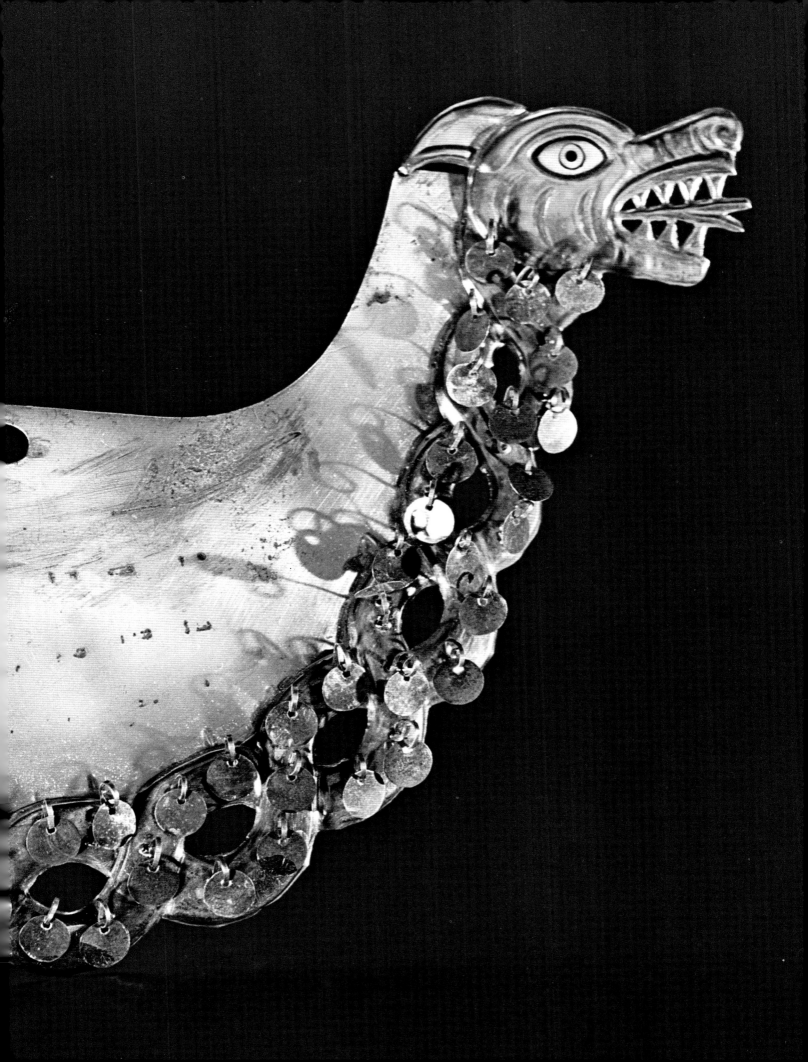

These three works from Precolumbian America show variations on the theme of the reptile. Left, a repeating double-headed serpent design from a Nazca textile from Peru. Above right, the image of the double-headed serpent is repeated, held in the mouth of a frog, possibly illustrating an episode in a myth. This cast-gold pendant from Chiriquí, Panama, dates from about A.D. 1000–1530. Below right, the menacingly coiled stone rattlesnake is from the Aztec Empire of central Mexico, which was destroyed by the Spanish conquerors in 1520. The Spaniards were notably horrified by the live rattlesnakes kept in the temples—this carving itself probably came from a shrine. To the Aztec, the rattlesnake, the "yellow lord" of all snakes, symbolized lightning and the natural cycles of rebirth and renewal.

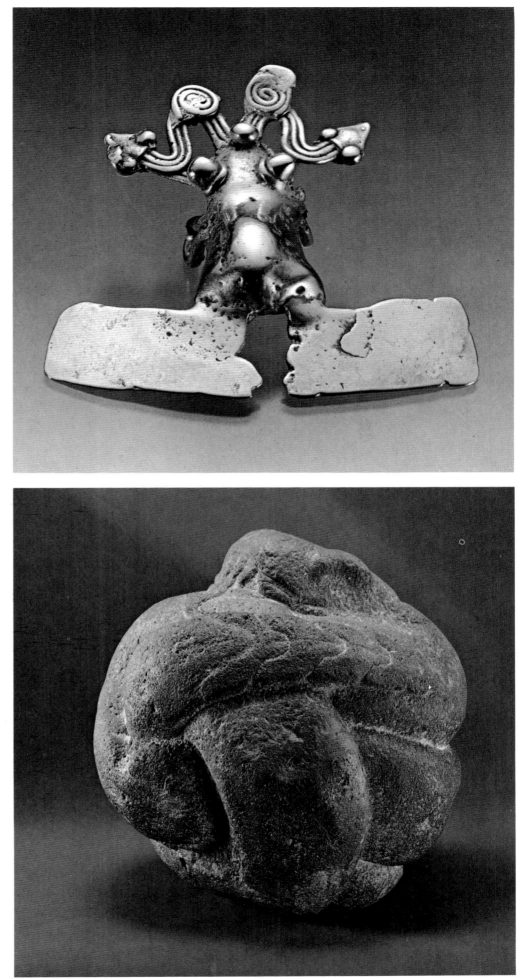

The stone fish, above, with sections of its body and the tail stacked in neat
registers above its head, is from Veracruz (Classic period, A.D. 300–900). It
is a ceremonial version of an <u>hacha</u>, one of the trio of ornaments—the
others being the yoke and the <u>palma</u> —attached to the belt of a player in
the ritual ball game of ancient Middle America. The long-beaked fish at
right is a brass weight used for measuring gold dust by the Ashanti of
Ghana. These were originally made in sets; they often represent all kinds
of creatures, people, or scenes from daily life.

Pages 208–9: Another huge nose ornament on a silver sheet base from the
Loma Negra site in Peru. In this case the applied gold attachments show a
pair of crayfish.

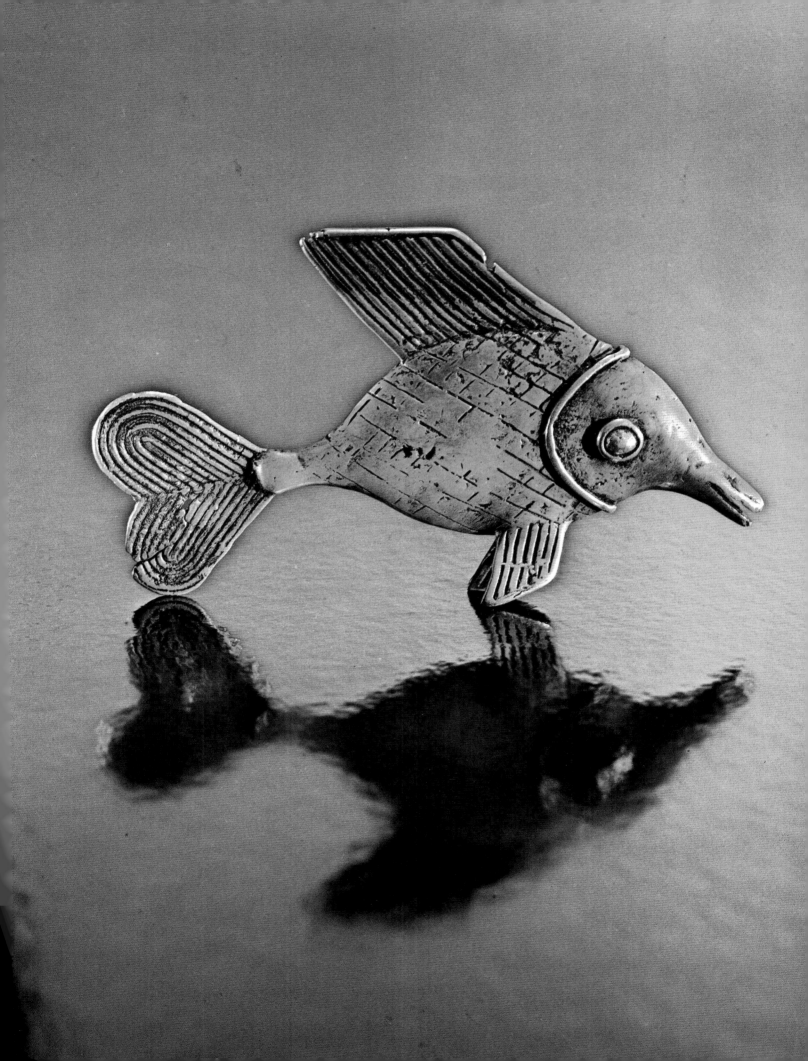

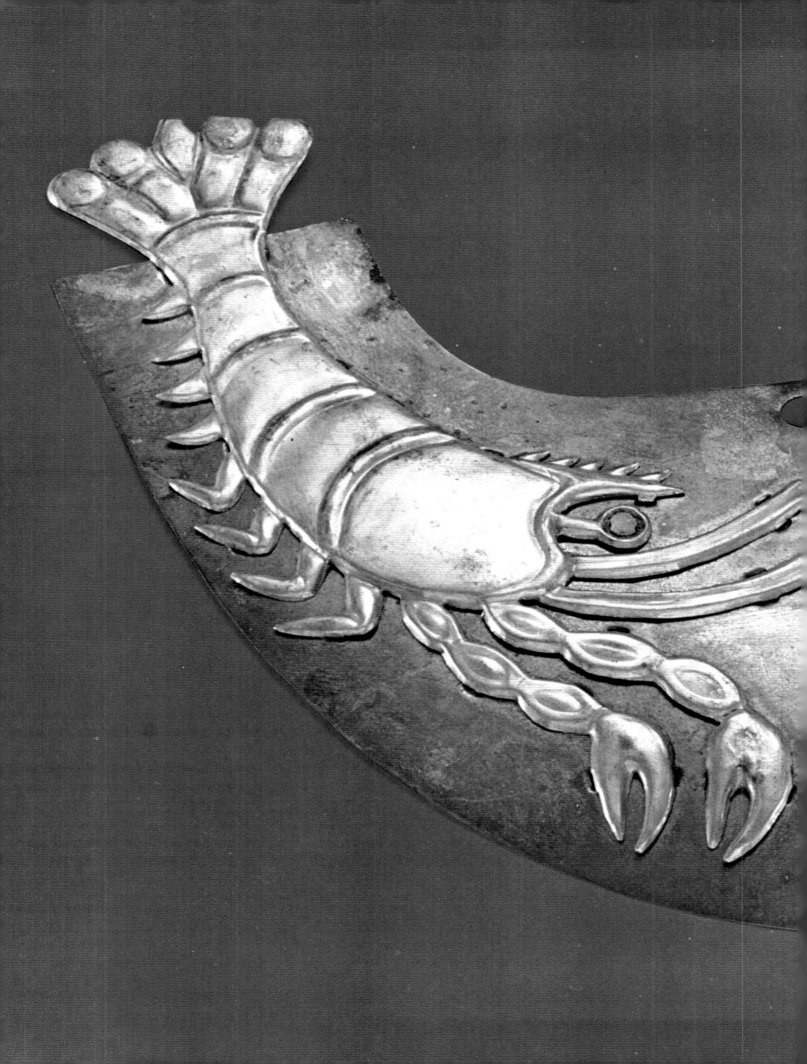

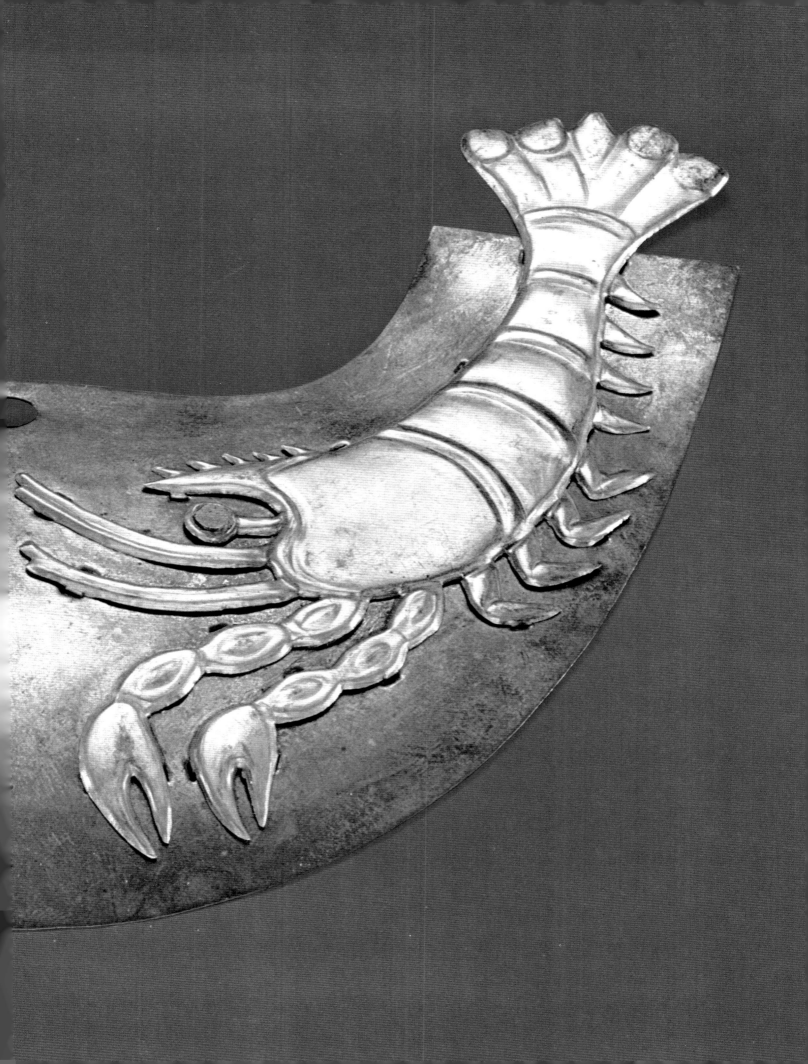

Birds as predators are seen here in two precious objects from different parts of the Americas. The pendant in gold, below, shows what is commonly called an eagle, but in this case really may be a horned owl, grasping in its beak a small animal—probably a jaguar cub. It is in the Chiriquí style of Panama, of about A.D. 800—1500. The piece has been cast by the lost wax process, with the wings and tail subsequently hammered out to thin them. The headdress ornament, right, is from an unidentified Northwest Coast tribe, and dates from the late nineteenth century. Here a hawk, with certain human features about the face, holds between its claws an otter.

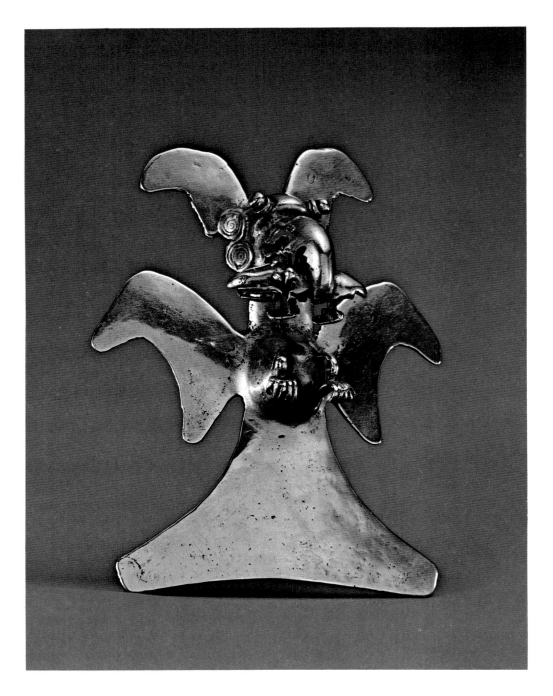

A design of a single bird, repeated in rows facing in opposite directions and in several variations in color (pages 212—13), is part of a panel decorating one corner of a mantle made by the Huari of Peru's south coast about A.D. 600—1000.

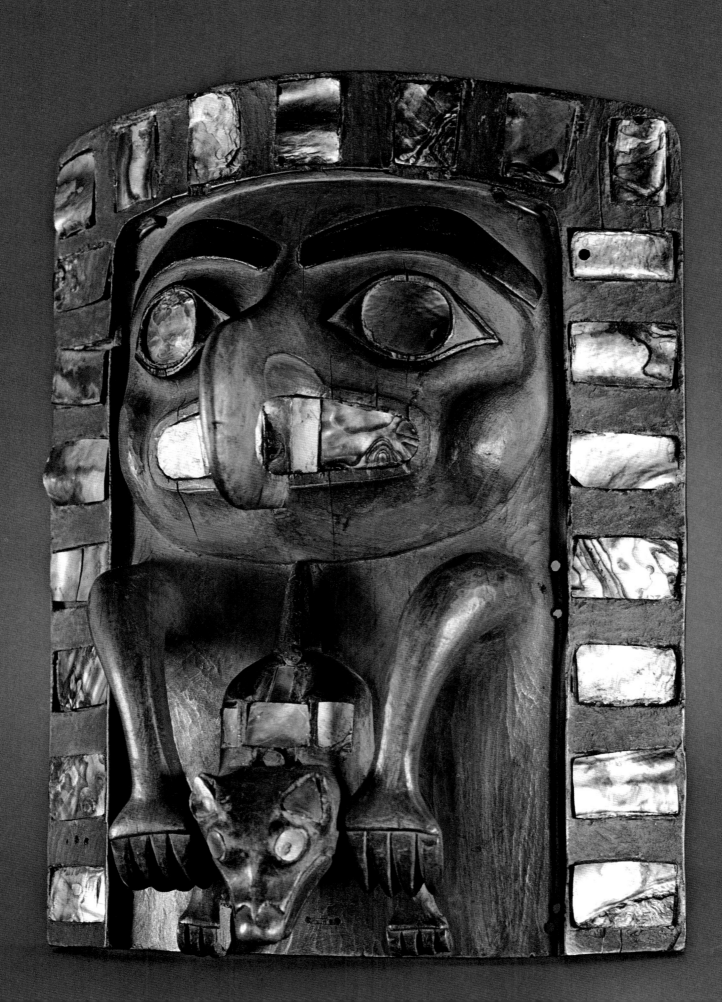

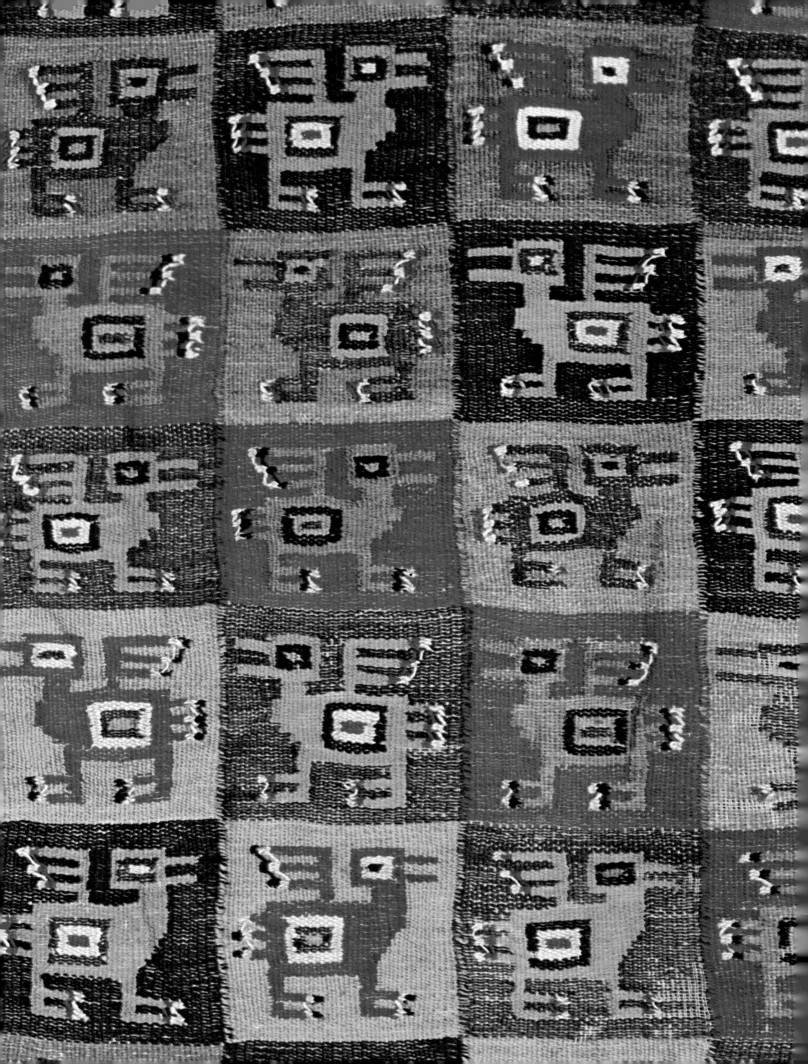

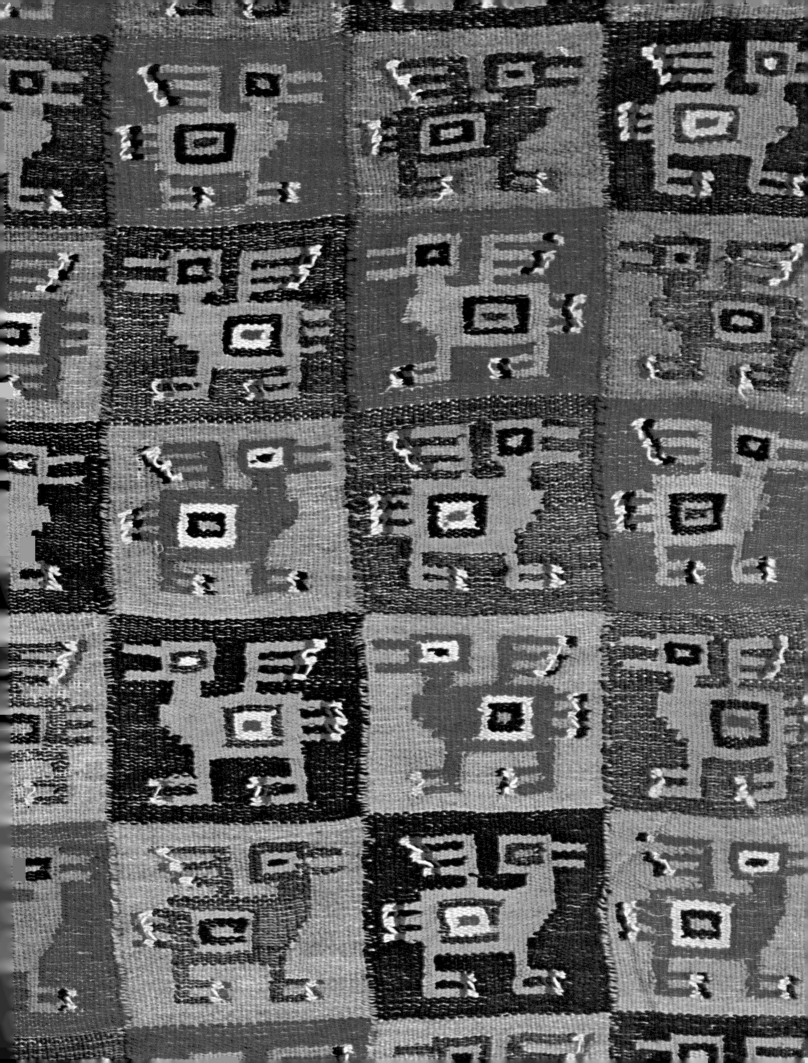

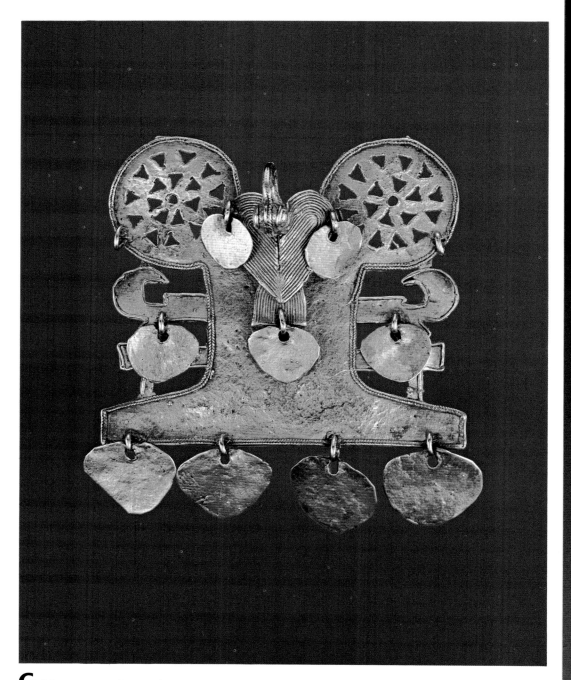

Gold pendants in the forms of various birds were common in the ancient cultures of Central and South America. The example above, with its flat form, applied thin fillets, and attached dangles, is typical of the style of the Muisca, who once lived near what is now Bogotá in the highlands of Colombia. The Spaniards who conquered them in 1537 were attracted to the area by the actual wealth of the Muisca, and by a legend that retains its power to this day: that of El Dorado, the Gilded Man who bathed annually in the sacred Guatavita Lake. Further north, and earlier, the conquistadores had discovered the golden treasure of Panama and Costa Rica. The bird pendant, right, from that area is in the Veraguas style (A.D. 800–1500); the "ear"-like projections on either side of the head are stylized crocodile heads. From the mid-nineteenth century, great quantities of such objects were melted down by grave-hunters; even so, a very large number remain to testify to the wealth and skill of the Precolumbian goldsmiths.

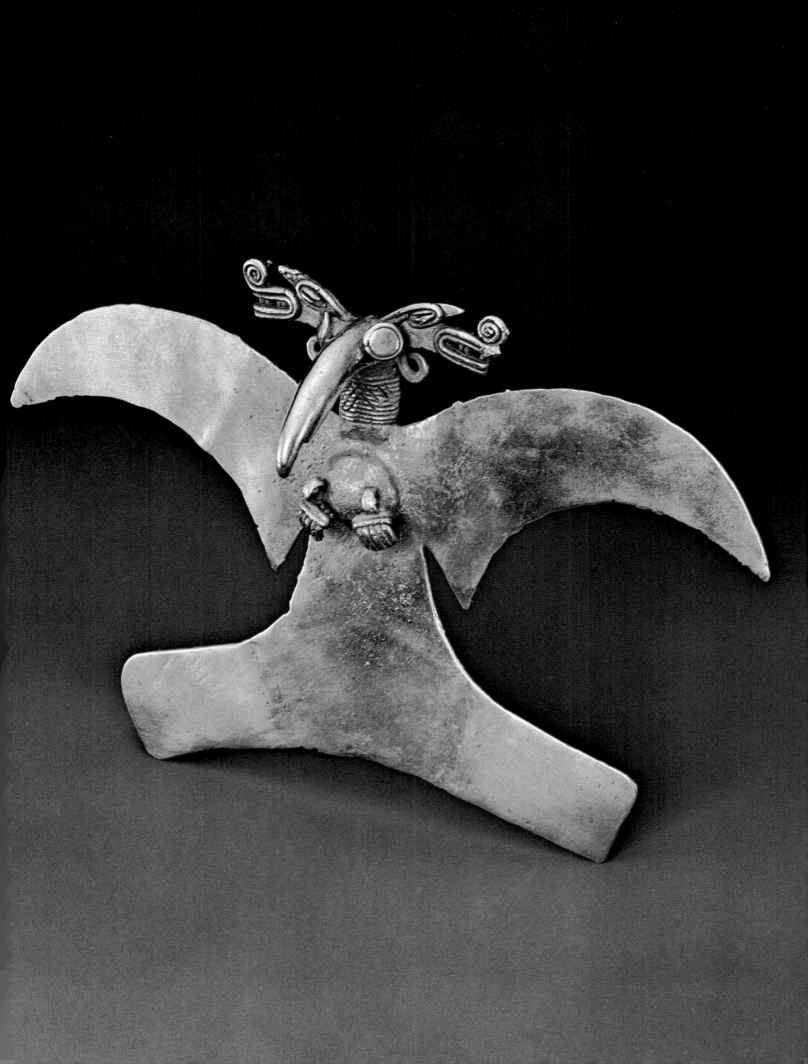

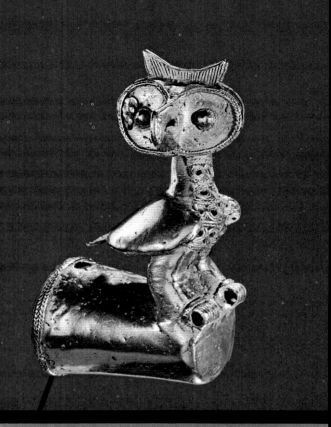

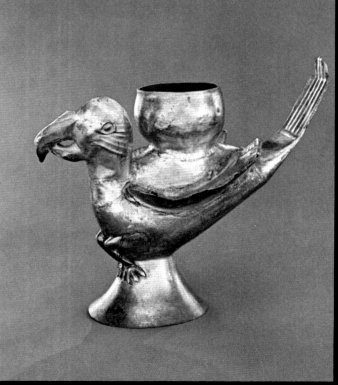

The golden owl, at top, is the finial of a staff carried, evidently as a badge of office, by a Sinú chieftain in Colombia about A.D. 600–1200. Beneath the owl, the long-tailed bird, probably a parrot, is a cup from the same large group of Chimu silver objects shown elsewhere. The fragment, right, of a netted textile dates from late in the Chancay culture (A.D. 1200–1450) of Peru.

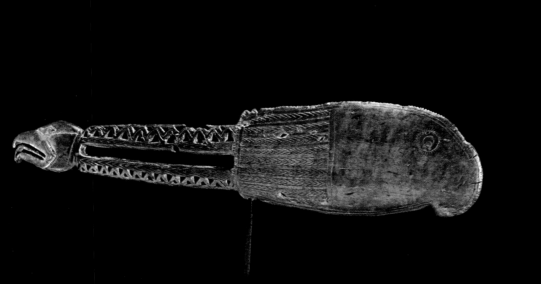

In this mixed bag of creatures from land, sea, and air is included—top left—a "slave-killer" stone club from Oregon, of uncertain date. The wooden carving with heads of an eagle and a dugong—middle left—was used by the Kiwai people living on the Gulf of Papua (New Guinea) as a charm in the hunting of the great sea mammal. Of the three ornamental gold pins—below left—two are from the Calima culture of Colombia (A.D. 400–700); they are topped with a fantastic seated figure and a monkey biting on a snake. The other, terminating in a bird, is from the Coastal Huari of Peru (A.D. 600–1000). The rooster grasping a crocodile's head, right, is a wood carving attached to the end of a bamboo tube container for lime (used in betel-chewing). It was presented to a boy of the Iatmul tribe of Papua New Guinea upon passing the ordeals of initiation.

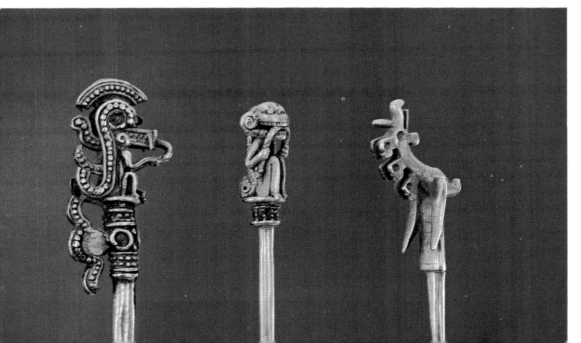

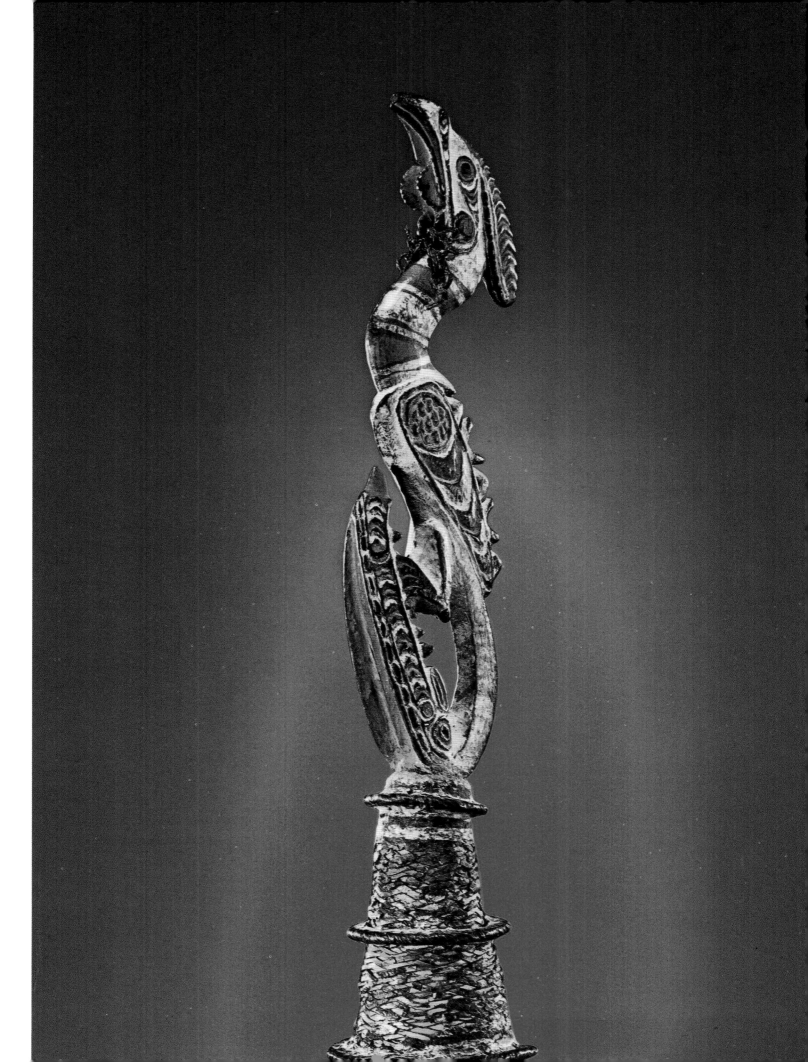

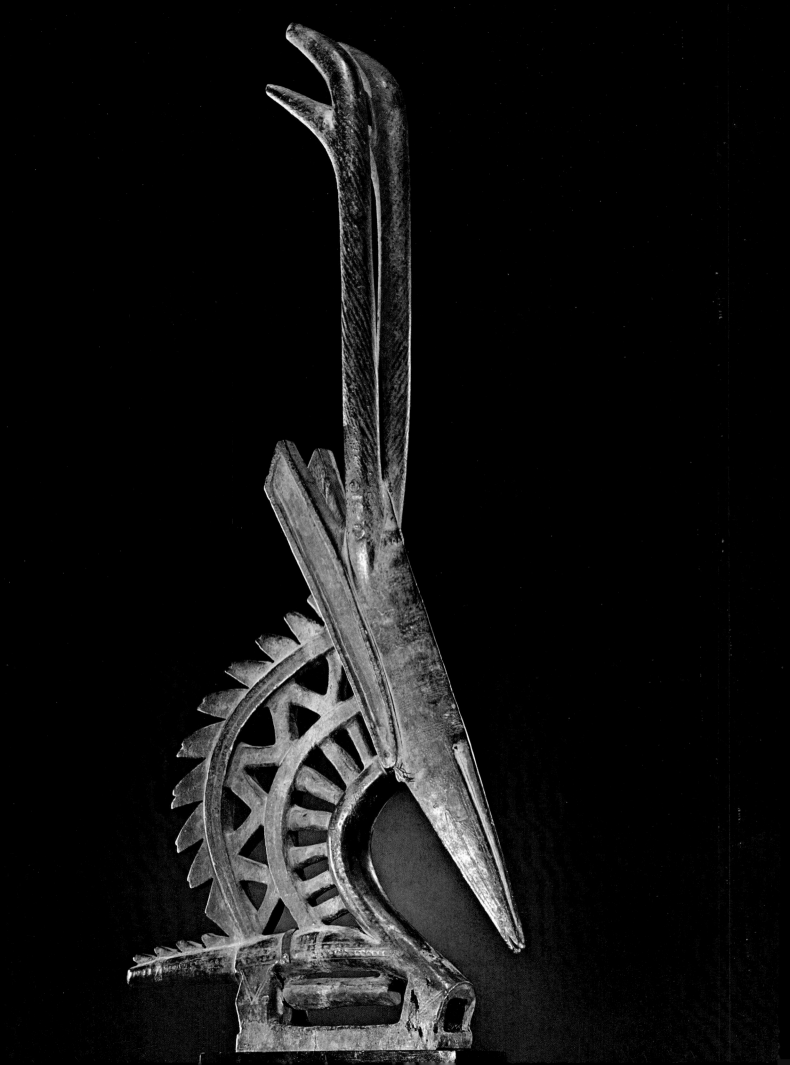

The tyi wara dance of the
Bamana (Bambara) of Mali is one
of the best known of African cere-
monials largely because of the
wooden antelopes worn attached
to basketry caps by the perform-
ers. They are carved in many
styles, from abstract to naturalis-
tic—the pair shown here comes
from the eastern group of the
tribe. Male and female pairs
appear at hoeing and ground-
clearing occasions, the faces
and bodies of the young men who
wear them being concealed by
long costumes. The hardest
workers are chosen for this, and
they leap and turn to the beating
of drums in imitation of the ani-
mals. The masks recall the mythi-
cal being, also called Tyi Wara,
who taught mankind the secret
of agriculture.

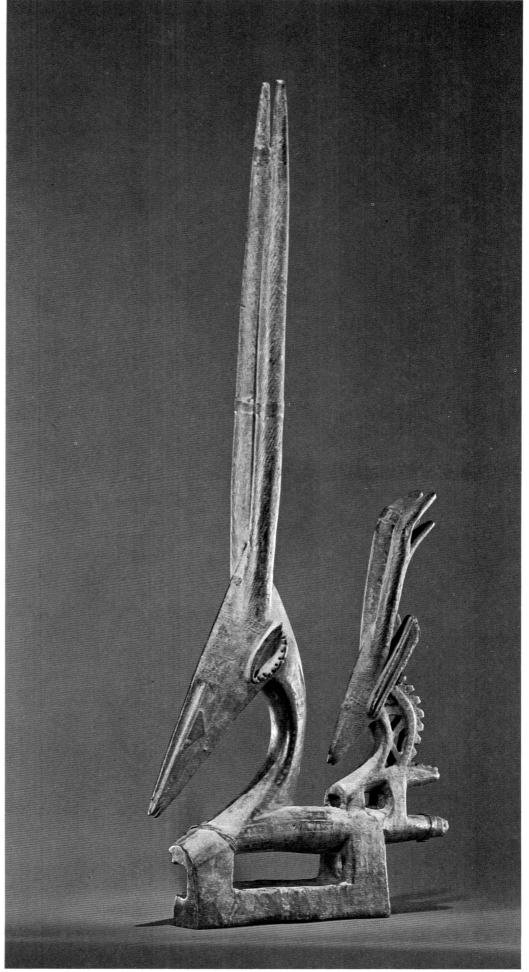

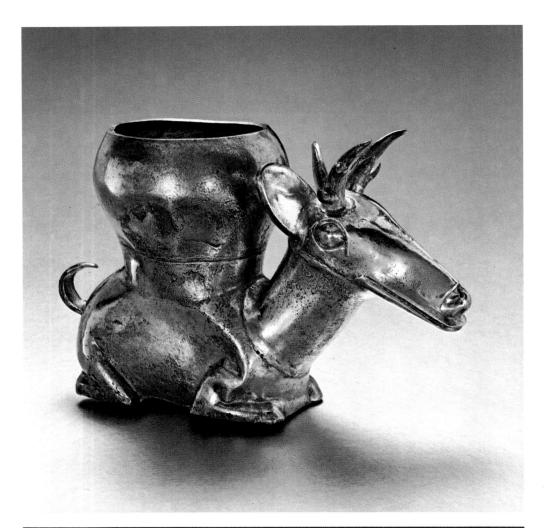

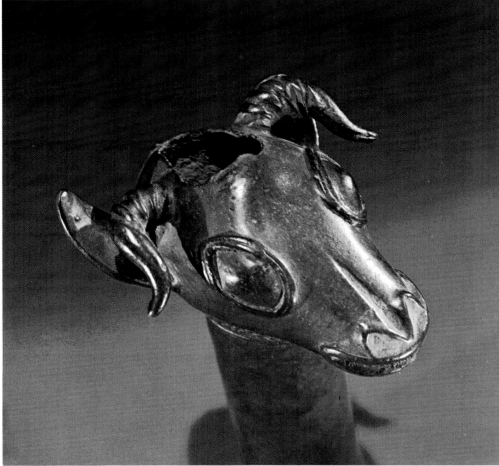

Horned animals: Above left, a container in the form of a deer, made in sheet silver; found as part of the rich furnishings of a tomb, it dates from the Chimu Empire (A.D. 1000–1450) of the north coast of Peru, and is said to have been discovered near Chan Chan, the Chimu capital city. Below left, a ram's head in bronze, found at Benin City in Nigeria in 1895, but probably cast in another area of the Lower Niger River about 1750. Right, a gold pendant made by the Baule tribe of the Ivory Coast, in the form perhaps of a buffalo's head.

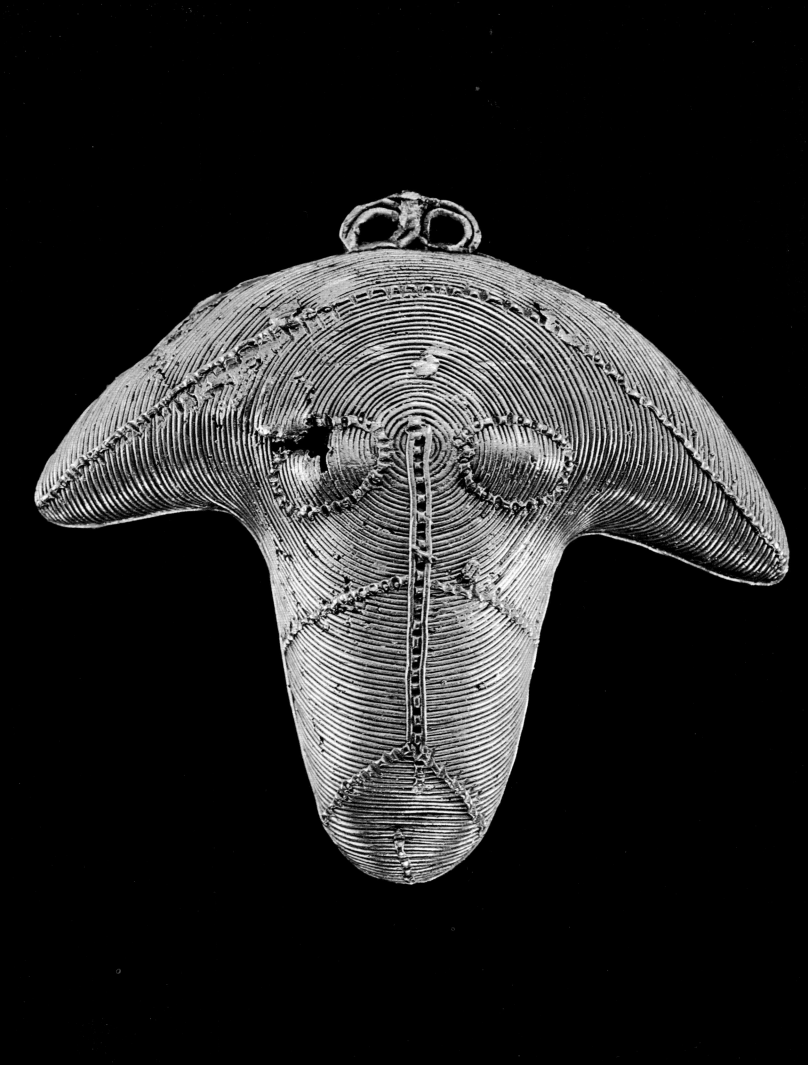

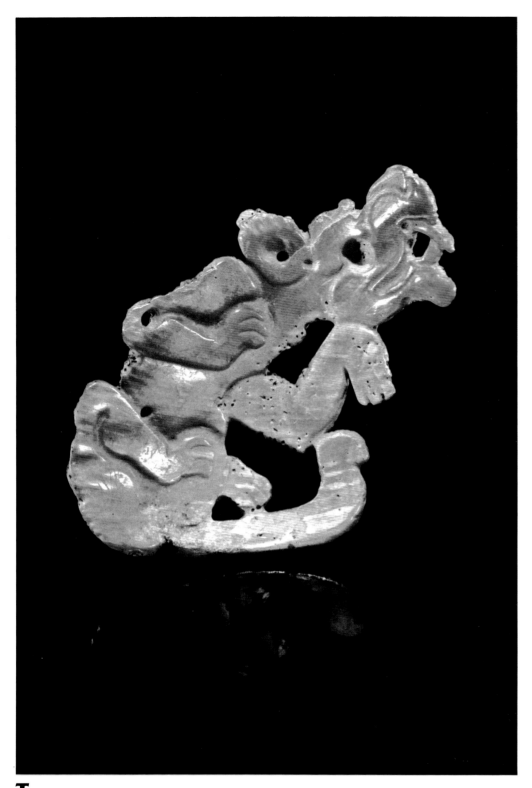

Two aspects of a howling coyote. One, above, is an ornament from the Maya of Campeche (Late Classic period, A.D. 600–900), carved in bright orange shell. The large animal, right, in ceramic with details touched in resinous black paint is from Veracruz, and dates from approximately the same period. The coyote was an important animal in Precolumbian mythology, apparently considered the companion and equivalent of the jaguar. Both were associated with water, which in turn had many mythological aspects.

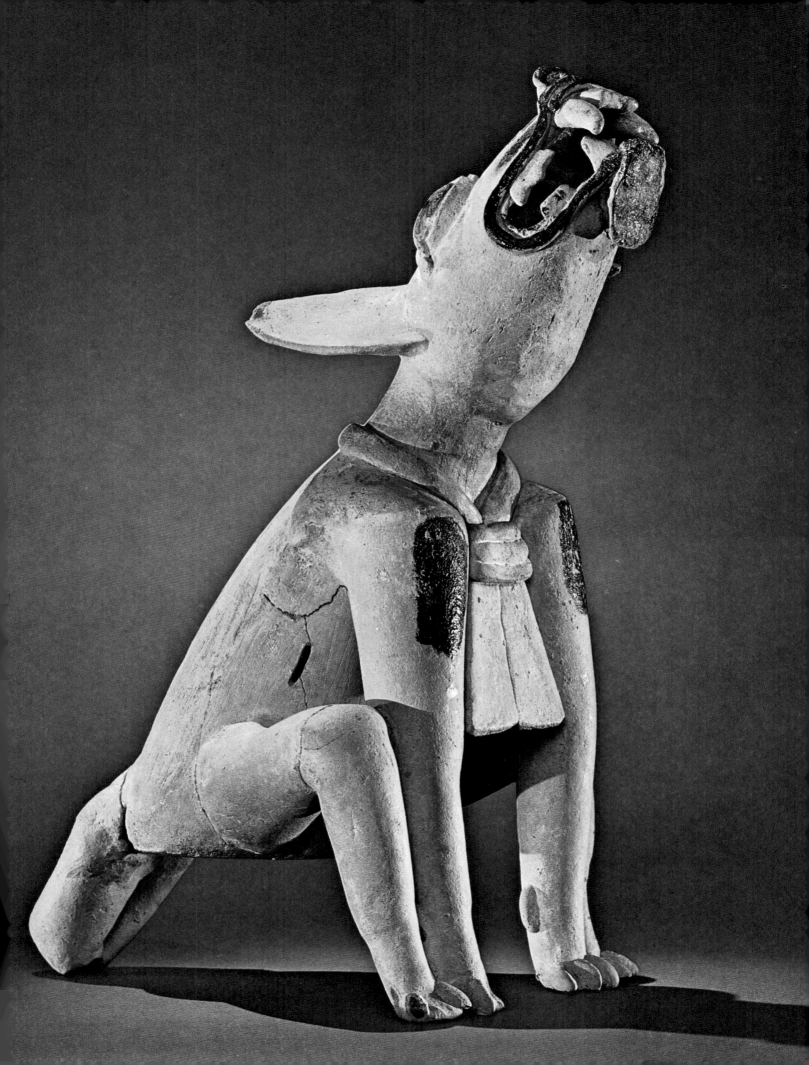

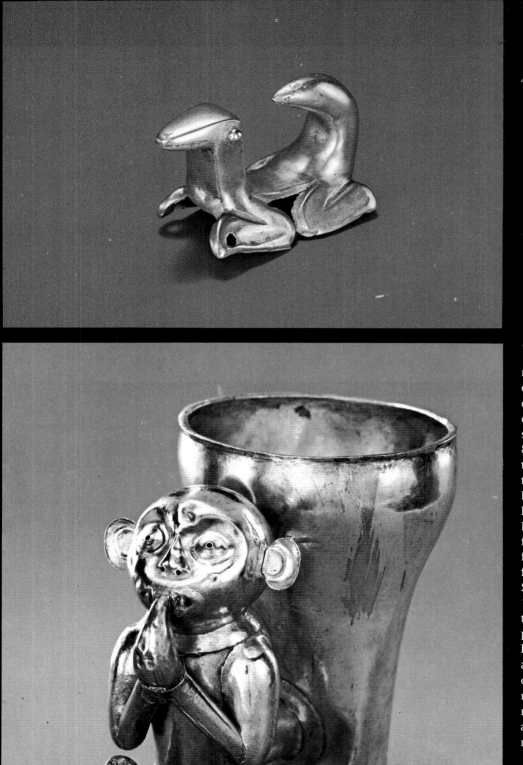

The prehensile tails of certain monkeys seem to have made a considerable impression on Precolumbian artists. The gold pendant, above left, in the late Coclé style of Panama (about A.D. 800—1200) seems to have the thick tail of a woolly monkey, though this is not altogether borne out by the possibly feline head. The Chimu silver beaker, left, has an unmistakable monkey figure, however, shown in a favorite occupation— eating fruit. In the Ica poncho, right, of South Coast Peru (A.D. 1000—1450), all is confusion. On the right are a rampant feline and perhaps another with human headdress. To the left, a feline appears to be strangling another crowned cat with its remarkably monkey-like tail. The modern mind boggles, and can only assume the scene was highly significant to its makers.

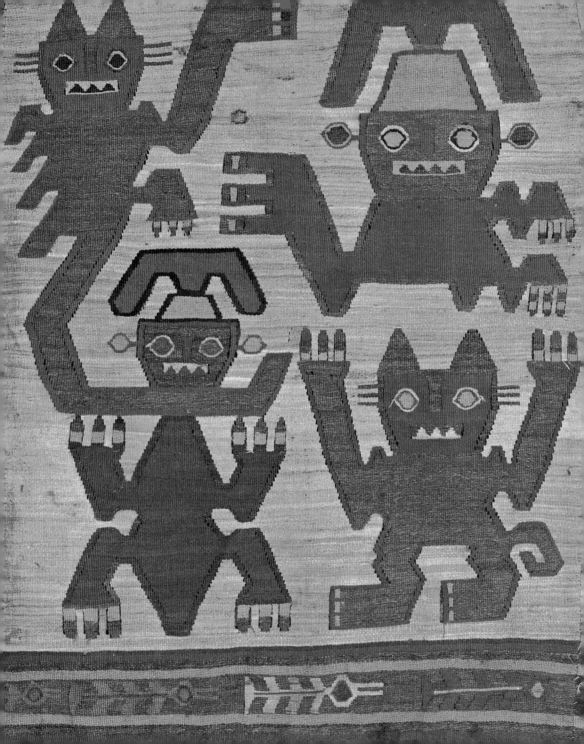

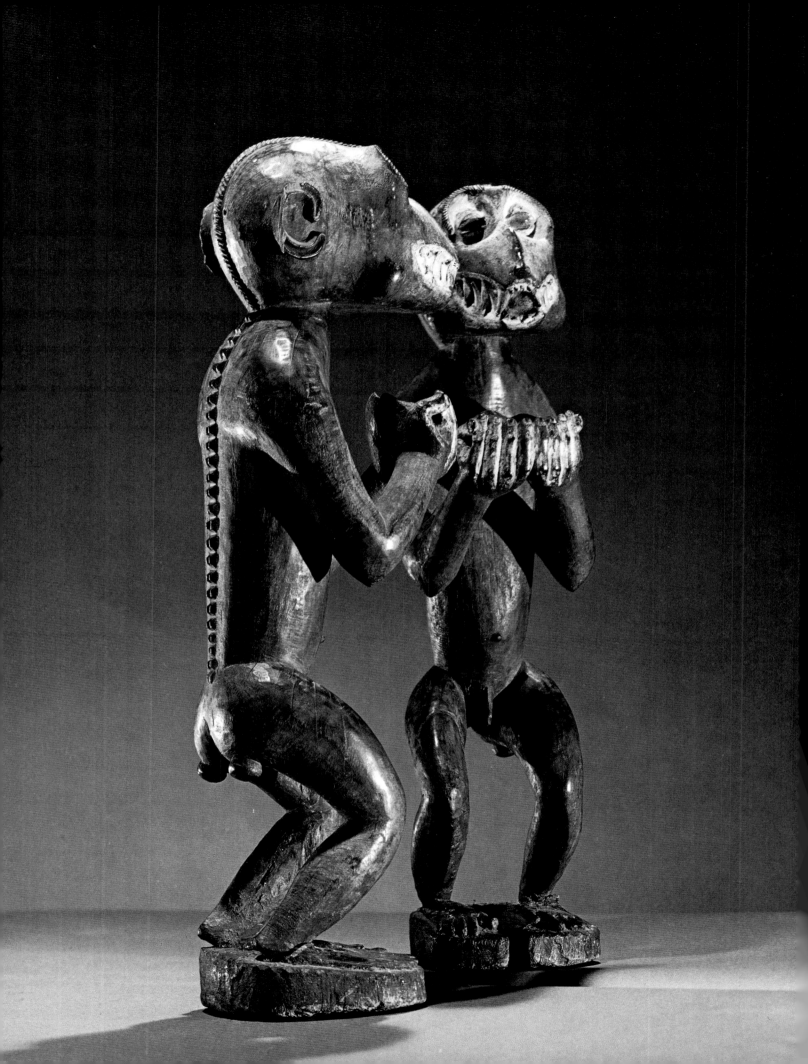

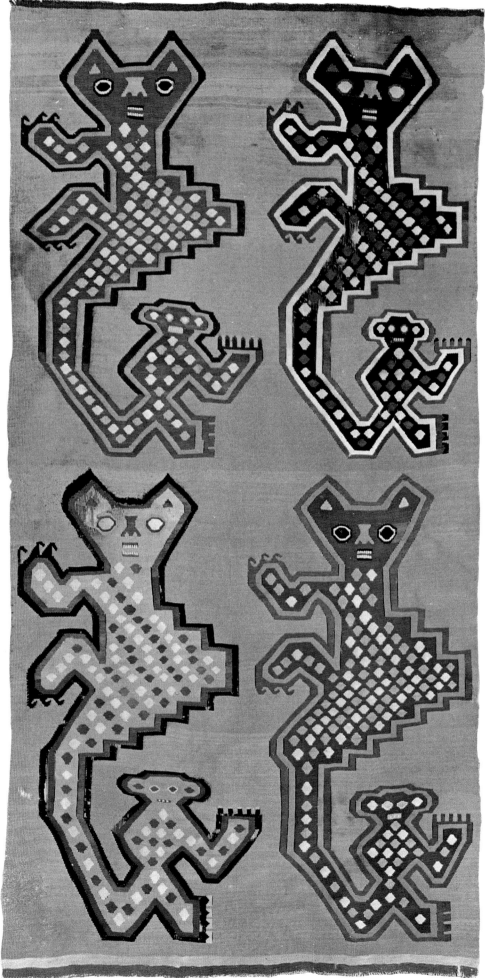

The baboon, left, seen from two angles is Ndyadan, a deity of the Baule people of the Ivory Coast. Originally he was their protector against the hazards of lightning; in time he became a benevolent being who could be appealed to by both men and women for material favors. The section of a poncho, right, made in the Ica Valley of Peru about A.D. 1000—1450, shows four composite creatures. The larger animals are felines, possibly the mild ocelot of southern Peru; their tails terminate in small monkeys whose spots reflect the needs of art rather than the realities of nature.

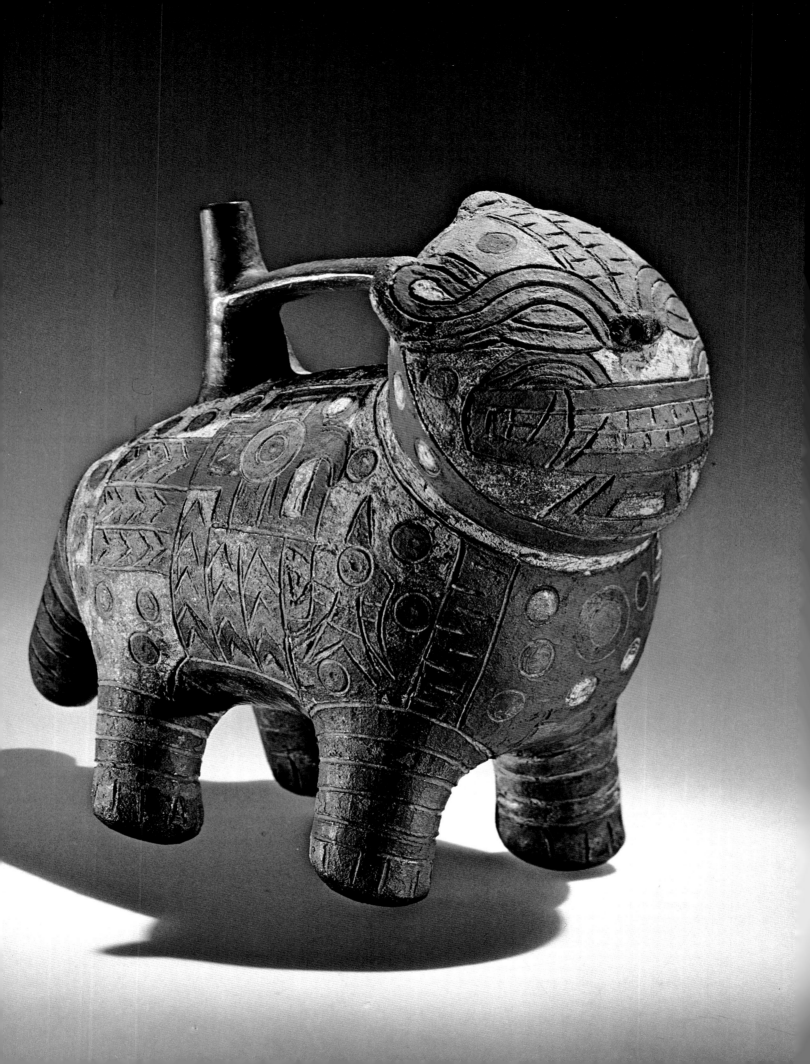

Through the many centuries of civilization in Middle and South America, the jaguar was a powerful element in native symbolism and thought. Its image—sometimes reduced to the terrifying fangs—recurs innumerable times. A relatively modest example, this vessel from the Ica Valley, left, made in the Early Paracas period (700–500 B.C.) of Peru, shows the whole animal. The body is engraved with designs, including stylized birds, and the vessel is brightly colored with resin paint. The textile, below, of which only a section is shown here, dates from the following Middle Paracas period (500–300 B.C.). The painted design shows eight creatures, in two reversed rows, recognizable as desert foxes by their long, undulating tails.

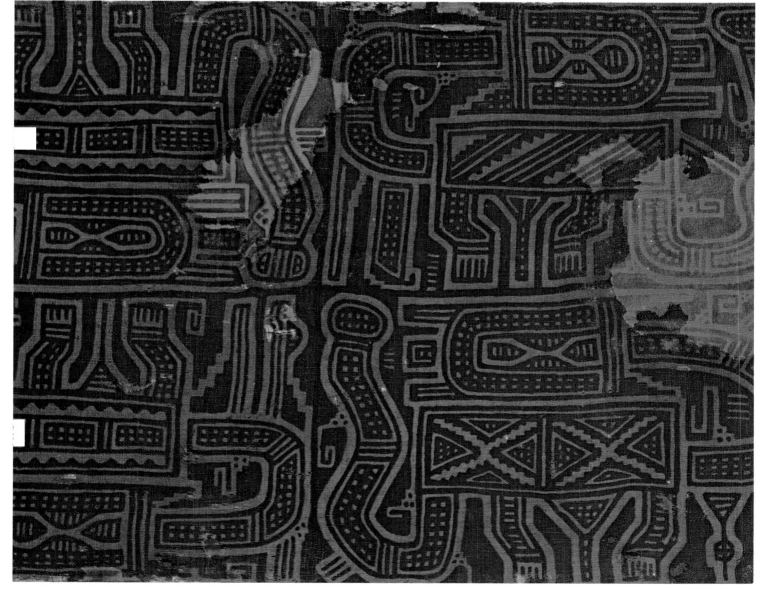

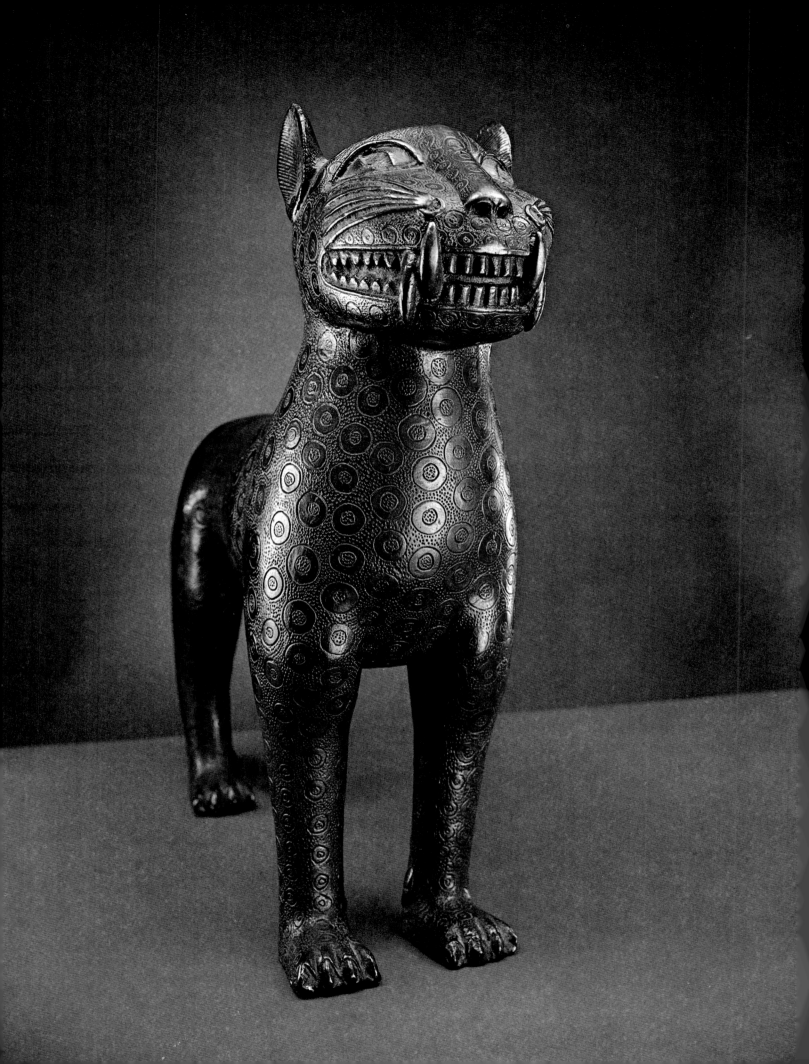

The eighteenth-century bronze leopard, left, from Benin City in Nigeria was a royal beast; kept in the palace as symbols of the ruler's power, leopards were led on leashes before him during processions. The bronze beast was also used for liquids, filled through an opening in the top of the head. The Late Chavin period (700—500 B.C.) work from Peru, below, is another vessel, representing the South American jaguar, perhaps crouching to spring.

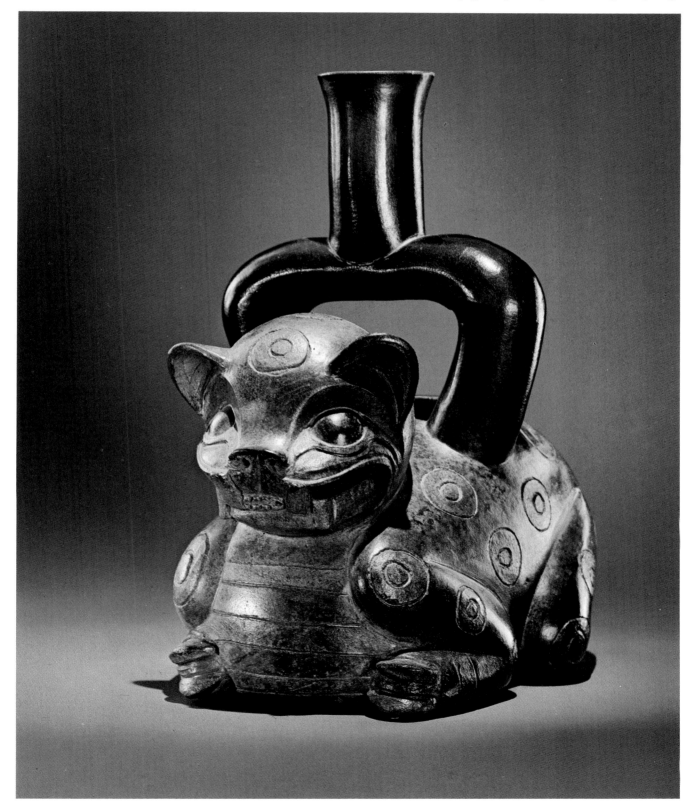

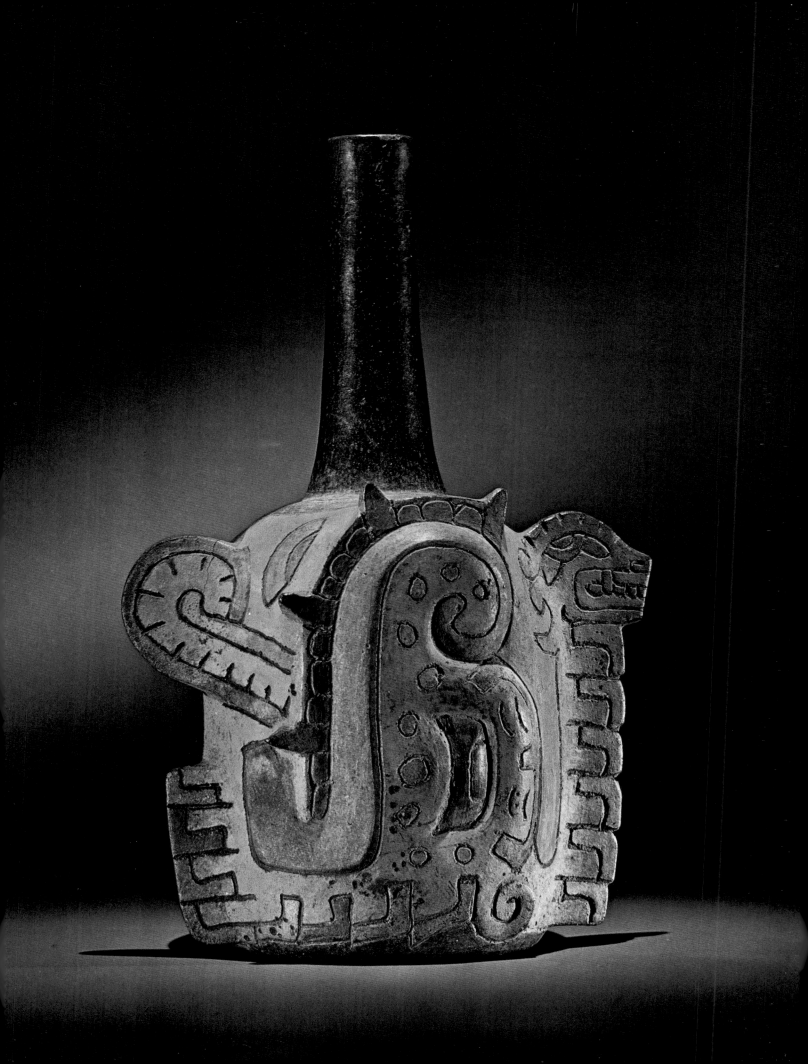

The relief forms on the bottle at left, from Tembladera in the Jequetepeque Valley of North Coast Peru, show a small feline head terminating a stylized feathered serpent. A fairly common theme in the art of the Late Chavín period (700–500 B.C.), it is a forerunner of many uses of this combination in Precolumbian art. The ceramic vessel, right, from the other end of the Peruvian time scale, the Inca period just before the Spanish conquest, is an extraordinary example of virtuosity. The double-chambered container has two spouts, one a bird, the other a llama (?) head. A jaguar—or its skin—sprawls over the top of the container. Below right is a detail from a poncho in wool and cotton, from the Chancay Valley near Lima on the central coast of Peru (A.D. 1000–1450). A confronted and rampant feline appears on each side of the wearer's chest and back, while similar felines make up the border.

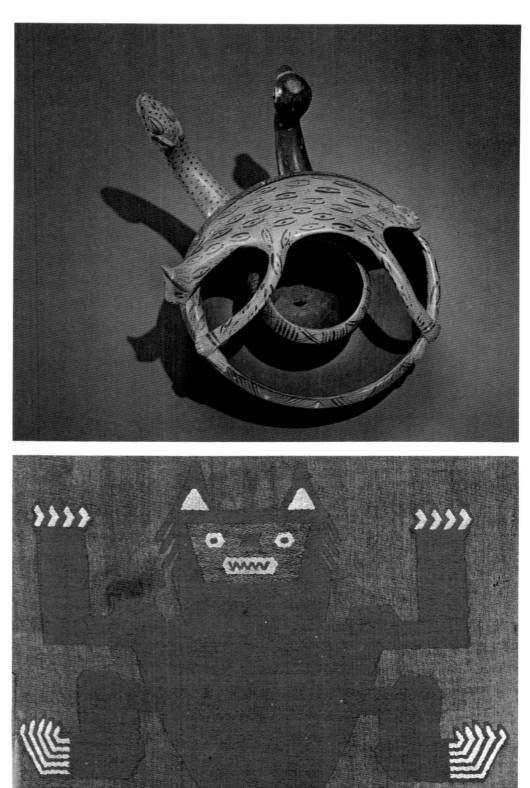

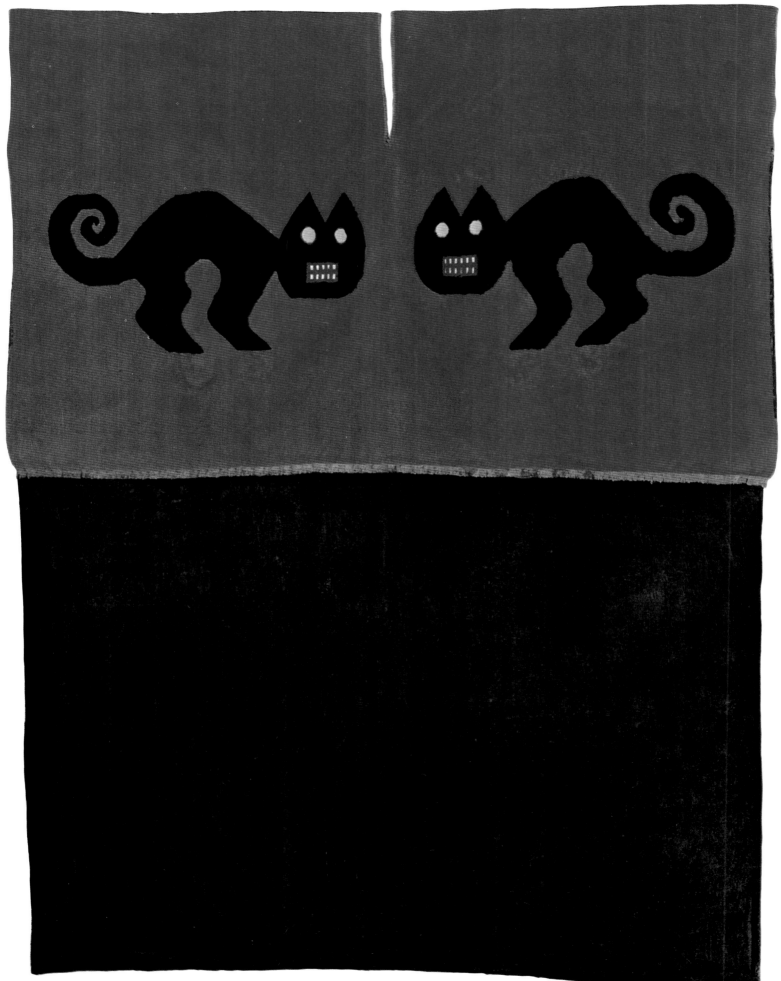

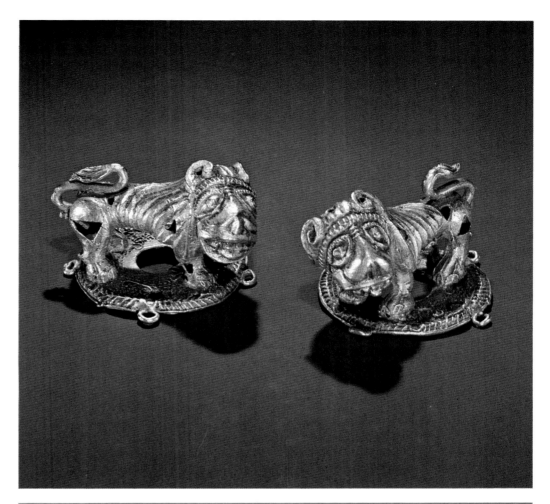

Another treatment, left, of the same theme that occurred on the Chancay poncho illustrated on the preceding page. The stylistic difference is due to its later period, that of the Inca (A.D. 1438–1532), and its geographical source, the Ica Valley of the south coast of Peru. The simplicity and vigor of color and design are typical of both. Above right, a pair of lions in gold from Africa—a metal sacred to the Ashanti of Ghana, used to portray beasts which (like the leopards of Benin) were associated with royalty. Below right, a pendant from Veraguas, Panama, shows the joined forequarters of two jaguars (A.D. 1000–1530). The metal is tumbaga, an alloy of gold with copper, the decay of which has produced the green-black areas.

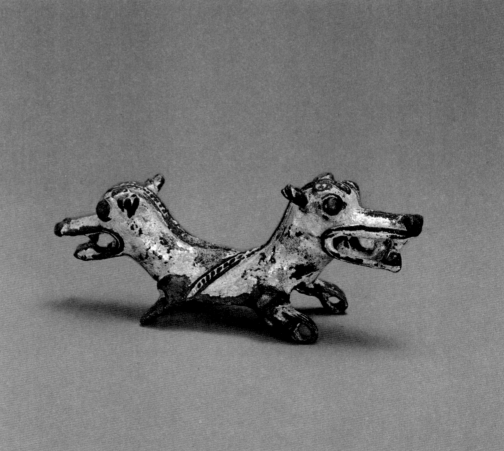

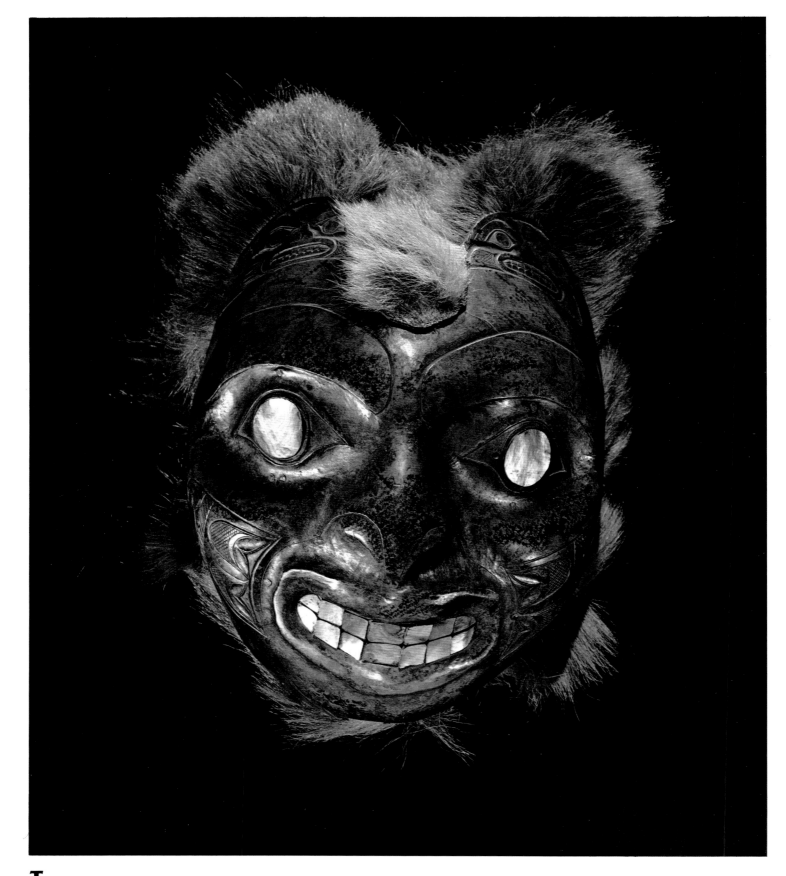

The mask of a sea-bear, above, was beaten out of copper; it is trimmed with sea otter fur and inlaid with plates of haliotis shell for eyes and teeth. Tattooing patterns are engraved at the corners of the mouth, and subsidiary masks are on the upstanding eyes. The metal was relatively rarely used by the Indians of the Northwest Coast of America, but a second bear-mask, made by the same artist of the Haida tribe in the nineteenth century, is known to exist. Another treatment of the bear image, right, here holding a salmon, is similarly inlaid with shell. Originally part of a headdress made of cloth, ermine skins, and bristles, it was worn by a chief of the Northwest Coast Tsimshian tribe.

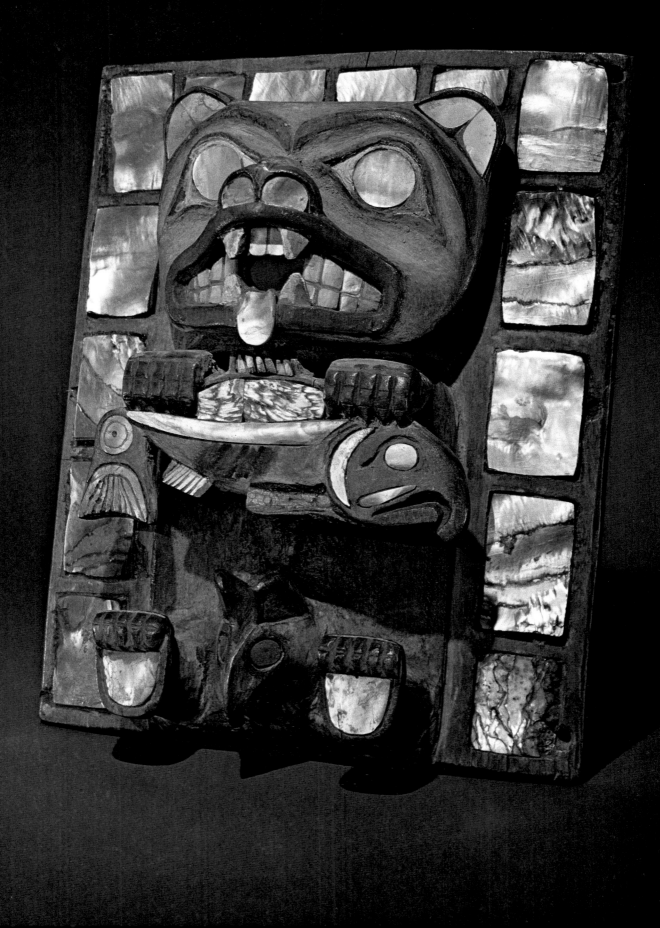

Abstractions

Abstractions

Broadly speaking, the art of the primitive world is representational. The vision which animates it may differ very widely from what has often been regarded as representational art in the West; but at that, Western concepts of visual verisimilitude have themselves varied widely from period to period. Even more marked is the divergence of any human representational art, whether in two or three dimensions, from the natural phenomenon it purports to portray. Each of us sees what our society and our time tell us that we see; and we portray a personal version of what society tells us. In many primitive societies the stresses on what elements are to be seen are filtered through different lenses to the artist's eye. The sixteenth-century bronze head of a Nigerian ruler is no less true to nature than a photographic portrait by Julia Margaret Cameron, nor is it more removed. Even in many of the distortions of primitive art, the artist does not invent far beyond the limits of nature; he relies upon it—or, as we have learned, he is being faithful to the testimony given him by the dream.

But, somewhat rarely, beyond the realms of the animals, men, and gods—often interchangeable as they are—there lies yet another realm, less immediately accessible in its meaning. It includes works of art in styles which we might think are akin to those we would call abstract.

The primitive artist moves from naturalism to abstraction without embarrassment, even in the same work. One of the most famous examples of this is to be found in the art of the Massim area of New Guinea (page 246), where there is an extraordinary range of gradations from one mode to the other based on a single theme, the head of the frigate bird. They span the possibilities between naturalism and reduction of the form to a simple scroll

A stirrup-spout vessel in Early Chavin style (1200–1000 B.C.) from northern Peru.

(which A. C. Haddon used to illustrate his theory of "degeneration"). Some such works do indeed bear a fairly close resemblance to styles which have appeared only recently in the Western world, for instance the geometric engravings made by some Australian aboriginal groups, consisting of arrangements of concentric circles linked by straight lines (page 250, bottom). Again there are the apparently totally abstract designs of New Ireland breast ornaments (page 251): superb examples of intricate pattern constructed from repetition of the simplest elements. The Australian engravings, on slabs of stone or wood, are in fact emblematic illustrations of sacred myths. The New Ireland designs may refer to stylized human or bird figures.

There are instances, however, in which flat pattern can be abstract—at least as far as we know. Among them are those in which pattern seems to have been used for purely decorative purposes, including the brilliant feather-decked ponchos of the Inca aristocracy (pages 244–45). Even these, however, may have been keyed to the wearer's family or rank.

From humble materials to the most precious, the command of three-dimensional form is manifested in these arts. It is rarely more clear than when those forms bear the least immediate resemblance to the recognizable. The Peruvian stirrup-spout pot of the Paracas Necropolis period (page 243), with its modelling in clay of a faceted shape, perhaps a fruit, can be compared with the multiple, breast-like units of a great Mochica gold necklace, made several centuries later (page 250, top). Clay and gold may be at opposite ends of the scale in terms of the value placed on them by their makers; but the same rigorous control of form and the same degree of sophistication are to be found in each.

Right, a double-spouted vessel with strap handle in Paracas Necropolis style (200–100 B.C.) from South Coast Peru.

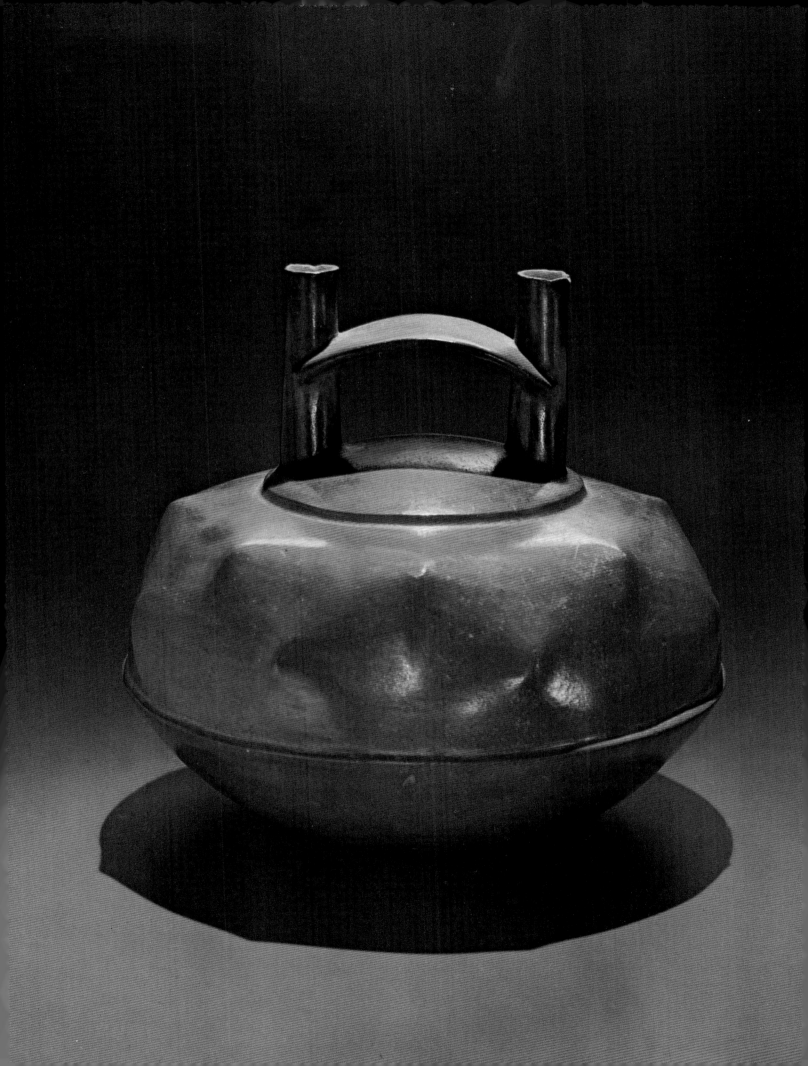

These miniature ponchos (both sides of the one above are shown) are two from a lot of over a hundred found together in Peru. Clearly of no practical use, they were apparently made specifically as a funerary offering. They show the great range of designs used for these garments by the Inca nobility (1438−1532). The use of feathers from tropical birds found only far to the east is an indication of the huge area through which they carried on trading.

The large curved panel, left, from the Massim area in southeast Papua New Guinea was originally set as a vertical decoration on the prow of a seagoing canoe; a small decorative panel was attached to the tab at the top. The relief decoration consists of highly stylized birds, symbolizing speed and rapacity.. In some of the Solomon Islands, small plates of giant clam shell, above right, were decorated with openwork designs and, mounted in clusters on rods, used as grave markers. Among the body decorations created in gold by the people of Precolumbian Colombia, nose ornaments—below right—figure largely. These three were made by the Sinú (about A.D. 600–1200); they were fitted through the pierced septum and held in position by the central loop.

The pair of ear spools shown on pages 248–49 was worn by some grandee of the Coastal Huari people living in the Nazca Valley of Peru about A.D. 600–1000. The support is of bone; the elaborate mosaic in shell and stones inlaid on the discs is at first glance abstract, yet it actually includes not only geometric elements but also the heads of felines.

Pages 250–51: Above left, breastlike shapes in hollow gold beads of graded size form a necklace by the Mochica of Peru (about A.D. 300–600). The stone slab, below left, engraved with designs that probably represent sacred waterholes and the tracks between them, is the sacred object of a central Australian aboriginal tribe. In New Ireland, breast ornaments—right—were made of turtle shell sawed into intricate patterns by the use of string and abrasive powder, and set on plates of giant clam shell.

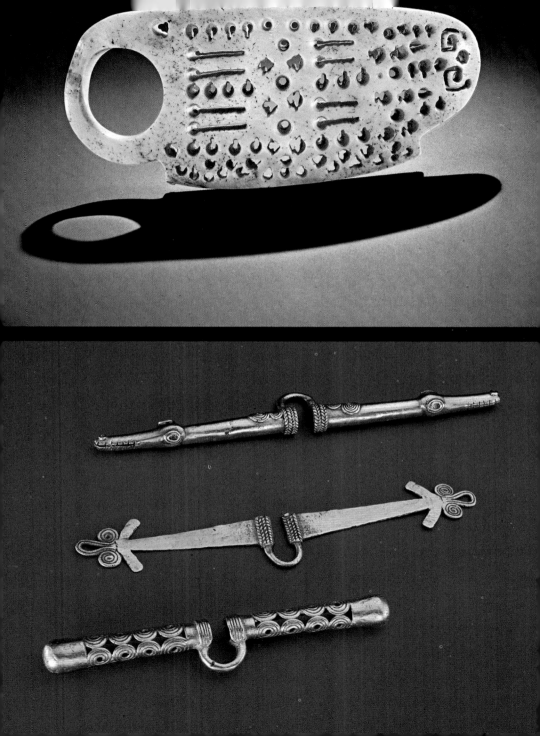

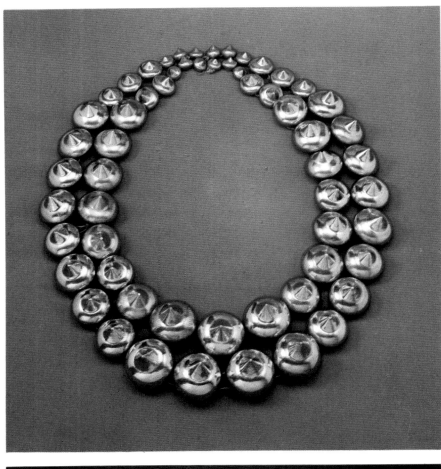

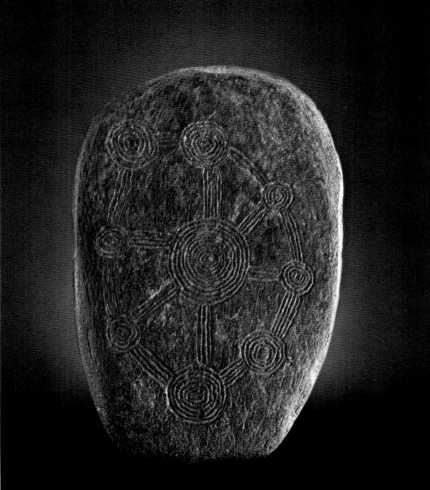

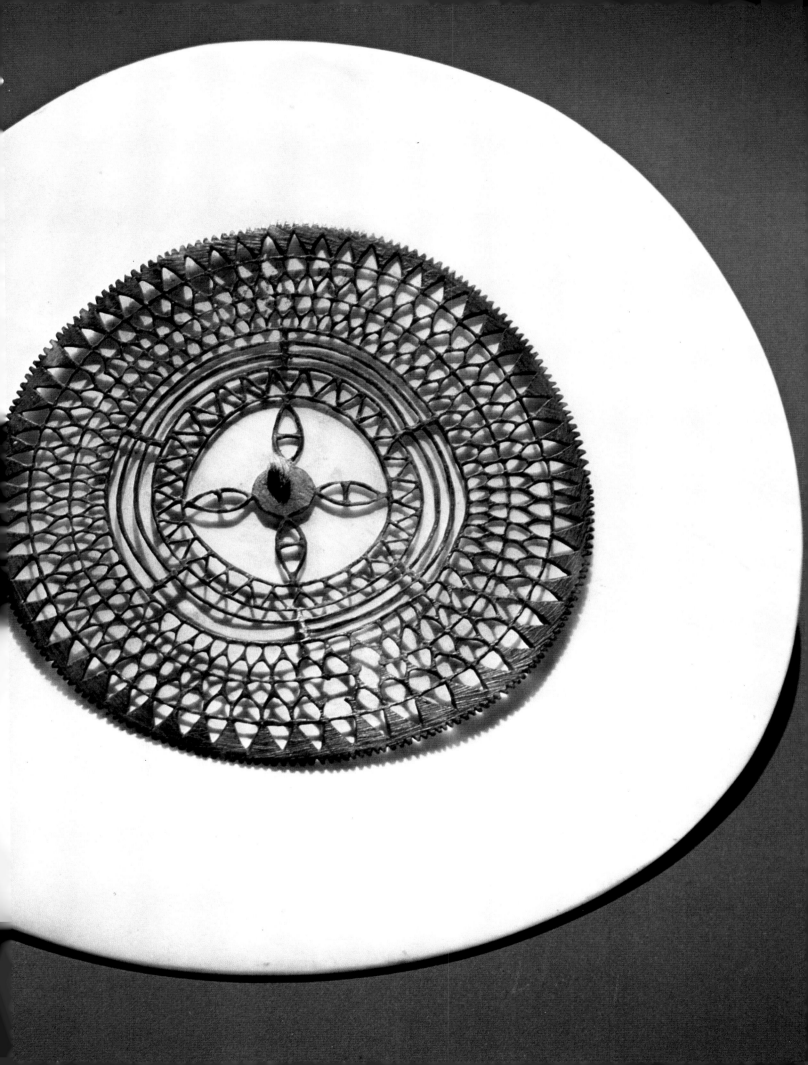

Catalog

LISTED BELOW are complete catalog entries for all objects from The Museum of Primitive Art collection illustrated in the color plates in this book. The information is arranged as follows: The first item after the page number is the title or description. The cultural, stylistic, or tribal origin is given, followed by geographic provenance and by the date (when known). Materials and size are given. The final item is The Museum of Primitive Art registration number. An asterisk following this number indicates that the object is now part of The Metropolitan Museum of Art, The Michael C. Rockefeller Collection of Primitive Art.

Undated African and Oceanic objects are presumed to be late nineteenth— early twentieth century.

Page 66, top right
Mask
Lega tribe, Zaïre.
Ivory, H. 8½ in. 65.4

Page 66, bottom
Rattle
Tsimshian, British Columbia,
Canada; late 19th century.
Wood, leather, H. 12⅝ in.
62.152

Page 67
Mask
Kwele tribe, Congo.
Wood, coloring, H. 20¾ in.
56.218

Page 68
Pectoral with Ornamented Face
Calima, Colombia, provenance
unknown; A.D. 400−700.
Hammered gold, W. 11 in. 57.57

Page 69
Ornamental Pin with Face
Quimbaya, Colombia, provenance
unknown; about A.D. 400−700.
Gold, H. 7⅜ in. 61.109

Page 70
Dead-Man Mask
Tlingit, Alaska; 19th century (?).
Wood, paint, hide, metal,
H. 13⅝ in. 56.330

Page 71, left
Mask
Tolai tribe, Gazelle Peninsula,
New Britain.
Wood, paint, H. 12¹/₁₆ in.
67.130*

Page 71, right
Mask
Biwat tribe, Yuat River, East Sepik
Province, Papua New Guinea.
Wood, paint, other materials,
H. 12⅛ in. 61.281

Page 72
Male Mask
Lwalwa tribe, Zaïre.
Wood, hide thong, paint, H. 12⅝ in.
60.170

Page 73
**Spouted Vessel in Form
of Trophy Head**
Paracas Necropolis, Peru;
200−100 B.C.
Ceramic, H. 7¼ in. 62.166*

Page 74, left
Head
Tolai tribe, Gazelle Peninsula,
New Britain.
Stone, H. 9 in.
Gift of
Dr. Marion A. Radcliffe-Taylor.
65.125*

Page 74, right
Mask
Bron tribe, Ghana.
Bronze, H. 7½ in. 57.27

Page 75
Mask
Kongo tribe, Zaïre
Wood, H. 14⅝ in. 56.347

Page 76
Headdress
Upper Cross River area,
Cameroon.
Wood, skin, human hair, resin,
rattan, metal, H. 9½ in. 69.35

Page 77
Effigy Face Beaker
Ica, Peru, Central or South Coast;
about A.D. 1500.
Silver, H. 9¾ in. 63.106

Page 78
Head for Yam Cult
Yau tribe, East Sepik Province,
Papua New Guinea.
Wood, paint, H. 42½ in.
Gift of Mr. and
Mrs. Wallace K. Harrison. 74.13*

Page 79
Figure for Yam Cult
Yau tribe, East Sepik Province,
Papua New Guinea.
Wood, paint, H. 48 in.
Gift of Mr. and
Mrs. Wallace K. Harrison. 74.14*

Pages 80−81
Butterfly Mask
Bobo tribe, Upper Volta.
Wood, paint, hemp, W. 5¼ in.
60.167

Page 82, left
Face Mask
Grebo tribe, Cape Palmas area,
Ivory Coast.
Wood, paint, H. 27½ in. 56.217

Page 82, right
Mask
Songe tribe, Zaïre.
Wood, coloring, H. 17¾ in.
62.70*

Page 83
Mask
Songe tribe, Zaïre.
Wood, coloring, H. 17½ in.
58.171

Page 84
Ceremonial Fence Element
Eastern Iatmul tribe, Kararau
Village, East Sepik Province,
Papua New Guinea.
Wood, paint, shell, H. 60½ in.
56.410*

Page 85, top left
Head from Slit-Gong
Fanla Village, Ambrym Island,
New Hebrides.
Wood, H. 61¼ in. 59.281*

Page 85, bottom left
Head for Divination
Yoruba tribe, Nigeria.
Ivory, H. 3⅛ in. 60.114*

Page 85, right
Shield
Iatmul tribe, style of Yentscha-
mangua Village, East Sepik
Province, Papua New Guinea.
Wood, paint, bamboo, H. 54½ in.
56.322*

Page 86
Mask
Tlatilco, Valley of Mexico;
800−400 B.C.
Ceramic, pigment, H. 5¼ in.
63.31*

Page 87
Bird Snare (?)
Maori, New Zealand.
Wood, shell inlay, L. 9¾ in.
62.72

Page 88
Head
Kwoma tribe, Tongwindjamb
Village, East Sepik Province,
Papua New Guinea.
Ceramic, paint, H. 15½ in.
65.43*

Page 89
Mask
Mambila tribe, Cameroon.
Wood, H. 17½ in. 68.77*

Page 90, top
Mask
Dan tribe, Liberia.
Wood, other materials, H. 8⅛ in.
59.260*

Page 90, bottom
Mask
Tolai tribe, Gazelle Peninsula,
New Britain.
Skull, clay, paint, hair, H. 9⅞ in.
60.155*

Page 91
Mask
Erub Island, Torres Strait, Papua
New Guinea.
Turtle shell, hair, H. 16⅛ in.
59.106*

Page 92
Helmet Mask
Elema tribe, Gulf of Papua, Papua
New Guinea.
Barkcloth, paint, raffia, H. 37¾ in.
58.309*

Page 180, top
Double-spout Bottle,
Two Figures
Paracas Necropolis, Peru, South
Coast; 200−100 B.C.
Ceramic, resin paint, H. 5 in.
64.36

Page 180, bottom
Stirrup-spout Vessel
Mochica, Peru, North Coast;
A.D. 200−500.
Ceramic, slip. H. 12⅜ in. 61.17*

Page 181
Lintel, Presentation Scene
Late Classic Maya, Mexico,
Yaxchilan-Bonampak area;
A.D. 600−900.
Stone, paint, H. 35 in. 62.102

Page 182, left
Equestrian Figure
Lower Niger Valley, Nigeria.
Bronze, H. 10 in. 70.41

Page 182, right
Bracelet
Court of Benin, Nigeria; 17th or
18th century.
Ivory, H. 4 in. 56.352

Page 183
Plaque with Warrior
Court of Benin, Nigeria; about
A.D. 1550−1680.
Bronze, H. 19½ in. 57.231*

Page 184
Poncho Section
Coastal Huari (Tiahuanaco), Peru;
A.D. 700−1000.
Alpaca wool, cotton, 40¾ x
19⅞ in. 56.195

Page 185
Figure on a Dog: Fetish
Kongo tribe, Zaïre.
Wood, glass, pigment;
H. 13 in. 66.80*

Page 186
Shrine Figure
Ijo tribe, Nigeria.
Wood, paint, H. 25 in.
Gift of the Matthew T. Mellon
Foundation. 60.128

Page 187
Vessel with Lid Surmounted by
Equestrian Figure
Dogon tribe, Mali.
Wood, H. 33¾ in. 60.39

Page 188, left
Flute Ornament
Eastern Sawos tribe, Kwoiwut Vil-
lage, East Sepik Province, Papua
New Guinea.
Wood, shell, other materials,
H. 62¾ in. 61.266*

Page 188, right
Vessel in Form of Man and Llama
Recuay, Peru, Central Highlands;
300 B.C.− A.D. 700.
Ceramic, slip, H. 6¾ in. 65.113*

Page 189
Double-chambered Vessel
Early Classic Maya, Mexico or
possibly the Peten area;
A.D. 300−600.
Ceramic, H. 11⅞ in. 62.46*

Page 190
Whistle, Standing Figure with
Bird Head
Classic Veracruz, Mexico, Vera-
cruz; A.D. 300−900.
Ceramic, H. 20¼ in. 61.73*

Page 191, top
Pendant, Pair of Birds
Coclé, Panama, from Sitio Conté
area; A.D. 800−1200.
Gold, quartz, H. 1¾ in. 57.32

Page 191, bottom
Vessel in Form of Bird-headed
Figure
Mochica, Peru, North Coast;
A.D. 200−500.
Ceramic, slip, H. 12⅜ in. 58.212

Page 192, left
Sleeveless Shirt
Coastal Huari (Tiahuanaco), Peru;
A.D. 600−1000.
Wool, cotton, 41½ x 42¼ in.
56.430

Page 192, top right
Incised Celt
Olmec, Mexico; 1200−400 B.C.
Jade, H. 14⅜ in. 56.52*

Page 192, bottom right
Pendant, Anthropomorphic
Figure
Coclé, Panama, Parita, Azuero
Peninsula; A.D. 1100−1500.
Gold, tooth (restored),
L. 4⅛ in. 65.140

Page 193
Shirt Section
Coastal Huari (Tiahuanaco), Peru;
A.D. 600−1000.
Alpaca wool, cotton,
21 x 12⅞ in. 56.196

Page 194, top
Pendant: Fantastic Creatures
Veraguas, Panama, provenance
unknown; A.D. 1100−1500.
Gold, H. 2⅞ in. 59.117

Page 194, bottom
Pendant, Fantastic Creature
Veraguas, Panama;
A.D. 1100−1500.
Gold, H. 4¼ in. 58.283

Page 195
Pendant, Figure with
Crocodile Head
Costa Rica, Chiriqui;
A.D. 1000−1500.
Gold, pyrite, H. 6 in. 63.4

Page 198
Sampler (detail)
Early Nazca, Peru, South Coast;
100 B.C.− A.D. 200.
Wool, cotton,
27¾ x 41½ in. 59.161

Page 199
Emblem in Form of Turtle
Ashanti tribe, Ghana.
Gold, H. 4 in. 60.36

Page 200
Pendant of Fantastic
Crocodiles (?)
Coclé, Panama; A.D. 800−1200.
Gold, quartz, H. 1½ in. 58.186

Page 201
Emblem in Form of Double Lizard
Ashanti tribe, Ghana.
Gold, H. 3¾ in. 59.303*

Pages 202−3
Nose Ornament
Mochica, Peru, Loma Negra area;
200 B.C.− A.D. 500.
Silver-laminated copper, gold.
W. 8³/₁₆ in. 69.41

Page 204
Textile (detail)
Peru, South Coast;
A.D. 1450−1550.
Cotton, wool,
22½ x 97½ in. 59.238

Page 205, top
Gold Pendant in Form of Frog
Chiriquí, Panama;
A.D. 1000−1530.
Gold, L. 2¾ in. 59.223

Page 205, bottom
Rattlesnake
Aztec, Mexico, Valley of Mexico
(?); A.D. 1300−1520.
Stone H. 14 in. 57.2

Page 206
Hacha in Form of Fish
Classic Veracruz, Mexico, Vera-
cruz, Ignacio de la Llava (?);
A.D. 300−900.
Stone, shell inlays, paint,
H. 14⅞ in. 66.12*

Page 207
Fish, Gold Weight
Ashanti tribe, Ghana.
Brass, H. 3¼ in. 68.16*

Pages 208–9
Nose Ornament
Mochica, Peru, Loma Negra area;
200 B.C.–A.D. 500.
Silver-laminated copper, gold,
W. 7⅜ in. 69.52

Page 210
"Eagle" Pendant
Chiriquí, Panama; A.D. 800–1500.
Gold, H. 5⅝ in. 59.217

Page 211
Headdress Ornament
Style undetermined, Alaska or
British Columbia; late 19th
century.
Wood, paint, shell inlays,
H. 7¼ in. 57.277

Pages 212–13
Mantle
Coastal Huari (Tiahuanaco), Peru,
Central Coast, area of Patvilica (?);
A.D. 600–1000.
Cotton, wool, 72 x 64 in.
Gift of Arthur M. Bullowa,
1973. 73.26*

Page 214
Pendant
Muisca, Colombia; before
A.D. 1520.
Gold, H. 4¼ in. 57.105

Page 215
Pendant, Eagle
Veraguas, Panama;
A.D. 800–1500.
Gold, H. 4½ in. 58.188

Page 216, top
Finial, Owl
Sinú, Colombia; A.D. 600–1200.
Gold, H. 4¾ in. 59.243

Page 216, bottom
Effigy Vessel of Bird
Chimu, Peru, North Coast, area of
Chan Chan; A.D. 1000–1450.
Silver, H. 6¾ in. 67.10*

Page 217
Headcloth
Chancay, Peru, Central Coast,
from Chancay Valley (?);
A.D. 1200–1450.
Cotton, wool,
20 x 25¾ in. 61.182

Page 218, top
"Slave-killer" Club
Columbia River, Oregon, found
near Sauvies Island; date
uncertain.
Stone, L. 14½ in. 58.229

Page 218, middle
Dugong Hunting Charm
Kiwai tribe, Fly River.
Papua New Guinea, Gulf of Papua
area.
Wood, L. 24⅜ in. 61.95*

Page 218, bottom left
Ornamental Pin: Fantastic Figure
Calima, Colombia; A.D. 400–700.
Gold, H. 15⅛ in. 57.85

Page 218, bottom center
**Ornamental Pin: Monkey
with Snake**
Calima, Colombia; A.D. 400–700.
Gold, H. 9¾ in. 57.149

Page 218, bottom right
Ornamental Pin: Bird
Coastal Huari (Tiahuanaco), Peru,
South Coast; A.D. 600–1000.
Gold, L. 13⅜ in. 58.221

Page 219
Lime Container
Eastern Iatmul tribe, Papua New
Guinea, Middle Sepik River.
Wood, paint, reed,
H. 22¼ in. 57.5

Page 220
Antelope Headpiece
Bamana tribe, Mali.
Wood, H. 35¾ in. 61.248*

Page 221
Antelope Headpiece
Bamana tribe, Mali.
Wood, H. 28 in. 61.249*

Page 222, top
Effigy Vessel of Deer
Chimu, Peru, North Coast, area of
Chan Chan; A.D. 1000–1450.
Silver, H. 5 in. 67.6*

Page 222, bottom
Head of a Ram
Lower Niger Valley style, Nigeria;
about A.D. 1750.
Bronze, H. 7½ in. 58.219*

Page 223
Pendant in Form of Buffalo Head
Baule tribe, Ivory Coast.
Gold, H. 3⅜ in. 56.398*

Page 224
Ornament, Coyote
Maya, Mexico, Campeche;
A.D. 600–900.
Shell, H. 3¾ in. 61.69

Page 225
Howling Coyote
Remojadas, Mexico, Veracruz;
A.D. 600–900.
Ceramic, H. 20 in. 60.185*

Page 226, top
Monkey (?)
Coclé, Panama, provenance
unknown; A.D. 800–1200.
Gold, H. 1½ in. 57.154

Page 226, bottom
Effigy Vessel of Monkey
Chimu, Peru, North Coast, area of
Chan Chan; A.D. 1000–1450.
Silver, H. 5¼ in. 67.13*

Page 227
Shirt (detail)
Ica, Peru, South Coast;
A.D. 1000–1450.
Wool, cotton,
23½ x 30¼ in. 57.211

Page 228
Figure: Baboon
Baule tribe, Ivory Coast.
Wood, paint, fiber,
H. 20¾ in. 62.157*

Page 229
Shirt Section
Ica, Peru, South Coast;
A.D. 1000–1450.
Wool, cotton,
35 x 16½ in. 56.197

Page 230
**Bridge and Spout Vessel
in Form of Jaguar**
Early Paracas, Peru, South Coast;
from Collango, Ica Valley;
700–500 B.C.
Ceramic, resin paint,
L. 8¼ in. 65.114

Page 231
Painted Textile (detail)
Middle Paracas, Peru, South
Coast, possibly from Ocucaje, Ica
Valley; 500–300 B.C.
Cotton, paint,
21 x 70 in. 60.123*

Page 232
Leopard
Court of Benin, Nigeria; about
A.D. 1750.
Bronze, H. 15½ in. 58.90*

Page 233
**Stirrup-spout Vessel
in Form of Jaguar**
Late Chavin, Peru, North Coast,
from Tembladera Jequetepeque
Valley; 700–500 B.C.
Ceramic, H. 9⅛ in. 68.68*

Page 234
Bottle in Form of Feline Head
Late Chavin, Peru, North Coast,
from Tembladera Jequetepeque
Valley; 700–500 B.C.
Ceramic, H. 12¾ in. 67.122*

Page 235, top
Double Bowl
Inca, Peru, A.D. 1438–1532.
Ceramic, L. 7 in. 65.115

Page 235, bottom
Shirt (detail)
Chancay, Central Coast, from
Chancay Valley (?); A.D.
1000–1450.
Wool, cotton, 49⅞ x 70 in. 61.75

Page 236
Sleeveless Shirt
Coastal Inca, Peru, South Coast,
Ica Valley; A.D. 1438–1532.
Wool, cotton, 41½ x 31 in. 65.3*

Page 237, top
Pair of Lions, Royal Emblems
Ashanti tribe, Ghana.
Gold, H. 2¼ in. 61.272 and
61.273

Page 237, bottom
**Pendant of Double-headed
Jaguar**
Veraguas, Panama;
A.D. 1000–1530.
Gold, (tumbaga),
H. 1⅝ in. 58.317

Page 238
Sea-bear Mask
Haida, British Columbia or Alaska;
late 19th century.
Copper, fur, shell inlays,
H. 12 in. 58.329

Page 239
Headdress Ornament
Tsimshian (?), British Columbia;
19th century.
Wood, paint, shell inlays,
H. 7⅜ in. 56.333

Page 242
Stirrup-spout Vessel
Early Chavin, Peru;
1200–1000 B.C.
Ceramic, H. 9⅝ in. 59.4*

Page 243
Double-spout Bottle
Paracas Necropolis, Peru, South
Coast; 200–100 B.C.
Ceramic, H. 6⅜ in. 60.125*

Page 244
Feather Poncho
Inca, Peru, Central Coast, Lower
Ica Valley; A.D. 1438–1532.
H. 11 in. 60.24

Page 245
Feather Poncho (two views)
Inca, Peru, Central Coast, Lower
Ica Valley; A.D. 1438–1532.
H. 8⅞ in. 60.27

Page 246
Canoe Prow Ornament
Suau Island, Papua New Guinea.
Wood, paint, H. 42½ in. 56.84*

Page 247, top
Funerary Ornament
Solomon Islands.
Tridacna shell, W. 6⅞ in. 56.82

Page 247, bottom photo, top
Nose Ornament
Sinú, Colombia; A.D. 600–1200.
Gold, L. 6¾ in. 63.64

Page 247, bottom photo, middle
Nose Ornament
Sinú, Colombia; A.D. 600–1200.
Gold, L. 6⅜ in. 57.146

Page 247, bottom photo, bottom
Nose Ornament
Sinú, Colombia; A.D. 600–1200.
Gold, L. 4⅞ in. 57.144

Pages 248–49
Pair of Ear Spools
Coastal Huari (Tiahuanaco), Peru,
South Coast, from Cahuachi,
Nazca Valley; A.D. 600–1000.
Bone, shell, stone,
Dm. 1⅞ in. 68.67

Page 250, top
Necklace
Mochica, Peru; A.D. 300–600.
Gold, Circum. ca. 48 in. 56.396

Page 250, bottom
Sacred Plaque
Pidgentara tribe, Central
Australia.
Stone, H. 12 in. 56.73

Page 251
Pectoral (Kap-Kap)
New Ireland.
Shell, turtle shell,
Dm. 5¼ in. 57.178

Bibliography

General

Adam, Leonhard. **Primitive Art.** 3rd ed., rev. London: Penguin Books, 1954. First edition, 1940.

Biebuyck, Daniel P., ed. **Tradition and Creativity in Tribal Art.** Berkeley: University of California Press, 1969.

Boas, Franz. **Primitive Art.** Oslo, 1927. (Instituttet for Sammenlignende Kulturforskning. Serie B; Skrifter 8.)

———. **Race, Language and Culture.** New York: Macmillan, 1940.

Dutton, Denis. "Art, Behavior and the Anthropologists," **Current Anthropology,** vol. 18, no.3 (1977): 387–407.

Forge, Anthony, ed. **Primitive Art & Society.** Published for The Wenner-Gren Foundation for Anthropological Research, Inc., London. Oxford University Press, 1973.

Fraser, Douglas. "The Discovery of Primitive Art." **Anthropology and Art,** edited by Charlotte M. Otten, pp. 20–36. Garden City, N.Y.: Natural History Press, 1971.

Fry, Roger. **Last Lectures.** Cambridge: At the University Press, 1939.

Goldwater, Robert. **Primitivism in Modern Art.** Rev. ed. New York: Vintage Books, 1967. First edition, 1938.

Haddon, Alfred C. **Evolution in Art.** London: Walter Scott, 1895. (The Contemporary Science Series.)

Haselberger, Herta. "Method of Studying Ethnological Art," **Current Anthropology,** vol. 2 (1961): 341–84.

Jones, Owen. **The Grammar of Ornament.** London: B. Quaritch, 1868. First edition, 1856.

Jopling, Carol F., ed. **Art and Aesthetics in Primitive Societies.** New York: E. P. Dutton, 1971.

New York. Metropolitan Museum of Art. **Art of Oceania, Africa and the Americas, from the Museum of Primitive Art.** New York, 1969.

New York. Metropolitan Museum of Art. **The Chase, the Capture: Collecting at the Metropolitan,** by Thomas Hoving. New York, 1975.

Otten, Charlotte M., ed. **Anthropology and Art.** Garden City, N.Y.: Natural History Press, 1971. (American Museum Sourcebooks in Anthropology.)

Paris. Musée de l'Homme. **Arts Primitifs dans les Ateliers d'Artistes.** Paris: Société des Amis du Musée de l'Homme, 1967.

San Francisco. Golden Gate International Exposition, 1939. Department of Fine Arts. **Pacific Cultures.** San Francisco, 1939.

Semper, Gottfried. **Der Stil in den Technischen und Tektonischen Künsten, oder Praktische Aesthetik.** 2 vols. Frankfurt-am-Main: Verlag für Kunst und Wissenschaft, 1860–63.

Smith, Marian W., ed. **The Artist in Tribal Society.** London: Routledge & Kegan Paul, 1961. (Royal Anthropological Institute Occasional Paper, no. 15.)

Trowell, Margaret, and Hans Nevermann. **African and Oceanic Art.** New York: Abrams, 1968.

Africa

Bascom, William R. **African Art in Cultural Perspective.** New York: W. W. Norton, 1973.

Bravmann, René. **Open Frontiers.** Published for the Henry Art Gallery by the University of Washington Press, Seattle, 1973. (Index of Art in the Pacific Northwest, no. 5.)

Brooklyn. Brooklyn Museum. **African Art of the Dogon,** by Jean Laude. New York: The Brooklyn Museum in association with the Viking Press, 1973.

Cornet, Joseph. **Art of Africa; Treasures from the Congo.** New York: Praeger, 1971.

D'Azevedo, Warren, ed. **The Traditional Artist in African Societies.** Bloomington, Ind.: Indiana University Press, 1973.

Duerden, Dennis. **The Invisible Present; African Art & Literature.** New York: Harper & Row, 1975.

Elisofon, Eliot, and William Fagg. **The Sculpture of Africa.** New York: Praeger, 1958.

Fagg, William. **Nigerian Images.** New York: Praeger, 1963.

Fagg, William, and Margaret Plass. **African Sculpture.** London: Studio Vista, 1964.

Forman, Werner, and Philip Dark. **Benin Art.** London: Paul Hamlyn, 1960.

Fraser, Douglas, ed. **African Art as Philosophy.** New York: Interbook, 1974.

Fraser, Douglas, and Herbert Cole, eds. **African Art & Leadership.** Madison, Wis.: University of Wisconsin Press, 1972.

Gerbrands, Adrianus A. **Art as an Element of Culture, Especially in Negro-Africa.** Leiden: E. J. Brill, 1957. (Rijksmuseum voor Volkenkunde. Mededelingen, no. 12.)

Griaule, Marcel. **Masques Dogons.** Paris: Institut d'Ethnologie, 1938. (Université de Paris. Travaux et Mémoires de l'Institut d'Ethnologie, 33.)

Guillaume, Paul. **Sculptures Nègres,** 24 photographies précédées d'un avertissement de Guillaume Apollinaire. Paris: Paul Guillaume, 1917.

Hanover, N.H. Dartmouth College. Hopkins Center Art Galleries. **Royal Art of Cameroon,** by Tamara Northern. Hanover, 1973.

Herskovits, Melville. **Dahomey.** 2 vols. New York: J. J. Augustin, 1938.

Himmelheber, Hans. **Negerkunst und Negerkünstler.** Brunswick, Germany: Klinck-

hardt & Biermann, 1960. (Bibliothek für Kunst-
und Antiquitätenfreunde, bd. 40.)

Krieger, Kurt. **Westafrikanische Plastik.** Berlin:
Museum für Völkerkunde, 1965– 69.
(Veröffentlichungen des Museums für
Völkerkunde, Berlin, N. F. 7, 17, 18; Abteilung
Afrika 2, 4, 5.)

Laude, Jean. **The Arts of Black Africa.** Berkeley:
University of California Press, 1971.

Leiris, Michael, and Jacqueline Delange. **African
Art.** New York: Golden Press, 1968.

Leuzinger, Elsy. **Africa; the Art of the Negro
Peoples.** New York: McGraw-Hill, 1960.

Los Angeles. Frederick S. Wight Art Gallery. **Afri-
can Art in Motion,** by Robert Thompson. Los
Angeles, University of California Press, 1974.

Los Angeles. Frederick S. Wight Art Gallery. **The
Arts of Ghana,** by Herbert M. Cole and Doran H.
Ross. Los Angeles, The Regents of the Univer-
sity of California, 1977.

Los Angeles. Museum and Laboratories of Ethnic
Arts and Technology. **Black Gods and Kings;
Yoruba Art at UCLA,** by Robert Thompson. Los
Angeles, 1971. (Occasional papers of the .
Museum and Laboratories of Ethnic Arts and
Technology, University of California, Los
Angeles, no. 2.)

Minneapolis. Walker Art Center. **Art of the Congo.**
Minneapolis, 1967.

New York. Museum of Modern Art. **African Negro
Art,** edited by James Johnson Sweeney. New
York, 1935.

New York. Museum of Modern Art. **African
Textiles and Decorative Arts,** by Roy Sieber.
New York, 1972.

New York. Museum of Primitive Art. **Bambara
Sculpture from the Western Sudan,** with an
introduction by Robert Goldwater. New York,
1960.

New York. Museum of Primitive Art. **Senufo Sculp-
ture from West Africa,** by Robert Goldwater.
Greenwich, Conn.: Distributed by New York
Graphic Society, 1964.

Olbrechts, Frans. **Les Arts Plastiques du Congo
Belge.** Brussels: Éditions Erasme, 1959.

Rattray, Robert. **Religion & Art in Ashanti.**
London: Oxford University Press, 1959.

Robbins, Warren. **African Art in American
Collections.** New York: Praeger, 1966.

Shaw, Thurstan. **Igbo-Ukwu.** Evanston, Ill.: North-
western University Press, 1970.

Storrs, Conn. William Benton Museum of Art, Uni-
versity of Connecticut. **The Sign of the Leopard;
Beaded Art of Cameroon,** by Tamara Northern.
Storrs, 1975.

Willett, Frank. **African Art.** New York: Praeger,
1971.

Zayas, Marius de. **African Negro Sculpture,** photo-
graphed by Charles Sheeler. New York, 1918.

Oceania

Archey, Gilbert. **Whaowhia; Maori Art and Its
Artists.** Auckland, N. Z.: Collins, 1977.

Banks, Joseph. **The Endeavor Journal of Joseph
Banks, 1768– 1771,** edited by J. C. Beaglehole.
Sydney, Australia: Trustees of the Public Library
of NSW, 1962.

Barrow, Terence. **Art and Life in Polynesia.**
Rutland, Vt.: C. E. Tuttle, 1973.

———. **Maori Wood Sculpture of New Zealand.**
Wellington, N.Z.: A. H. & A. W. Reed, 1969.

Behrmann, Walter. **Der Sepik (Kaiserin-Augusta-
Fluss) und sein Stromgebiet; Geographischer
Bericht der Kaiserin-Augusta-Fluss-Expedition
1912– 13.** Berlin: Ernst Siegfried Mittler, 1917.
(Ergänzungsheft Nr. 12 der Mitteilungen aus den
Deutschen Schutzgebieten.)

Berndt, Ronald. **Australian Aboriginal Art.** New
York: Macmillan, 1964.

Buehler, Alfred, Terry Barrow, and Charles Mount-
ford. **The Art of the South Sea Islands, Includ-
ing Australia and New Zealand.** New York:
Crown, 1962.

Chicago. Art Institute. **The Sculpture of Polynesia,**
by Allen Wardwell. Chicago, 1967.

Cook, James. **The Journals of Captain James Cook
on His Voyages of Discovery.** 4 vols. Cambridge:
Published for the Hakluyt Society at the Univer-
sity Press, 1955– 74. (Hakluyt Society, London.
Works. Extra series, nos. 34– 37.)

Cox, J. Halley, and William H. Davenport. **Hawaiian
Sculpture.** Honolulu: University Press of Hawaii,
1974.

Deacon, Arthur. **Malekula.** London: Routledge &
Sons, Ltd., 1934.

Elkin, Adolphus, Catherine Berndt, and Ronald
Berndt. **Art in Arnhem Land.** Chicago: Univer-
sity of Chicago Press, 1950.

Gerbrands, Adrianus A. **Wow-Ipits. Eight Asmat
Woodcarvers of New Guinea.** The Hague:
Mouton, 1967. (Art in Its Context; Studies in
Ethnoaesthetics. Field Reports, vol. 3.)

Guiart, Jean. **The Arts of the South Pacific.** New
York: Golden Press, 1963.

Haddon, Alfred. **The Decorative Art of British New
Guinea.** Dublin: Royal Irish Academy, 1894.
(Cunningham Memoirs, no. 10.)

Hamilton, Augustus. **The Art Workmanship of the
Maori Race in New Zealand.** Dunedin, N.Z.:
Fergusson & Mitchell, 1896– 1900.

Heyerdahl, Thor. **The Art of Easter Island,** fore-
word by Henri Lavachery. Garden City, N.Y.:
Doubleday, 1975.

Kelm, Heinz. **Kunst vom Sepik.** 3 vols. Berlin,
Museum für Völkerkunde, 1966– 68.
(Veröffentlichungen des Museums für
Völkerkunde, Berlin, N.F. 10, 11, 15; Abteilung
Südsee, 5– 7.)

Métraux, Alfred. **Easter Island.** New York: Oxford
University Press, 1957.

New York. Museum of Modern Art. **Arts of the
South Seas,** by Ralph Linton and Paul Wingert, in
collaboration with René d'Harnoncourt. New
York, 1946.

New York. Museum of Primitive Art. **The Art of
Lake Sentani,** by Simon Kooijman. New York,
1959.

New York. Museum of Primitive Art. **Art Styles of
the Papuan Gulf,** by Douglas Newton. New York,
1961.

New York. Museum of Primitive Art. **Crocodile and Cassowary; Religious Art of the Upper Sepik River, New Guinea,** by Douglas Newton. New York, 1971.

Newton, Douglas. **New Guinea Art in the Museum of Primitive Art.** New York: Museum of Primitive Art, 1967. (Museum of Primitive Art Handbooks, no. 2.)

Paris. Unesco. **The Art of Oceania,** by Roger Duff and Stuart Park. Paris, 1975.

Rockefeller, Michael C. **The Asmat of New Guinea,** edited with an introduction by Adrianus A. Gerbrands. New York: Museum of Primitive Art, 1967.

Rousseau, Madeleine. **L'Art Océanien; sa Présence,** introduction by Paul Rivet. Includes essays by Guillaume Apollinaire and Tristan Tzara. Paris: APAM, 1951. (Collection "Le Musée Vivant," no. 38.)

Schmitz, Carl. **Oceanic Art.** New York: Abrams, 1971.

————. **Wantoat.** The Hague: Mouton, 1963. (Art in Its Context; Studies in Ethnoaesthetics.)

North America

Amsden, Charles. **Navaho Weaving.** Santa Ana, Calif.: Fine Arts Press, 1934.

Berlant, Anthony, and Mary Hunt Kahlenberg. **Walk in Beauty; The Navajo and Their Blankets.** Boston: New York Graphic Society, 1977.

Brody, J. J. **Mimbres Painted Pottery.** Santa Fe, N.M.: School of American Research, 1977. (Southwest Indian Arts Series.)

Chicago. Art Institute. **The Native American Heritage,** by Evan M. Maurer. Chicago, 1977.

Chicago. Art Institute. **Yakutat South,** by Allen Wardwell. Chicago, 1964.

Covarrubias, Miguel. **The Eagle, the Jaguar, and the Serpent; Indian Art of the Americas: North America.** New York: Knopf, 1954.

Dockstader, Frederick. **Indian Art in America; the Arts and Crafts of the North American Indian.** Greenwich Conn.: New York Graphic Society, 1961.

Ewers, John. **Plains Indian Painting.** Stanford, Calif.: Stanford University Press, 1939.

Feder, Norman. **American Indian Art.** New York: Abrams, 1971.

Fundaburk, Emma, and Mary Foreman. **Sun Circles and Human Hands: The Southeastern Indians.** Luverne, Ala.: Emma Fundaburk, 1957.

Haberland, Wolfgang. **The Art of North America.** New York: Crown, 1964.

Haury, Emil. **The Hohokam. Excavations at Snaketown, 1954–1965.** Tucson, Ariz.: University of Arizona Press, 1976.

Hawthorn, Audrey. **Art of the Kwakiutl Indians and Other Northwest Coast Tribes.** Vancouver, B.C.: University of British Columbia, 1967.

Inverarity, Robert. **Art of the Northwest Coast Indians.** Berkeley: University of California Press, 1950.

Kansas City. Nelson Gallery of Art and Atkins Museum of Fine Arts. **Sacred Circles; Two Thousand Years of North American Indian Art.** Kansas City, 1977.

New York. Museum of Modern Art. **Indian Art of the United States,** by Frederic H. Douglas and René d'Harnoncourt. New York, 1941.

Ray, Dorothy. **Artists of the Tundra and the Sea.** Seattle, Wash.: University of Washington Press, 1961.

————. **Eskimo Art, Tradition and Innovation in North Alaska.** Seattle, Wash.: University of Washington Press, 1977. (Index of Art in the Pacific Northwest, no. 11.)

————. **Eskimo Masks; Art and Ceremony.** Seattle, Wash.: University of Washington Press, 1961.

Siebert, Erna, and Werner Forman. **North American Indian Art…from the Northwest Coast.** London: Paul Hamlyn, 1967.

Swinton, George. **Sculpture of the Eskimo.** Greenwich, Conn.: New York Graphic Society, 1972.

Washington, D.C. National Gallery of Art. **The Far North,** by Henry Collins, Frederica de Laguna, Edmund Carpenter, and Peter Stone. Washington, D.C., 1973.

Middle America

Anton, Ferdinand. **Art of the Maya.** New York: Putnam's, 1970.

Bernal, Ignacio. **Ancient Mexico in Colour.** New York: McGraw-Hill, 1968.

————. **The Olmec World.** Berkeley: University of California Press, 1969.

Boston. Museum of Fine Arts. **The Gold of Ancient America,** by Allen Wardwell. Boston, 1968.

Coe, Michael D. **The Maya.** London: Thames & Hudson, 1966. (Ancient Peoples and Places, vol. 52.)

————. **Mexico.** New York: Praeger, 1962. (Ancient Peoples and Places, vol. 29.)

Covarrubias, Miguel. **Indian Art of Mexico and Central America.** New York: Knopf, 1957.

Díaz del Castillo, Bernal. **The Discovery and Conquest of Mexico, 1517–1521,** edited by Genaro García; translated with an introduction and notes by A. P. Maudslay. New York: Grove Press, 1956.

Disselhoff, Hans, and Sigvald Linné. **The Art of Ancient America.** New York: Crown, 1961.

Dockstader, Frederick J. **Indian Art in Middle America.** Greenwich, Conn.: New York Graphic Society, 1964.

Easby, Elizabeth. **Pre-Columbian Jade from Costa Rica.** New York: André Emmerich, 1968.

Emmerich, André. **Art Before Columbus.** New York: Simon and Schuster, 1963.

————. **Sweat of the Sun and Tears of the Moon.** Seattle, Wash.: University of Washington Press, 1965.

Greene, Merle, Robert Rands, and John Graham. **Maya Sculpture.** Berkeley: Lederer, Street & Zeus, 1972.

Kubler, George. **The Art and Architecture of Ancient America.** 2d ed. Harmondsworth, England: Penguin Books, 1975. (Pelican History of Art.) First edition, 1962.

Lothrop, Samuel, and H. Roberts. **Coclé, an Archaeological Study of Central Panama.** Cambridge, Mass., 1937–42. (Harvard University. Peabody Museum. Memoirs, 7–8; 1937–42.)

MacCurdy, George. **A Study of Chiriquian Antiquities.** New Haven, Conn.: Yale University Press, 1911. (Connecticut Academy of Arts and Sciences. Memoirs, 3; 1911.)

New York. Center for Inter-American Relations. **El Dorado; the Gold of Ancient Colombia, from El Museo del Oro, Banco de la República, Bogotá, Colombia,** by Julie Jones. New York, 1974.

New York. Metropolitan Museum of Art. **Before Cortés,** by Elizabeth Easby and John Scott. New York, 1970.

New York. Metropolitan Museum of Art. **The Iconography of Middle American Sculpture,** by Ignacio Bernal, Michael Coe, Gordon Ekholm, et al. New York, 1973.

New York. Museum of Modern Art. **American Sources of Modern Art,** by Holger Cahill. New York: W. W. Norton, 1933.

New York. Museum of Modern Art. **Twenty Centuries of Mexican Art.** New York: Museum of Modern Art in collaboration with the Mexican Government, 1940.

New York. Museum of Primitive Art. **The Jaguar's Children,** by Michael D. Coe. New York, 1965.

Prescott, William. **History of the Conquest of Mexico and History of the Conquest of Peru.** New York: Random House, 1931. First published separately, 1843, 1847.

Stone, Doris. **Pre-Columbian Man Finds Central America.** Cambridge, Mass.: Peabody Museum Press, 1972.

Von Winning, Hasso. **Pre-Columbian Art of Mexico and Central America.** New York: Abrams, 1968.

Wauchope, Robert, ed. **Handbook of Middle American Indians.** 16 vols. Austin, Tex.: University of Texas Press, 1964–73.

Willey, Gordon. **Das Alte Amerika,** mit Beiträgen von Ignacio Bernal, et al. Berlin: Propyläen Verlag, 1974. (Propyläen Kunstgeschichte, 18.)

South America

Benson, Elizabeth. **The Mochica.** New York: Praeger, 1972. (Art and Civilization of Indian America.)

Dockstader, Frederick. **Indian Art in South America.** Greenwich, Conn.: New York Graphic Society, 1967.

Harcourt, Raoul d'. **Textiles of Ancient Peru and Their Techniques.** Seattle, Wash.: University of Washington Press, 1962.

Hébert-Stevens, François. **L'Art Ancien de l'Amerique du Sud.** Paris: Arthaud, 1972.

Lanning, Edward. **Peru Before the Incas.** Englewood Cliffs, N.J.: Prentice-Hall, 1975.

Lapiner, Alan C. **Pre-Columbian Art of South America.** New York: Abrams, 1976.

Lehmann, Walter, and Heinrich Doering. **The Art of Old Peru.** New York: E. Weyhe, 1924.

Lumbreras, Luis. **The Peoples and Cultures of Ancient Peru,** translated by Betty J. Meggers. Washington, D.C.: Smithsonian Institution Press, 1974.

Mason, John. **The Ancient Civilizations of Peru.** Harmondsworth, England: Penguin Books, 1975.

Mujica Gallo, Miguel. **The Gold of Peru.** Recklinghausen, Germany: Aurel Bongers, 1959.

New York. Museum of Modern Art. **Ancient Arts of the Andes,** by Wendell C. Bennett. New York, 1954.

New York. Museum of Primitive Art. **Art of Empire: The Inca of Peru,** by Julie Jones. New York, 1964.

New York. Museum of Primitive Art. **Chavin Art, an Inquiry into Its Form and Meaning,** by John Howland Rowe. New York, 1962.

New York. The Solomon R. Guggenheim Museum. **Mastercraftsmen of Ancient Peru,** by Alan Sawyer. New York, 1968.

Sawyer, Alan. **Ancient Peruvian Ceramics: The Nathan Cummings Collection.** New York: Metropolitan Museum of Art, 1966.

Steinen, Karl von den. **Unter den Naturvölkern Zentral-Brasiliens, Reiseschilderung und Ergebnisse der Zweiten Schingú-Expedition, 1887–1888.** Berlin: Reimer, 1894.

Steward, Julian, ed. **Handbook of South American Indians.** 7 vols. Washington, D.C.: Government Printing Office, 1946–59. (U.S. Bureau of American Ethnology. Bulletin 143.)

Credits

The text of this book was set in Egyptian, with display in Friz Quadrata, photo-composed in film on the VIP by Typographic Images, Inc.

Color separations by A. Mondadori Editore
Printed and bound in Verona, Italy, by A. Mondadori Editore

Book, jacket and binding design by James Wageman

Production and manufacturing directed by Peter Mollman
Copy editing and proofreading supervised by Nora Titterington

●

Series coordinator—Megan Marshack
Editor and project director—Paul Anbinder